BAD
GIRLS
and
SICK
BOYS

BAD GIRLS

and

SICK BOYS

FANTASIES IN CONTEMPORARY ART AND CULTURE

Linda S. Kauffman

UNIVERSITY OF CALIFORNIA PRESS

Berkeley Los Angeles London

University of California Press
Berkeley and Los Angeles, California

University of California Press, Ltd.
London, England

Parts of this book were previously published as
follows:

Parts of Chapters 1, 2, and 6 appeared as "Bad
Girls and Sick Boys: Inside the Body in Fiction,
Film, and Performance Art," in *Getting a Life:
Everyday Uses of Autobiography*, ed. Sidonie Smith
and Julia Watson (Minneapolis: University of
Minnesota Press, 1996). Copyright © 1996 by the
Regents of the University of Minnesota.

Parts of the Prologue and Chapter 9 appeared in
the *Cardozo Arts and Entertainment Law Journal*
11:3 (1993): 765–75. Copyright © 1992 Linda S.
Kauffman.

Parts of Chapters 1, 2, and 3 appeared in *Two Girls
Review* 1:1 (1995): 82–91 and 1:2 (1995–96):
112–21. Copyright © 1995 Linda S. Kauffman.

Library of Congress Cataloging-in-Publication Data

Kauffman, Linda S., 1949–
 Bad girls and sick boys : fantasies in contem-
 porary art and culture / Linda S. Kauffman.
 p. cm.
 Includes index.
 ISBN 0–520–21030–1 (cloth : alk. paper).—
 ISBN 0–520–21032–8 (pbk. : alk. paper)
 1. Human figure in art. 2. Body, Human,
 in literature. 3. Fantasy in art. 4. Feminism
 and the arts. 5. Postmodernism. 6. Arts,
 Modern—20th century. I. Title.
NX650.H74K38 1998
700'.457—DC21 97-28651
 CIP

Manufactured in the United States of America
9 8 7 6 5 4 3 2

For Ira Mehlman and
in memory of Bob Flanagan
(December 26, 1952–January 4, 1996)

Contents

Illustrations

Acknowledgments

When I began research on this book in Berkeley in 1991, I could never have imagined the odyssey that lay ahead. I did not even know what I was looking for, but what I found were generous friends all over the United States and Europe. In the San Francisco Bay area, Iain Boal, Terry Castle, Carol Clover, and Jeff Escoffier helped give shape to early bad drafts and sickly prose. Jim Brook introduced me to J. G. Ballard's work; Rita Cummings Belle became my scout in cyberspace. I'm grateful for a fellowship in 1991–92 at the Humanities Institute at the University of California, Davis, particularly for the comradeship of Kay Flavell and Laura Mulvey.

In 1993, the University of California Humanities Research Institute at U.C. Irvine invited me to participate in the faculty seminar "Minority Discourse." I thank Mark Rose, U.C.H.R.I. director, and Valerie Smith, as well as the institute's staff, especially researcher Chris Aschan.

I owe both of these fellowships to six indefatigable referees—John Bender, Deirdre David, Frank Lentricchia, Marjorie Perloff, Garrett Stewart, and Catharine Stimpson. Tanya Augsburg, Marcie Frank, Glenn Marcus, and Peggy Phelan shared ideas and research. John Arno, Anthony DeCurtis, Mark Harris, Howard Norman, Jane Shore, Alice Wexler, and David Wyatt challenged and inspired me, while providing all sorts of practical help.

For research leave, funds, and technical support, I am grateful to the English Department and staff, the College of Arts and Humanities, the

Office of Graduate Studies and Research, the Office of International Affairs, and the Committee on Africa and the Americas, all of the University of Maryland, College Park. My students, particularly my intrepid researchers Jonathan Ferguson, Marsha Gordon, Reva Gupta, Katrien Jacobs, Devin Orgeron, David Paddy, Joe Schaub, Elizabeth Swayze, Deb Taylor, and Caroline Wilkins, gleefully supplied me with numerous examples of bad girls and sick boys.

My agent, Andrew Blauner, has been an unwavering supporter, faxing me a steady supply of items hot off the press. His acumen and intellect made this a better book. At the University of California Press, I thank Naomi Schneider, my editor; Rachel Berchten, Robert Irwin, and Ruth Veleta; as well as readers Gloria Frym, Lisa Lowe, and especially David Shumway for immeasurably improving the manuscript.

Finally, among the artists who so generously shared their time, J. G. Ballard, David Cronenberg, Matuschka, Orlan, Sheree Rose, and Carolee Schneemann deserve special mention. My gratitude to John and Frances MacIntyre, Kay Austen, Richard Dysart, Kathryn Jacobi, and Dr. Robert Gerard is boundless. I dedicate this book in loving memory of Bob Flanagan, who died too soon, and to Ira, who found me just in time.

September 15, 1997
Washington, D.C.

Prologue

Contemporary culture is saturated not with pornography but with fantasy. The performers, filmmakers, and writers in this book are dedicated to decoding those fantasies. The bad girls in these pages are savage satirists with a keen sense of the absurd. Some of the sick boys similarly exhibit their own bodies as medical specimens; others seize medicine as material and metaphor. Collectively, the work of the women and men whom I discuss is too literal for art, too visceral for porn. These artists approach the body as material in every sense of the word: as matter—tangible and tactile—it is what matters most. The body is the materialist base, a methodological field for investigations of politics, history, identity. The body is simultaneously evidence of and material witness to the process of metamorphosis mapped here. That metamorphosis is the result of radical innovations in science, medicine, and technology, but the specialists responsible for these innovations seldom analyze their larger implications. In public policy and the news media, moreover, these developments are usually depicted in either utopian or apocalyptic terms—as if they will lead to either salvation or doom. In contrast, the artists in this book serve as interpreters of this brave new world, for by seizing these new technologies to radicalize artistic practices, they challenge society's most cherished assumptions about the body's integrity and rectitude.

We need artists to interpret the new technologies, for only they have the means to go beyond technology to analyze the underlying motivations and contradictory impulses inherent in it. Only they can expose the

latent and manifest meaning of the world that already invisibly envelops us. These artists are the real translators of contemporary culture, revealing *what is really happening* at a moment when we are moving toward a very different understanding of what culture might be.

STRUCTURE AND METHODOLOGY

This study is divided into nine chapters, each subdivided into three parts. Part 1, "Performance for the Twenty-first Century," is devoted to performers who exhibit what is past, passing, and to come for the human body. Some explore the body's elemental origins and earliest mythologies, while others focus on a posthuman future. *Posthuman* signifies the impact technology has had on the human body. Any candidate for a pacemaker, prosthetics, plastic surgery, or Prozac, sex reassignment surgery, in vitro fertilization, or gene therapy, can be defined as posthuman. Our views of these developments derive wholly from what specialists—doctors, researchers, psychiatrists—report; however, artists are beginning to intervene. In the process, they provide new insights and new metaphors, deconstructing the ideas of the *museum* and the *human.*

Since one seldom hears from the patient whose body is turned into a "specimen," the first two chapters are devoted to two artists who "go inside" their own bodies: Bob Flanagan and Orlan. Flanagan, one of the sick boys of my title, had cystic fibrosis. Orlan, a French performance artist, orchestrates plastic surgery operations in art galleries, turning her own face into a composite of classical paintings, a living computer "morph." Orlan is one of several women in my second chapter, devoted to cutups in beauty school; these radical body artists expose the culture's deepest psychic investments in beauty and femininity. They are wicked comedians who dissect male medical, scientific, and aesthetic ideologies with surgical precision.

Part 2, "Visceral Cinema," asks why sex and violence have such abiding *appeal*. Chapter 3, "Impolitic Bodies," deals with a number of astonishing films produced by a group of young British and American filmmakers, most of whom are black. They consider Hollywood completely irrelevant and instead focus on relationships between the social and the psychic. Ngozi Onwurah's *Body Beautiful* (Great Britain, 1991) depicts things never before seen on-screen: the sexual fantasies of an aging white woman whose mastectomy elicits visceral responses from the other characters and the audience alike. Scott McGehee and David Siegel's *Suture* (United States, 1993), similarly revolves around a hospital setting where

a black amnesia patient, victim of attempted fratricide, struggles to come to terms with racial identity. Isaac Julien's *Attendant* (Great Britain, 1992) focuses on the homosexual fantasies of a black guard in an art museum. As he moves among the paintings, gay men come and go, thinking of Robert Mapplethorpe. These films highlight fantasy's new formations, postcolonial influences, phantasmic constructions of subjectivity and identity.

To understand the appeal of sex and violence, one need look no further than the film genres of pornography and horror. What better way to analyze cinema's effects than by focusing on films that deal with how those effects are created, with the business of moviemaking? Chapter 4, "Sex Work," is devoted to John Byrum's *Inserts* (1976), Brian De Palma's *Body Double* (1984), and Gus Van Sant's *My Own Private Idaho* (1991). While all three films satirize the porno industry, they also counteract the feminist antipornography movement's mythic construction of man as oppressor by portraying male subjectivity with considerable poignancy.

A similar point is made in David Cronenberg's films, too, although as Chapter 5 shows, Cronenberg goes furthest in exploiting cinema's visceral capacities and in exploring the impact of technology. Cronenberg is our epoch's Ovid, fascinated with metamorphoses: organic to inorganic, male to female, human to insect. He advances the explorations of the performers discussed in Part 1, for all his films show how pharmaceutical, genetic, and reproductive breakthroughs have irrevocably altered the very notion of the human.

Part 3, "Arresting Fiction," deals with novelists who have been targets of censorship. Like the performers and filmmakers in my study, they too explore the impact of new technologies on aesthetic forms. Chapter 6, "J. G. Ballard's Atrocity Exhibitions," is devoted to an author who maps the coordinates of sex and violence in the media, advertising, car crashes, outer and inner space. Ballard's topic is the nervous system, by which he means not just the human body, but the body as an aggregate of invisible networks of power.

In Chapter 7, "Criminal Writing," I discuss John Hawkes and Robert Coover, who pay homage to the Marquis de Sade's regime of rituals and discipline. Hawkes and Coover transform sexual "discipline" into a metaphor for the creative process; simultaneously, they remind us of the sensuous properties of prose, the erotics of reading and writing. To them, writing is by definition "criminal," an act of rebellion against conventional morality.

Chapter 8, "New Inquisitions," focuses on Kathy Acker and William Vollmann, who are emerging as two of the leading "underground" voices of a younger generation. They are willing to risk a profound social anger seldom seen in novels canonized by the popular press. Acker's *Don Quixote* (1986) and Vollmann's *Whores for Gloria* (1991) both reinvent Cervantes's *Don Quixote*. Each transports the Knight of the Woeful Countenance to postmodern America—where it is not sex but power that is obscene.

Inquisitions are also the topic of my final chapter, "Masked Passions," which deals with the antipornography activism of Catharine MacKinnon and Andrea Dworkin and the impact of the Meese Commission on Pornography. It also juxtaposes Dworkin's *Mercy* (1990) and Bret Easton Ellis's *American Psycho* (1991). Ironically, although their views on pornography are diametrically opposed, both novelists portray America's greed, disintegration, and psychosis. The fact that two novelists at opposite ends of the ideological spectrum have *both* been targets of censorship should make one wary of censorship campaigns in general.

Bad Girls and Sick Boys features interviews and correspondence with J. G. Ballard, Bob Flanagan, Sheree Rose, Orlan, Carolee Schneemann, and David Cronenberg. In addition to visual and literary works, I analyze discourses in public policy, the news media, and the law. Two of my previous books helped lay the groundwork for the present study: *Discourses of Desire: Gender, Genre, and Epistolary Fictions* (1986) examines how literary genres are formed, deformed, and transformed—from Ovid to the twentieth century. *Special Delivery: Epistolary Modes in Modern Fiction* (1992) concentrates solely on twentieth-century fiction (most written after 1962), while tracing the development of the avant-garde from the Futurists and Russian formalists to postmodern writers. Since my background in literary theory and feminist theory informs *Bad Girls and Sick Boys,* some readers may find "too much" theory in these pages, but I have purposely simplified this specialized language, since my audience extends to many "lay people" in legal, feminist, and artistic circles who find it academic—in both senses of the word. In so doing, I am merely following the example of the artists themselves: most are well versed in theory, but their art is not pedantic. As a feminist, moreover, I find it disheartening that when one thinks of "radical feminists," only Catharine MacKinnon and Andrea Dworkin come to mind, to the exclusion of many other feminist activists. By expanding the scope of my audience, I hope to reclaim the word *radical* for anticensorship feminists.

Despite that caveat, a remarkable wealth of scholarship has appeared

in recent years that is indebted to theory, tracing the historical construction of the body, sexuality, and gender. This scholarship provides valuable insight into the past.[1] As Barbara Stafford points out, every major aesthetic, critical, biological, and humanistic issue now facing us would be illuminated via refraction through the prism of the early modern period. That period paved the way for synthetic realism, disembodied information, simulated events, and virtual imagery.[2] Nevertheless, much remains to be done on implications for the future. It has become a critical commonplace to speak of the new identities emerging in cyberspace, but one must still evaluate the *type* of subject the new communications systems encourage. So far, analysts have focused on efficiency and productivity; their aim is to reinforce traditional forms: the rational, autonomous man of law; the educated citizen of representative democracy; the "economic man" of capitalism.[3]

These are precisely the forms subverted throughout my study: utilitarianism in all its guises; narratives of social order, normalization, and regulation; idealized visions of the rational man, citizen, and consumer. By highlighting the vicissitudes of psychic life, these artists subvert cherished notions of autonomy and rationality. My subtitle thus signifies the unconscious as well as the body's "insides." These artists are interested in the *mythologies* of sexuality—the cherished assumptions that sex is the key to identity, the last refuge of interiority, the source of liberation, and the property of individuals. I call these artists "boys and girls" to highlight fantasy's infantile origins. They are not interested in "the facts of life"; instead they are interested in the sexual theories children concoct to explain conception and sexual difference. This is an important distinction, because it frees them from positivist traps about whether Freud was "right" or not. To them, all versions of a myth are in some sense "true," including the kinds of lies, evasions, and disavowals that Freud himself analyzed. Approaching psychoanalysis as "our beautiful modern myth" frees these artists to embroider on its topographical and spatial metaphors, to invent what some call a new "metaphorology," others a new "symptomology." They do not endorse a universal, essentialist notion of the human psyche, but they do exploit the myths and narratives that pervade Western culture, from folktales to Oedipus. These artists explore sexuality in all its guises—as a drive, an act, an identity, a set of orientations.[4] Freud is thus fundamental, for he provides an archive of fantasy's shadow realm.

They approach Jacques Lacan in the same spirit, for he transformed Freud's biological and organic metaphors into linguistic and structural

ones. Many of these artists draw implicitly or explicitly on his analysis of what happens in the Mirror Stage, between the ages of six and eighteen months, when an infant sees his or her reflection in a mirror. The infant invests the mirror image with the sense of coordination she or he does not yet possess, propped up by the mother. The moment is "Imaginary"—dependent on images, the imago, the illusory. But it is based in the tangible reality of the body, which is unintegrated and uncoordinated. The moment is thus "anticipatory"; the infant wants his or her body to match the mirror-image ideal. But ideal and reality never do merge, although memory of that mirror ideal remains imprinted on the psyche. The Mirror Stage is the inaugural moment when subjectivity is irremediably split. Projection, Lacan concludes, is an ontological structure; the agency of the ego is situated in a *fictional* direction.[5]

These concepts help unravel multiple misconceptions about the relationship of reality to fantasy, for rather than being diametrically opposed, they are indissolubly linked and interdependent. The body has a tangible reality that contributes to the phantasmic formation of the ego. But if the ego is a projection, it does not project the real, anatomical body; instead, it projects its libidinal investments in its own body.[6] The artists I discuss repeatedly remind us of these libidinal investments and their phantasmic origins.

What makes Lacan so interesting to literary theorists is precisely the "fictional direction" of the ego.[7] Lacan's mirror is both literal and metaphorical, for if subjectivity is a process of fiction making, then art, literature, cinema, and popular culture all contribute to the "Image-repertoire." We should speak as confidently of the Mirror Stage in Cervantes, Flaubert, and Dostoyevsky as of Hamlet's Oedipus complex, for in *Don Quixote, Madame Bovary,* and *Notes from Underground,* the mirror ideal lies in books; life is but a poor imitation. As Dostoyevsky's underground narrator laments: "We are so unused to living that we often feel something like loathing for 'real life' and so cannot bear to be reminded of it. We have really gone so far as to think of 'real life' as toil, almost as servitude, and we are all agreed . . . that it is better in books. . . . We don't even know where 'real life' is lived nowadays, or what it is, what name it goes by."[8] Significantly, each of these novelists was responding to the popular culture of his day: Cervantes's Knight is enchanted to the point of madness by courtly romances; Emma Bovary (who is sometimes called "the female Quixote") is a voracious devourer of mass-produced books. She has implicit faith in all the clichés of pulp fiction. Just as *Madame Bovary* is Flaubert's revenge on smug French philistines, *Notes from Underground*

is a vehement reaction to the smug self-satisfaction of the Great Exhibition of 1851—an event which, not coincidentally, was the first public celebration of commodity culture; it offered people a new mode of social existence, as relations between people dissolved into relations between things, and relations between things materialized into the society of spectacle.[9]

Today, one need only supplement Dostoyevsky's *books* with *songs, television, advertising,* and *movies:* these new media further propel the fractured ego in multiple fictive directions, which is why Bret Easton Ellis's *American Psycho* begins with an epigraph from *Notes from Underground.* Popular culture is a "desire-producing machine." Today, the confusion about popular culture's impact is pervasive in public discourse; antipornography activists insist that images of sex and violence have a direct impact on audiences, while anticensorship activists deny this. *Bad Girls and Sick Boys* shows that both factions are wrong: popular culture *does* have an impact, but not in the formulaic ways its detractors imagine.

If the psychic is one foundation for my study, the social is thus the other, with particular emphasis on aura, ideology, and spectacle. Where Lacan analyzes the Mirror Stage schism between "copy" and "original" by dismantling the myth of the self's inviolate authenticity, Walter Benjamin dissects human sense perception from another angle. Far from being natural, universal, and unchangeable, the five senses are constructed, contingent, and must be contextualized politically. In "The Work of Art in the Age of Mechanical Reproduction," Benjamin demonstrates that while the meaning and value of a work of art are imbedded in the fabric of tradition, tradition itself is contingent and variable. Where the ancient Greeks venerated a statue of Venus, for example, clerics in the Middle Ages viewed it as an ominous idol. But both epochs were confronted with the uniqueness of Venus's aura, which had its foundation in ritual. Reproductions, however, by definition have no aura or authenticity. By shifting the angle of perception away from ritual and toward everyday life, reproduction shattered tradition forever. Through their capacity for reproducibility, photography and film liquidated the traditional value of the cultural heritage, shifting its basis from ritual to politics. The total function of art was irrevocably transformed.[10]

Today, when politicians and pundits complain that art has become "too political," they are thus ignoring a long, historical process. Moreover, their exhortation to go back to "the classics" ignores the fact that the classics contain merciless satires of people like *them* who attack art, as in the work of Cervantes, Dostoyevsky, Flaubert. Nevertheless, they hold tenaciously to an image of a past when art was allegedly "above"

ideology.[11] This belief demonstrates that the Mirror Stage is not just individual but social, for the myth that salvation lies in some golden past is part of a collective fantasy, a social "Imaginary." But the only sure thing about the organic society, as Raymond Williams has commented, is that it is always gone.[12]

Detractors also accuse contemporary performers, novelists, and filmmakers of undermining an innate, universal, human essence, heretofore inviolate, but these artists are hardly the first to expose the inside of the body, to plumb the lower depths. Instead, their endeavors are merely continuations of Galen's conception of anatomy as an "opening up in order to see deeper or hidden parts," which, as Stafford notes, drives to the heart of a central problem for the Enlightenment: how to see inside, how to master the interior of the human.[13] Scientific experiments in biology, physiology, and anatomy, aided by technological inventions (magnifying glass, microscope, surgical instruments), gave us access to those depths. They also gave us new metaphors, for the eighteenth century's encyclopedic classification of the human body transformed it into the symbol of all structures, an organic paradigm for all complex unions.[14] By the early nineteenth century, the organic metaphor was already being supplanted by a technological one; man's perception of himself as an aggregate of machine technology has its origins in the early Industrial Revolution.[15] The invention of photography and cinema further reoriented the five human senses, foregrounding the dialectics of seeing.[16] Photography, which appeared simultaneously with socialism, was a revolutionary means of reproduction, changing how and what we see. The camera was the first in a rapid succession of repetition machines (typewriter, phonograph, cinema); the random generation of words, sounds, and images undermined cherished beliefs about both human subjectivity and cultural value.[17] Film changed human sense perception further by bringing our world closer spatially and humanly, documenting such aspects of everyday life as labor, strikes, famine, and revolution.

For the artists I discuss, the body is "revolting" in both senses—it is repulsive and in rebellion. Just as medical breakthroughs have caused seismic upheavals in perceptions of the body, so too have breakthroughs in the computer technologies used in film. One can now see the body's insides "opened up" in such films as David Cronenberg's Scanners, where, in a spectacular contest between psychic superpowers, a man's head literally explodes. "I don't particularly like cerebral movies," Cronenberg said of the scene. "On the other hand, I don't like movies that are all viscera and no brains."[18] His droll observation could serve as the motto for

Bad Girls and Sick Boys, for all the artists in these pages explode the definitions of pathology and pornography. The Greek *pornographos* means "the writing of, on, about, or even for harlots"; by extension, it signifies the life, manners, and customs of prostitutes and their patrons. Not just scenes of sex, in other words, but descriptions of everyday life, from the viewpoint of the masses.

THE LAW AND TRANSGRESSION

In censorship debates, "the masses" have been feared ever since the word *pornography* entered the language. *Regina v. Hicklin* (1868) declares the test of obscenity to be whether a publication had any tendency morally to corrupt the young or those otherwise "susceptible." Those whose minds were "open to immoral influences" included ladies, children, the feebleminded, immigrants, and minorities—as if those listed were all equivalent.[19] Vestiges of the hoary Hicklin doctrine resurface today whenever we hear warnings of the damage that MTV or rap music inflicts on "impressionable minds." The world was safer (so the argument goes) when the Victorian gentleman's secret museum of pornography was kept out of the hands of "the masses."

But mass *production* shattered that haven and that myth, just as Walter Benjamin predicted. In 1957, in *Roth v. United States,* Judge Jerome Frank ridiculed the notion that the elite could see materials that should be kept from the "impressionable minds" of "the masses." In a prophetic decision, he warned that Roth's conviction for mailing obscene, lewd, lascivious, or filthy materials meant that the relationships between law and aesthetics would be distorted forever after:

> The contention would scarcely pass as rational that the "classics" will be read or seen solely by an intellectual or artistic elite; for, even ignoring the snobbish, undemocratic, nature of this contention, there is no evidence that the elite has a moral fortitude (an immunity from moral corruption) superior to that of the "masses." And if the exception, to make it rational, were taken as meaning that a contemporary book is exempt if it equates in "literary distinction" with the "classics," the result would be amazing: Judges would have to serve as literary critics; jurisprudence would merge with aesthetics; authors and publishers would consult the legal digests for legal-artistic precedents; we would some day have a legal restatement of the canons of literary taste.[20]

That is precisely the situation today, forty years later, as evidenced in the transcripts of the 2 Live Crew trial and the prosecution of Dennis Bar-

rie and the Contemporary Arts Center in 1991 for exhibiting Robert Mapplethorpe's photographs in Cincinnati.

Justice William Brennan wrote the majority opinion in *Roth v. United States,* which paradoxically resulted in Roth's conviction but allowed Brennan to broaden the definition of protected speech. It is the *Roth* decision, indeed, that constitutionalizes certain types of obscenity. The Brennan doctrine also nationalized obscenity law, so that no book could be published in California and Massachusetts but banned in New York and Illinois. The Brennan doctrine ended censorship of the literary obscene by pressure groups, police, prosecutors, and judges. Chief Justice Warren Burger, however, undermined the Brennan doctrine in two ways. First, in *Miller v. California* (1973), the Burger court curtailed the Brennan doctrine by adopting the local community standard rule. Today, the legal prosecution of obscenity depends on: (1) "whether *the average person,* applying contemporary community standards, would find that the work, taken as a whole, appeals to the prurient interests"; (2) "whether the work depicts or describes in a patently offensive way, sexual conduct specifically defined by the applicable state law"; and (3) "whether the work, taken as a whole, lacks serious literary, artistic, political or scientific value."[21] Second, the Burger court effaced the traditional distinction between obscenity (which is a legal crime) and pornography (which isn't); today, that distinction has been wholly lost.[22]

The definition of transgression is even more elusive. *Transgression* means "to go beyond the boundaries or limits prescribed by a law, command, etc.; To break, violate, infringe, contravene, trespass against." But transgression is a slippery term, especially as it relates to the very conception of the "avant-garde." Since its inception, the idea of the avant-garde has been contested, and the value of shock, confrontation, and parody challenged. How does one transgress the ideology of the transgressive, sometimes called "avant-gardism"?[23] Following the Russian Revolution, the avant-garde sought to reintegrate art with everyday life. At least since the 1920s, the aim has been to create a more encompassing space for art in social life—in literature, visual art, crafts, architecture, design, and theater. While some theorists of the avant-garde are accused of reifying the very categories they claim to dismantle,[24] others eulogize the avant-garde's utopian ideals.[25]

Put another way, transgression—like nostalgia—isn't what it used to be. That paradox is the starting point for *Bad Girls and Sick Boys,* for the artists discussed here remain skeptical about the very possibility of transgression. On the one hand, obscenity prosecutions turn them into

martyrs—regardless of the work's merits—transgressive or not. On the other hand, commodity culture chews up anything transgressive, makes it palatable, and spits it out again. Today's transgression is tomorrow's television commercial. As Georges Bataille notes, "The transgression does not deny the taboo but transcends it and completes it."[26] While the artists I describe grapple with Bataille's intractable paradox, they simultaneously find themselves embroiled in public debates about the role and function of representation: is there a causal relationship between words and deeds, images and acts of sex and violence?

THE ANTIAESTHETIC: SIX MOTIFS IN THREE MEDIA

Why choose performance, film, and fiction? Because we are moving toward a new definition of culture, each medium is at a crossroads, for each must confront the paradoxes of transgression and assimilation in a culture of consumption. While gaining academic respectability, performance has to find ways to keep its cutting edge. Confronted with the fact that they are now merely one element among a vast array of fiction makers in advertising and popular culture, novelists must find ways to reinvent reading and restore its subversiveness. Electronic media have superseded cinema, too, as Laura Mulvey points out: "The political and psychological importance of representation systems escalates with the growth of entertainment and communications industries. These industries not only have an ever increasing importance in contemporary capitalism, but spectacle and a diminishing reference are essential to their spread and their appeal."[27] By "diminishing reference," Mulvey means that it is becoming more and more difficult to trace the proliferation of representations back to any single referent or historical event. Instead, we are surrounded by simulations—what might be called "Disneyfication" (as when Disney America planned to re-create a Virginia slave plantation as a theme park, minus slavery's "negativity"). By examining fiction, film, and performance jointly, one discovers strategies that subvert cultural amnesia and saturation by simulation. The performers, filmmakers, and novelists I have selected all experiment with multiple media for precisely these purposes. In the process, they are pointing the way toward not just new art but a new criticism. These artists have been selected because they are creating new spaces of knowledge.

Performance takes place in the present. It is live, spontaneous, ephemeral. It is unreproducible—no two performances are the same. It is also interactive, inviting spectators to reconceptualize the boundaries

between self and other, art and life, life and death. The focus is on the performer's body, in pain or pleasure. The corporeal is literally the *embodiment* of the psychic real.[28] By focusing on performers who consciously stage their own bodies as technological sites, one begins to see how utterly the human senses have been reoriented. Performance exploits tactility, materiality, and immediacy: it has a graphicness that the novelists and filmmakers in my study both envy and emulate.

In contrast to performance, film is far more technical and collaborative, combining recorded sounds and images, then manipulating them through editing, special effects, and computer technology. To explain cinema's origins, film critics traditionally contrast the different styles of the two founders of film tradition, Louis Lumière and Georges Méliès. Lumière represents cinema's fascination with science and naturalism; he recorded current events, and his work is seen as the predecessor of the newsreel and documentary. Méliès, in contrast, is a conjurer and illusionist who exploited the magical and fantastic elements of film. But even such critical commonplaces have recently been called into question, for in disengaging fleeting perceptions from scenes of everyday life, Lumière followed in the Impressionists' footsteps. Conversely, Méliès documents, analyzes, and anticipates the actual technological transformations in modern society; in this regard, he could be seen as a proto-Brecht, a critical social realist.[29] Since David Cronenberg explicitly compares himself to Méliès, it will be interesting to see *which* Méliès he has in mind. If film theory is in the process of metamorphosis, so are the films themselves: for example, *The Body Beautiful,* by Ngozi Onwurah (1991), creates a new hybrid from documentary, one that might be called "performative documentary."

In fiction, the contrast between what the texts are saying and what critics, reviewers, and pundits are saying about them is more marked than ever. By showing how certain classics are reinvented, one begins to see current controversies about censorship in a different light. (One also learns better how to read the old masters.) Since hypertextual experiments make reading interactive and spontaneous, fiction is beginning to exploit techniques traditionally associated with performance and film. The computer dissolved the idea of the text as the sacred property of the author; hypertext's interactive spontaneity may finally free fiction from the stranglehold of Aristotelian mimesis.

No single orthodoxy unites these audacious, original artists. There is no coherent (anti)aesthetic—and probably never will be, thank goodness. But in these pages, one will find six recurrent motifs:

1. Critiques of mimesis: these artists subvert the notion that the aim of art is to hold the mirror up to nature. Instead, they highlight the experimental, partial, fragmentary aspects of artistic production. For instance, Robert Coover's *Spanking the Maid* is "hysterical" in both senses of the word—a funny and frantic flow of Freudian slips, dreams, and riddles that thwart any attempt to see the novel as a representation of reality. Instead, it is a supremely self-referential exercise about writing's frustrations.

2. The ironic awareness that no antiaesthetic is wholly transgressive or even *new*. Indeed, the notion of an antiaesthetic has ancient generic roots, dating back to Menippean satire, which has been illuminated in contemporary criticism by Mikhail Bakhtin's theories of the carnivalesque. Carnival's roots in pre-Christian Greece and Rome subsequently became associated in the Middle Ages with pre-Lenten celebrations—a brief moment when the lords of misrule sanctioned pleasure and carnality.[30]

3. The rejection of Art for Art's Sake. While some maintain that *l'art pour l'art* has long been dead, it is a notion constantly resurrected, most recently in Wendy Steiner's *Scandal of Pleasure,* a spirited defense of "aesthetic bliss."[31] Not surprisingly, there is considerable confusion right now about pleasure and beauty—pleasure in looking, touching, thinking. *The Atrocity Exhibition* and *Crash* defy conventional expectations about plot, character, and linear narrative; what "beauty" they find lies in geometry, fusions of flesh and metal, Surrealist juxtapositions of icons, and iconoclasm.

4. Rather than debating the nature of truth, these artists focus on the struggle for control of "truth"[32]; rather than promoting the aesthetic of beauty, they critique the ideology of aesthetics. Autonomy and objectivity are illusory, too; one cannot claim "mastery" of a work merely by enumerating its formal qualities as an object. Legally, a work is obscene if, "taken as a whole," it "lacks serious literary, artistic, political or scientific value," but that criteria cannot do justice to works that are fragmented, disorienting, ephemeral. Postmodern fiction, film, and performance art consist of holes, not wholes.[33]

5. Dissolution of dichotomies dividing high and low culture, theory, and practice. While Orlan lies on the operating table, she reads from Lacan, Artaud, Julia Kristeva. Their work serves as a kind of annotation of her "ordeal art." The antiaesthetic dismantles Carte-

sian dualisms; sometimes the lower body in all its grossness and carnality is juxtaposed with intellect and rationality, as in John Hawkes's *Virginie: Her Two Lives;* sometimes mind and body are melded in virtual reality to create "New Flesh," as in Cronenberg's *Videodrome.* Far from exalting the true, the good, and the beautiful, the antiaesthetic often substitutes the ugly, the perverse, the antiromantic—a welcome antidote to the ideology of romantic love (the very ideology that hooked Emma Bovary).

6. The strategic definition of postmodernism as an oppositional politics, rather than a mere pastiche of parodic moments. There are two different "postmodernisms": one preserves the humanist tradition by turning postmodernism into a mere style; the other deconstructs traditions, critiques origins, questions rather than exploits cultural codes to expose social, sexual, and political affiliations.[34] *Bad Girls and Sick Boys* is in the latter camp.

When we examine how these six motifs are played out in three different media, a very different concept of culture and criticism in the current landscape begins to emerge. One thing we shall discover is that politicians and pundits are looking for porn in all the wrong places. Another is that some specialists who confine themselves to one medium perpetuate misconceptions about the other two, particularly concerning feminism, postmodernism, and theory. For example, performance artist Joanna Frueh, in her *Erotic Faculties,* wants to "fuck theory"; she attacks postmodernism for mystifying cant and canceling the erotic. Frueh perpetuates the clichéd dichotomy between male theory and female experience. She wants to celebrate body consciousness, which she claims has been eliminated by the "unloving tongue of Postmodern Mysteries."[35] If Frueh were to read John Hawkes and Robert Coover, however, she would find many of her own ideas confirmed: the glory of the erotic, sensuous, tactile, voluptuous. Kathy Acker goes even further in putting into practice the very ideas Frueh espouses about the revolutionary power of women's laughter and "writing the body." Moreover, Acker acknowledges her indebtedness to the theoretical work of Julia Kristeva and Hélène Cixous.

Where Frueh blames postmodernism and "male theory" for stifling feminism, Robert Ray and Steven Shaviro blame feminism, specifically feminist psychoanalytic theory, for stunting the field of film studies. Where Ray traces film's avant-garde impulses back to Surrealism, Shaviro proposes an anti-Freudian model based on Bataille, Deleuze, and Guattari.

Frueh, Ray, and Shaviro are all complaining about the institutionaliza-tion of certain theoretical practices—they simply disagree about who the culprit is and what the alternatives should be. Ironically, my own study has surprising parallels to those of all three authors, but by enlarging the frame of reference to include fiction, film, and performance, one discovers that neither feminism, nor psychoanalysis, nor postmodernism, nor "theory" can be dismissed so readily. What one sees depends on the frame. I examine how the issues and impulses are framed; what the implications are; what the frame of reference is.

Numerous books about pornography have appeared in recent years, but they usually focus on one artistic medium, or one area, such as legal cases.[36] Typically, the legal controversy overshadows analysis and exe-gesis of the art on its own terms. Nor is art in one medium contextual-ized in relation to other media. Only by connecting the dots between fic-tion, film, and performance can one see how pervasive the shared objectives and theoretical interests are among the artists in my study. "Why," they ask with childlike curiosity, "are certain things—foods, bod-ily functions, sex acts, fetishes—taboo?" These artists not only defy taboos but dissect them, like anthropologists investigating an alien cul-ture (their own). Obsessed with what goes in and comes out of the body, they use technology (cinematic special effects, medical and computer im-aging) to open it up. They do not, however, view technology as either a utopia or a dystopia. On the one hand, they seize its apparatuses and de-construct the phallic order that sustains it: the drive to dissect, to clas-sify, to categorize all viscera into abstract intellectual schemata. On the other hand, they use technology to reinstall tactility and materiality, to stage the material body. They demonstrate that sex is only one of nu-merous symbolic and sacrificial practices to which a body can open it-self. They deal with fantasies that have not been co-opted by consumer culture. The artists in *Bad Girls and Sick Boys* place our assumed ideol-ogy before our eyes. They explore taboos no pornographer would touch: the intersections between sexuality, old age, and disease, between masochism and medicine, between death and desire. They are cartogra-phers, mapping the fin-de-millennium environment that already invisi-bly envelops us. Collectively they point toward a new paradigm of spec-tatorship, one that is generated from or driven by the insides of the body, one in which the human body is simultaneously the spectacle, the per-formance space, the subject, and the object of pleasure and danger.

Performance for the Twenty-first Century

1

Contemporary Art Exhibitionists

June 27, 1995, Washington, D.C.: The Christian Action Network (CAN) stages a "degenerate art" exhibition in the Rayburn Building, sponsored by Rep. Robert Dornan, to drive the final nail in the coffin of the National Endowment for the Arts (NEA). They hand out black-bordered death certificates, which they urge guests to sign and deliver to their congressmen before the 103rd Congress departs for summer recess. The death certificate reads:

> *Decedent's Name:* NEA. *Sex:* Anything unnatural. *Father's Name:* Lyndon Johnson. *Mother's Name:* Jane Alexander. *Decedent's occupation:* Attacking religion, tradition, morality. Funding left-wing causes. Promoting homosexuality. Lying to the media and Congress about its activities. *Cause of death:* using taxpayer funds to depict Christ as homosexual, a drug addict, and a child molester.

The event demonstrates yet again how expert the religious Right has become in its own bizarre brand of theater—and how spectacular its own fantasies are. Jane Alexander, the *mother* of the NEA? What specific "left-wing" causes did the agency fund? If homosexuals *could* "promote" homosexuality, wouldn't they be less beleaguered today? To these people, homosexuality, drugs, child abuse, and blasphemy are all synonymous, the moral equivalent of the Anti-Christ.

I pause to collect some of the propaganda, opening a book by CAN's president, Martin Mawyer, entitled *Silent Shame: The Alarming Rise of*

Child Sexual Abuse and How to Protect Your Children From It. Mawyer claims that *Lolita* "provided pedophiles with many rationalizations favoring child sex," although he confesses that he read the novel solely for the sex scenes. Sounding remarkably like a high school sophomore, he writes: "The story drags on . . . [and] becomes tiresome. . . . Though the story . . . has no socially redeeming value, it did provide child predators with common arguments and language: A 'Lolita' is a female nymphet."[1] If this is the caliber of criticism applied to Vladimir Nabokov, I shudder to think what Mawyer will make of contemporary performance artists and photographers. Soon, I find out: the guilty artists include the usual suspects—Joel-Peter Witkin, Ron Athey, Annie Sprinkle, Andres Serrano, Robert Mapplethorpe, Carolee Schneemann, Mike Kelley, and Bob Flanagan. And some unusual ones: Why, I wonder, does CAN consider Bruce Nauman's clown or Cindy Sherman's photograph of dinner leftovers "patently offensive"? It is as if some bright undergraduate researched all the most interesting artists working today, then reached all the wrong conclusions. One corner of the room is devoted to sexually explicit gay videos, some of which come from Highways, an alternative performance space in Santa Monica, California, where I first saw Annie Sprinkle and which hosts an annual *Ecce Homo* festival. I'm amused to see hordes of white, heterosexual, mostly male Christians and twenty-something Republican staffers primly studying each image, grimly scrutinizing each sex act. Which ones, I wonder, are amazed, amused, secretly turned on? Someone with a video camera asks me what I think. "I fully support CAN's right to explore its prurient interests," I say on camera. I have infiltrated the meeting to investigate whether CAN violated Bob Flanagan's copyright. (They did.) Ironically, Flanagan never received NEA funds.

SADOMEDICINE: BOB FLANAGAN

Bob Flanagan is a forty-three-year-old poet, writer, and performance artist who suffers from cystic fibrosis (CF), a hereditary disease that affects the glands and lungs and makes breathing and digestion treacherously difficult. It usually kills those afflicted before they turn thirty. While enormous advances in gene therapy have given hope for a cure for CF, it won't come in time to save Flanagan's life.

Visiting Hours is a site-specific installation he and his partner, Sheree Rose, exhibited at the Santa Monica Museum of Art in 1992–93, the New Museum in New York City in 1994, and the School of the Museum

of Fine Arts in Boston in 1995. *Visiting Hours* transforms the museum into a pediatric hospital ward, complete with a waiting room filled with toys, medical X rays of Flanagan's lungs, and video monitors of his naked, bound body. In one chamber, the visitor comes upon Flanagan himself, propped up in a hospital bed, his home away from home.

Bob Flanagan is a live model of the posthuman, for he illustrates step by step how the human senses—taste, touch, smell, hearing, and sight—have been utterly reorganized by technology. Just as the microscope, oscilloscope, speculum, and X ray not only altered *what* we saw but *how* we perceived the human body in the past, the current sophisticated imaging techniques (CAT scans, PET scans, MRI, and so on) raise scores of questions: What is pathology? What is "sick"? (Like Kirby Dick's film, one of Bob's performances is called *Bob Flanagan's Sick;* his cheerful motto is "Fight Sickness with Sickness.")[2]

Flanagan juxtaposes the pathology of CF with the "pathology" of masochism. He traces his masochistic proclivities back to infancy, when he spent long hours bound in his crib. From infancy forward, he was prodded and probed, X-rayed, transformed into a medical "specimen." No part of his body was immune, in any sense of the word. With Sheree Rose, his dominant "mistress," Flanagan takes sadomasochism into the art museum. While Robert Mapplethorpe's exposure of the forbidden world of gay sadomasochism was an important precursor, Flanagan and Rose make us realize how little theorizing has been devoted to *heterosexuality,* which for so long has been presumed to be "natural."[3]

Male heterosexual submissives, moreover, constitute a substantial subculture, unacknowledged because their existence defies too many taboos. Flanagan exposes one of commercial sadomasochism's best-kept secrets: the majority of customers are not sadistic men seeking submissive women. Instead, a growing number of men are willing to pay hefty sums to be clothed in diapers, put in playpens, suckled with bottles. On the one hand, such playacting permits men to return unashamedly to the preoedipal bliss of harmony with the mother. On the other hand, they enjoy being punished, spanked, made to clean house, do dishes. Since these men are often highly successful in public life, their sexual proclivities suggest a strong compulsion to repudiate masculine authority and privilege privately.[4]

The regression is not, however, limited to men. Men are not fleeing from masculinity, they are fleeing from adulthood—adult responsibilities, failures, impossible social problems, unhappiness, complex relationships with women *and* with other men. Women are fleeing, too. But where men pay

to act out fantasies of babyism privately, women prance down fashion runways in babydoll dresses. How else can one explain the current fashion phenomenon of preteen waifs carrying baby rattles and pushing other fashion models in prams? If the 1980s were about power lunches and dressing for success, the stock market crash of 1987, the recession, and downsizing in the 1990s have made many long for Mommy—not to *be* a mommy, to *have* one. Advertising has seized this trend: Volvo appeals to "all those who continue to be a kid, even when they have one"; Keds pastes childhood photos over adult faces. Even Nuveen Municipal Bonds gets in on the act, promoting "the human bond": "Sometimes she holds me like she did when I was a child."[5] Pop psychology's promotion of "the inner child" has migrated to Madison Avenue.

Visiting Hours explores head on what fashion and advertising explore at one or more removes: the fulfillment of childhood wishes *un-idealized* by Madison Avenue. Those childhood wishes turn out to be considerably more sexual than even advertising is willing to admit. Flanagan places particular emphasis on the preoedipal stage, before the infant is socialized, before the unconscious is censored.

Mike Kelley explores this same stage. In Kelley's universe, however, the infant seems to have crawled away momentarily, leaving the detritus of his existence (toys, excrement, bottles, messes), whereas Flanagan installs himself firmly, like all babies, at the center of the universe. Kelley shops in secondhand stores for stuffed animals, then sews them all together, as if to suggest the Mirror Stage of oneness, harmony, wholeness. His found objects and threadbare stuffed animals are normally considered too trivial or unworthy to be art—they have been called low, infantile, white trash.[6] Mike Kelley and Bob Flanagan have worked as collaborators, dedicated to dismantling the penis's prestige and the phallus's authority. Kelley photographed Sheree Rose, eerily humping a stuffed toy rabbit (appropriately, since she is dominant, she is on top), while Bob, a "bottom," is smeared with excrement, wiping his bottom (Fig. 1).

Flanagan revels in narcissism and exhibitionism. He is a psychic omnivore: everything revolves around his needs, his demands, his libidinal dynamism. He is aggressive in his passivity. All his life, Flanagan confesses, he has been "nothing but a big baby and I want to stay that way, and I want a mommy forever, even a mean one, especially a mean one; because of all the fairy tale witches, and the wicked step mother."[7] The "mean mother" is the phallic mother who punishes, spanks, disciplines. Far from being terrified of her, Flanagan wants to be her slave. When he met Sheree, he got his wish. Instead of ostracizing him, she relished her

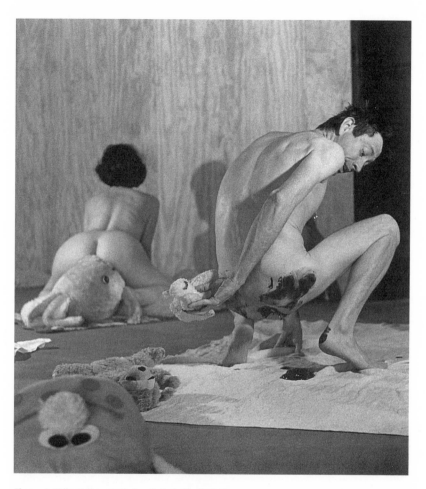

Figure 1 Mike Kelley, study for diptych *Manipulating Mass-Produced Idealized Objects / Nostalgic Depiction of Innocence of Childhood,* 1990, black and white photo. 8 in. × 10 in. In *Bob Flanagan: Supermasochist* (San Francisco: Re / Search Books, 1993). Courtesy Mike Kelley, Re / Search Books, Bob Flanagan, and Sheree Rose.

role. Who wouldn't let a man who lusts to vacuum have his way? He scrubbed the floors with a toothbrush (inspired, perhaps, by *Mommie Dearest*).

Signs of infantile existence litter the museum: a port-a-potty, pacifiers, blankets, a crib that seems more like a cage, toys like a Superman doll and Visible Man, which is designed to teach children anatomy, although this one excretes shit, mucus, and sperm. *Visiting Hours* evokes a scene that the spectator has visited long before, but as with the psychoanalytic session, its buried content comes to the surface only when restaged. Everything about the exhibit is uncanny, at once strange and disturbing, hysterical and hilarious. A toy chest that contains sadomasochistic paraphernalia and stuffed animals sits in one corner. The writing on the toy chest confirms the exhibition's fairy-tale quality:

> Mine is the bittersweet tale of a sick little boy who found solace in his penis at a time when all else conspired to snuff him out or, at the very least, fill his miserably short life span with more than its share of pain, discomfort and humiliation. The penis seemed to thrive on whatever shit the rest of the body was subjected to and rose to the occasion of each onslaught, soaking it up like a sponge or, to be more succinct, the corpus spongiosum became full of itself and my stupid prick danced in the spotlight of sickness and suffering. That first swat on the ass from the obstetrician's skilled hand not only started my diseased lungs sputtering to life, but it also sent a shock through my sphincter, up my tiny rectum, and straight into the shaft of my shiny penis, which ever since then has had this crazy idea in its head that pain and sex are one and the same.

Flanagan satirizes the quest for rational explanations of his twin "maladies," CF and SM, by using medical language ("corpus spongiosum"), comic colloquialisms ("snuff him out," "whatever shit"), and puns (the penis's crazy idea in its "head"). Flanagan's narrative evokes the Hobbesian notion of life as "nasty, short, and brutish," as well as Tristram Shandy's account of a prolonged and difficult quest for and through birth. In Flanagan's case, the journey toward inevitable death is equally prolonged and painful. Linguistically, the chest (of toys) parallels the chest (of the body).

Metaphorically, the toy chest suggests Pandora's box—the vehicle that will unlock all the mysteries (and miseries) of sexuality—female sexuality, that is. By identifying with Pandora, he deftly disposes of the stereotype of man as oppressor and woman as victim, the antiporn crusade's founding premise. Reading *The Story of O*, Flanagan identifies not with Sir Stephen but with O herself: "How desperately I wanted to be her."

Such reversals raise the following questions: Is Flanagan's sexuality "feminine" because it is masochistic? Or has male masochism simply received short shrift in the discourse of sexuality?

Visiting Hours is thus saturated with a strange sense of initiatory power, an initiation that begins in childhood. Neither money, success, fame, nor possessions bring happiness, Freud warned; the only source of satisfaction comes from the fulfillment of *childhood* wishes. *Visiting Hours* evokes scenes of infantile satisfactions (oral and anal, passive and aggressive). Since antipornography activists always argue that pornography must be banned so as not to sully the "impressionable minds" of children, it is particularly interesting how much *Visiting Hours* concentrates on childhood. Childhood, the exhibit implies, is tinged with sexual curiosity. Children concoct their own theories to explain birth, sexuality, and sexual difference, as Flanagan illustrates in vivid detail. One of the many fascinating things about Flanagan is that he seems to have almost total recall about the images in popular culture that sexually excited him in early childhood: he remembers cartoons of Porky Pig in bondage, force-fed, with his bare bottom and open mouth, always being punished for his insatiable orality; and of Cinderella, sexily disciplined by her wicked stepmother and stepsisters. As a child, Flanagan instinctively recognized the latent obscenity and violence in fairy tales and cartoons. They turned him on and he turned his "play" into art.

Freud was among the first to take child's play seriously. He showed how fantasy functions on three temporal levels simultaneously: (1) the *present* provides the context, the material elements of the fantasy; (2) the *past* provides the wish, deriving from earliest experiences; (3) the dream imagines a new situation in the *future,* which represents the fulfillment of the wish. Fantasy is a unique concept in psychoanalysis, first because it refers to a psychic process which is both conscious and unconscious, and second because it juxtaposes the social with the psychic.[8]

Speaking of the trend toward "babyism" in the commercial sado-masochistic industry, Anne McClintock notes: "Babyism may also grant men retrospective control over perilous memories of infancy: nightmares of restraint, rubber sheets, helplessness, inexplicable punishments, isolation, and grief. . . . In their secret nursery for Goliaths, babyists ritually indulge in the forbidden, nostalgic spectacle of the power of women. . . . The land of Fem-Dom is frequently described by men as a 'feminist' utopia, a futuristic paradise in which women are 'fully liberated and universally recognized as the Superior Sex.'"[9] Ironically, such a world (which sounds exactly like J. G. Ballard's dystopic novel, *Rush-*

ing to Paradise [1994]) may be what Catharine MacKinnon and Andrea Dworkin want, but the laws they have drafted would ban Flanagan's art as degrading to *women.* The foundation of the antipornography campaign is that man is the oppressor, woman is victim. Pornography is the theory, rape the practice. Flanagan turns such clichés on their head. If sadomasochism is the practice, Flanagan's art is the theory: he places our assumed ideology before our eyes. Femininity and masculinity are cultural constructs, neither innate nor natural. Flanagan's art audaciously exposes the *process* of gender construction, particularly its weird ridiculousness. Rather than disavowing castration anxiety, Flanagan acts it out—he *performs* it. Rather than fetishizing the female body, he pokes and pierces his own. He was inspired in part by Rudolf Schwarzkogler, who "had himself photographed (supposedly) slicing off pieces of his penis as if it were so much salami."[10] Schwarzkogler's acts, however, are fake, whereas Flanagan's actions are real. He pierces the penis, attaches weights, clothespins, and nails it to a board. His acts are at once too literal for art, too visceral for porn. While Camille Paglia worships the penis and Andrea Dworkin damns it, Flanagan deflates it and them both.[11]

Needless to say, Flanagan's masochism is equally threatening to men. At a pro-choice benefit, he shows up naked, impersonating Randall Terry (leader of the antiabortion Operation Rescue campaign). Toy babies dangle from fishhooks in his flesh and penis, to show what it would mean, and how it would *feel,* if men had to bear children. But even here, his role is feminine, for being "attached" to babies by flesh is very different from the abstract concepts of paternity and patriarchy, which are what Operation Rescue really wants to shore up. The fetus has come to symbolize everything that is Right about America.[12] (Not surprisingly, this was one of the photos that the Christian Action Network found most objectionable.) It should be clear by now that CAN's research targeting transgressive artists did not come from the bottom up, but from the top down, as illustrated by Sen. Jesse Helms's letter to former NEA chairman John Frohnmayer in 1989 (Fig. 2). Helms's list is particularly interesting because it employs the same tactics of harassment used by the Meese Commission (see Chapter 9): it targets not only individuals, but also corporations, funding agencies, sponsors, and publishers. Among the latter, V. Vale and Andrea Juno are especially notable, for they published not only *Modern Primitives,* but also J. G. Ballard's *Atrocity Exhibition, J. G. Ballard, Bob Flanagan: Supermasochist,* and *Angry Women,* which features (among others) Annie Sprinkle, Valie Export, Carolee Schneemann, Karen Finley, Kathy Acker, and Diamanda Galas. The bias against homosexu-

als that provides the momentum for both CAN's and Helms's campaign is evident in the letter's request for information about "Witnesses: Against Our Vanishing."[13] Item 2, a grant to the Durham/Chapel Hill chapter of the American Institute of Architects, reveals that even *affordable housing* is suspect (as Communist?). Items i and k refer to Sheree Rose and Bob Flanagan ("comedian Bob F."). In the late 1960s, Bob and I attended the same high school in Orange County, California—cradle of crackpots, including the ultra right-wing John Birch Society. Senator Helms is from the *other* Orange County—in North Carolina.

If Sylvester Stallone and Arnold Schwarzenegger are "living phalluses," displaying the pumped body in/as excess, Flanagan's display of his puny body is a Freudian textbook definition of "the uncanny." Freud defines the uncanny as ambiguity about the extent to which something is, or is not, alive. But even while satirizing macho bravado, Flanagan's acts require endurance: in *Visiting Hours,* a pulley occasionally hoists him from his bed to the ceiling, where he hangs upside down and naked (Fig. 3). On opening night at the New Museum, an awed hush fell over the crowd of jaded New Yorkers as Bob slowly ascended to the ceiling. Was he a combination of a tableau vivant and a nature morte, or a cross between Mantegna's *St. Sebastian* and Chaim Soutine's butchered carcass?

Flanagan identifies with "ordeal artists," like Chris Burden and Vito Acconci. In *Seedbed* (1971) Acconci masturbated under a ramp, while amplifiers projected the sound of his breathing throughout the museum. In 1990, his *Adjustable Wall Bra,* consisting of two mammoth cups, permitted visitors to curl up in the fetal position and watch cartoons. The cups pulsed with music or with the sound of a woman breathing. Acconci, like Flanagan, brings babyism into the art museum.

Flanagan's transformation of physical pain into sexual pleasure might be understandable from a clinical perspective, but is it art? Put another way, how do fantasies work personally and for a public audience? By acting out his fantasies, Flanagan preempts the psychoanalyst (the *authorized* interpreter of fantasy). First, he evokes fantasies that involve original wishes which are widely shared (the wish for health, sexual satisfaction, Mommy, and so on). Second, they are contingent. This is where the emphasis on everyday life becomes crucial, for Flanagan demonstrates how we draw on events of the day to produce our own fantasies. Third, we also adopt and adapt the ready-made scenarios from cartoons, television, and movies, as if their contingent material had been our own.[14]

Flanagan exposes the regimes of medicine as well as those of psychoanalysis. He builds a wall of 1,400 alphabet blocks juxtaposing the letters

United States Senate

WASHINGTON, DC 20510

November 7, 1989

Mr. John E. Frohnmayer
Chairman
National Endowment for the Arts
1100 Pennsylvania Avenue, N.W.
Washington, D.C. 20506

Dear Mr. Chairman:

I am curious whether **any** of the institutions or artists
listed below **have received Endowment support since 1982**,
particularly for the enumerated projects or works, and if so,
I'd like to receive the purpose and amount of the support
granted.

 1) <u>Southern Exposure at Project Artaud</u> - 401 Alabama
Street, San Francisco, CA -- exhibition entitled "<u>Modern
Primitives</u>." (see enclosed pamphlet) - A visual exhibition
and series of live events on Contemporary Body Modification,
curated by Andrea Juno and V. Vale, featuring photography by
Bobby Neel Adams.

 a) <u>Andrea Juno</u>
 b) <u>V. Vale</u>
 c) <u>Bobby Neel Adams</u>

 d) <u>Center On Contemporary Art</u> (COCA) in Seattle
Washington - original organizer of "Modern Primitive" show.

 e) <u>Project Artaud or Project Artaud Corporation</u>

 f) <u>Art Matters, Inc.</u>

 g) <u>Allied Arts of Seattle</u>

 h) <u>RE/SEARCH PUBLICATIONS</u>

 i) <u>Sheree Rose</u> - video work featuring genital
piercing/ photography of tattooing, piercing, sacrification
(sic) combined with a provocative bondage & discipline
bloodletting ritual.

 j) <u>Leslie Gladsjo</u> - video entitled "Modern
Primitives."

 k) Comedian <u>Bob F.</u> (sic) - emotional presentation
of his autoerotic scaffold.

 l) <u>Don Ed Hardy</u> - master tattooist.

5

Figure 2 Letter from Sen. Jesse Helms to NEA
chairman John Frohnmayer, November 7, 1989.

m) **Karen Bruhman** - South American scholarship.

2) **Durham/Chapel Hill Section of North Carolina Chapter of American Institute of Architects** - grant to produce a document on an Affordable Housing Competition for the benefit of the Habitat organization.

3) **David Strough,** 3225 S. W. Corbett, Portland, Oregon 97201.

4) "**Witnesses: Against Our Vanishing**" - show put on by Artists Space involving 23 artists containing sexually explicit homosexual photographs. A catalogue of this show is requested.

5) "**Trouble in Paradise**" - show by Jay Critchfield which opened October 5, 1989 at the **List Visual Arts Center** at the Massachusetts Institute of Technology, which sponsored the show.

I thank you in advance for your assistance in this matter. Should you have any questions, please don't hesitate to call Ann Dotson or John Mashburn of my staff at 224-6342.

Kindest regards.

Sincerely,

Jesse Helms

JESSE HELMS:ad

Enclosure

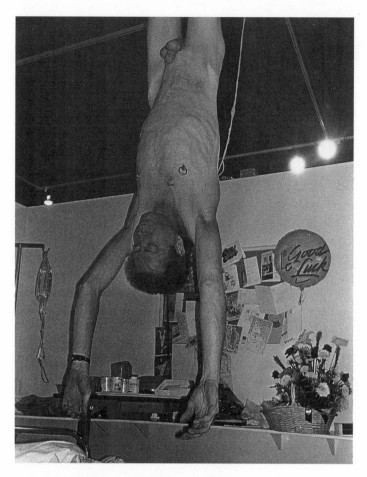

Figure 3 Bob Flanagan in *Visiting Hours,* Santa Monica
Museum of Art, December 1992. Photo: Scott Boberg,
1992. Courtesy Bob Flanagan.

CF and SM, as if to evoke the DNA codes, the letters that have become crucial in the gene therapy that will one day provide a cure for cystic fibrosis. The alphabet wall also reminds us that pornography (from the Greek *pornographos*) has a linguistic component. The alphabet blocks memorialize two simultaneous landmarks in childhood: the acquisition of language (a system built on differences) and the discovery of sexual difference.

I learned better how to read Lacan by writing about Bob Flanagan, particularly what Lacan means in "The Mirror Stage" by libidinal dynamism, narcissism, and aggressivity. Lacan refers to man's "organic insufficiency in his natural reality"; in Flanagan's case, cystic fibrosis makes literal the notion of "organic insufficiency." What Lacan calls the fragmented body's "aggressive disintegration" recurs not only in Flanagan's dreams but in his art. Lacan describes a Hieronymus Bosch landscape symptomatically, with its "inner arena and enclosure . . . dividing it into two opposed fields of contest where the subject flounders in quest of the lofty, remote inner castle."[15] Flanagan's art is similarly divided into two opposed fields of contest between confinement and escape, descent and ascent, reflected in his twin obsessions with such confining apparatuses as cages, ropes, coffins, and his invented persona as a sexualized Superman (Fig. 4).

Flanagan thus fuses medicine with sadomasochism to problematize the relationships between the social and the psychic, between disease and desire. The sterile medical environment is itself a "perverse implantation." That is an important point, because, as J. G. Ballard suggests, "Bizarre experiments are now a commonplace of scientific research, moving ever closer to that junction where science and pornography will eventually meet and fuse. Conceivably, the day will come when science is itself the greatest producer of pornography. The weird perversions of human behavior triggered by psychologists testing the effects of pain, isolation, anger, etc. will play the same role that the bare breasts of Polynesian islanders performed in the 1940s wildlife documentary films."[16] As if confirming Ballard's prophecy, Flanagan was to be the subject of a forthcoming photo-essay not in a porno magazine or even an art one, but in *National Geographic,* which planned to devote an issue to the phenomenology of pain. (The project was eventually canceled because the magazine capitulated to the climate of fear that Jesse Helms created.)

The antipornography campaign is sometimes called "the redemptive sex project." That is why Bonnie Klein's exposé of the sex industry on Forty-second Street in New York City was called *Not a Love Story: sex*

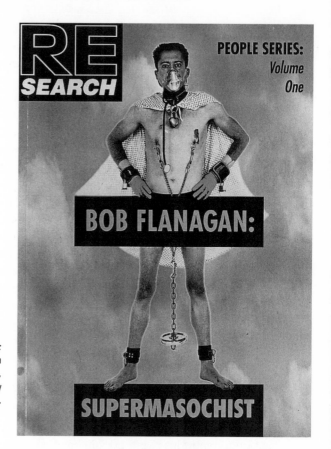

Figure 4 *Bob Flanagan: Supermasochist* (San Francisco: Re/Search Books, 1993). Courtesy Re/Search Books.

should be about love, though this film is *not*. Ironically, one point every commentator who sees *Visiting Hours* fails to mention is that Flanagan's and Sheree Rose's relationship *is* a love story too. To defend sadomasochism as "consensual" does not begin to describe the subtlety of their dynamic, shaped by *two* strong wills, two wicked wits. Rose's contributions to Flanagan's art are indispensable; far more than muse, she deserves recognition as cocreator. Sexually, Flanagan points out, "I am ultimately (this is what every masochist hates to hear, or admit) in full control" (BF, 32). Before meeting Bob, Sheree was in a traditional, constraining marriage, so part of her pleasure with Bob had a "certain revenge aspect of ordering a man about." While dominating him, Bob reports with a laugh, she gets a little smirk on her face. Sadomasochism,

moreover, is not about pain per se, it is about stimulation and heightening of the senses. Flanagan explains, "I want to give something up and be part of somebody else"; for him, sadomasochism is the ultimate closeness (BF, 32–34, 39–40). Bob and Sheree try to explain how sadomasochism has created an astonishing bond, but it is only apparent to those who know them well.

The two greatest taboos Flanagan violates involve both sex and death. Flanagan forces us to speculate about the unthinkable: the sexuality of diseased bodies. Does anyone doubt that this topic is taboo? AIDS comes immediately to mind, and while much has been written about public policy and AIDS activism, the notion that those afflicted go on feeling sexual, or having sex, or being desirable to others is still wholly taboo.[17] The Benetton advertisement of multicolored condoms (Fig. 5) is illustrative. Had I been able to reproduce this illustration in color, you would see the entire spectrum of the rainbow. The multicolored condoms float freely, detached from any tangible bodies, any tangible sexual acts, any sexual desires. While implying that the only color that matters is the color of your condom, the advertisement glosses over the reality that people of color are dying in disproportionate numbers from AIDS. The rainbow coalition of condoms ignores all such painful injustices and realities, cashing in while seeming to cultivate a social conscience.

Disease *feminizes* Flanagan, since historically women were the first to be "hystericized" by the medical establishment.[18] I am not implying that Flanagan's doctors are evil scientists; in fact, they support his art, visit his exhibitions, cooperate with videotaping, and so forth. But as medicine becomes increasingly technological, death becomes more and more abstract. We know we must die, but the knowledge remains theoretical until "the end." Flanagan maps this uncharted country with considerable courage, since the terminal disease is his own.

Bob told me that what surprised him most about *Visiting Hours* is how museum visitors turned him into a father-confessor, sitting by his bedside and sharing stories of their own experiences with cancer, leukemia, and other diseases. He gives new meaning to the idea of "social work," for there is something about his utter frankness that inspires strangers to confide in him. One could argue that strangers confide in talk show hosts all across America every day. The difference is that Flanagan does not titillate and tease; where talk show hosts are shamelessly manipulative, Flanagan is fascinating because he lives without shame.

Flanagan works annually in a CF summer camp, but he objects to CF foundations that sensationalize "cute little dying kids. . . . And I'm like

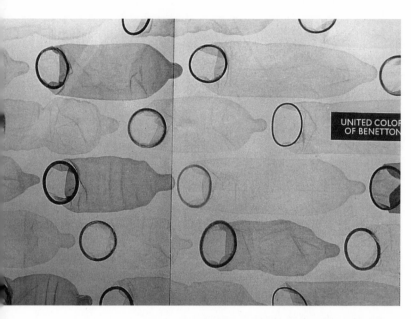

Figure 5 Benetton advertisement: multicolored condoms. Courtesy United Colors of Benetton. Concept and photo: O. Toscani, spring-summer 1991.

the poster child from *hell* saying, '*Don't* give us money because we'll grow up to do things like *this!*'" Nevertheless, many of the "children" at camp see him as a hero. After he appeared in *Modern Primitives*, one boy hailed him: "Hey—saw you in that magazine, *man!*" Asks another, "Where did you get your nipples pierced? Do you have anything *else* pierced?" The Make-a-Wish Foundation recently asked Bob to fulfill the dream of a seventeen-year-old girl named Sarah, described by the foundation as a "nineties hippie and talented artist" who sees Bob as a mentor. Her dying wish was to meet him. Young CF campers warm to him because he refuses to condescend to them or to reduce them to some stereotypical "impressionable young mind." They are grateful that he refuses to sentimentalize death. Wallace Stevens was right: sentimentality *is* the death of feeling, and all of Flanagan's art is about living with heightened feeling, sensation, consciousness.

Visiting Hours thus destroys the spectator's repertoire of received ideas about the transcendence and immortality of art, the nobility of suffering,

the romanticism of death. "The basis of horror," David Cronenberg observes, "is that we cannot comprehend how we can die."[19] On the one hand, Flanagan demonstrates how conceptual death has become, and on the other he confronts spectators with a "terminal case"—theirs, as well as his own. Amid the sadomasochistic paraphernalia and the video monitors of Bob's naked, bound body, the most stunning object in the New Museum exhibition is an expensive, full-size casket, decorated with wreaths. When you peer inside, Bob's face suddenly pops into view on a video monitor, placed where his head would be (*will* be)—in the coffin. As you peer more closely, suddenly your own face appears on the monitor, thanks to a hidden camera. The effect is startling, uncanny. Death, not sex, is the last mystique, and doctors seldom pull back the curtain to give us a peek.

Flanagan stages the horror, but his mordant wit thwarts every cliché about death: he undermines pity with satire, fear with fervor. He confronts visitors with their own voyeurism by turning the tables. He, after all, is propped up in bed, watching *you* watch him (Fig. 6).

By actually moving into the museum, Flanagan deconstructs the cherished concept of the human by staging the elemental, alimental body. He simultaneously deconstructs the concept of the museum, irrevocably transforming the pristine, inviolate art space with the messy debris of everyday life, sex, and illness: intravenous tubes, bedpans, food, and the ubiquitous oxygen tank nearby.

From Poe to De Palma, horror often has a fiendishly funny streak. *Visiting Hours* captures that macabre comedy through surreal juxtapositions of objects: a bed of nails on a gurney (on which Flanagan occasionally reposes), a port-a-potty with a big pillow beneath it, "for someone's weary head." Since he got his start as a stand-up comic, he is mercilessly satirical about sentimentality. Bob appears as himself in a parodic cameo in *The New Age,* Michael Tolkin's satire on phony spiritualism in Hollywood. Bob's black comedy supplied the film's publicity tag: "A shopping spree for the morally bankrupt." He has also composed a song, to be sung to the lyrics of *Mary Poppins*'s "Supercalifragilisticexpialidocious":

Supermasochistic Bob has cystic fibrosis
He should have died when he was young but he was too precocious . . .
Now 40 years have come and gone and Bob is still around . . .
With a lifetime of infections and his lungs all filled with phlegm
The CF would have killed him if it weren't for S and M.

David Leslie, a performance artist known for his deconstructed re-creations of heroic moments in media, compares Flanagan to Amelia Earhart and

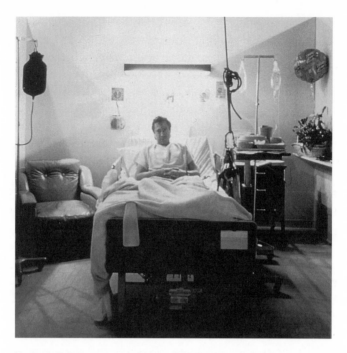

Figure 6 Bob Flanagan in bed. Courtesy Bob Flanagan
and Sheree Rose.

Evel Knievel, in terms of his courage.[20] Bob and Sheree have also appeared
in heavy metal rock videos by Godflesh; Danzig's *It's Coming Down*
(1993), produced and directed by Jonathan Reiss; and "Happiness Is Slav-
ery" by Nine Inch Nails, which Sen. Robert Dole helpfully catapulted to
fame when he damned it in a speech on May 31, 1995. By showing the
link between sex and technology, Flanagan does for medicine what J. G.
Ballard did for cars. Their "deviant technology . . . provided the sanction
for any perverse act. For the first time, a benevolent psychopathology beck-
oned towards us, enshrined in the tens of thousands of vehicles moving
down the highways, in the giant jetliners lifting over our heads, in the most
humble machined structures and commercial laminates."[21]

In *Men, Women, and Chain Saws,* Carol Clover observes that ado-
lescent fans of slasher films shift their allegiances from villain to victim
while watching the movie.[22] Similarly, in his short story, "Body," Flana-
gan describes hammering a nail through his penis, blood flowing every-
where: "I methodically cleaned everything up, just like Tony Perkins, my

blood swirling down the drain like Janet Leigh's."[23] Flanagan not only recognizes how weirdly comic Hitchcock's *Psycho* is, but adeptly shifts his own identifications from villain to victim, male to female. When he reads this story to a live audience, men faint, women laugh. Sexually, Flanagan may be a "bottom," but when he performs, he relishes the opportunity to go over the top, to control the action and confront the audience with their own psychic investments in penis (the piece of meat) and phallus (the symbolic privileges masculinity confers). He opens himself up to expose the ills flesh is heir to. Flanagan, one of the "sick boys" in my title, is a stoic comedian.

Literally hundreds of other recent art exhibitions besides Bob Flanagan's demonstrate that experimentation with the body is *the* aesthetic at century's end.[24] Three exhibitions, *The Physical Self, Post Human,* and *Abject Art,* are particularly notable because they so amply illustrate the motifs I trace in this book: the interaction of high and low, theory and practice; multimedia experimentation; and the emphasis on technology's reorganization of body, senses, psyche. These exhibitions take nothing for granted, nor do they see anything natural, innate, or universal about the human, the body, or humanism. Instead they concentrate on the constructedness not just of gender, but of all experiences, from birth to death. As do J. G. Ballard and Bob Flanagan, they ask what it means to see the human as an organism, to see that organism as an "atrocity," to see that atrocity as an "exhibition"—on display like an artifact in a museum. The human body is a methodological field, one that has to be revisited, revised, memorialized for the millennium.

THE PHYSICAL SELF (1991)

Filmmaker Peter Greenaway *(The Draughtsman's Contract, The Belly of an Architect, Prospero's Books, The Cook, the Thief, His Wife, and Her Lover)* curated a series of exhibitions all over Europe between 1991 and 1994: *Flying Out of This World* at the Louvre; *One Hundred Objects to Represent the World* in Vienna; a series of live landscape exhibitions that traveled to Geneva, Tokyo, New York, Berlin, and Moscow, followed by simultaneous events in Bilbao, Madrid, and Barcelona in 1994.[25]

The Physical Self, seen in Rotterdam in 1991–92, featured live, naked humans in Plexiglas cases. The exhibition is made up of items and images from the Boymans–van Beuningen Museum's collection that Greenaway rearranged to comment on the body from youth to old age "with a mingled sense of humour, surprise and some nostalgia, those intimate

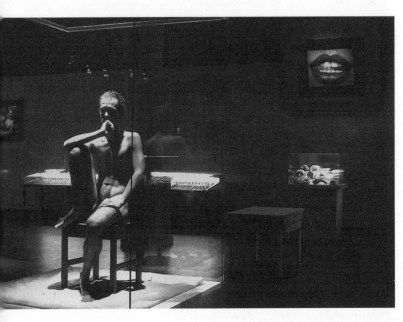

Figure 7 Male nude in Plexiglas case, first part of the exhibit *The Physical Self,* curated by Peter Greenaway. Boymans–van Beuningen Museum, Rotterdam (October 27, 1991–December 1, 1992).

mortal traces that consciously and unconsciously, it has left behind."[26] The first "item" to confront the spectator is a naked man (Fig. 7) "presented and illuminated like a consciously exhibited museum-object" (PS, 11).

Greenaway's aim is consciously to withhold the "value-judgment connotations" of the terms *naked* and *nude.* The live humans are "the markers, the templates" to which all the paintings, sculptures, drawings, and artifacts relate. Two of the figures are male, two are female; one stands, two sit, one reclines. These naked people make particular demands on the viewer to look and to see, as does Bob Flanagan. Far from being obscene, they remind the viewer of the *process* behind the "product"—it is as if one has stepped into a life-drawing class. Greenaway consistently highlights the material base of artistic production, stripping away its mystique in the process.

The next image to arrest the viewer is a just-delivered bloody newborn, still attached to the umbilical cord (Fig. 8). In place of an artist's

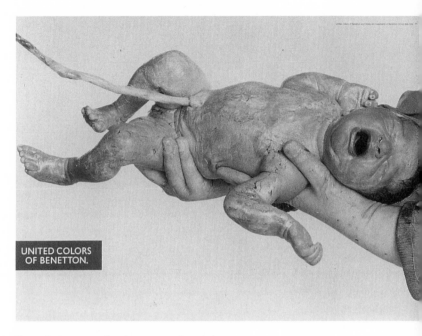

Figure 8 Benetton advertisement: newborn baby. Courtesy United Colors of Benetton. Concept and photo: O. Toscani, fall–winter 1991–92.

signature, the image has a corporate logo: United Colors of Benetton. Greenaway takes pains to point out that this image was banned in Britain. An ironic reversal: Bob Flanagan is censored for portraying death; Benetton for portraying birth. As with the multicolored condom advertisement, the message here is that we are all alike, united at birth, but—as in the condom ad—all the material differences that point to ugly realities (like the disproportionately high infant mortality rate among people of color) are effaced here, too. By effacing the mother's body but including the obstetrician's hands, the ad implies that mothers no longer matter, only the right to life matters—and only doctors "deliver."

By installing an advertisement in an art museum, Greenaway's aim is to subvert the distinction between high art and commercial products. He points out that "it is an advertisement making reference to manufacture, propaganda, sale, price and commerce which are conditions to be recalled in the substance of every one of the artefacts on display in this exhibition, both at the moment of their manufacture and now. Every image is an ad-

vertisement for a concept, or an attitude, a presentiment, a belief or a desire, and every object in varying degrees of consciousness, bears a signature—a consciously placed design label" (PS, 14). Whether that label is signed Benetton or Braque, it reveals the contingency, arbitrariness, and ideology at work in the culture industry. Priceless monuments do not form an ideal order among themselves—someone constructed not just the monument, but the ideal, the order, and the art space. Greenaway deconstructs the human and the museum simultaneously. He highlights "the artificiality of a museum display . . . fashioned by many subjectivities—collector's taste, national dictates, financial pressures, academic eclecticism" (PS, 15).

As a curator and a filmmaker, Greenaway's abiding obsessions are with classification, taxonomies, taboos. He approaches the human as an artifact, a remnant of an organic age that already seems long ago and far away. He combines the obsessive-compulsive mind of a taxonomist with the perversity of a fetishist, organizing the exhibit metonymically, so that a display on "hands" includes all the objects that bear the marks of hands, including the fetishist's leather glove. In the "feet" section, one finds the Magritte painting *The Red Model,* a picture of metamorphosing feet, "a familiar password, like soft watches, among surrealists" (PS, 82). Greenaway notes: "They bear, more than any other human garment, the intimacy of the individual, and can make a strong identity of the physical self. . . . Pitiful reminder too perhaps of the collections of the poorhouse . . . and the Holocaust—they mark the autobiographical step and tread of more than two hundred individuals walking more than ten thousand miles" (PS, 83).

As the Benetton newborn illustrates, Greenaway is particularly interested in what comes out of the body (like babies), and with what goes in, especially food. Few detractors recognized, for example, that two of his films, *The Cook, the Thief, His Wife, and Her Lover* and *The Baby of Macon,* are meditations about the history of painting. He is a classical filmmaker known for his rigorous intellectual control; each frame is composed like a painting. He shares with his fellow-Briton J. G. Ballard a gift for allegory: *The Draughtsman's Contract* exposes the British as predators who suck the creativity and lifeblood from the Irish. *The Cook, the Thief,* similarly, is a Jacobean revenge tragedy, a fact that most reviewers failed to recognize when they condemned it as pornographic. Food is a metaphor for the Thatcher era of conspicuous consumption, which is why the finale features cannibalism: the State is eating its citizens alive. (As we shall see in Chapter 9, Bret Easton Ellis similarly uses

cannibalism as a metaphor for Reagan's United States.) As with Ballard and Flanagan, Greenaway's work combines wit, irony, black humor, and perversity. He has an abiding obsession with the interpenetration of word and text, sex and text. His most recent film, *The Pillow Book,* which is about a Japanese woman's erotic obsession with words painted on skin, premiered at the Cannes Film Festival in May 1996. At the press conference, Greenaway (whose fascination with numbers is legendary), suggested that the millennium might have been miscalculated,[27] a rumination very much in keeping with the issues that preoccupy him as curator, for *The Physical Self* is an elegy without nostalgia for the idea of the human.

POST HUMAN (1992)

If *The Physical Self* looks back elegiacally, the *Post Human* show looks forward. We may not quite be ready to embrace the idea that the human organism is made, not born, but *Post Human* examines the implications of that radical proposition. Curator Jeffrey Deitch boldly asks whether a new model of the posthuman person is emerging, constructed from images in new technologies and consumer culture. Plastic surgery and "genetic reconstruction are adding a new stage to Darwinian human evolution," Deitch argues; "our children's generation could very well be the last generation of 'pure' humans."[28] The posthuman person's predominant interactions are with machines rather than with people.

Post Human assembles a dazzling array of commodities: televisions, stereos, shoes, clothes, food, compact discs, and toys point to the insatiable demands of consumption. Just as Peter Greenaway highlighted the materialist base of artistic production in *The Physical Self,* labor is omnipresent here, too: the cagelike confinement of alienated labor is the subject of Damien Hirst's *The Acquired Inability to Escape* (1991), a steel and glass enclosure for a white work-space and office chair. Why is the worker unable to escape? Because he is a slave to his acquisitions.

The babyism Bob Flanagan evoked recurs throughout the *Post Human* show: Mike Kelley's *Brown Star* consists of undifferentiated blobs of stuffed toys sewn together, dangling from the ceiling. Kelley takes trivial objects and trivial labor (sewing is women's work), and melds them into a metaphor for the preoedipal bond of mother and child, although mother and child are both absent from the scene. Taro Chiezo assembles five little dresses, which march smartly down a Tokyo street, but

they remain uninhabited by girls' bodies. Martin Kippenberger's *Martin, Stand in the Corner and Shame on You* (1990) (Fig. 9) is a witty bronze sculpture of a grown man (presumably the artist) standing in the corner like a bad boy. It conveys the same poignancy of George Segal's plaster casts, combined with the erotic energy of Bob Flanagan's scenarios of discipline and punishment. Charles Ray's enormous female *Mannequin* (244 cm) makes a male onlooker look like a child, thus deflating the legendary power of the male gaze. Cindy Sherman's photographs of male and female mannequins with interchangeable, obscene body parts are as disturbing as the Hans Bellmer dolls so admired by J. G. Ballard, with their reversed orifices and paradoxical anatomy. Indeed, as with *Visiting Hours,* this exhibit memorializes all the nastiness, curiosity, and cruelty of childhood: Yasumasa Morimura's blood-red photograph *Brothers* features boys pointing toy guns and toy howitzers at each other on a devastated battlefield, an atomic bomb's mushroom cloud in the background.

The show demonstrates that the new construction of the self is conceptual rather than natural, aided by computer morphs and plastic surgery. Since the new concept of self is devoted to surfaces rather than depths, Deitch maintains that the Freudian model of the psychological person is dissolving into a new model that dispenses with analysis of how the subconscious molds behavior; there is a new sense that one can free oneself from the past and the genetic code. As we shall see in the next chapter, Orlan seems to echo this when she proclaims, "The body is obsolete. I fight against God and DNA!" Orlan, however, realizes that one cannot simply repudiate psychoanalysis. Indeed, the very fact of being in love with one's own image, as Orlan confesses, brings one right back to Lacan's Mirror Stage, with its emphasis on the agency of the ego being located in a fictional direction.

Yet many of the artists in the *Post Human* show consciously evoke Freud, Lacan, and Kristeva. Amid all the technological toys in the exhibition, numerous works highlight the elemental, alimental body. The pristine space of the gallery is defiled with simulacra of sperm, feces, undigested food, blood, and dirt. For example, Kiki Smith's *Tale* (1992) (Fig. 10) is a sculpture of a naked woman on all fours, feces trailing from her anus, as if she were in the midst of some evolutionary metamorphosis from animal to human. Helpless, vulnerable, exposed—the sculpture epitomizes abjection. It also historicizes abjection: the five senses are historically determined, shaped and reshaped by evolution. *Pre*history perhaps marked the most radical evolution. The sculpture reminds us that

one of the earliest innovations that reorganized the human senses was the ability to walk upright; in exchange, humans sacrificed the sense of smell. Freud speculates:

> In the nursery . . . excreta arouse no disgust in children. They seem valuable to them as being a part of their own body which has come away from it. Here upbringing insists with special energy on hastening the course of development which lies ahead, and which should make the excreta worthless, disgusting, abhorrent and abominable. Such a reversal of values would scarcely be possible if the substances that are expelled from the body were not doomed by their strong smells to share the fate which overtook olfactory stimuli after man adopted the erect posture.[29]

Figure 9 Martin Kippenberger, *Martin, Stand in the Corner and Shame on You* (1990). Photo: Martin Kippenberger and Ronald S. Lauder Collection. Courtesy Jeffrey Deitch.

Figure 10 Kiki Smith, *Tale* (1992).
Collection of Jeffrey Deitch.

Freud cites this as evidence of how quickly civilization marshals its energies to enforce a repression that begins by being "organic." To repeat, I call the artists in my study "boys and girls" because they revisit the time before their infantile values—what one might call their *objectivity*—were reversed, a time before objects became invested with the values of "purity and danger."[30]

I said earlier that many of the artists, filmmakers, and novelists in my study are like anthropologists, investigating an alien culture. They are also engaged in a recovery project: to restore and record what the media sanitizes. Smith's *Tale* is thus the perfect antidote to all those commercials and advertisements for "feminine products." *Tale* was created in the same spirit that led J. G. Ballard, in "What I Believe," to say, "I believe in the body odours of Princess Di." Since the media capitalizes on cultural amnesia, these artists specialize in the opposite: memory, history, material production, evolution.

How exactly does advertising capitalize on cultural amnesia? One has

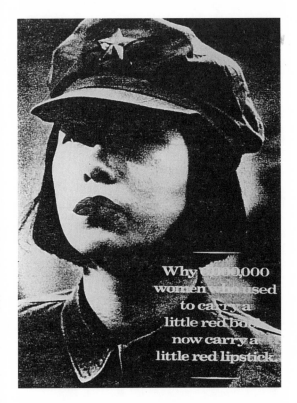

Figure 11 Advertisement for *Allure* magazine (May 1991).

only to turn to *Allure* magazine (Fig. 11), which features a Chinese-looking young woman in drab, Maoist, totalitarian garb. The grainy, gray photo is offset by one vivid slash of red lip color. The copy reads: "Why 6,000,000 women who used to carry a little red book now carry a little red lipstick. Beauty makes a statement. And when nail polish becomes political, and fashion becomes philosophy, Allure magazine will be there. With reporting about fragrance and fitness, cosmetics and culture, travel and trends. . . . Allure: the revolutionary beauty." The advertisement "works" (by which I mean it does invisible ideological work) by conflating six million Jews with six million "fashion victims" and by destroying any sense of history as struggle. Most ironic of all, few people under thirty even know what the little red book is! Thus for many consumers, the ad does not need to make sense to be effective. This image exemplifies my statement in the introduction that we are moving toward a very different understanding of what culture might be, for the historical referent is continually receding—to the point of extinction. I think J. G. Ballard had a paradox like this one in mind when he noted that

someday soon, Warhol will no longer make sense; not just the original but even what the *copy* referred to has already disappeared. That awareness gives the art in *Bad Girls and Sick Boys* its singular urgency and poignancy, for these artists *refuse* to forget or repress material conditions of production and historical specificity.

Their investigations are indebted to Mary Douglas's *Purity and Danger,* a pioneering anthropological study that analyzes how different cultures define dirt and cleanliness. They are also indebted to Julia Kristeva (whose own work draws on Mary Douglas). In *Powers of Horror: An Essay on Abjection,* Kristeva says that the distinguishing characteristics of abjection include fear of the female in general, the female body in particular—menstruation, lactation, sexuality, and reproduction. Fear of the vagina dentata isn't the half of it: the devouring maw, the messy involvement with babies' bodily functions, the myth of omnivorous sexual and reproductive capacities are all signs of the abject. Above all, the abject signifies the lack of undifferentiation, the permeable boundaries (as in pregnancy) between self and other, inside and outside, life and death (as Freud described the uncanny). The maternal is the realm of the Imaginary; it precedes the oedipalization process of socialization into the Symbolic, and has been repressed by Western culture, buried beneath the myths of femininity.

Kiki Smith's *Tale* is clearly a study in abjection: the prostrate woman exposes the flayed body beneath all our defenses.[31] Genetic manipulation may create outward perfection, but inner neuroses, instincts, and bodily functions are not so easy to mold, and Kiki Smith's flayed bodies bear witness to the emotional wreckage that festers below the plastic surface, as Deitch points out.[32] Smith's sculpture also evokes the Wolfman case, Freud's study of infantile neurosis, for the Wolfman became sexually aroused only when he saw a woman on all fours, and he suffered from an obsession with feces. Smith's *Tale* returns us to the primal scene: when the Wolfman witnessed his parents making love from behind, he made a bowel movement in his bed. The primal scene inaugurated his fear of castration and the Oedipus complex. The Oedipus complex is one of the "tales" Western civilization tells, one that has captured the imagination of artists throughout the twentieth century. Another tale that is equally pervasive is the tale of femininity, which relegates woman to a pedestal (elevated but confining). Smith provokes the viewer by dispensing with femininity's vestigial pedestals. She kicks the foundation away from the feminine mystique. Beneath that mystique, Smith illustrates, lies a deep revulsion and repression of the female.

ABJECT ART (1993)

The Whitney Museum show *Abject Art: Repulsion and Desire in American Art* in 1993 continues the dialogue on abjection that *The Physical Self* and the *Post Human* shows began. Just as Greenaway's declared aim was to display live, naked humans "presented and illuminated like a consciously exhibited museum-object" (PS, 11), this exhibit's title is a pun on object art, with an emphasis on found objects, degraded materials, absurd juxtapositions. The show investigates the fundamental premise of psychoanalytic object relations theory: the paradigmatic "good object" is the mother's breast; once weaned, the psyche substitutes supplemental objects (makes good and bad object choices) to fill a lack that by definition is unfillable. The defiant choice of "bad objects" is celebrated in all four exhibitions discussed in this chapter; the compulsive search for supplemental objects is one explanation for the emphasis on fetishism in these exhibitions.

One of the aims of the *Abject Art* show is historical: it juxtaposes such objects as Duchamp's urinal, Claes Oldenburg's *Soft Toilet,* and Louise Bourgeois' *Nature Study,* with its pendulous bronze balls and breasts, with more recent works. Some of the same artists in the *Post Human* show are also represented here: Mike Kelley's photograph of Bob Flanagan and Sheree Rose, Cindy Sherman's mannequins, and works by Kiki Smith and Robert Gober. Here, too, the exhibition's theoretical foundation is Julia Kristeva's *Powers of Horror*. Kristeva writes as a psychoanalyst-semiologist; she analyzes both Freud and Lacan, as well as writings ranging from Leviticus to Derrida. She traces the process by which the maternal feminine came to be constructed as monstrous in the Old Testament, and analyzes the semiotics of biblical abomination. She then shows how that monstrosity was reinforced through the ages. The mother-child relationship is the paradigm for all subsequent subject-object divisions; she is interested in object relations theory, its application to linguistics, and how that original process results in viewing others as objects. Abjection dismantles Western civilization's dichotomies: self-other, male-female, inside-outside, subject-object, life-death. Abjection is closely related to desire and to the death drive. She defines *abjection* as the recognition of *want,* on which any being, meaning, language, or desire is founded.

Kristeva shows how these themes recur in the great masterpieces of Western literature; in addition to her stunning exegesis on religion, anthropology, and psychoanalysis, she offers brilliant insights into Dos-

toyevsky, Artaud, Proust, James Joyce, Bataille, Borges, and Céline. Each writer represents a different typology of abjection, different psychic, narrative, and syntactic structures (PH, 26). Céline, for example, links abjection to maternity; his early career as a medical student focused on puerperal fever. But abjection also signifies otherness, subordination, and expulsion; in her chapter on Céline, Kristeva shows how anti-Semitic fantasy codes the Jew as abject—a scapegoat who is feminine and weak, yet threatening; Jewishness signifies "sex tinged with femininity and death" (PH, 185). As Judith Halberstam notes,

> The Jew, for Kristeva, anchors abjection within a body, a foreign body that retains a certain familiarity and that therefore confuses the boundary between self and other. The connection that Kristeva makes between psychological categories and socio-political processes leads her to claim that anti-Semitism functions as a receptacle for all kinds of fears—sexual, political, national, cultural, economic. . . . The Jew . . . is . . . transformed into a figure of almost universal loathing who haunts the community and represents its worst fears.[33]

The public debate over the NEA similarly reveals how thoroughly these artists became the receptacle for all kinds of repressed fears about the body and the body politic. Some artists, like Hannah Wilke, simulate body scarification to subvert the phallic power of the male gaze; others explore ways of coming to grips with death. Some of the artists approach sadomasochism as a means of dissolving the boundaries between self and other. Still others use their art to highlight the imagos of the Mirror Stage, which—as I mentioned in discussing Flanagan earlier—Lacan described as having a Boschlike emphasis on fragmentation, dismemberment, dislocation, and devouring. The "armor of the I" and its vulnerability to shock, trauma, and persecution are the artists' topics.

With the exception of Bob Flanagan's and Joel-Peter Witkin's work, most of the work the Christian Action Network highlighted that hot June night was from the *Abject Art* show. On a big easel, they quoted the catalogue's introduction: "Our goal is to talk dirty in the institution and degrade its atmosphere of purity and prudery by foregrounding issues of gender and sexuality in the art exhibited. Such a project was deemed urgent partly because of a disturbing trajectory of 'politics' in America . . . through the Reagan and Bush administrations" (AA, 7).

The highlight of the evening was a debate between Cal Thomas, former NBC journalist, representing CAN, and Paul Begala, Clinton's campaign advisor, on whether or not to kill the NEA. Begala's position was the "one bad apple" argument: don't throw out opera and the New York

Philharmonic just because of a few "mistakes." He steadfastly refused even to look at the art in the adjoining room, much less to defend it. Ironically, his stance reinforces the argument I have been making about controversial artists themselves being abject, for by blaming "foreign bodies" or "outside agitators," Begala reveals the extent to which contemporary writers and artists are scapegoats, receptacles for all the disturbing elements of existence (disease, mortality, mutability, alienation, hostility) that the nation most wants to disavow.

In his rebuttal, Cal Thomas began by mentioning that William Faulkner never got a federal grant. I asked Thomas if he realized that Faulkner's fiction features idiots in love with cows *(The Hamlet)*, castrated black men *(Light in August)*, incest and miscegenation *(Absalom, Absalom!)*, necrophilia ("A Rose for Emily"), and a sociopath who rapes a judge's amoral daughter with a corncob *(Sanctuary)*. Faulkner was no stranger to censors; he knew that in their view, the only good genius is a dead one. Indeed, booksellers of both *Sanctuary* and *The Wild Palms* were prosecuted for obscenity; these were among the books Judge Jerome Frank defended in *Roth v. United States* (1957).[34]

July 29, 1995: One month after this spectacle, Congress votes to cut the NEA's budget by 40 percent in the current year and phase it out entirely by 1998 or 1999. CAN's lobbying turned out to be enormously effective; when Sen. Nancy Kassebaum voted against the NEA, she singled out Highways' *Ecce Homo* exhibit as particularly (and patently) offensive. Jane Alexander, the NEA chairperson, said the attack will hurt the 1.3 million people who work as artists in America.[35] Grants to individual artists are now a thing of the past. Two women's photos dominate the front page of the *Washington Post* on July 29, 1995: Jane Alexander's and Susan Smith's. When Smith confessed to drowning her two young sons on November 3, 1994, Newt Gingrich blamed the Democrats for the breakdown in "family values" that led Smith to murder. When testimony showed that Smith was sexually abused for eight years by her stepfather, a Bible-toting Republican prominent in South Carolina politics, Gingrich was silent. Perhaps J. G. Ballard was right: the insane *can* see the sick souls of their caretakers.

2

Cutups in Beauty School

Emma's head was turned towards her right shoulder, the
corner of her mouth, which was open, seemed like a black
hole at the lower part of her face . . . her eyes were
beginning to disappear in a viscous pallor, as if covered by
a spiderweb. . . . They had to raise the head a little, and a
rush of black liquid poured from her mouth, as if she were
vomiting.

Gustave Flaubert, *Madame Bovary*

Madame Bovary was not banned merely because of the sex scenes—it
was the nihilism of passages like the epigraph above, which by repudi-
ating the teachings of the Church posed an "outrage to public morals."
Flaubert confessed that he could never look at a beautiful woman with-
out visualizing her corpse. Since his father was a doctor in Rouen, the
hospital was his childhood playground; its scenes and smells were a gritty
antidote to what he called "the cancer of Romanticism," which he cau-
terized by writing *Madame Bovary*, "a book about nothing . . . held to-
gether by the strength of its style."[1]

The cancer of Romanticism, nevertheless, lives on. In the fall of 1993,
Time magazine created a special issue titled "The New Face of America:
How Immigrants Are Shaping the World's First Multicultural Society"
(Fig. 12). The cover girl is 15 percent Anglo-Saxon, 17.5 percent Mid-
dle Eastern, 17.5 percent African, 7.5 percent Asian, 35 percent South
European, and 7.5 percent Hispanic. While seeming to promise racial
tolerance and assimilation, the cover girl is only a composite created by
cyber-geneticists who combined six races to create a "morph" (short for
metamorphosis) of their ideal beauty.[2] No wonder minorities are skep-

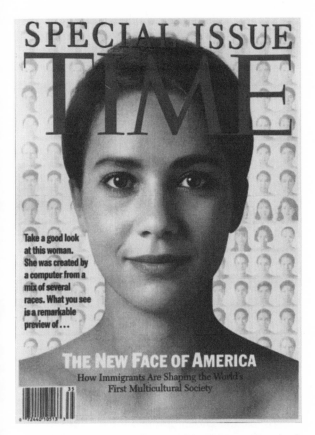

Figure 12 "The New Face of America,"
cover *Time* magazine (fall 1993) special issue.
Copyright 1993 Time Inc.

tical of the buzzword *assimilation:* the composite eliminates all racial and ethnic markers, although the cyber-geneticists seem blithely unaware that this oversight could conceivably be perceived as racist. *Time*'s editor writes: "As the onlookers watched the image of our new Eve begin to appear on our computer screen, several staff members promptly fell in love. Said one, 'It really breaks my heart that she doesn't exist.'"[3] The men do not seem to grasp that no breathing woman could match their ideal. They have fallen in love with their own invention, like the frustrated infertility researcher in David Cronenberg's *Dead Ringers* who protests petulantly, "We have the technology! It's the woman's *body* that's

all wrong!" Was there ever a time when woman's body was not "all wrong"? Ever since the Judgment of Paris, anonymous young women have paraded before male judges, who inevitably find all but one wanting. Centuries of mythology, art, culture, and commerce capitalize on that lack, exploit that (invented) inadequacy. Whatever else divides twenty-something women from feminists over forty, at least they agree that beauty is a racket.[4]

No wonder so many women artists are Gorilla Girls and Angry Women,[5] actively creating a new antiaesthetic by interrogating those who have the power to define beauty and to proclaim that the woman's body "needs work." I call them cutups because they are often bawdy comics, satirizing the culture's investments in femininity. Beneath the comedy, however, lies a serious shared objective: to examine the vicissitudes of psychic life, particularly the drives that lead men to turn the female body into a fetish, icon, or cut-out.

CAROLEE SCHNEEMANN

"How can I have authority as both an image and an image maker?" Carolee Schneemann, a pioneering performance artist, filmmaker, and writer, has been asking that question since the early 1960s. By using her own body, she transforms it from object into subject—a historically unprecedented and widely influential concept. She anticipated the Body Art movement of the 1960s and 1970s and choreographed for the Judson Dance Theater (whose members included Meredith Monk and Yvonne Rainer). *Eye Body* (1963), a happening realized in collaboration with the painter Erró, records the artist's trancelike self-transformations, captured on film over several hours. *Viet-Flakes* (1965), her first completed experimental film, is the film component of *Snows,* which focuses on the atrocities of the Vietnam War.[6]

Schneemann shows how the antiaesthetic relates specifically to the insides of the body, staging the body as a carrier of signs and as a cipher, literally extracting internal messages. *Interior Scroll* (1975) is one of Schneemann's signature "kinetic actions": a naked Schneemann extracts a paper scroll from her vagina and reads a text on "Vulvic Space" (Fig. 13). Far from merely celebrating the body's unmediated essentialism, Schneemann sees the work as being about "the power and possession of naming—about the movement from interior thought to external signification and the reference to an uncoiling serpent, to actual information, like a ticker tape, rainbow, torah in the ark, chalice, choir loft,

Figure 13 Carolee Schneemann, *Interior Scroll* (1975).
Photo: Anthony McCall. Courtesy Carolee Schneemann.

plumb line, bell tower, the umbilicus, and tongue."[7] In an interesting reversal, Schneemann locates thought inside the *body* rather than equating thought with *mind;* what "comes out" are more signifiers than can ever be categorized and labeled. If the serpent, for instance, evokes Eve in the garden in the Book of Genesis, it is also the Egyptian symbol of eternity. Of Schneemann's assemblage *Pharaoh's Daughter,* Robert C. Morgan writes: "On the spectrum between artifact and ritual, Carolee Schneemann's work moves closer to the latter. It conveys rites of passage—particularly in reference to the emerging secularization of women—as expressed through metaphor and symbol."[8]

The snake's coiling energy also connotes the cosmic energy of the womb; throughout Europe, regeneration was symbolized by the sculpting of large breasts, vulvas, and serpentine umbilical cords.[9] *Interior Scroll* simultaneously evokes the umbilical cord and menstruation (still a taboo topic in most religions *and* pornography). Its significations cannot be disconnected from the vicissitudes of psychic life, as Schneemann notes: "You do get an instinct for where the repression is. . . . We live in a *culture of oblivion* that perpetrates a kind of *self-induced denial* in which the meaning of the recent past is continually lost or distorted . . . much like feminist history was always lost or distorted."[10] The cultural amnesia induced by the *Allure* magazine advertisement (Fig. 11) again comes to mind: if advertisers induce oblivion, Schneemann's aim is to *re-member*. She rescues women's history and art from denial and disavowal. Schneemann shows that bodies are made, not born—their exit from the womb is wholly mediated by the interventions of religion, custom, taboo, technology.

Schneemann's *Meat Joy* is a performance of nearly naked humans among wet paint, raw fish, chickens, and sausages which aims to "dislocate, compound and engage our senses, expanding them into unknown and unpredictable relationships" in "an exuberant sensory celebration of the flesh."[11] The performance entailed "intense, concentrated group energy structured over weeks of rehearsals." As the director, Schneemann had to focus on "subtle interrelationships in which both absolute concentration and spontaneity were demanded of each participant."[12] Her themes are the metamorphosis from animal to human and transgressive femininity. *Meat Joy* was one of the targets of the Christian Action Network's exhibit of "degenerate art" in 1995 (see Chapter 1). As with the other artists in the *Abject Art* show, Schneemann mixes the elements that religious injunctions insist must never be mixed: meat and dairy products, blood and milk. As Katrien Jacobs points out, the human soul was originally conceived of as residing in body fluids; both *Meat Joy* and *Interior Scroll* are indebted to Schneemann's research into shamanistic rituals and practices. Her ecstatic Dionysian orgies reunite spirit, mind, and body "within the most basic real of human performance."[13]

Her other works are witty antidotes to Duchamp's sterile "bachelor machines": motorized violins mounted on the wall move rhythmically as if simulating sexual intercourse; a high, wooden box contains lights, slides, paint, a clock, discarded flashbulbs, wads of magnetic tape, and shards of glass (*Pharaoh's Daughter,* 1966). The objects point toward a chaotic, possibly futile effort to document (via magnetic tape and flashbulbs) some-

thing in time (the clock)—not a single event, but many moods and feelings which have found some material manifestation within a disturbing and intimate space.[14] The box paradoxically combines a methodical application of materials with randomizing techniques—what Schneemann calls "controlled burning."[15] The shards suggest the detritus of civilization, Walter Benjamin's ruins and debris. Translucent as skin, the shards can cut deep, suggesting lacerated emotions and the threat of castration. Schneemann is my first example of a "cutup in beauty school."

But a cutup is also a comic, and many of Schneemann's works are wickedly funny. She documents the meals of her cat, Kitch, devoting an entire Super-8 diary film (1972–76) to him and a photographic wall (*Infinity Kisses* [1981–86]) to kisses from another cat, Cluny. Katrien Jacobs's videotext quotes Schneemann in 1975: "This is Kitch. . . . She definitely influenced my theater. Definitely." Jacobs narrates: "In *Up to and Including Her Limits,* Schneemann . . . does not speak, she does not write, she does not act. She destroys the human languages and enters a 'cat level' of consciousness."[16] While conventional wisdom might view this consciousness as "lower," the Egyptians thought differently. Among the multiple significations of *cat* in Schneemann's texts and videos, one in particular stands out: the vulgar *pussy.* Schneemann asks, "Is this what you're so scared of: this moist pussy? It *this* the Terrifying Other—the clitoris that has to be excised or chopped off or rendered mute?"[17] In *Up to and Including Her Limits* (1973–76), she suspended her naked body in a swinging harness and wrote on the walls with chalk, spontaneously inscribing the wisdom that came from the body: "I am hungry," she wrote; "way out of sync"; "I am a sound."[18]

Equally comic is *Vulva's School,* which resembles a pedagogic manual on "becoming woman," a catechism of femininity's idées reçues:

> Vulva goes to school and discovers she doesn't exist!
> Vulva goes to church and discovers she is obscene. . . .
> Vulva reads essentialist Feminist texts and paints her face with her menstrual blood and howls when the moon is full.

Why, Vulva asks, is "cock a thing and cunt a place"? In my introduction, I said that I call the artists in this book "boys and girls" because they approached the body with childlike curiosity; like a child, Vulva asks scores of questions. Schneemann shares the archaeologist's zeal for unearthing shards of alien cultures and mythology. She reminds us that in ancient Minoan, Sumerian, and Celtic cultures, older women were revered as repositories of erotic knowledge; men were acolytes. Of men,

Schneemann notes: "My work celebrates the male, is inspired by men who seek equity with passion and grace; whose affinity with the ancient sacral is—as ever—full of risk."[19] Schneemann reflects, "In some sense I made a gift of my body to other women: giving our bodies back to ourselves."[20] Vulva resembles Hélène Cixous' "Laugh of the Medusa" with her myriad questions and laughter. She talks and talks. She is all mouth. She brings us back to our senses. Schneemann excavates and recontextualizes such Freudian topographies as "the dim Minoan regions." In *Cycladic Imprints,* at the San Francisco Museum of Modern Art, Schneemann merges her motorized violins with nude torsos and images on four projectors of Cycladic sculpture, which originated in the Aegean islands and were contemporary with Minoan culture. Her aim is to highlight the generative vulva's significance and to recontextualize it in history and culture. Since the vulva's significance has long been displaced by both pornography and medicine, Schneemann's aim is to reintegrate it as a literal and allegorical source of erotic power.[21]

Several works in the last decade confront mourning and mutability. *Video Rocks* (1989) is a sculptural field of handmade rocks, an inquiry into the Impressionist landscape, and a rendering of the cyclical movement of human process. *Mortal Coils* (1994), another mixed-media installation, is based on the kinetic experience of a space that comes alive with evocations of recently deceased friends through photos, words and sounds, and moving projections. *Known/Unknown: Plague Column* (1996) uses photographic, video, and sculptural elements to continue this exploration of the repressed material in the culture. As with Bob Flanagan's work, *Known/Unknown* deals with illness, medicine, and death. (The column is a sculpture Schneemann photographed in Austria, built by monks in 1750 to ward off the plague.) Using video monitors, photographs, and sculptural objects, Schneemann reassembles cellular and microscopic representations of visual information: the cellular, erotic, and clinical collide in these images. She makes us wonder what exactly we know about life and death, love and sex, biology and history in this profoundly intimate installation of life's fleeting essence.[22]

Schneemann's inspiring example is an affirmation of how artists can combine painting, drawing, performance, writing, film, video, and photography. Her unflinching exploration of her own archives demonstrates what discipline and philosophical rigor the examined life requires. Her abiding preoccupation with archetypal forms is testament to humanity's hunger for community, ritual, and transcendence.

ANNIE SPRINKLE

Annie Sprinkle lacks Schneemann's formal artistic training, but she too focuses on erotic power, calling herself a "post-post porn modernist."[23] She participated in "The Second Coming," a month-long series organized by a collective called Carnival Knowledge (echoing Bakhtin's notion of the carnivalesque). Formed to counter the Moral Majority and antiabortion activists, one of the collective's objectives is the invention of a feminist pornography.[24]

While some feminists fear that the body will disappear with the advance of technology, Annie Sprinkle makes lesbian and bisexual desire, sexuality, and the body substantial—tangible, material, and in your face—sometimes literally and sometimes with a vengeance. In *Public Cervix Announcement,* her most notorious routine, Sprinkle inserts a speculum, disperses flashlights, and invites the audience to look inside, as if to say, "You want to look up my skirt—why not *go all the way?*" (Fig. 14). Indeed, when I saw her perform at Highways in Santa Monica, California, in 1993, I was seated next to a "dirty old man" armed with a camera. Sprinkle singled him out when she came onstage, spreading her legs and amiably inviting him to come closer; he demurred. By cheerfully giving him permission, Sprinkle deftly deflated the spectacle's prurience. Onstage, she proceeds to chatter gaily about her menstrual periods and daintily administers a douche. Her motives for exhibiting her cervix: "Be-

Figure 14 Annie Sprinkle with speculum and flashlight, in *Angry Women,* ed. V. Vale and Andrea Juno (San Francisco: Re/Search Books, 1991). Courtesy Re/Search Books.

cause it's fun—and I think fun is really important; because I want to share that with people. There are other reasons: I think it's important to demystify women's bodies."[25] At Highways, to my dismay, the entire audience lined up for a look. Although I fretted that we would be there all night if *everybody* had a look, I had to admit that here was something most people, women as well as men, had never seen before—it was for the gynecologist's eyes only. Sprinkle is unquestionably adept at turning the tables. When she concluded by giving herself a prolonged orgasm while we in the audience did tantric chanting, I had to laugh: Sprinkle was trotting out—*acting* out—all the clichés of women's sexual insatiability and masturbatory self-sufficiency, and men's irrelevance to female pleasure. The clichés were having a ball. Was Annie indulging men by exposing herself, or did her over-the-top orgasms confirm men's sexual insecurities? In contrast to men's routinized, unimaginative, and uninspired approach to sexuality, Sprinkle was having a blast. Unlike them, she clearly had a vast repertoire of sexual techniques; she knew things about women's sexual responsiveness (her own and that of her lesbian lovers) which men had not even dreamt of.

Sprinkle is a droll and bawdy satirist who consciously evokes the legacy of Sophie Tucker, Mae West, and female burlesque, a form several feminist performers have accentuated. But it is herself—rather than some exotic species—that she is scrutinizing, often with the earnest deadpan voice of an eighth-grade science teacher. (At Highways, under her direction, we all got an anatomy lesson, repeating after her and spelling out U-T-E-R-U-S, like happy children on *Sesame Street*.) At the same time, she manages to convey something of the nasty tone of children playing doctor[26]— a tone Bob Flanagan also expertly mimics.

Sprinkle is an "unruly woman": she belongs with big ladies like Roseanne and pig ladies like Miss Piggy, and all those lewd, lusty, polymorphously pan-sexual heroines in popular culture.[27] Just as Roseanne has metamorphosed from ugly duckling to self-proclaimed domestic goddess, Sprinkle chronicles her own transformation from ugly duckling to porno star. She must have gotten a kick when the Society for Cinema Studies Panel (May 1992) hotly debated whether her show's spectacular climax consists of ejaculate or urine.[28] And she has clearly hit a nerve, as Linda Williams notes, for when Sprinkle performed in Cleveland in 1990, the vice squad came and made her omit the speculum in her next show. Williams drolly remarks, "It is a fascinating comment on American culture that when Annie Sprinkle performed live sex shows in that

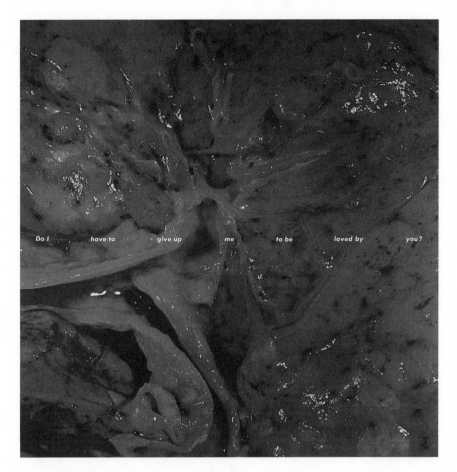

Figure 15 Barbara Kruger, *Heart (Do I have to give up me to be loved by you?)* (1988). Photographic silkscreen/vinyl, 111½ in. × 111½ in. Collection: Emily Fisher Landau, New York. Courtesy Mary Boone Gallery, New York.

same city, she was never visited by the vice squad."[29] Parody works best when it exposes the irrationality and absurdity of the censors.

What are they afraid people might see? Barbara Kruger's photograph *(Heart)* gives us some idea (Fig. 15). The small writing asks, "Do I have to give up me to be loved by you?" Kruger forces us to ask what the notion of *identity* in general and the word *me* in particular really signify,

as well as what *love* is, thus leading back to my earlier point about what women stand to gain by endorsing an antiaesthetic that critiques the ideology of romantic love. Kruger's motto is "Seduce, then intercept."[30] This is actually a photograph of the heart, not the cervix, but to the untrained eye the one muscle resembles the other. The point is that Kruger, like Sprinkle and Schneemann, literalizes a specific organ in order to defamiliarize the stereotypical connotations enveloping it: heart equals love, romance, passion. These artists stage their own bodies as sites of contestation through parody, defamiliarization, and incongruous juxtaposition. They substitute the lower carnal body for the upper regions of intellect. From Cervantes and Rabelais to *Madame Bovary* and *Notes from Underground,* the ugly, the perverse, and the antiromantic have been used to satirize the true, the good, and the beautiful. Like the genre of romance, porn is a timeless and fabulous world: the men are always erect; the women always insatiable. But pornography parts ways with romance where love is concerned. Indeed, in my view, one of the *virtues* of porn is that it is antiromantic, for since women have been most subjected to the ideology of romantic love, they may have the most to gain by endorsing an antiaesthetic that defies it.

Many other women artists seem to agree. Like Annie Sprinkle, a number of them have worked in the sex industry: Kathy Acker, Sheree Rose, Susie Bright, Pepper the Mexican sex goddess, Elvis Herselvis, and Maria Beatty (who collaborates with Carolee Schneemann). Just as Bob Flanagan's art explores his heterosexual masochism, Maria Beatty's explores her lesbian masochism. In her roles as performer, videographer, and sex worker, she is always inventing new techniques by which to test the thresholds of pain and pleasure. She defies conventional categories: in her personal life, her lesbian lover is a dominatrix, but in her professional life as a sex worker, most of her clients are men. Other artists are seizing the technology in both computer and medical labs. However much they lust after their ideal beauty, *Time*'s cyber-geneticists would never want to *see* the gruesome plastic surgery that would be necessary to make a woman's face match the computer morph. Where the virtual and the visceral fuse, one finds Orlan.

ORLAN

"Orlan" is the fictional name of a French art history professor and performance artist who, through plastic surgery, is transforming her face into a composite of the icons of feminine beauty. She tracks the interrelation-

ships between sexuality and pathology, between the female body and the body politic. Just as Bob Flanagan dismantles masculinity, Orlan deconstructs femininity. Through a series of plastic surgeries, she is in the process of acquiring the chin of Botticelli's *Venus*, the nose of Diana, the forehead of the *Mona Lisa*, the mouth of Boucher's *Europa*, the eyes of Gérôme's *Psyche*. She chose these women not for their looks but because she was intrigued with the weave of *stories* surrounding them: the rumor that the *Mona Lisa* was a self-portrait of Leonardo in drag; the mythological tales of the adventuress, Diana.[31] Like *Time*'s cyber-geneticists, Orlan relies on a digital computer to visualize her ideal "morph," but by putting their theories into practice, she exposes all the implications they overlooked: the arbitrariness of the standards, the impossibility of meeting them, the unchallenged assumption that every woman *wants* beauty.

Orlan has variously been described as "a beautiful woman who is deliberately becoming ugly,"[32] a "slightly plump woman of average height,"[33] or "46 and still rather ugly—even after six operations. . . . her pug-like face would need something more than the skill of a surgeon's knife to reach the Grecian ideal of perfection."[34] Attitudes like these explain why it took Orlan two years to find a surgeon who understood that her aim was *not* to make herself more beautiful. In New York City, she finally found a feminist surgeon (and amateur sculptor) whom she calls a "surgical aesthetician."[35] Orlan told me that Hilton Kramer remarked dismissively that if she *really* wanted to do something transgressive, why not put both eyes on one side of her head, like a Picasso? In fact, Orlan comes as close as she can: cheek implants have been implanted above her brow, giving her the owlish look of a character on *Star Trek* (Fig. 16).

"What," Simone de Beauvoir asked, "is Woman?" The answer: a person of the female sex. Only in certain relations of power and exchange does she become a servant, a womb, or a sexual partner.[36] "Woman," Orlan shows, is a projection of male fantasies compiled through the centuries in myth, art, religion. Orlan exposes the process of projection, production, distribution, and exchange. She peels away the sedimentary layers that have made this artificial process seem "natural." As Barbara Rose observes, "Orlan's performances might be read as rituals of female submission. . . . But actually she aims to exorcise society's program to deprive women of aggressive instincts of any kind. . . . If the parts of seven different ideal women are needed to fulfill Adam's desire for an Eve made in his image, Orlan consciously chooses to undergo the necessary mutilation to reveal that the objective is unattainable and the process horrifying."[37]

Orlan points out that there are not many images that cannot be looked at; one has only to turn on the evening news to see murder, rape, and massacres in living color. As J. G. Ballard notes, "The hidden logic at work within the mass media—above all, the inadvertent packaging of violence and cruelty like attractive commercial products—has already spread throughout the world."[38] Therefore, it is all the more remarkable how difficult it is to watch Orlan under the knife. Her skin is essentially cut away from her face and laid across her nose, whereupon implants "lift" the skin and pull it taut. Blood is everywhere. Orlan is awake, submitting only to local anesthetic. "I try to suffer as Christ did," she says, reminding us that the etymological meaning of *passion* is "suffering."

GENERIC ANTECEDENTS AND IMPLICATIONS

While Orlan heralds the world of the posthuman, that world is paradoxically peopled with ghosts: primitive rituals of sacrifice and purifi-

Figure 16 Orlan with implants above eyebrows, 1993. Courtesy Orlan and Sandra Gering Gallery, New York.

cation; medieval rituals of fleshly mortification; mystical Indian rites; baroque transports of ecstasy. She calls one operation "The Reincarnation of St. Orlan" and poses as a Baroque White Virgin, in imitation of Bernini's *Ecstasy of St. Theresa*. For over twenty years, Orlan has worked specifically with Baroque iconography; inspired by Caravaggio, she carved a prototype out of marble, then sent it out to be enlarged to full scale. But to subvert the madonna-whore dichotomy of the old masters, she leaves one breast exposed.[39]

Peter Greenaway's *Baby of Macon* is an intriguing analogue to Orlan's work; they share an abiding fascination with the history of painting in general, the Baroque in particular. The deepest theme in *The Baby of Macon* is the pictorial representation of Madonna and Child. The plot revolves around an infant who may or may not be Christ. A beautiful young woman claims to be his mother, after she murders his true mother, an old hag, who is "unseemly" in the regime of representation. The surrogate Madonna is subsequently condemned as a whore and raped to death. The infant is first adored, then sacrificed and dismembered by his worshipers.[40] As allegorical as a medieval morality play, the film raises disturbing questions about articles of faith and the suspension of disbelief, as does Orlan. Orlan's *femme morcélé* parallels Greenaway's bébé morcélé; both trace the links between sacrifice and eroticism, death and sensuality, following Bataille's theories on transgression and taboo. In the "Christianity" chapter, Bataille laments that Christianity reduces religion to its benign aspect. He argues that the modern view of the orgy must be rejected, for "Bacchic violence is the measure of incipient eroticism whose domain is originally that of religion."[41] Surrounded in the operating room by nearly naked black men doing a striptease, Orlan arranges all the props for an orgy; the orgies in Greenaway's film are so numerous and violent that watching is almost unbearable. In *The Baby of Macon* the juxtaposition of innocence and violence tests several film taboos, oscillating repeatedly between reality, film, and morality-play-within-a-play. Greenaway desacralizes Christianity in general, the Catholic Church in particular, as does Orlan. As Greenaway explains: "The Baroque age was the first time various art forms were combined to create a certain form of propaganda which . . . was put to use for the church. . . . here in the end of the 20th century we're now again in an enormous Baroque period, this time with a small b. . . . In our lives, we have seen the Baroque used as propaganda for the two great C's, capitalism and communism."[42] Both Orlan and Greenaway illustrate that in order for the institution of Christianity to be erected, Christ himself had

to be ejected. Without the crucifixion, there would have been no church. The "eject," as Kristeva points out in her discussion of Bataille, is always *abject*. Like the artists in the *Abject Art* show, Greenaway and Orlan are obsessed with the way subjects are sutured into the cinematic or visual space. They examine how subjects simultaneously subject themselves and others to institutionalized violence and power.

In Orlan's work, the juxtaposition of posthuman technology and ancient religion serves several additional functions. First, it provides an apocalyptic frame of reference, for while *apocalypse* generally connotes catastrophe, it also signifies revelation of what was, is, and will be. Orlan is Janus: one side faces the past, which memorializes the obsolete body, carefully preserving its viscera as reliquaries. The other side faces the cyborg future, when the inorganic far outweighs the organic elements of the body. Artificial hearts, breasts, hair implants, reproductive technologies, organ transplants have already transported us into the world of tomorrow; Orlan serves as intermediary between present and future. Her installation at the Pompidou Center's *Hors Limites* show in 1994 was called *Entre* (In between two): she stands between past and future, human and posthuman. (When she learned about Jeffrey Deitch's *Post Human* show, she let him know that she should have been included. She is right.) She did participate in the Virtual Futures conference at the University of Warwick in England in the summer of 1995, which had the declared aim:

> To bury the 20th century and begin work on the 21st. We are children of the 21st century and live already in the future unknown, uncovering every day vast new landscapes for exploration. We will not know the results of the tumultuous global changes we are undergoing and creating for a hundred years or more, if we can survive them, but we are less interested in knowledge than in experiencing these changes.[43]

Orlan's own aims are not quite so utopian, for she does not approach the millennium with either fervor or fear; instead she dissects both ideological poles with surgical precision. Like Ballard, she embodies a new psychopathology of everyday life.

Orlan's actions cut through three discrete genres: (1) Western classical painting, from Leonardo da Vinci onward; (2) the genre of the psychoanalytic case study, with specific attention to Lacan and Freud (who wrote a famous essay on Leonardo)[44]; (3) the genre of epistolarity, which has undergone several recent transformations as a result of technology. Jean Cocteau was the first to link ancient epistolary conventions to a new

communications technology, the telephone, in *La Voix Humaine* (1930), a woman's dramatic monologue on the telephone with the lover who abandoned her. Nicholson Baker's novel *Vox* (1991) substitutes anonymous phone sex for the letter, but his title pays homage to Cocteau. E-mail novels have already begun to appear: Avodah Offitt's *Virtual Love* (1994) consists of on-line correspondence between two psychiatrists.

Orlan invents a new model for epistolarity and simultaneously performs it. While the surgeons operate, Orlan opens a window to the world via satellite, visiophone, picture Tel, fax, and modem. Well-wishers around the globe "correspond" with her; everybody is plugged in and hooked up. While she is on the operating table, she receives messages from Tokyo, Moscow, Paris, Latvia. Epistolarity is now international, instantaneous, and interactive. She makes the verbal and the visual intersect, for Orlan's "correspondents" can see as well as hear her, just as she sees, hears, and responds to their questions and comments. This takes epistolary communication far beyond the powers even of E-mail. The "correspondence" is visual, aesthetic, and clinical—all at the same time. It is multiple, spontaneous, and staged—all at the same time (Fig. 17).

Orlan is our age's Cocteau, the missing feminist link between the Surrealists' unconscious, the Situationists' spectacle, and Baudrillard's simulacra. Like virtual reality and God, Orlan is everywhere and nowhere. She stages the problematic of belief, its causes and consequences. Lying prone and vulnerable, she shares with the world an overwhelming desire to communicate.[45] Orlan's New York show at the Sandra Gering Gallery in 1993 combined the concepts of omnipresence and virtual interactivity: while the surgeons operated, supporters around the globe not only watched the operation, but transmitted messages back to her instantaneously. One fax transmittal read: "Paris is with you, Orlan"—the city of Paris, that is, not the mythological beauty contest judge.[46]

"I was able," she says, "without feeling any pain, to answer people who were feeling their own pain as they were watching me." Those words are an uncanny description of the psychoanalyst's function—to answer people who are feeling their own pain. "To answer," however, means "to respond"; it does not imply that either the analyst or Orlan *provides* the answers. Orlan invests "the talking cure" with new significance. Just as her face is a composite of many icons, she combines the functions of intercessor, cyborg, mother, and analyst (on whom one projects one's loves and hatreds). Orlan uses the new technologies in medicine and telecommunications to create a psychological self-portrait, one that reflects how profoundly the human senses have been reorganized by those technolo-

Figure 17 Orlan, *Omnipresence:* scene from the operating room during seventh plastic surgical operation, November 21, 1993. Courtesy Orlan and Sandra Gering Gallery, New York.

gies. Rather than "playing" the passive patient, Orlan plays the pedagogue: during surgery, she reads from Lacan's "Mirror Stage" and Kristeva's *Powers of Horror*. Small wonder that Orlan would one day like to do a whole exhibition on abjection: she is Exhibit A. What is it about the body, she asks, that evokes such revulsion, particularly the female body? Why is every stage of women's art, history, and subjectivity repressed, disavowed—right up to the present moment, with herself? As a panel participant with Orlan, I have witnessed firsthand the hostility she arouses. She recalls a New York dinner party for art dealers, curators, and collectors with whom she hoped to discuss her work. Instead, they were suspicious of her, particularly the women. Suddenly, she no-

ticed that all the women had the same nose! Her very presence simultaneously affronted and exposed their psychic and economic investments, quite literally.

If the Mirror Stage is the structuring moment when an ideal of unity, harmony, wholeness (with self and other) is imprinted on the mind's eye, Orlan cracks the mirror, exposing the optical trick that creates it. She never lets the spectator forget that the ideal is illusory. "I no longer recognize myself in the mirror," says Orlan. Recognition: the act of knowing involves doubling, repetition, re-creation. The agency of the ego is founded in a fictional direction; subjectivity is not only fractured, but based on *mis*recognition. Narcissism, Lacan argues, is ontological, which illuminates Orlan's numerous comments about her own image: "I've worked with my own image for twenty years," she tells me. "Being a narcissist isn't easy when the question is not of loving your own image, but of re-creating the self through deliberate acts of alienation."

Although many feminists have taken issue with Freud for equating femininity with narcissism, Orlan *performs* that equation with a Medusan vengeance. She documents each step of the process, photographing her bruised and bandaged face every day for forty-one days. She emphasizes the *plasticity* of her body as an aesthetic and technological medium. Since psychoanalysis involves "working through" old materials (dreams, fantasies, traumas), it seems fitting that Orlan recycles every material thing. (One of the defining traits of the fetish is its untranscended materiality, its status as a material object.) As the French representative to the Sydney Biennial in December 1992, she included in the exhibition vials containing samples of her liquefied flesh and blood drained off during the "body sculpting" part of the operations. These "relics" are marketed to raise funds for the remaining operations.

As gruesome as all this sounds, Orlan actually transforms the operating room into a carnival of campy humor. She and the medical team don costumes designed by Paco Rabanne or other couturiers. She brandishes a skull's head, pitchfork, or crucifix, delighting in absurd juxtapositions, like the Surrealists' "exquisite corpse" projects, collaborative art works in which one artist designs the head, another the torso, a third the feet for a single painting. It almost seems as if she wants to transform the famous Surrealist image of an umbrella and a sewing machine on an autopsy table into a tableau vivant. Orlan shares Peter Greenaway's and Jeffrey Deitch's view that "the body is obsolete." Orlan herself is the "exquisite corpse," the body merely a costume. She sheds one costume after another, staging femininity literally as masquerade. She is a

relic in both senses of the word—a religious relic, and a relic of an age that will soon seem long ago and far away.

Just as her own body is a *cadavre exquis,* she grafts Brecht's theory of the alienation effect with Artaud's Theater of Cruelty. Her studio on Rue de Raspail (the celebrated scientist) is next to the asylum where Artaud died, and one of her staged facelifts was performed in homage to him. Artaud defined cruelty as the painful reorganization of the theater and the urgent demand for a new type of corporeal speech: "We need above all a theater that wakes us up: nerves and heart." His manifesto exhorts actors to create a spontaneous corporeal force between actor and the "shocked" neuromuscular responses of the spectator.[47]

The Viennese Actionists took up the historical legacy of Artaud, exposing the process-oriented, ritualistic, performative characteristics that characterized Body Art of the 1960s and 1970s.[48] From Marcel Duchamp, Orlan took the idea of using cast-off materials, found objects as art, an idea she takes to an extreme by using her own body as a "ready-made." Orlan calls her work "carnal body art for the 1990s." Yves Klein also had a dramatic impact on her work.[49] The members of the art movement Fluxus (among them Valie Export, Yoko Ono, Henry Flynt, Joseph Beuys, and Jean Dupuy) are also Orlan's precursors, especially with their emphasis on "chance operations," indeterminacy, and the unconscious.

Many of these artists were represented in the *Hors Limites* show in Paris at the Pompidou Center in 1994–95, an ambitious comprehensive retrospective from 1952 forward which, appropriately, begins with Guy Debord. Orlan's early art suggests the kind of agitation synonymous with Debord and the Situationists, so named because they became notorious for staging absurd "situations" that mocked both state power and the art establishment. Orlan shares their aim of transforming life through art. The Situationists argued for a collective view of play; play must invade life.[50] In the wake of Debord's *Society of Spectacle,* Orlan improvised a series of absurd feminist spectacles, such as lying down in the streets of Paris and using her own body as a ruler to measure Rue Lamartine, Rue Victor Hugo, as well as streets named for famous men in other cities. She uses her petite body to "take their measure." Other measuring actions related her body to a medieval convent and to the Guggenheim Museum. Like the Situationists, Orlan wants to launch a cultural revolution against consumer society. In 1977, *Le Baiser de l'Artiste* featured a life-size photo of her torso transformed into a slot machine, which she labeled "automatic kiss-vending object." By inserting five francs, a customer could watch the coin descend from her breasts to her crotch,

whereupon she leapt from her pedestal to kiss the customer, a burlesque of the processes that idealize and objectify woman, while commodifying the art *and* the artist.

As in the *Post Human* exhibition, Orlan points to a new concept of the self, ruled by metaphors not of depth but of surface. It is in this sense that she develops a new metaphorology. She demonstrates that subjectivity does not control the image; instead the image shapes subjectivity, whether the image comes from Renaissance art or contemporary advertising. (In *The Physical Self,* Greenaway uses the Benetton image of a newborn to make the same point.) When her metamorphosis is complete, Orlan—a synthetic name for a synthetic identity-in-process—will let an advertising agency assign her a new name to go with her new "look."

Orlan and Greenaway are trying to drive the same point home: subjectivity itself has undergone a profound transformation as a result of televisual technologies. A recent essay entitled "Television" asks whether television fundamentally *determines* our experience: "*Is the television a—or the—dominant but unacknowledged epistemological model of subjectivity?* Do we understand ourselves as presentational constructions, moved by prefabricated, precoded information, precipitated—in a strangely evacuated but somehow 'electric' space—according to certain definable procedures?"[51] Orlan traveled to India to obtain enormous flashy billboards of the type used to advertise Indian films, because they have the kitschy look of 1950s Hollywood posters. Her pilgrimage testifies to the lengths to which she will go to show how our self-images are cobbled from advertisements and films. She is an expert in the hyperreal, the saturation of reality by simulacra.

Nevertheless, sensationalistic media coverage in both Europe and the United States consistently portrays Orlan as a freak. When she was interviewed by CBS's Connie Chung in 1993, Chung could not disguise her revulsion, which was particularly hypocritical, since she herself had gone under the knife years ago to make her eyes look more "Western." Orlan merely takes to an extreme what Chung and many other celebrities take halfway. She exposes the processes that doctors and patients go to such lengths to disavow. Orlan has nothing against plastic surgery per se. Her critique is directed against the regime of beauty it so rigidly enforces, to which celebrities (and New York art dealers) so slavishly conform.

When Orlan calls herself the first "woman-to-woman transsexual," she destroys the neat divisions between male and female, culture and nature, outside and inside. That litany of dismantled dichotomies is by now familiar, but Orlan uses her self-description with surgical precision, for

where the transsexual undergoes sex reassignment in order to be "complete," Orlan is never complete.[52] The whole point is to avoid perfection, fixity, positiveness. Parveen Adams calls Orlan "an image *trapped* in a woman's body," but it is Orlan who sets the trap, Orlan who upsets the tranquil categories of gender and genre. Adams is right, however, to conclude that the image is empty. It is not a face but a gap[53]— not unlike the "black hole at the lower part of her face" that opens in Emma Bovary's corpse, spewing out black liquid.

With Bob Flanagan, Orlan points to a newly emerging aesthetic, generated from or driven by the insides of the body. With Greenaway and Deitch, they are creating not just *performances* for the twenty-first century, but *bodies*. If Flanagan is Sacher-Masoch, Orlan is de Sade. Both are stoic comedians, exhibitionists, displaying the corporeal self as an "atrocity museum." They interpret medicine's texts: codes, alphabets, letters, sequences, and blueprints are the signatures of all things they are here to read.

No wonder the medical establishment weighed in on the "issue" of Orlan; in 1991, the *Revue Scientifique et Culturelle de Santé Mentale* devoted a special issue to the question of whether she is sane or mad, and whether her work is art or not. (The strictly regimented dichotomy of options is revealing: sane or insane, art or not-art.) Essays by psychologists, critics, and artists explored the relationship of her work to psychopathology and aesthetics, and conclude that her surgery projects are indeed art.[54] Not everyone agreed: as Tanya Augsburg notes, one expert finds in Orlan's work symptoms of Body Dysmorphic Disorder (BDD): "Orlan has literally become 'detached' from her original body, the new creation being something distant, foreign, unnatural. The further dislocations produced by the constant photographing, videotaping and filming of several 'before' and 'after' images can only lead to an extreme case of identity confusion, a state that would fall within the psychiatric diagnosis of Depersonalization Disorder, another mental disorder related to BDD."[55] This sounds like one of J. G. Ballard's parodies of clinical psychiatric manuals in *The Atrocity Exhibition*. The culture of experts has the technical lingo, but it comprehends nothing, it tells us nothing. It is judgmental and prescriptive, not descriptive. Orlan could not help but be amused by the *Revue;* she rolled her eyes as she told me how fixated the interviewers were on her relationships with her mother and father. First she parodied the genre of the psychiatric case study, then the experts proceeded to turn her into one.

Having traced Orlan's generic antecedents, let me mention some of

the important implications of her work for theorists of genre. The first implication is that however much a genre is deformed, traces of its roots remain visible, even when radically altered by technology. In *The Handmaid's Tale* by Margaret Atwood, for instance, a tape cassette stands in for a letter, but all the generic characteristics of epistolarity remain intact, as clearly visible as in Cocteau's *La Voix Humaine*. A primary example is certainly *Madame Bovary*, prosecuted for its "outrage to public morals." Only later did it become clear that by the end of the first chapter, point of view in the novel had changed forever; the collective "we" who observe Charles Bovary's first day of school disappear, and *indirect discours libre* makes it impossible to determine how "we" are to interpret from that point forward. Flaubert is perhaps the first to make "looking awry" part of narrative structure itself.

The same applies to Orlan's innovations: no one theory adequately explains her work, even though she reads theory during her performances. Just as the epistle (according to Derrida) "is not a genre, but all genres, literature itself," Orlan illustrates Derrida's theory of genre: the trait that enables one to determine genre does not appear in genre itself. It is important to remember that when Orlan's operations are complete, she will not look like the *Mona Lisa*, the Botticelli *Venus*, or the other paintings—instead, she will be a composite of them all. In this sense, she perfectly embodies Derrida's definition of genre: "A sort of participation without belonging—a taking part in without being part of, without having membership in a set."[56]

Genre also has important implications for theories of spectatorship. The etymology of *obscenity* may derive from *ob-scene*, and suggests "that which takes place offstage, off to the side,"[57] but the fact that Orlan uses multiple visual technologies *on*stage indicates that we are witnessing a paradigm shift in the making where spectatorship is concerned. The most important theory of spectatorship in the past twenty years is Laura Mulvey's "Visual Pleasure and Narrative Cinema," written in 1973 and published in *Screen* in 1975. The idea of the "male gaze" that she introduced has become so widely dispersed across so many genres and media that it is worth revisiting some of Mulvey's original points, which have sometimes been lost in translation.

All of Mulvey's work focuses on the deep structure of the Oedipus complex, the persistence of fetishism and fascination. Following Freud, she argues that woman signifies castration; man projects voyeuristic or fetishistic mechanisms to circumvent the threat of castration. Cinema is a screen much like the Lacanian mirror, an "imaginary signifier." It is ironic that

her essay has taken on a life of its own, dispersed across multiple genres, because it is an argument about *genre*—narrative fiction film in classical Hollywood cinema, with specific emphasis on film noir and Hitchcock: "The place of the look defines cinema. . . . Going far beyond highlighting a woman's to-be-looked-at-ness, cinema builds the way she is to be looked at into the spectacle itself."[58] Furthermore, many who took Mulvey to task for being "reductive or un-objective" failed to notice that the essay itself belongs to a very specific genre: it is a manifesto.[59] As in the Futurist Manifesto and the Surrealist Manifesto, objectivity is hardly the aim. The aim is to incite people to action—two actions in particular. First, Mulvey wants people to recognize the political usefulness of psychoanalysis, a blind spot for the British Left in the late 1960s and early 1970s, and one that materialist feminists like Mulvey, Juliet Mitchell, and Jacqueline Rose insisted on. As Rose points out, despite the publication of Lacan's essay and Althusser's famous article on Lacan in *New Left Review* in 1968, the commitment to psychoanalysis was not sustained even by that section of the British Left which had originally argued for its importance. They ignored its radical antiempiricist potential—the very potential Mulvey's manifesto exhorts us to recognize.[60]

Second, Mulvey wants "to destroy pleasure." She uses the word *pleasure* interchangeably with *beauty*: "It is said that analyzing pleasure, or beauty, destroys it. That is the intention of this article."[61] No more pleasure in seeing one part of a fragmented body, no more pleasure in turning woman into "a cut-out or icon."[62] Put another way, Mulvey wants cinema to *cut out the cuts* that make pleasure possible, for the cuts to women are the unkindest cuts of all. Although some of the male theorists who criticized Mulvey denied that they desired or intended to do this to women, J. G. Ballard frankly confirms Mulvey's hypothesis. He clearly has Freud's theory of fetishism and the castration complex in mind when he confesses what the breast signifies:

> Were [Mae West's] breasts too large? No . . . but they loomed across the horizons of popular consciousness along with those of Marilyn Monroe and Jayne Mansfield. Beyond our physical touch, the breasts of these screen actresses incite our imaginations to explore and reshape them. The bodies of these extraordinary women form a kit of spare parts, a set of mental mannequins that resemble Bellmer's obscene dolls. As they tease us, so we begin to dismantle them, removing sections of a smile, a leg stance, an enticing cleavage. The parts are interchangeable.[63]

Enter Orlan. If Orlan had not existed, Mulvey might have invented her, for Orlan deliberately assembles and reassembles her own "spare

parts." She is a "living doll" who plays with herself. In so doing, she inverts the "natural" order, revealing (and reveling in) the pornography of science. What do pornography and science have in common? Both "perverse implantations" rely on repetition and experimentation. Both isolate objects or events from their contexts in time and space in order to concentrate on a specific activity of quantified functions. Both murder to dissect. These are all traits pornography and science share with cinema, for "the male gaze" freezes the look on the erotic image. Mulvey writes: "The presence of woman . . . tends to . . . freeze the flow of action in moments of erotic contemplation. . . . Playing on the tension between film as controlling the dimension of time (editing, narrative) and film as controlling the dimension of space (changes in distance, editing), cinematic codes create a gaze, a world and an object, thereby producing an illusion cut to the measure of desire."[64]

What Orlan wants to do is to trace the passage from Nature to Culture, with specific attention to the cuts along the way. (The three nasty newspaper reviews I cited earlier, by Dovkants, Fox, and Rosen, each tried to suture Orlan into the regime of beauty, and found her wanting.) Like Mulvey, Orlan reminds us that "the male gaze" does not spring from *omnipotence* but from *fear:* Man assuages his own fears of castration by projecting those fears onto woman, turning her into an object of voyeurism and/or a fetish object. By literally showing how the cuts are made, Orlan reverses the suturing process of ideological interpellation. Whereas Mulvey shows how the female star is filmed in such a way that maintains her position in relation to the male subject, in Orlan's work the male has no relevance, no paternity or divinity, which is what Orlan means when she proclaims, "I fight against God and DNA!"

She also thwarts the pleasures of passivity—the final trait she shares with Mulvey, for what Mulvey wants to destroy is the pleasure of passivity, a point in her essay which, along with her wit, is often overlooked today. If Schneemann, Sprinkle, Kruger, and Orlan are four of the "cutups in beauty school" referred to in my title, Mulvey is another one, for she made a spectacle of herself by getting arrested for disrupting the Miss World beauty contest in London in 1970. Today, it is more important than ever to remember: "The Spectacle Is Vulnerable," the title of Mulvey's account of her arrest. Today, furthermore, it is almost impossible to remember the spirit of camaraderie that accompanied such high jinks. That is what makes Wendy Steiner's comparison of Mulvey to Andrea Dworkin so unjust in "The Literalism of the Left" *(The Scandal of Pleasure),* for nothing could be further from Mulvey's mischief-making than Dworkin's grim censor-

ship campaign. Dworkin's and Mulvey's leftism, feminism, and intellectualism could not be more dissimilar. Dworkin is a self-proclaimed "radical" feminist; she has declared war on any image that can be construed as "subordinating women." Mulvey is a British materialist-feminist, an early champion of popular culture, and what interests her most about Freud are his metaphors—hardly evidence of literalism. Yet to Steiner,

> Much more worrisome is the feminist critique of aesthetic pleasure. . . . According to some feminists, the experience of traditional art amounts to a seduction by a beautiful object. . . .
>
> Just as feminist extremists invest pornography with an extraordinary power over reality, Mulvey's critique invests the cinema with the power of a Freudian fetish. Hollywood cinema, she says, is a magic realm of wish-fulfillment in which male fears of castration are deflected onto a castrated woman. . . . The only way to control aesthetic pleasure for the dedicated fetish-buster is to destroy beauty.
>
> Thus for many artists and theorists, the experience of art is necessarily pornographic, sadistic, and ultimately destructive of women. . . . To see art as enactment of a one-way power relation is adequate neither to women nor to art.[65]

Far from interpreting all art as "victim art," as Steiner claims, Mulvey explores the pleasures of passivity. Far from being a "fetish-buster," she is fascinated by the logic of the fetish. Far from taking Freud literally, Mulvey is interested in the ways these master narratives of Oedipus, Pandora, and others are disseminated over and over in films from *Citizen Kane* to *Blue Velvet*. (It is revealing that Steiner does not support her argument with a cinematic example, but instead cites Toni Morrison's *Beloved*.) Far from exhorting us to ban even the classics, Mulvey merely *analyzes* them, while exhorting filmmakers to consider new strategies in avant-garde filmmaking.

Orlan's performances demand a story, but she withholds the plot, the raison d'être, and—like Flaubert—an authorial point of view. She does not demand one, single "proper response" to her art. She thwarts passivity by shoving spectators' voyeurism down their throats. As Michael Prince observes, "the beauty contest transforms a culture's anxiety about the contingency of its defining values into a spectacular reenactment and overcoming of that very anxiety."[66] Those consoling transformations and values are precisely what first Mulvey and then Orlan thwart. This is an especially crucial point, because while film theorists in recent years have devoted considerable attention to fantasy, more work remains to be done specifically on *anxiety*.

Not only does the act of cutting create anxiety, but the erasure of origins does too. If Orlan is a model that cannot be copied, she is also a copy that has no single origin. "Orlan" (a name reminiscent of the synthetic fabric Orlon) refers to a personality composed from what Flaubert called its idées reçues. Orlan clearly has Flaubert's novel *Bouvard and Pécuchet* in mind: the novel consists of a dictionary of received ideas, or clichés, obsessively recorded by two maniacal copyists. Orlan also mimics *Bovarysme,* which means the act of seeing oneself as others see you, just as Emma Bovary formed a self-image in her mind's eye compiled from Parisian couturiers' catalogues. Flaubert duplicated the clichéd language *and emotions* Emma Bovary borrowed from books (specifically from Lamartine and Victor Hugo). In forming her "Image-repertoire" from books, she is a female Quixote; Orlan is her daughter.

Orlan's performances annotate the body of French literature. She gives new meaning to an "anatomy of criticism." She cannibalizes the canon, as if to say, Let us now lie down in the streets named for famous men. But the idea that one's most intimate emotions are mere copies can be traced back to La Rochefoucauld's *Maxims:* "Some people would never know love if they had not heard it talked about" (# 136). Her performances are forms of literary criticism, not unlike Roland Barthes's *S/Z,* which cannibalizes Balzac's tale of Sarrasine, a sculptor who falls in love with a beautiful opera singer named La Zambinella, who is eventually exposed as a castrato. The slash in the title is the sign of castration. When Zambinella's duplicity is revealed, "she" falls to her knees, eyes raised, arms outstretched. Barthes writes: "Derived from a complex pictorial code, La Zambinella here achieves her final incarnation, or reveals her ultimate origin: the *Madonna with Raised Eyes.* This is a powerful stereotype, a major element in the Code of Pathos (Raphael, El Greco, Racine's Junie and Esther, etc.)."[67] Barthes concludes that "nature copies the book," a motto that illuminates Orlan's motives for copying the old masters. But she simultaneously refuses to "invest in the divinity of the masterpiece," to cite the words photographer Barbara Kruger slashes across her reproduction of Michelangelo's Sistine Chapel (Fig. 18). Kruger's protest, like Orlan's, is directed at those who can conceive of art only as an economic investment. She is also challenging the patriarchal lineage from God the Father, "giving birth" to man. Finally, Kruger points to the aura that surrounds the unreproducible work of art and makes it priceless. Kruger also accosts the viewer with the word *you: you* are complicit in these systems of exchange. Your investments are both social and psychic.

Orlan and Kruger both talk back to Charcot, the doctor who was

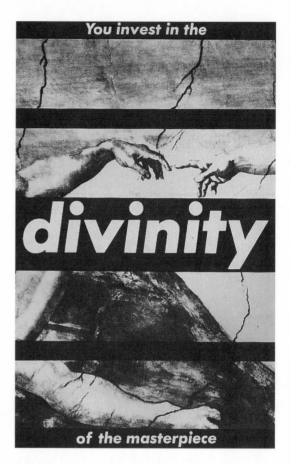

Figure 18 Barbara Kruger, *Untitled (You invest in the divinity of the masterpiece)* (1982). Photograph, 73 in. × 47 in. Collection: Museum of Modern Art, New York. Courtesy Mary Boone Gallery, New York.

Freud's mentor and famous for parading female hysterics before his medical students in the amphitheater in his Paris hospital.[68] If Sprinkle's performances are "hysterical" in the sense of being humorous, Orlan's return us to the word's etymology. Medicine's regimes hystericize and cannibalize the female body throughout history, as Kruger's *Untitled (No Radio)* illustrates (Fig. 19). The doctor is holding one of the prone patient's internal organs, probably her heart. As usual in Kruger's work, the text acts as an interdiction, a bar to signification, intercepting the visual image, as if to say, "Don't bother breaking into me, there is nothing left to steal, to appropriate, to dissect." Like Kruger's, Orlan's work trains the spotlight on the drive to frame woman as a collection of symptoms and neuroses—to make a spectacle of her body.

But the spectacle Orlan incites in the *audience* is by far the best part of the show. I first met Orlan at The Illustrated Woman conference in San Francisco in February 1994. The audience consisted of artists, writers, "modern primitives," the piercing and tattoo crowd, the leather community, gays, lesbians, and transsexuals. Not for academics only, in short. Collectively, they embodied what is becoming known as "the last sex," which—like the posthuman—signifies how profoundly *conceptual* both gender and sex have become. As Arthur and Marilouise Kroker explain in *The Last Sex,*

> In the artistic practice of medieval times, the privileged aesthetic space was that of anamorphosis. The aesthetics, that is, of perspectival impossibility where the hint of the presence of a vanishing whole could only be captured by a glance at the reflecting surface of one of its designed frag-

Figure 19 Barbara Kruger, *Untitled (No Radio)* (1988). Photograph, 51½ in. × 68½ in. Collection: Don and Doris Fisher, San Francisco. Courtesy Mary Boone Gallery, New York.

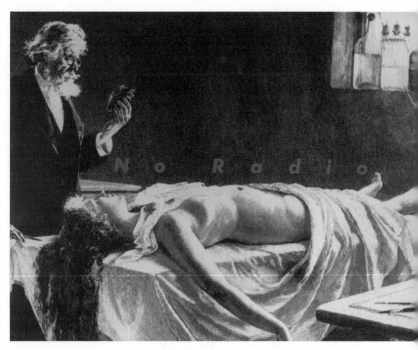

ments. . . . Now anamorphosis returns as the privileged perspective of vir-
tual sex, of intersex states. . . . It is that new sexual horizon, post-male and
post-female, that we now call the perspectival world of the last sex.[69]

Anamorphosis defines the Mirror Stage. The *Oxford English Dictio-
nary* defines *anamorphosis* as "a distorted projection or drawing of any-
thing, so made that when viewed from a particular point, or by reflec-
tion from a suitable mirror, it appears regular and properly proportioned;
a deformation." One famous example is Hans Holbein's *Ambassadors:*
in the foreground, one sees a blur or a skull, depending on one's point
of view or—more accurately—views, for anamorphosis demonstrates that
there are *two* moments of viewing: when one concentrates on the worldly
objects in the painting, one only sees a blur, but when one looks again,
it becomes a skull, radically subverting the smug complacency of the good
bourgeois owners of the objects. One must "look awry" to see.[70]

At the San Francisco conference, Susan Stryker, a male-to-female trans-
sexual, read her memoir about her operation, fantasizing about seduc-
ing the "adorable surgeon" who flays her "awkward little penis; when
I lift my hips to meet the knife, he'll see that nothing but my desire brings
him here." Another lesbian artist photographed the lesbians in the
leather community who were undergoing female to *male* transsexual op-
erations. Although clearly not a squeamish crowd, their response to Or-
lan was hostile. When Orlan called herself the first "woman-to-woman
transsexual," only I laughed. Confronted with the graphic video images,
the audience groaned and looked away. Many accused her of sensation-
alism and aggression. Others accused her of maligning the medical
profession (merely by exposing its *labor*)! Finally, one member of the au-
dience seemed to "get it." She asked Orlan, "Have we, the audience, ade-
quately performed our role as inquisitors by demanding signs of your
suffering, visible proof of your stigmata?" Orlan smirked.

Now that I have seen this hostility reenacted on two coasts, I realize
that it is a reaction to what the audience perceives as Orlan's aggression.
But in reality, it is the audience who is projecting aggression; Orlan is
merely the object of transference. (One sign that the transference is al-
ready working is when the analysand finds faults with the analyst.)[71]
While she lectures onstage with the aid of a translator and someone who
signs for the deaf, enormous video screens behind her show the opera-
tion in process. The standard "before" and "after" photos used to ad-
vertise plastic surgery leave an enormous gap where a picture of "dur-
ing" belongs—that is what one is seeing *for the first time ever* on the

screen behind her. As Parveen Adams points out: "The succession of the moments of anamorphosis are presented simultaneously. The gap between the two images empties out the object. It is not that surgery has transformed her, but that surgery has changed our experience of the image. Of course this is only one instance of emptying the image. The space which has opened is radical and has always been there. It is savagely inconvenient. But it is the space which is new from the point of view of knowledge."[72]

J. G. Ballard had the same space and the same setting in mind during the early 1970s when he speculated on all the new technologies that would necessitate the writing of a new *Psychopathology of Daily Life,* but at the time, the most radical surgical procedures were Dr. Christiaan Barnard's heart transplants: "A whole new kind of psychopathology, the book of a new Krafft-Ebing is being written by such things as car crashes, televised violence, the new awareness of our own bodies transmitted by magazine accounts of popular medicine, by reports of the Barnard heart transplants, and so on."[73] If Ballard is the oracle, Orlan is the "atrocity exhibition" who fulfills his prophecies. Her exhibitionism juxtaposes two temporalities and seems to challenge the audience: "I am here, I did that, I orchestrated the entire event, everyone capitulated to my will—from the lab technicians to the surgeon to the well-wishers around the globe." Like Bob Flanagan, she becomes the center of the universe. Hard to like a woman like that. She is supremely *self-possessed*—a delicious irony, since what she is doing is emptying the self, revealing that there is nothing "beneath" the mask.[74]

The Pandora myth posits that femininity is a trap and a mask; female sexuality is a box that, once opened, lets sin and death loose upon the world. Schneemann's question again comes to mind: Vulva asks, "Why is cock a thing and vulva a place?" Pandora is the site of that split between outside and inside, which becomes synonymous with seductiveness and deceit: a beautiful exterior conceals a pernicious interior. No wonder so many women artists are striving to make literal the metaphor of "looking inside": their aim is to dispel that myth. In "Pandora: Topographies of the Mask and Curiosity," Laura Mulvey notes:

> The story of Pandora's creation installs her as a mythic origin of the surface/secret polarity that gives a spatial or topographical dimension to this phantasmagoric representation of female seductiveness and deceit. . . . The recurring division between inside and outside is central not only to understanding representations of femininity in socially constructed fantasy, but also illustrates the uses of psychoanalytic theory for feminism. It is be-

cause of the kind of problem posed by the Pandora phenomenon that feminist aesthetics has turned to semiotics and psychoanalysis, to transform the work of criticism into a work of decipherment . . . the topography [of] . . . Pandora is an important clue for deciphering the fantasy. And understanding the "dialectics of inside and outside" is a possible point of departure.[75]

That is the point of departure seized by all five of the women I have discussed in this chapter. Rather than sealing the lid on Pandora's box, in various ways Schneemann, Sprinkle, Kruger, Mulvey, and Orlan turn it inside out, exposing the fears of castration that underwrite misogynistic fantasies, fetishes, and fixations. In different ways, all five women are "cutups in beauty school," dissecting the culture's deep-seated economic and psychic investments in woman's "to-be-looked-at-ness."

Along with Bob Flanagan, Orlan desacralizes our culture's investment in medicine, which she sees as our epoch's religion. The medical amphitheater is our sacred sanctuary. In view of the new medical imaging devices that are transforming artistic practices, something else Barthes once said now resonates with added significance: "The Image always has the last word." By seizing control of the medical apparatus, Orlan strips it of mystique. In so doing, she invokes another epistolary classic, Mary Shelley's *Frankenstein.* Since Mary Shelley's mother died giving birth to her, Mary never lost the uncanny conviction that she had been born of dying parts. Orlan is Frankenstein, the monster, and the Bride of Frankenstein all rolled into one.

I began this chapter with the quotation from Flaubert to illustrate that the myth of the inviolate body has been a long time dying. That is what elicited anxiety among Orlan's San Francisco audience, hence their hostility. Finally, someone asked: "Is the point of piercing the skin, showing how the scalpel goes in at the temple and comes out at the neck, to get to the bottom of *interiority?*" "No," Orlan replied, "I don't believe in interiority." (I think again of *Madame Bovary:* "At the pharmacist's request, Monsieur Canivet . . . performed an autopsy, but found nothing.")[76] Therein lies the true scandal, the final cut: Orlan opens herself up and finds nothing.

Visceral Cinema

Impolitic Bodies

RACE AND DESIRE

The films in the following three chapters share one basic premise: it is
not pornography that is everywhere, it is fantasy.[1] They show how fan-
tasy functions through a complex repertoire of identifications and asso-
ciations. That repertoire and its cinematic expression are my subject. If
the artists in Part 1 show how fantasy is influenced as much by the so-
cial as the psychic, the filmmakers in this chapter expand that focus by
exploring the formations of fantasy among blacks and between blacks
and whites. They endorse the antiaesthetic delineated in my introduc-
tion, particularly concerning postmodern oppositional strategies, for
"marginalization" signifies differently where race and sexuality intersect.

In "De Margin and De Centre," Isaac Julien and Kobena Mercer lay
out the issues confronting filmmakers and film theorists today.[2] Their es-
say appears in a special issue of *Screen* devoted to race, but they attack
the "special issue" approach, which merely magnifies marginalization.
Instead, they call for an end to Eurocentrism and ethnic absolutism. Only
when the Caucasian race receives equal scrutiny will it cease to be the
unacknowledged but universal "norm." Conversely, Julien and Mercer
want black filmmakers and critics to move beyond celebratory gestures,
which preclude serious criticism. The aim is not consensus and harmony,
nor is there an essential black subject who is the mouthpiece of the race.
Instead they ask, "What does it mean to be black, when that encompasses
diverse minority communities of Asian, African, and Caribbean origins?

How does one effectively speak *from* (not *for*) black experiences?"[3] What does it mean to be the first generation to identify with a diasporic culture that is both black and British? As Coco Fusco points out, workshops like Sankofa and the Black Audio Film Collective bridge the chasms between university theory and urban realities; these young black filmmakers are continuing the inquiry they began at university about the mechanisms of cultural production in newspapers, advertisements, television, cinema. They want to launch a two-pronged critique against film theory's silence about racial issues and against the racism of mainstream media. They have been remarkably prolific since the 1981 Handsworth "riots," the subject of Isaac Julien's *Territories* (1985), the Black Audio Film Collective's *Handsworth Songs* (1986), and Maureen Blackwood and Isaac Julien's *Passion of Remembrance* (1986), produced by Sankofa's collective.[4] The British Film Institute, The Greater London Council, and British television's alternative Channel 4 have showcased the work of these filmmakers. *Passion of Remembrance* views personal relationships, families, and institutions as systems of control. The film "took things to point zero: family, the man, the woman, used as metaphors for experience in Britain at the time."[5] Some films juxtapose oppressive urban space with a dreamscape of open land, sign of deliverance. Others, like Martina Attille's *Dreaming Rivers* and Onwurah's *Body Beautiful,* use mother-daughter relationships to symbolize the complex racial heritage (and concomitant ambivalence) between "mother Britain" and her former colonies. Onwurah is black and white: her father was Nigerian, her mother is British. *The Body Beautiful* explores the impact of her mother's mastectomy and, like Orlan, critiques the medical establishment and other arbiters of beauty.

Not only do these filmmakers criticize the aesthetics of beauty, they expose the ideological foundations of aesthetics. "How," they ask, "is the black subject sutured into a place that includes it only as a term of negation? What does the black spectator identify with when his/her mirror image is structurally absent or present only as Other?"[6] Scott McGehee and David Siegel's *Suture* (1993) examines that question. Their film is both a psychoanalytic case study and a film noir, and its title puns on the ways spectators are seamlessly "sutured" in their roles as ideological subjects, blind to the difference race makes. Like Onwurah, McGehee and Siegel expose the mechanisms that reinforce that myopia. I saw the film in London in the spring of 1995, at the Institute of Contemporary Art; it was screened in conjunction with other events and exhibitions that were organized around the theme of mirage and charted the

influence of Frantz Fanon's *Black Skin, White Masks* on a generation of young black artists. Drawing on Hegel, Sartre, and Lacan, Fanon's landmark study analyzes the psychic processes that lead blacks to internalize the view whites have of them, and records the resulting consequences. While some black theorists now see psychoanalysis as a dead end of inquiry, others find ways to appropriate its methods in order to show how the black male's "visual punishment" is one of Hollywood's "narrative pleasures."[7] The filmmakers in this chapter are in the latter camp. Mercer and Julien ask, "What happens when the object of the male gaze is not a woman, but another *man?*"[8] Julien's *Attendant* (1992) is about a black museum guard, whose homoerotic fantasies are aroused by a painting of a slave ship. *The Attendant* calls into question the neat divisions between high art and low, deconstructing the very idea of the museum in the process.

The filmmakers addressed in this chapter reinforce the antiaesthetic objectives outlined in my introduction: they portray the contested struggles over both truth and beauty; the critique of realism, modernism, and the autonomous work of art; the exploration of dream and reverie. Most important to my method in this book, they insist on what Mercer and Julien call a "conjunctural approach," analyzing cinema in conjunction with other media: "The move towards a more context-oriented view . . . indicates that although dominant discourses are characterised by closure, they are not themselves closed but constantly negotiated and restructured by the conjunction of discourses in which they are produced. The way in which ethnic 'types' are made afresh in contemporary movies like *An Officer and a Gentleman* and *Angel Heart*—or more generally in current advertising—demands such a conjunctural approach."[9] That approach is necessary because new formations of fantasy have arisen from such incongruous sources as new technologies, communications, and merchandise. The emphasis on advertising is particularly notable; as J. G. Ballard points out, "These things are beginning to reach into our lives and change the interior design of our sexual fantasies."[10] Since consumption is an activity that is neither single nor simple, and since the consumer's motivation may involve instant gratification, impulse, or unconscious desires, selling products has much in common with psychoanalysis: both rely on the powers of suggestion and persuasion; both utilize the instincts and defenses.[11] The three films discussed in this chapter accentuate the roles that advertising, commodities, and consumption play in the formation of fantasy, whether the subject is a fashion model, an amnesia victim, or a museum guard.

NGOZI ONWURAH, *THE BODY BEAUTIFUL* (1991)

Like Orlan, Ngozi Onwurah uses surgery to investigate the culture's complex and contradictory psychic investments in femininity. Together they track the interrelationships between sexuality and disease, the female body and the body politic. *The Body Beautiful* is an autobiographical memoir that explores Onwurah's conflict as the half-black daughter of an aging, white mother (Ngozi's mother, Madge, plays herself). Her mother marries a Nigerian medical student in 1957; when civil war breaks out, he sends his young daughter and his pregnant wife to England. They never see him again. His absence, however, is palpable: the camera pans to photos, mementos, and mirror images of him as part of the family trio—a ghostly memory trace of harmony and wholeness. That lack of wholeness is mirrored in the mother's own body, for once pregnant, she develops breast cancer; the fetus and the cancer grow inside her until "pain crucifie[s] her." She has a mastectomy shortly after giving birth: her breast is the price of her son's life. Onwurah uses different actresses to represent herself at the ages of (approximately) seven, thirteen, and seventeen.[12] One of the film's audacious innovations are jump cuts that alternate between the daughter's subjectivity and the mother's. Sometimes the spectator sees things through the mother's eyes but hears the daughter's voice, or vice versa. Madge's menopause coincides with Ngozi's first menstruation; as Ngozi stands naked in front of a mirror, the mother's voice-over remarks: "When you bear the red fountain flowing from your aroused womb, she embraces you and whispers, 'This is our shared body and this is our blood.'" Despite such affirmations, the film is starkly unsentimental, commencing with a flashback of a brutal confrontation between mother and daughter at the age of thirteen, who cruelly calls Madge "a titless cow."

Onwurah illustrates that advertising, film, and fashion have a profound effect on the unconscious: they are "desire-producing machines" that point toward a new psychopathology of everyday life, influenced by new technologies. At seventeen, Ngozi is a budding fashion model, framed by Onwurah as a spectacle in the network of commodity culture. The viewer sees her "pumping up" her sexuality for a fashion magazine layout, responding to the tantalizing entreaties of the photographer to "jack it up a bit—give me sex, give me passion! Use your hair, use your lips!" The voice-over of a fashion expert assures us, "The '90's woman no longer has to sacrifice her femininity to be taken seriously": feminist validation is exploited as a marketing ploy. The fashion industry is on a con-

tinuum with the porno industry; both use sex to sell. Hardly a novel idea, but Onwurah ironizes it by exposing the gap between Madge's acute consciousness and the daughter's blithe complacency; the girl does not realize that half-black models are merely this season's hot ticket.

Ngozi initially lacks that capacity for cultural critique, but the mother provides it when she wryly observes that her daughter "was penciled in by men who define a sliding scale of beauty that stops at women like me." In a clever visual pun, Ngozi is dressed in red on a modeling assignment; when Madge utters these words, Madge suddenly appears out of focus in a reverse shot, similarly dressed up in red. She is visible to the viewer but not to the fashion photographer, for aging women are obsolescent in youth-oriented culture, relegated to the mythical epoch of "ungendered peace" not only by society but by her own daughter, who confesses that she thinks of her mother as "ageless, sexless, and safe." In retrospect, the daughter reflects, "I didn't have a clue." This scene illustrates how Onwurah combines expository documentary (which is overly didactic and emphasizes the real) with reflexive documentary (which raises political questions and engages in metacinematic critique). By blending the two modes of documentary, Onwurah creates a hybrid, one that might be called "performative documentary," since it stresses subjectivity and the politics of embodiment.[13]

Cinema's aim is not merely to make visible, but to make visceral. Onwurah depicts several things never before seen on the screen, such as repeated close-ups of a mastectomy. Like Bob Flanagan and Orlan, she demonstrates that many taboos have nothing to do with sexuality. Indeed, female aging itself is what Susan Sontag calls "a process of becoming obscene. . . . That old women are repulsive is one of the most profound esthetic and erotic feelings in our culture."[14] In a crucial scene in a sauna, Onwurah contrasts conflicting messages about what a woman "should be." Ngozi thinks Madge should be uninhibited; she cajoles her into a sauna with other naked women, reproaching her for being "uptight." Madge is self-conscious about her scar, but as she falls asleep, her towel slips from her chest. The camera follows from Ngozi's matter-of-fact gaze to a reverse shot of the other women in the sauna; their sidelong glances express horror and dread at Madge's mutilation. In place of a breast they see a gap, a ragged scar, and the anxiety in their expressions results from imaginary identification: "That could be me." But they also disavow identification, for whether they are fat or thin, ugly or beautiful, at least they are "whole." Their womanhood is intact. The scene exemplifies Slavoj Žižek's concept of "looking awry": a single image evokes contradictory

responses, all slightly askance; only a sideways glance reveals the latent content, the repressed meaning of the looks. The women's reactions are conveyed solely through a complex repertoire of glances; the only words uttered are Ngozi's: "This was the first time my mother appeared to me as a woman. I was forced to see her as others might"—that is, as an object of pity and terror.

In many ways, *The Body Beautiful* is a discourse of others, a polyphony of institutional voices that repress women in conventional roles. Far from expressing empathy, the medical establishment is coldly matter-of-fact: in a voice-over, one medical advisor is crisply reproachful: "It's important for you to realize that you are far from being the first woman to face the prospect of losing a breast." How to cope with the anguish following the mastectomy? Another medical voice-over briskly advises, "Keep calm; try to relax; bring a kit, wadding up your husband's handkerchief where your breast used to be, so that when you leave the hospital, you'll be partially compensated." The voice-overs are like a chorus in an absurdist play, totally at odds with the emotions of the patient whom they mean to console and reassure. Their clinical expertise is in harsh contrast to the patient's subjective experience of loss, and through the voice-overs of "experts," Onwurah indicts the medical establishment's callousness.

Onwurah thus joins Orlan as part of a growing group of women in the arts who have been reassessing the female body, especially in relation to medicine. The Women's Caucus for Art staged a Women's Health Show in New York galleries in February 1994, including exhibits like *Examining Room,* which exposed the medical establishment's bias against women of color and older women; *Female Trouble; Gathering Medicine;* and *Psycho, Sexual, Love.* Hannah Wilke's self-portraits of her progressive stages of terminal cancer are also powerful testaments that demystify the female body and death simultaneously. Susan B. Markisz's photographs were selected to appear in the exhibition *Healing Legacies: A Collection of Art and Writing by Women with Breast Cancer,* in the U.S. House of Representatives in October 1993, but her self-portrait of her mastectomy was one of three images banned from the show on the grounds that it broke the rule against "depicting subjects of contemporary political controversy or of a sensationalist or gruesome nature."[15]

Is an exposed breast pornographic? What about an exposed mastectomy? When the *New York Times Magazine* featured the self-portrait of artist-activist Matuschka's mastectomy on the cover to accompany the article "You Can't Look Away Anymore: The Anguished Politics of Breast Cancer," the magazine received four times the usual responses to a ma-

jor article (Fig. 20).[16] To anyone who has ever wondered what an *uneroticized* breast might look like, Matuschka offers one indelible answer. Although her photograph was nominated for a Pulitzer Prize in 1994, the award was given for the photograph of an American soldier's body dragged through the streets in Somalia. Matuschka remarks: "I am disappointed that the Pulitzer went to another war photo."[17] Mastectomy survivors see themselves as warriors, too, battling not just the disease but medieval attitudes and censorship. Deena Metzger, who was diagnosed with breast cancer in 1977, was fired from a tenured position after teaching a poem she had written about censorship; in a major victory for academic freedom, she won her appeal to the California State Supreme Court. She subsequently collaborated with photographer Hella Hammid on *The Warrior,* a postmastectomy photo of Metzger. Hammid subsequently died of breast cancer on March 1, 1992.[18]

About two-thirds of the letters to the *New York Times* praised the cover; one defender called it "the most significant image of the century." Detractors revealed how complex the connections between the body, sexuality, and pornography are. One man wrote: "I find it ironic that you will show a surgically altered breast on your cover when you would never allow a normal female breast to appear there." Another asked if the *Times* "would publish a cover photograph of an attractive male torso, trousers at half-mast, with the camera focused on the lumps and fissures where testicles and penis once existed." These contradictory responses speak volumes, revealing the unconscious equation of breast with femininity, penis with masculinity. The dispute in some ways resembled the furor when *Hustler* magazine published two cartoons about Betty Ford's mastectomy, provoking national outrage. The two situations are not identical, however, since Matuschka took her own self-portrait, whereas Betty Ford was represented in a cartoon. But if one thinks beyond one's initial indignation, Laura Kipnis's defense of *Hustler* has some merit, for the magazine

> might be seen as posing, through the strategy of transgression, an interesting metadiscursive question: which are the subjects that are taboo ones for even sick humor? . . . a man without a limb is considered less tragic by the culture at large, less mutilated, and less of a cultural problem than a woman without a breast; a mastectomy [is] more of a tragedy. . . . What is a woman without a breast in a culture that measures breasts as the measure of the woman? Not a fit subject for comment. It's a subject so veiled that it's not even available to the "working through" of the joke. (It is again a case where *Hustler* seems to be deconstructing the codes of the men's magazine: where *Playboy* creates a fetish of the breast . . . *Hustler* per-

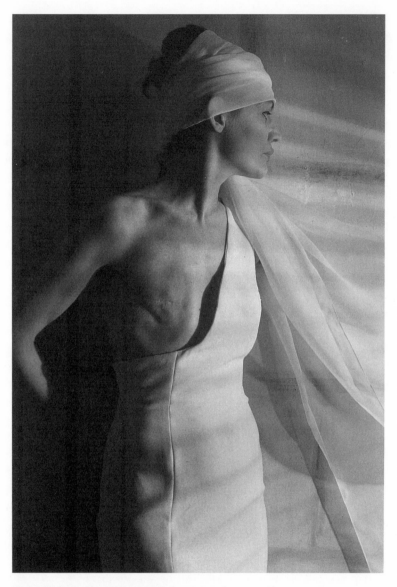

Figure 20 Matuschka (self-portrait), *Beauty out of Damage. New York Times Magazine* cover, August 15, 1993. Courtesy Matuschka.

versely points out that they are, after all, materially, merely tissue—another limb.)[19]

The Body Beautiful does not tackle the topic of pornography at length, but it does suggest how central a woman's breasts are to her sexual allure. In one scene, young black men pore over a men's magazine, joking specifically about the models' breasts, while Madge watches. But rather than reacting with righteous indignation, Madge suddenly fantasizes that one of the men is making love to her. As the scene cuts to her fantasy sequence in a theatrical space of gauze and candles, the spectator suddenly sees something else never before screened: an aging, overweight, cancer survivor's sexuality. Like Bob Flanagan, Onwurah explores the taboo topic of the sexuality of diseased bodies. In Madge's fantasy, the virile young black man carries her to bed, caressing her scarred breast. She reflects: "I saw the look in his eyes and remembered it from somewhere in the past. A youth, a mere boy . . . I wanted him for his very ordinariness, his outrageous normality. A single caress from him would smooth out the deformities. Give me back a right to be desired for my body, and not in spite of it. A forbidden fantasy, a fairy tale with no beginning." The scene could easily have slipped into the kind of escapism one finds in harlequin romances. Bill Nichols calls the scene "a remarkable representation of love . . . *testimonio* of an exceptional kind, embodied knowledge of a profound degree."[20] But Onwurah injects into the fantasy the jarring, accusatory voice of the daughter: "Don't be so uptight. . . . You titless cow!" Fantasy may be the mise-en-scène of desire, but even in fantasy the discordant voices of demanding children intervene, ravenous for attention, acting to censor the unconscious.

Onwurah subtly reveals how pervasive fantasy is and how it functions in political as well as personal terms. As we saw earlier in the *Abject Art* exhibition (Chapter 1), abjection signifies more than the maternal: it involves otherness in racial, national, and political terms. Onwurah examines all the ways that abjection is anchored within a body, and is a foreign body. Because that "foreign" body is familiar, the boundary between self and other disappears, just as the fetus and the cancer grow together in Madge's body. Onwurah emphasizes the connections between psychological categories and sociopolitical processes. She takes pains to situate fantasy in a postcolonial context by interweaving the mother's fantasies and the daughter's memories.

In *Anti-Oedipus: Capitalism and Schizophrenia*, Gilles Deleuze and Félix Guattari elaborate on Fanon's pioneering work; he is one of their heroes and his influence can be seen in such insights as the following:

It is strange that we had to wait for the dreams of colonized peoples in order to see that, on the vertices of the pseudo triangle, mommy was dancing with the missionary, daddy was being fucked by the tax collector, while the self was being beaten by a white man. It is precisely this pairing of the parental figures with agents of another nature, their locking embrace similar to that of wrestlers, that keeps the triangle from closing up again, from being valid in itself, and from claiming to express or represent this different nature of the agents that are in question in the unconscious itself.[21]

The dreams of "colonized peoples" offer alternatives to the traditional focus on the bourgeois nuclear family and on Western ethnocentrism, themes that are recurrent motifs in "Third Cinema." Onwurah testifies to the exhilarating potential of Third Cinema, which ignores Hollywood completely.[22] The young man in the aging mother's fantasy is an "agent of another nature," who stands in for her lost Nigerian husband, wrested from her as a result of civil war. The scope of the unconscious extends beyond those aspects of Western civilization associated with Europe and the Caucasian race.

Feminists have long maintained that the real revolution occurs not when daughters slay their mothers symbolically (the oedipal model between sons and fathers), but when they discover how much they have in common. Identification with the (M)Other is the film's utopian ideal. Only at the end do we realize that the film is a bildungsroman: the cumulative force of the daughter's flashbacks lead her to an epiphany about what it feels like to be her mother: "I tried to imagine life without a breast, but it is like trying to imagine being blind by closing your eyes." The screen goes black. "But the whole point [of blindness] is knowing you can never open your eyes again."

In contrast to the brutal confrontation with which the film commences, in the final scene, mother and daughter lie naked together in bed, as if returning to preoedipal bliss. Ngozi reflects, "If I hadn't come from within that body, I too would have turned away. . . . A child is made in its parents' image. Yet to a world that sees only in black and white, I was made in the image of my father. Yet she has molded me, colored the innermost details of my being. She lives inside me and cannot be separated. She may not be reflected in my image, but my mother is mirrored in my soul." Ngozi's confession that she would have repudiated Madge had they not been related is unsparing in its frankness. Her subject is the complexity of consciousness and emotion. "Color" thus subtly signifies that whites and blacks must draw on the imaginative processes of identification; oth-

erwise, they shall remain strangers to themselves and others, locked in rigid racial divisions. Onwurah transforms how we think about the complex interrelations between nation and race, disease and desire. Like Orlan, she dramatizes the cuts women endure. As a result of this radical surgery, neither femininity nor sexuality will ever be the same. *The Body Beautiful* is also the Body Politic. If the Other is Onwurah's central theme, the body is the bottom line.

SCOTT McGEHEE AND DAVID SIEGEL, *SUTURE* (1993)

Written and directed by two Americans, *Suture* is a film noir thriller about an amnesia victim. The film evokes Hitchcock's *Spellbound,* but while the trauma in *Spellbound* involves black parallel lines on a white background (a fork on a tablecloth, skis on snow, wrought-iron spikes), *Suture* "whites out" blackness altogether. The film opens with a rich man, Vincent Towers, orchestrating his own "homicide," perhaps because of bad debts. He arranges a reunion with his impoverished twin brother, Clay. After dressing Clay in his Armani suit and giving him his white Rolls Royce, Vincent activates a car bomb by remote control.

Miraculously, Clay survives, but awakes in the hospital with amnesia. The film is modeled on Delmer Daves's *Dark Passage* (1947), starring Humphrey Bogart, who plays a character named Vincent. As in the 1947 version, *Suture*'s hero spends much of the film in bed, wrapped in bandages, and acquires a new woman, falling in love with the plastic surgeon who gives him a new face. But he is not able to assimilate in the world around him, despite the efforts of a Japanese-American psychoanalyst who urges him to talk, to dream, to revisit scenes that may help him recover his memory and identity. When Vincent returns to finish him off, Clay kills him in self-defense, and his memory is restored.

The film's central conceit is that the evil brother is white, the good "twin" is black. Although the viewer sees this, the characters do not; instead, they consistently marvel at the uncanny resemblance of these "identical twins." *Suture* thus comments ironically on how "natural and universal" whiteness is assumed to be. The film's ultimate twist is that once Clay recovers his identity, he disavows it. Set in Phoenix, the film ironizes the idea of his resurrection from the ashes; instead, he turns the past into a bucket of ashes. *Suture* is a conversion narrative in reverse: rather than redemption, the hero is converted to conspicuous consumption. He relishes his lavish lifestyle—his futuristic white house (which resembles Dis-

ney's Tomorrowland house and De Palma's luxurious bachelor pad in *Body Double*), his white Rolls Royce, and his white fiancée.

Since the evil connotations of whiteness can be traced back to the Bible's "whited sepulchres" and *Moby Dick,* one might argue that the hero adopts the devil's motto, "Evil be thou my good." Although the psychoanalyst warns Clay that he gains the world and loses his soul, *Suture* does not moralize explicitly. In Chapter 2, I showed how Orlan turns gender into a performance and repudiates the concept of interiority. Are *Suture*'s motives similar? If *Suture*'s point is that race and ethnicity are performative, too, it is important to emphasize that what is being performed here is *whiteness*. That does not mean the other characters are "colorblind"; instead it means that they see others as themselves. They are blind to blackness and to the difference it makes.

What *is* the difference? The key lies in the film's title, which refers literally to the sutures necessary to stitch the hero back together. His burned body becomes not a tabula rasa but a "tabula noir," so to speak, the passive receptacle for the fantasies and projections of others. His role, in other words, duplicates the role of woman in classical Hollywood cinema: he is a cutout or icon, visually punished. Like Janet Leigh's brutal murder in the shower in *Psycho,* the hero awaits his attacker in a white circular tub in the bathroom of his all-white circular house. (The circularity seems to reinforce the tautology of the film's central conceit: everywhere whites look, they see only themselves.)

The film's title also signifies the process by which the viewer comes to identify with the gaze of what is variously called "the Absent One," or "the Other"—the invisible camera. To create verisimilitude, the camera must deny its own existence and substitute the shot/reverse shot formation. The 180-degree rule fosters the illusion of autonomy, the illusion that what we see on-screen has not been created by technical means, but is "natural." In psychoanalytic terms, the viewer experiences shot one as imaginary plenitude, unbounded by any gaze, unmarked by difference. But the viewer eventually becomes aware of an absent field, and soon discovers that the frame itself is arbitrary. The viewer soon understands that one sees only what another's gaze (the director and/or cinematographer) authorizes one to see.[23] Thus the role of suturing in cinema replicates Clay's role in *Suture:* his race is the absent field, he exists only in the discourses of others. He is literally a reconstruction. McGehee and Siegel make the viewer acutely conscious of what is absent—awareness of race. Without awareness of race, there can be no awareness of ra*cism.* Speaking of Hitchcock's *Psycho,* Kaja Silverman describes the way that

the film terrorizes the viewing subject, refusing ever to let him or her off the hook. That hook, she says, is the system of suture.[24]

That is the point of *Suture*: however you finally choose to explain Clay's ultimate repudiation of memory, history, and identity, you remain complicit in the film's central conceit, forced to confront stereotypical questions: Under the circumstances, who wouldn't want to "pass" for white? Who wouldn't want all the (white) things money can buy—house, Rolls, woman, and so on? The problem, of course, is that such questions merely reinforce the racial and moral myopia that are the film's subjects. Fanon puts it this way: "However painful it may be for me to accept this conclusion, I am obliged to state it: For the black man there is only one destiny. And it is white."[25] Hence the irony of the twins' names: the white brother is Vincent Towers, suggesting the invincibility of white privilege, while the black twin is "clay," to be remolded in the image of white desire, projection, transference.

The only character who accurately assesses the *damage* Clay's decision entails is the Japanese-American psychoanalyst. His ancestry may be a reverential homage to Hiroshi Teshigahara's *Face of Another*, a film adapted from Kobo Abe's novel, which is quite similar in style and subject matter. (The central conceit of whites' blindness requires the analyst to be nonwhite; he is frequently portrayed against the backdrop of a Rorschach test.) The analyst warns the hero that the more he flees his fate, the more he will embrace it. The repressed material will surface one day, and the hero will someday realize that he survived being burned alive, only to be buried alive. What might account for such a perverse decision on Clay's part? Fanon is again illuminating: "The analysis that I am undertaking is psychological. In spite of this it is apparent to me that the effective disalienation of the black man entails an immediate recognition of social and economic realities. If there is an inferiority complex, it is the outcome of a double process: primarily, economic; subsequently, the internalization—or, better, the *epidermalization*—of this inferiority" (emphasis added).[26]

By staging the economic differences between the evil white and the good black "twin" so starkly, *Suture* underscores Fanon's economic emphasis, then moves on to examine the implications of Fanon's metaphorical shift from internalization to epidermalization. Far from concluding that race is "only skin deep" or that "we are all the same beneath the skin,"[27] what the black man has "got under his skin" is the white man's castrating attitude toward him. "Epidermalization" does not connote superficiality, rather it emphasizes that inferiority is indelible; it pervades

every pore. Fanon's formulations are indebted to Lacan, whose concept of the Mirror Stage is expanded by Louis Althusser to encompass social relationships. Where Lacan sees the Mirror Stage as spontaneous, Althusser insists, in words eerily applicable to the racial myopia in *Suture*, on its social constructedness:

> What . . . is . . . ideology if not simply the "familiar," "well known," transparent myths in which a society or an age can recognize itself (but not know itself), the mirror it looks into for self-recognition, precisely the mirror it must break if it is to know itself? What is the ideology of a society or a period if it is not that society's or period's consciousness of itself, that is, an immediate material which spontaneously implies, looks for and naturally finds its forms in the image of a consciousness of self living the totality of its world in the transparency of its own myths?[28]

Since the subject constantly rediscovers himself in the same ideological representations in which he first discovered himself, he must break the mirror in which he finds a prefabricated identity[29] (the kind of prefabricated identity handed to *Suture*'s hero). That does not enable one to transcend ideology, merely to be aware of its operations.[30] No one is immune to or "above ideology"—not the hero, the "color-blind" cast, or the audience, for what matters is not only whether one recognizes racial markers, but how one responds to that recognition.

One of the cleverest traps the filmmakers set in *Suture* is to lull viewers into believing that since we have superior knowledge which is withheld from the characters in the film, we are somehow more "enlightened." But through virtuoso camerawork frequently mediated by mirrors (such as magnifying mirrors and medical paraphernalia), McGehee and Siegel instead convey a mirage. "The question," Fanon insists, "is whether *basic personality* is a constant or a variable."[31] *Suture*'s conclusion is that it varies in response to the prejudices and environment surrounding it, but the price of such adaptation is high. In such films as *White Man's Burden, A Family Thing,* and *Secrets and Lies,* mainstream cinema tries to tackle topics similar to those of *Suture. A Family Thing* depicts antagonistic half-brothers, one black, one white; by the end, the white brother recognizes his racism, realizes that "family is everything," and repents. The harmonious resolution is a contrived exercise in wish-fulfillment, especially in contrast to *Suture,* which exposes the folly of the wish for assimilation, the treachery beneath the ideal of family. *Suture* remains starkly uncompromising in its exploration of the unconscious, and of the causes and consequences of denial and disavowal.

ISAAC JULIEN, *THE ATTENDANT* (1992)

Filmmakers so often use art to advance the plot, characterization, or mise-en-scène that for some it is a veritable trademark: Buñuel, Fellini, Eisenstein, Renoir, Antonioni, Cocteau. The following films also come to mind: the initial seduction in Brian De Palma's *Dressed to Kill* takes place in an art gallery (this homage to Hitchcock also recalls *Vertigo* and *Blackmail,* where paintings figure prominently); De Palma's *Obsession* and Nicholas Roeg's *Don't Look Now* both involve restorers of Venetian frescoes; Jon Jost's *All the Vermeers in New York* follows the lives of three young women and a male stockbroker who gazes at them; all of Peter Greenaway's films explore art history; *The Object of Beauty* involves the theft of a Henry Moore sculpture; Martin Scorsese's *Age of Innocence* brings paintings of Edith Wharton's New York to life; Bernardo Bertolucci's *Last Tango in Paris* commences with Francis Bacon's paintings, and in *Batman,* the sole painting the Joker refuses to deface is also by Bacon.[32]

Blacks are notably absent from this catalogue. Julien strives to redress that omission by portraying those who "attend" or wait on the aesthetic pleasures of others; a vigilant black museum guard stands by silently. But the paintings give pleasure to the attendant, too, by initiating his own reveries, particularly when he stands in front of a painting of a slave ship, which prompts him to fantasize that he is being beaten by a gay white man in black leather. The camera pans from the slave painting to a series of Robert Mapplethorpe photographs of gay sadomasochistic tableaux.

Far from implying that slavery was pleasurable, this film transforms historical fact into sexual fiction to illustrate how fantasy functions in the unconscious. The guard transforms pain into pleasure. The sudden appearance in the background of the Mapplethorpe photographs, moreover, shows how silly it is to censor contemporary images of sadomasochism, when they are ubiquitous in the history of art.

The significance of Mapplethorpe's photographs for black gay spectators reveals other aspects of fantasy. In "Skin Head Sex Thing," Kobena Mercer records his initial discomfort when confronted by Mapplethorpe's use of well-endowed black males as subjects: is the photographer exploiting white fears of black sexual prowess to justify castrating the black man? Fanon illustrates that in white culture, the black man is always reduced to his penis. Working through his ambivalent feelings

about the photographs, Mercer concludes that Mapplethorpe's work is "a subversive deconstruction of the hidden racial and gendered axioms of the nude in dominant traditions of representation."[33] Further, Mercer takes pleasure in Mapplethorpe's humor and sense of irony (traits Julien shares). While the black man is indisputably fetishized in these images, fetishism is not invariably a bad thing. Mercer invokes Laura Mulvey to argue that what is necessary is a "contextual approach to the political analysis of fetishism's 'shocking' undecidability."[34] Mapplethorpe's photos dramatize "the splitting of levels of belief, which Freud regarded as the key feature of the logic of disavowal in fetishism. Hence, the implication, 'I *know* it's not true that all black men have big penises, but still, in my photographs they *do*.'"[35] The logic of denial and disavowal inflicted damage on the black hero in *Suture* because it reinforced white supremacy, but in a different context, fetishistic disavowal can augment visual pleasure.

Mercer and Julien argue that one must consistently contextualize desire and highlight intersectionality—between the museum's inside and outside, between high and low art, margin and center, race and homosexuality. Julien establishes the connection between inside and outside, for instance, in the opening shot: the viewer sees the art museum "from the bottom up," the bottom steps looking up at the marble pillars. The steps divide the screen horizontally, like a bar, a barrier to signification. The camera slowly "climbs" the steps, only to be confronted with another barrier: the attendant himself, who authorizes or denies entry.

The aesthetic canon functions through the same inside-outside dichotomy, a point Julien makes with great economy and wit by training the camera on some familiar faces in the galleries, including Stuart Hall and Hanif Kureishi. The traditional role of the "gatekeeper intellectual," after all, is to be the arbiter of taste, to determine what goes inside and what remains outside the museum. What makes these solemn cameo appearances so amusing is that these are precisely the dichotomies that critics like Hall and Kureishi are dismantling. The quick cut to Mapplethorpe, moreover, perhaps alludes to the protest staged when the Corcoran Gallery of Art canceled his exhibition in July 1989: art activists staged an impromptu slide show of his photos on the Corcoran's *exterior* walls. While deconstructing the protocols of gazing, Julien simultaneously deconstructs the idea of the museum in ways similar to the messy, infantile littering in Bob Flanagan's and Mike Kelley's installations. Julien, however, adds the category of race to the chain of significations surrounding that pristine *white* space.

Uncannily, art imitated life imitating art in February 1996, when Washington, D.C.'s National Museum of American Art and the National Portrait Gallery held its annual Staff Exhibition, which included works by three male museum guards (one white, two black).[36] *The Attendant* makes the imaginative life and creativity of the museum guard visible, as well as his humanity. When the attendant inspects the bag of a young gay white man with a shaved head, their eyes meet, and Cupid circles his head to signal his attraction to this art-lover in leather. Just as suddenly he becomes an African god, adorned in kitschy gold, with cupids circling his fierce brow. Camp and kitsch have become aesthetic subjects, further undermining the divide between high and low. Other fantasies serve the same function: the attendant imagines he is an opera singer, and suddenly we find him singing Dido's aria in Purcell's opera:

When I am laid in earth,
May my wrongs create
No trouble in thy breast;
Remember me, but ah! forget my fate.

(In the opera, the aria is followed by a summons from the chorus to cupids.) A lone woman in the balcony gives him a standing ovation, clapping soundlessly.

Each of these scenes is presented as an isolated tableau. They are not seamlessly connected, nor is there any visible logic. But taken together, they present a portrait of the black spectator as agent rather than object of white fantasies. One might say that if "De Margin and De Center" is the theory, *The Attendant* is the practice, dedicated to the dream factory we call cinema. In reference to the infantile aspects of sexuality, it is worth citing Fanon once more: "I believe that the fact of the juxtaposition of the white and black races has created a massive psychoexistential complex. I hope by analyzing it to destroy it. . . . The last two chapters are devoted to an attempt at a psychopathological and philosophical explanation of the *state of being* a Negro. The analysis is, above all, regressive."[37] Only by tracing regressive impulses back to their sources can one discover where the resistance is—that aim is central in *The Body Beautiful* as well as in *The Attendant*. The analyst in *Suture* is right when he warns that the repressed material will resurface; no trauma remains buried forever. Fanon haunts the margin and the center of all three films;[38] they are scripts for a whole new psychopathology, filtered through new technologies in science and medicine, through fashion, design, and advertising. They experiment with cinematic genres to create new hybrids:

Onwurah's performative documentary combines expository and reflex-
ive documentary; *Suture* combines the noir thriller and the case study;
The Attendant pays homage to camp, kitsch, and the magic of Méliès.
They chart treacherous waters, illuminating the formations that shape
fantasy: the physical body, the cash nexus, ethnic codes and connota-
tions, postcolonial influences. As Colin McCabe notes, we are now mov-
ing toward a very different understanding of what culture might be.[39] In
all three films, fantasies oscillate rapidly on the screen; the subject is in
flux, rather than being a fixed and static entity. Nor is the subject a sexual
or racial spokesperson. Conversely, the monuments of art surrounding
the attendant are also in a continual process of metamorphosis. They do
not, as T. S. Eliot insists, form an ideal order among themselves. Instead
they are open to interpretation and subversion, responses which, like fan-
tasy itself, cannot be legislated.

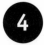

Sex Work

PRODUCING PORN

In 1983, feminist filmmaker Bonnie Klein made a semi-"documentary" film, *Not a Love Story,* which took viewers on a tour of the peep shows and strip joints on Forty-second Street in New York City. *Not a Love Story* fueled the growing Women against Pornography (WAP) campaign, founded in 1979, which marched on Times Square seven thousand strong, led by Robin Morgan and Andrea Dworkin. To eradicate pornography and prostitution, Dworkin and legal scholar Catharine MacKinnon have since drafted numerous city ordinances, beginning in Indianapolis and Minneapolis (see Chapter 9 herein). *Not a Love Story* is a feminist conversion narrative: one porno model sees the error of her ways, renounces her job, and "finds feminism," the way her Victorian counterparts "found religion." No wonder real-life sex workers are suspicious of feminists and antiporn crusaders: in the name of protecting the hookers from "harm," these feminists would eliminate the means of livelihood for legions of women. Their morality is Victorian; their sentimentality is repressive; they are hooked on the ideology of romantic love, for—as the film's title implies—sex *should* be about love, although this film is *not.* The prostitutes point out that guilt over recreational sex is the overriding issue; anonymous sex is as valid as any other kind of sex. It is time for feminists to take the testimony of sex workers as valid.[1]

The three filmmakers discussed in this chapter take the prostitutes' propositions as their starting point, focusing on those who work in the sex industry, either in porno films (*Body Double* and *Inserts*) or as male

models or prostitutes *(My Own Private Idaho)*. These directors give a voice to the disenfranchised workers whom crusaders seek to silence. Rather than seeing pornography as the root of all evil, they demystify it by exposing the behind-the-scenes labor necessary to produce it. Nothing thwarts prurience faster than exposing how much *work* sex entails.

JOHN BYRUM, *INSERTS* (1976)

Byrum's *Inserts* opens with the sounds of fraternity boys in the 1970s watching a 1920s porno film: "Hey, is this in color?" "That guy looks homo to me." "Takes one to know one." "Hit her!" "On Hollywood Boulevard you can buy these by the shitload." Suddenly they realize they've been cheated, for this particular reel has no obligatory "cum shot" (also known as the money shot, because actors performing it earn more money).[2] The remainder of the film attempts to solve the enigma of the missing shot by transporting us back to the 1920s when the film was being made. The black-and-white film suddenly becomes an insert in the larger film. *Inserts* explores a recurrent theme in this book: it isn't sex but power that is obscene. Boy Wonder (Richard Dreyfuss), a genius who burnt out early, now ekes out a living making porno films in his decrepit mansion, working for Big Mac (Bob Hoskins), a sleazy producer who symbolizes the wave of the future: social relationships based on dominance and exploitation. He is an anti-intellectual philistine whose sole talent is investment. Nicknamed "Mr. Money," he invests in hamburgers and freeways as well as in porn.

Inserts repeatedly highlights rehearsal, playacting, and the confusion of illusion and reality. The actors "frame" each other in this film-within-a-film. Sex is anything but "natural"; Rex can produce an erection on demand, but Boy Wonder is impotent. Performing with Big Mac's girlfriend, Cathy, Boy Wonder's libido is miraculously aroused, but he forgets to turn on the camera *and* to withdraw for the requisite "cum shot." His ardor was genuine, but Cathy fakes it; her furious discovery that her "performance" has been wasted sharpens the film's nasty edge. Big Mac vows to wreak vengeance on Boy Wonder: "You're gonna disappear. I'll hold on to this film because it ain't what you wanted." That is true in multiple senses: the day's labor did not produce the footage Boy Wonder wanted, nor does sex with Cathy produce the happy ending conventional Hollywood cinema promises.

"Inserts" are close-ups, "the garish interludes," during which the male lead labors off-screen to sustain the requisite erection, a chore that Boy

Wonder describes as "quite a taxing little horror." *Inserts* might be sub-titled, Everything You Never Wanted to Know about Making a Porno Film: how temperamental actors are, how difficult the "meat shots" are, what a hassle it is to deal with egomaniacal producers, technical glitches, unreliable cameras, and primitive working conditions. It is seedy, tedious labor. Byrum exposes all the elements that are anathema in porn: comedy, parody, satire, tedium, hostility, frustration, impotence. The film is about lack and labor: the lack of the vital shot, the lack of time, money, and incentive to make a "real movie," the lack of politesse among the principals.

Perhaps inspired by Michael Powell's *Peeping Tom* (1960), Byrum transforms *Inserts* into a metacritical study of cinema itself, a study of time and mutability.[3] Boy Wonder, who "fulfilled [his] brilliant future at an early age," is modeled on Orson Welles, whose meteoric career was crushed by RKO by the time he was twenty-five. (RKO's subsequent motto was "Not genius but showmanship"—that is, *not* Orson Welles.) Byrum implicitly asks whether the same is true of cinema itself, for "boy wonders" are a dime a dozen, geniuses who burned out even while cinema was still in its youth. A running gag is the anticipated arrival of Clark Gable, who will restore Boy Wonder's reputation. It is an old theme, but Byrum makes it new precisely by using pornography as a metaphor for all kinds of prostitution—of people, talent, ideas. Byrum strips away "movie magic": Boy Wonder finally becomes sexually aroused *despite* pornography, not *because* of it. The juxtaposition of the cinematic medium's crudeness (in 1920s' black and white) with the spectators' crudeness (in color in the 1970s' fraternity house) highlights the film's stark cynicism. By foregrounding the reception of the 1920s film in the 1970s, *Inserts* flouts all the conventions of arousal. The parallel structure frustrates the viewer, for Byrum thwarts two sets of cinematic convention simultaneously: the pornographic ones (the fraternity boys do not get their climax) and the conventional denouement (Clark Gable never shows up; Boy Wonder doesn't get the girl or make a comeback—he doesn't even complete the film). The only thing that has been accomplished is that he got an erection—a fleeting and perhaps unrepeatable achievement. All that is solid melts into air. Byrum reveals how much aggression, manipulation, and voyeurism filmmaking entails. The only mainstream films that rival Byrum's for sheer bitterness are *S.O.B.* by Blake Edwards and *The Player by* Robert Altman. Ostensibly a comedy, Byrum's satire has bite, bile, and bitterness; how such a nasty (in both senses of the word) film ever got made in Hollywood remains a mystery.

BRIAN DE PALMA, *BODY DOUBLE* (1984)

Body Double had the dubious distinction of premiering at the same time as the Minneapolis antiporn ordinance drafted by MacKinnon and Dworkin.[4] Inevitably, it became Exhibit A in the ensuing controversy that led one antiporn protestor to set herself on fire in a Minneapolis adult bookstore.[5] No one seemed to notice that *Body Double* is a textbook example of how *not* to make a porno film. First, De Palma highlights the labor that goes into the production of porn. Second, he deflates porn's pretensions and satirizes its conventions. *Body Double* is a comic book: the sex and violence are over-the-top, cartoonish, closer to *Mad* magazine than *Playboy*.

Body Double is a study in excess, featuring not one but two films-within-a-film: a horror film and a porno film. De Palma satirizes the clichés and conventions of each genre. Jake Sculley (Craig Wasson) is a two-bit actor in low-budget films; in the opening scene, he freaks out while playing a vampire lying in a coffin, overwhelmed by claustrophobia: "I closed my eyes, opened my eyes, the camera was right on top of me and I couldn't move!" The camera feminizes him, subjecting him to the penetrating, invasive gaze. As in *Suture, Body Double* draws on psychoanalysis to solve an enigma: what are the origins of Jake's claustrophobia? Analytic metaphors double for acting metaphors. When Jake's acting coach instructs him to "feel the fear," for example, he says, "You're a baby and you're afraid. You must *act*" (meaning both *rouse himself* and *perform*). Humiliated and ashamed, Jake remembers being locked in a freezer as a small boy. Since he has been "frozen" physically and emotionally ever since, it is appropriate that he falls into a gravesite at the end: the womb is the earth and the grave. Death-in-life is an abiding motif in De Palma's work, along with political corruption and organized crime *(Scarface, The Untouchables, Carlito's Way),* tyrannical and/or incestuous parents *(Obsession, Raising Cain, Sisters, Carrie),* and filmmaking itself *(Blow Out, Body Double).* Even *Mission: Impossible,* with its multiple vision machines and surveillance cameras, seems to comment self-reflexively on the cinematic apparatus.

De Palma is among the most visceral of filmmakers, which helps to explain why he fuses the two film genres of pornography and horror, for along with melodrama ("the weepies"), they are the three cinematic genres that elicit physical responses from the spectator, as Carol Clover points out: "Horror and pornography . . . exist solely to horrify and stimulate, not always respectively, and their ability to do so is the sole mea-

sure of their success: they 'prove themselves upon our pulses'. . . . The terms 'flesh film' ('skin flicks') and 'meat movies' are remarkably apt."[6] De Palma's characteristic technique is to seduce the viewer, then subvert his willing suspension of disbelief. One of horror's primary conventions is the first-person I-camera, which forces the viewer to look through the killer's murderous eyes, hear his heartbeat, peer with him into the window as he moves in for the kill. The result is that "the subjective camera makes killers . . . of us all."[7] De Palma exploits this convention, but he also satirizes it. In the climactic scene of *Body Double,* for example, the killer breaks the suspense by abruptly assuming the director's role: "Stop being so melodramatic!" he tells Jake. By obsessively commenting on its own theatricality, *Body Double* satirizes the processes that create arousal, fear, and suspense in the first place.

As with horror, so with porn: by satirizing porn's clichés, De Palma thwarts the viewer's pleasure. Porno filmmakers know that close-ups of genitalia in action resemble films of open heart surgery: how does one make the sex act arousing, suspenseful, appealing?[8] De Palma takes us behind the scenes to expose the hassles, the in-fighting, even the negotiations among the industry's stars. Far from being victimized by the porno industry, the female stars are shrewd negotiators; they understand the market, the competition, and the product. As porno star Holly Body (Melanie Griffith) tells a producer: "No s/m, water sports, fist-fucking, or coming in my mouth. I won't shave my pussy. I get $2,000 per day." Far from being a victim, she is a consummate businesswoman. She even satirizes Americans' naive faith in "scientific" indexes of consumer satisfaction (polls, ad campaigns, Nielsen ratings, and so on) when she boasts, "My masturbatory erotic dance is a 10 on the petermeter." Porn's utopian fantasy is a timeless world where women always want sex and men are always virile. The consumer of porn fantasizes that the girl wants him and him alone. But the opening credits have barely rolled before Jake discovers not only that his girlfriend wants someone besides him but that the man who cuckolds him is more skillful sexually: "How do you make a woman glow like that?" he asks plaintively. In contrast to antiporn feminists' stereotype of man as oppressor, research on consumers of porn reveals that they have deep-seated fears about sexual inadequacy, penis size, inability to satisfy or even appeal to women.[9] As Laura Kipnis observes in "(Male) Desire and (Female) Disgust: Reading *Hustler,*" "The magazine is tinged with frustrated desire and rejection: *Hustler* gives vent to a vision of sex in which sex is an arena for failure and humiliation rather than domination and power. There are numerous advertisements

addressed to male anxieties and sense of inadequacy: various sorts of penis enlargers . . . penis extenders, and erection aids. . . . *Hustler* does put the male body at risk, representing and never completely alleviating male anxiety."[10]

Body Double accentuates the same anxiety: housesitting in a lavish futuristic house which he could never afford to own, Jake watches porn on television. As Byfield and Tobier argue, television's deepest pleasure is frequently overlooked: it affords the pleasure of passivity.[11] Passivity is what Jake Sculley embodies above all. *Body Double* audaciously suggests that the male viewer of pornography is feminized; he identifies with the woman's position and even her orgasm. As Susan Barrowclough points out, even in *Not a Love Story,* "the male spectator takes the part not of the male, but the female. Contrary to the assumption that the male uses pornography to confirm and celebrate his gender's sexual activity and dominance, is the possibility of his pleasure in identifying with a 'feminine' passivity or subordination."[12] Sculley underscores that point when he is cast in a bit part in a porno film; he plays the subordinate to Holly Body, the dominatrix; his role is a wimpy nerd who "likes to watch," and when he does get some action, he ruins the scene by forgetting to withdraw for the obligatory "cum shot." To make sure no one missed the satiric broadsides (which antiporn feminists ignored), De Palma even turns the porno-film-within-a-film into a musical comedy number, more in tune with "Springtime for Hitler" in Mel Brooks's *Producers* than with *Behind the Green Door.* He mimics Hitchcock's *Rear Window* when Jake uses a telescope to spy on a naked woman neighbor while he is housesitting in the luxurious circular house. *Suture* seems to pay homage to *Body Double,* since the set features a similar house, and since the plot revolves around the same themes of repression, neurosis, and mistaken identity.

Bret Easton Ellis pays perverse homage to *Body Double,* too: the serial killer in his novel *American Psycho* has seen the film thirty-seven times. Whether or not the I-camera makes killers of us all, it certainly makes us all *consumers.* Just as Ellis relentlessly catalogues every imaginable product in *American Psycho,* De Palma juxtaposes the consumption of porn with other kinds of consumption: Mercedes Benzes, Hermès scarves, fancy lingerie, shopping from Rodeo Drive to Beverly Center. De Palma is fond of saying that he has no objection to being censored, as long as the mainstream media and its advertising sponsors are also censored:

When I'm on a talk show, there's a montage of every violent scene from movies and life before we even begin to talk. People interpret that as news. Then everybody asks me how I can make violent movies, and the television program is doing the same thing—except they're pretending it's news. They put sensational things on the air in order to sell advertising space. People don't understand that both presentations are entertainment. And news shouldn't be entertainment.[13]

It has been over a decade since De Palma made this observation, and the distinction between tabloids and "respectable" news has wholly disappeared. It is impossible to distinguish the sluts from "the suits." *Body Double* merely satirizes that cliché. Holly Body embodies Hollywood itself. The "suits" make profits the bottom line; actors are interchangeable body parts (or doubles). *Screw* magazine gushes, "Holly keeps the business where it belongs—in the gutter." She is sure to sweep the Adult Academy Awards, a parody of its self-congratulatory mainstream counterpart. Throughout "the industry," publicists, reviewers, and award shows all contribute to the hard-core hard sell.

Nine years after Holly Body hit the screen, Hollywood was rocked by the police bust of Heidi Fleiss, the so-called Madam to the Stars. (Women in the film industry dryly noted that at least *one* woman in Hollywood figured out how to get paid what she is worth.) Heidi implicated numerous producers and actors with public images as "family men," and succinctly summarized the hypocrisy of the controversy surrounding her: when one of her girls sold a datebook to the tabloid television show *Hard Copy*, she had to agree to appear on the show to get it back. "*Now* I feel like a whore," she said.[14]

Such hypocrisy compels De Palma to ask, What are the subjects that are taboo even for horror and porn? Critics of the film seldom mention the film's final scene, which consists of outtakes while the credits roll, but this coda reprises De Palma's major motifs and the mise-en-scène. Acting in yet another low-budget vampire flick, Jake sneaks up behind a woman in a shower, his fangs poised at her throat. Suddenly De Palma breaks the illusion one last time: the actress's body double steps in for close-ups of breasts. (The double has perfect breasts, but her face is plain, whereas the principal actress is pretty, but flat-chested.) Relishing the deception produced through the "magic of moviemaking," Holly Body assures the principal actress that she will get lots of dates when men see these close-ups. Jake's role requires that he be menacing and omnipotent, but the double turns on him with a sharp rebuke: "My breasts are

very tender and I got my period." As the cameras roll and Jake administers the vampire's bite, blood streams from her neck down her breasts. De Palma makes even the outtakes do double duty, for the viewer sees the contrast between Jake's acting and his "real" feelings of fear and uncertainty. The body double's rebuke reduces him to the same state of infantile insecurity and impotence he had in the film's opening scene. De Palma deconstructs porn and horror by deftly hinting at the metonymical displacement of blood from throat to vagina. The mere mention of menstruation sets *Body Double* apart from mainstream porn, for menstruation is one taboo no porno film will touch. (Few horror films would touch it either, until De Palma's *Carrie,* which commences with Carrie's terrified discovery of menstruation and her cruel humiliation at the hands of her classmates in the school gym as a result.)[15] Much can be gained by examining subjects that are taboo even within such marginal genres, for De Palma places our assumed ideology before our eyes. He exposes our literal and metaphorical investments in voyeurism and consumerism. His films are maps of the male psyche, portraits of male passivity and paralysis.

GUS VAN SANT, *MY OWN PRIVATE IDAHO* (1991)

Like Jake Sculley, Van Sant's protagonist in *My Own Private Idaho* is passive, here to the point of unconsciousness: Mike Waters (River Phoenix) suffers from narcolepsy, an infirmity that has a disastrous effect on his livelihood as a prostitute who services both men and women. As I mentioned in Chapter 2, recent studies in feminist film theory focus on the relationship between psychoanalysis and film to account for the representation of sexual difference in patriarchal culture. While mainstream cinema insists on promoting the female subject as an emblem of lack and fetishizing her body in order to assuage male castration anxieties, alternative gay cinema poses a radical challenge to male spectatorship and to conventional representations of sexual difference. In *My Own Private Idaho,* Gus Van Sant throws down the gauntlet. Through his dual focus on male subjectivity (in the characters of Mike and Scott), he offers a comprehensive critique of American masculinity.[16]

Since American masculinity is inextricably bound to the image of the cowboy as American hero, Van Sant explodes this mythology. The film accomplishes this in part by setting up an equation between the postmodern cowboy and the sexual outlaw, "the fair hustler in black leather" who services (and is serviced by) a predominantly gay clientele. Like *Body*

Double, My Own Private Idaho satirizes the porn industry. In one inspired scene, a parody of all those westerns where the saloon door swings open and a mysterious stranger in black strides in, a cowboy strolls into an adult bookstore in slow motion, past a wall of stroke magazines. By capturing the back of his large form as he enters the bookstore, the camera interpellates the viewer as the male speaking subject who, as is typical of classical cinema, controls the gaze. As the dark figure turns to glance at the porno magazines on his right, the straight male viewer might be surprised to note that the naked bodies on the covers are male. He would certainly be more startled that the gay magazines solicit the gaze of a man who, by his very appearance, seems to be an exemplar of normative masculinity. Not only does Van Sant's camera subvert his audience's expectations, but it also forces the unwary heterosexual male into a temporary alignment and identification with a gay male: for the rest of the sequence, the gaze is indeed the gay's.

As the camera slowly pans across the rack of gay porno magazines, the male bodies featured on their covers and the range of titles—*King Leer, Butch Torso, Honcho, Male Call, G String, Joyboy*—eroticize the signs of masculinity in an explicitly homosexual context and insist that the categories of sex and sexuality cannot be directly mapped onto gender. The camera zooms in for a close-up of Scott Favor (Keanu Reeves), cover-boy on *Male Call*. The cover copy says he is "Ready to Ride," but the caption "Homo on the Range" suggests that his mount will be neither female nor equine. The tableau vivant comes to life as Scott confesses that he would "sell [his] ass," but only for the money. His confession is greeted with whistles, catcalls, and mocking insinuations from the other cover-boys, who suddenly come alive, quarreling and flirting with one another. Mike, adorning the cover of *G String*, points out that since Scott is destined to inherit a lot of money, he must be hocking his wares for pleasure. Van Sant delivers the coup de grace to America's most venerated masculine icon by staining it with the lavender dye of homosexuality.[17]

But *My Own Private Idaho* does far more than satirize the porno industry; the remainder of this chapter shows how it works through several fundamental facets of Freud's *Beyond the Pleasure Principle* and Lacan's theories of the Mirror Stage. Just as the hero of *Inserts* is inspired by Orson Welles, Van Sant's film reworks *Chimes at Midnight*, Welles's film adaptation of Shakespeare's *Henry the Fourth, Part 1*.[18] Just as Prince Hal temporarily adopted Falstaff, Scott Favor, in the final weeks of his sustained flirtation with the lawless world of the male hustler, adopts Bob Pigeon, the Lord of Misrule, but he proclaims that on his twenty-first

birthday "all my bad behavior I will throw away to pay a debt." That debt is equivalent to the "mortgage" exacted from the male subject in exchange for the privileges of the phallus; the "bad behavior" signifies those pleasures of jouissance men sacrifice the moment they take their place in the symbolic order. In order to claim his inheritance, Scott will forfeit access to his sexuality. Van Sant implies that Scott's final capitulation to his father, Mayor Favor—representative of the phallus and paternal power—is more wounding than empowering. The mayor commands a retinue of politicians, lawyers, and policemen; he is disgusted by his "effeminate" son. The result of Scott's Faustian bargain is that he loses both "fathers": his cruel rejection hastens Bob's death, and while his comrades indulge in an orgy of grief at one funeral, he must remain seated at Mayor Favor's more decorous and solemn funeral, and assume his assigned role.

Scott's oedipal conflict is interwoven with Mike's enigmatic variation on Freud's family romance. Just as *Body Double* sets out to solve the riddle of Jake Sculley's claustrophobic paralysis, *My Own Private Idaho* sets out to solve the riddle of Mike's narcolepsy. Mike, who wears a mechanic's shirt embroidered with the name "Bob," knows neither who nor where he is. He blacks out without warning. The first words we see on the screen are written words—the dictionary definition of *narcolepsy,* from the Greek *narke:* a condition characterized by brief periods of deep sleep, related to *narcosis,* a state of arrested activity produced by narcotics, which dull the senses and pain. The word's slang antithesis is also relevant: "narcs" are agents of the law, committed to thwarting the desire for sleep, intoxication, euphoria. The narcs are the agents who bust the homeless teenagers who live by their wits and sell their bodies to survive. Like *pharmakon,* which means both poison and remedy, *narke* exemplifies language's internal tensions and irremediable divisions, as well as its irremediable distance from objects.

From the opening sequence forward, Van Sant wrests words from things, representation from reality. When the word *Idaho* appears on the screen on a blue background, Van Sant utterly dispenses with the idea of locale. Idaho is not a place, but a state of mind. (The film's title is borrowed from the B-52's song about living in one's own private Idaho.) Like Mark Lane, the protagonist in *Peeping Tom,* Mike is divided against himself. Even his memories fail to cohere. The film revolves around a search for origins (maternal, paternal, narrative), but the search is doomed to defeat. The scarcity of scenes of Idaho (except for those in Mike's dreams) situates the film firmly in the Imaginary.

Whenever Mike falls asleep, recurrent images appear: he lies in his mother's arms, infused with oceanic bliss. As I explained earlier, the co-ordinates of the Lacanian Imaginary involve the Mirror Stage. This stage is preoedipal; that is, the child has not yet been separated from the mother by the father, nor has he or she been initiated into the Symbolic stage of language acquisition. Mike's narcolepsy is a symptom of his arrested de-velopment in the Imaginary; the recurrent images in his dreams are part of his "Image repertoire." The Mirror Stage is the inaugural moment of the divided self, but the illusory images of unity and harmony haunt the subject forever after. Since Mike's mother abandoned him in infancy, his waking life is devoted (when he is not struggling for sheer survival) to solving the enigma of her disappearance and to making her return. The film thus dramatizes Freud's discovery of the "fort/da" game in *Beyond the Pleasure Principle:* observing his baby grandson mimic his mother's absence by tossing a spool and reeling it in, Freud concluded that we re-peat painful experiences with fetish objects in order to master through play what we cannot master in life. That "compulsion to repeat" remains constant throughout life. In Mike's dreams, his mother is associated with salmon spawning, leaping upward against the current—an apt symbol of his own futile quest and fate.

My Own Private Idaho is fascinating filmmaking because the specta-tor is transported into Mike's interior landscape. When he has a nar-coleptic fit, the screen goes black, with immediate jump cuts to the im-ages he sees in his dreams. Eric Edwards, Van Sant's cinematographer, explains that "the jump cuts are a plot device"[19]—they shift from Mike's present to past, showing how the ghostly shadow of his mother falls over everything. The jump cuts, which unfold without rhyme or reason, mime the workings of fantasy. Mike and Scott's doomed quest to find Mike's lost mother reveals that Mike is frozen in retrospective fascination, in limbo between past and present, memory and longing. While he may long for the mother's breast, it is important to remember that the desire be-comes sexual only retrospectively, through the operations of fantasy. The mother's breast provides not just nourishment but sensual satisfaction in suckling. In her absence, the infant's desire focuses not on milk but on a fantasy of lost satisfaction. By becoming split through representa-tion, desire moves into fantasy and becomes sexualized. Thus, in an ad-vanced representational system like cinema, fantasy is the mise-en-scène of desire. Fantasy is not the object but its setting. Fantasy depends on the *setting out* of images in which the subject is caught up.[20] That is pre-cisely what Van Sant does: he sets out images (salmon spawning, barns

falling, yellow wheat fields, blue sky) of Mike's dreams of his mother, with his head in her lap, like a baby. The lyrical beauty of these episodes is astonishing: the colors are so vibrant that they seem (as in Douglas Sirk's *Imitation of Life*) hyper-real, in contrast to the gray sordidness of Mike's waking life. Van Sant uses these images to shatter the ego, to display its fragmentation and inability to find a fixed locus or coherent core.

Narcolepsy, therefore, is not just a physical and psychic condition but a metaphor for the effect of cinema itself on the spectator, a disquieting dream in a dark theater. What, the film inquires, is the difference between waking and sleeping, public and private dreams, reality and fantasy? The spectator identifies with Mike's longing to fill a lack, and with the magnetic attraction to unconsciousness. In *Beyond the Pleasure Principle,* Freud argues that the final goal of all organic striving is to reach an old state of things, an initial state, from which all organisms departed and to which all—like the salmon—are striving to return. (Freud speculates that fish spawn in waters far removed from their customary haunts because they are seeking out localities in which their species formerly resided.) All living animals recapitulate all the structures from which they have sprung, driven by a compulsion to repeat. The instincts are thus fundamentally *conservative;* if they went unchecked, they would drive us into unconsciousness and inertia, quiescence.[21]

That quiescence is one sign of the many other myths Van Sant systematically dismantles, besides those involving the cowboy and the sexual outlaw, for Mike's condition *feminizes* him: he is prone, passive, vulnerable, irrational, overwhelmed—not the typical position antiporn feminists ascribe to the male oppressor. Not since *Deliverance* (1972) has a mainstream American film (outside the horror genre) subjected the male body to such assault. The film relentlessly deconstructs the protocols of gazing; the voyeuristic spectacle of Phoenix's contortions is astonishingly intimate. He is a tabula rasa, to be written on by the projected fantasies of others. (Life tragically imitated art on October 31, 1993, when River Phoenix's friends outside the Viper Room in West Hollywood mistakenly thought he was merely mimicking Mike Waters's narcoleptic fits when Phoenix went into convulsions from a drug overdose and died.)

In the film, the body in pieces parallels the plot in pieces: expressed wholly through Mike's subjectivity, the film invites us to share his frustration at false leads, clues, enigmas on his quest. The story is shot through with holes and gaps of memory; it is already phantasmic. Mike has a few tattered photographs, a memory of a jerky home movie, a plastic whirligig in the shape of a sunflower; these few fetish objects are ghostly

shadows both of his mother and of his loss. Nowhere is his trauma more apparent than when Scott and Mike visit Mike's brother, Richard. The moment Mike sees the trailer, he remembers being a toddler and watching his mother drive away with the trailer. (As in *Inserts*, black-and-white photographs and home movies transport the spectator back in time, into the protagonist's memory.)

Crazily compelled to "tell [Mike] the truth about his mother," Shari, Richard fabricates a patchwork of lies: Mike was placed in an orphanage after his mother murdered her faithless lover, whom Richard insists was Mike's father. Like the malevolent fathers in Sam Shepard's work, Richard is violent, alcoholic, delusional, dangerous. His mobile home testifies to his transience and instability; his story is a tall tale. As in Shepard's plays, the West itself is a vestigial fantasy: something that once had a coherent identity has been reduced to grotesque clichés: a giant cowboy statue looming over the local mall, or John Wayne in *Rio Bravo*. The entire scene is interspersed with images from infancy unreeling in Mike's head, images in which Richard appears for the first time as a baby-faced teenager kissing Shari with sexual passion. No wonder Shari's postcard comes from the Family Tree Motel. No wonder Mike, the product of mother-son incest, is obsessed with the mystery of origins: "Dick" is his father.

The film's title suggests that Mike inhabits an interior landscape all his own. He does not, however, *own* it, nor, since he lives on the streets, does he have any *privacy*, waking or sleeping. He subsists outside the pale of private property, paternity, legacies, and inheritances—the public world of Scott Favor, whose name suggests both the favors he dispenses to men for money, and his favored class status: unlike Mike, Scott is only slumming.

Mike is left triply bereft by his mother's abandonment, his unrequited love for Scott, and the death of Bob Pigeon. In the penultimate scene, we find Mike curled in a fetal position amid broken glass on the sidewalk, laughing as Scott rides by in his limousine. It is the Bataillean laughter of excess, nihilism, despair. In the end, Scott has become a connoisseur of luxury; Mike remains "a connoisseur of roads." As he falls in a seizure one last time in the West, two farmers stop the truck, pick over his body and possessions like vultures, and depart. Far from being powerful because he is male, Mike is acted on by forces which, whether for evil or good, are equally random and inexplicable.

What does it mean to be bereft, stranded in a culture that is exhausted, haunted by hollow myths of home, family, and the West? Van Sant bids farewell with the nasty words, "Have a Nice Day," accompanied by the strains of "America the Beautiful"; the trite disassociation is a damning

reflection of a nation that preys on the underclass while urging, "Don't worry, be happy." Homelessness is both literal and metaphorical. Mike embodies the dispersal of the subject, futilely searching *for* family while Scott defiantly flees *from* one. In Van Sant's bleak portrait of subjectivity and defeat, neither "hero" finds what he is looking for.

Each of the films discussed in this chapter describes fantasies that have not been co-opted by consumer culture, whether one thinks of Byrum's bitterness, De Palma's obsessions, or Van Sant's portrait of unrequited love between men. In all three films, the motor that drives the narrative revolves around oedipal trauma, fear and fascination, the compulsion to repeat. Drawing on intrinsic evidence from these three films, one might compose a set of guidelines for how *not* to make a porno film, which would look something like this:

1. Expose the mechanics of the production of pornography.
2. Frame the plot and characters by creating a film-within-a-film, or use other visual media, like home movies or photography.
3. Feminize the hero, making him passive, impotent, a fugitive, or a failure.
4. Make the past—in the form of one's parents or history—oppressively omnipresent.

My fantasy is for film reviewers to take this checklist with them to the movies, so they will know porn when they see it *and* when they don't.

5

David Cronenberg's Surreal Abjection

David Cronenberg further advances the antiaesthetic of *Bad Girls and Sick Boys* by dismantling mimesis and the Cartesian mind-body split. His films, like those in the preceding two chapters, trace the intersection of pornography and horror, psychoanalysis and cinema. But his oeuvre also has many affinities with Bob Flanagan, Orlan, and especially J. G. Ballard, for he too explores the impact of medicine, science, and biology. He too exhibits the body as "revolting" in both senses of the word—disgusting and rebellious. Cronenberg is a master of spectacular cinematic special effects; through his innovations in computer technology one can now see the body's insides "opened up" in such films as *Scanners* (1980), where a man's head literally explodes (Fig. 21).

This remarkable scene in *Scanners* shows how Cronenberg takes a metaphor and transforms it into a perceptible reality. The scene is perhaps the most explicit example of how Cronenberg makes the mental physical: the intense effort of cerebral concentration results in the head being shattered like a watermelon, brains splattering all over the conference table (at a conference on psychic phenomena).

Justly proud of the scene's special effects, Cronenberg confessed that while he does not particularly like cerebral movies, neither does he like "movies that are all viscera and no brains."[1] While culture and even subjectivity are disseminated through the cool medium of television (the theme of *Videodrome*), the body's "insides" are "hot," metamorphosing uncontrollably, wreaking havoc on the house of cards called

Figure 21 Exploding head, *Scanners* (Cronenberg, 1980); distributed by Image Organization. In *Cronenberg on Cronenberg,* ed. Chris Rodley (London: Faber and Faber, 1992).

civilization. Like the performance artists discussed earlier, Cronenberg depicts the impact of "posthuman" technology on the psyche: genetic experiments, radical behavioral therapy, reproductive technology, pharmaceutical breakthroughs, and electronic technologies have irrevocably transformed the human senses. Literally iconoclastic, he subverts mainstream cinema by combining the visceral and the literal. We saw earlier how Brian De Palma satirizes horror and pornography by highlighting each genre in a film-within-a-film in *Body Double;* Cronenberg combines horror and porn, too. He approaches medicine as a "perverse implantation" that seeks to control the body, and explores its impact on our psychosexual makeup. Medical research profoundly alters the sexuality of characters in *Shivers, Rabid,* and *The Fly;* psychiatrist-patient relationships are central in *Transfer, Stereo, The Dead Zone,* and *The Brood;* reproductive technologies and fused personalities dominate *Scanners* and *Dead Ringers.* He defamiliarizes the man-made technological universe that already invisibly envelops us, inaugurating the epoch of the posthuman.

Cronenberg says that his films "spring from the traditions of wonder and phantasm, the fantastic. If you go back to the two founders of film tradition—Lumière and Méliès—then I come from the Méliès side: *Rocket to the Moon*" (CC, 152). But since Méliès documented and anticipated the actual technological transformations of modern society, Cronenberg's affinities also encompass this aspect of Méliès. Moreover, since Lumière was a medical researcher who used film to study medical biology, pharmacodynamics, experimental physiology and photography, Cronenberg's sensibilities are linked to Lumière as well. Cronenberg's films depict "phenomena overwhelming consciousness," which is how Siegfried Kracauer defines cinema's function:

> Elemental catastrophes, the atrocities of war, acts of violence and terror, sexual debauchery, and death are all events which tend to overwhelm consciousness . . . call forth excitements and agonies bound to thwart detachment. . . .
> The cinema . . . aims at transforming the agitated witness into conscious observer. Nothing could be more legitimate than its lack of inhibition in picturing spectacles which upset the mind. This keeps us from shutting our eyes to the "blind drive of things."[2]

No definition of cinema applies more to Cronenberg, for in all his films, he transforms the agitated viewer into a conscious observer.

MAINSTREAM FILMS VERSUS REVOLTING BODIES
IN *SHIVERS, RABID,* AND *THE BROOD*

"The blind drive of things," particularly of the sex drive, is everywhere apparent in Cronenberg's films, for his characters lose all inhibitions: in *The Fly* (1986), the hero's sex life becomes more and more frenzied as he metamorphoses from human to insect. In *Rabid* (1976), a botched plastic surgery operation transforms a woman into a vampire with a penislike organ under her armpit, which she uses to siphon her victims' blood; eventually she turns the entire population into sexually voracious predators. Cronenberg uses horror and pornography to explore directly issues that are explored only at several removes in legitimate film. As Carol Clover notes, "pornography . . . engages directly (in pleasurable terms) what horror explores at one remove (in painful terms) and legitimate film at two or more. . . . Pornography . . . has to do with sex (the act) and horror with gender."[3] To illustrate, one might say that beneath the legitimate plot of *Wolf* (in which Jack Nicholson glorifies the "innate" male predator) lies the plot of *Rabid* (in which the vampire is a phallic woman); beneath that plot is *Deep Throat* (about another misplaced genital).

While purporting to be transgressive, *Wolf* is merely reactionary. Following the advent of AIDS and the stock market crash of 1987, scores of mainstream films (including *Fatal Attraction, Ghost, Pacific Heights, Bonfire of the Vanities, Unlawful Entry,* and *Regarding Henry*) appeared to examine the connection between sexual and economic prowess. But, like *Wolf,* they maintain a safe distance from the topic. The yuppie heroes are initially kings of their castles, confident of their privileges and entitlement, until the wake-up call: the hero discovers that home is vulnerable to intruders and foreclosure; all that really matters are "family values." *Regarding Henry* begins with a corporate "master of the universe" who discovers how to be human only when he gets mugged and loses everything. *Wolf* is merely the flip side of the same coin: Jack Nicholson is initially as timid as Walter Mitty, but once a wolf bite transforms him into a vampire, he regains his virility, throws away his reading glasses, and defies his corporate bosses. He regains his (presumably innate) competitive *instincts,* getting revenge on the sleazy nemesis who stole his wife and his job by pissing on the guy's suede shoes in the corporate john, "marking his territory." In the end, love leads him and Michelle Pfeiffer back to the primeval forest. "*Wolf,*" director Mike Nichols declares, "is about a hard-on."[4]

Anticipating *Wolf's* premiere, *Esquire* magazine heralded the return of "the Post-sensitive Man": "He's back, and boy is he pissed." But testosterone (like nostalgia) isn't what it used to be. *Wolf* proceeds from the premise that "real men" have lost their roots; only by rediscovering these roots will they reclaim their manhood. The film exploits the longing for a time when male and female roles were as uncomplicated as those in the animal kingdom. Some films go back to cowboys and Indians *(Dances with Wolves, Last of the Mohicans, 1492, Unforgiven, Wyatt Earp)*. Others go further back, to prehistoric times: *Clan of the Cave Bear, The Crow, Jurassic Park, Encino Man, The Flintstones*. Even comedians like Rob Becker, in his show *Defending the Caveman*, advises men to be patient while shopping with women, because men are hunters, women are gatherers. (As if the mall is the La Brea tarpits.) Insisting that women really *want* a neanderthal, *Esquire* quotes one woman: "My ideal guy's Tarzan. He doesn't complain at all about his feelings."[5] The "animal within" presumably needs "reclaiming" because alienated labor, a depressed economy, sexually transmitted diseases, and politically correct leftists, liberals, "minorities," and feminists all conspired to castrate him.

Wolf's promotional campaign claims to "free the animal within," but as Peter Sloterdijk points out, the suspicion that bourgeois individuals have of themselves being animals creates the cultural framework for modern depth psychology.[6] The longing for some prelapsarian authenticity is a deeply ingrained vestige of romanticism, a strain (in both senses of the word) that unites such dissimilar books as Clarissa Pinkola Estés's *Women Who Run with the Wolves* and Camille Paglia's *Sexual Personae*. (Paglia argues that men's superior cultural achievements can be traced to their ability to piss farther.)[7] Both women believe in some animal essence that has been lost; we must "reclaim" it by listening to either Native American tales (Estés) or Jim Morrison (Paglia). This vestigial romanticism is deeply reactionary, and even sheep's clothing cannot disguise it in *Wolf*.

In contrast, Cronenberg's refreshing challenge is this: if you *really* want to find your "roots," why stop with the animal kingdom? Why not go all the way back to crustaceans *(Naked Lunch)*, insects *(The Fly)*, and slugs *(Shivers)?* As a lepidopterist (and avid Cronenberg fan) explained to me, "*The Brood* is straight out of Coelenterata 1, and the beetles in *Naked Lunch* and *The Fly* are anatomically correct."[8] Cronenberg shares the biologist's detached view of humans as a species. He views the species in evolutionary terms, but rather than assuming that "evolution" is synonymous with "Enlightenment progress," he explores evolution from the point of

view of other organisms. Biomedical research in such fields as immune system interactions has given us new metaphors; Cronenberg deploys those metaphors by depicting a brave new denatured world of permeable boundaries, cell lineages, replication, and pathology. In metazoan organisms, for instance, two units of selection interact, the cellular and the individual, but their harmony is highly contingent, and there is no relation between part and whole; such discoveries have led biologists to realize how vulnerable, multiple, and contingent every construct of individuality is.[9] This feel for the organism forms the foundation for Cronenberg's aesthetic, which reverses "the normal understanding of what goes on physically, psychologically, and biologically. . . . it's hard to alter our aesthetic sense to accommodate aging, never mind disease" (CC, 83–84).

Shivers (also known as *They Came from Within, Orgy of the Blood Parasites,* and *The Parasite Murders,* 1975) focuses on precursors to the yuppies in *Ghost, Pacific Heights, Unlawful Entry,* and *Regarding Henry:* the smug inhabitants of the luxurious Starliner apartments have moved to this island complex to seal themselves hermetically from urban ills (robbery, rape, homicide, suicide, disease). The Starliner's facilities are so self-contained that one need leave only to go to work. It is a fortress. But like all well-regulated places, it produces boredom, monotony, anxiety. A doctor (aptly named Emil Hobbes) develops a parasite that can take over the function of failing body organs. Hobbes hopes to cure humans of excessive rationality, because man has become "an overintellectual creature who has lost touch with his body." Unfortunately, the parasite is also an aphrodisiac; once implanted in a sexually active young female resident of the Starliner, it spreads uncontrollably, oozing through plumbing, mail slots, laundry chutes, and air shafts, leaving a trail of blood and slime in the pristine building. The residents become more and more orgiastic as they lose their inhibitions and spread contagion. In homage to George Romero's *Night of the Living Dead,* they spread out over the countryside in the final scene. Cronenberg also pays homage to Hitchcock's film *The Birds,* for just as the birds' appearance is related to the heroine's sexual transgressions, the appearance of the sluglike organisms is related to a young girl's sexual licentiousness. Broken communications augment disaster in both films—between city and the country in *The Birds,* between officials and the Starliner in *Shivers.* Broken intercourse in communications (telephone, newspaper, radio, television) parallels anarchic intercourse: sexual surrender is presented as a feast of the organism on the host. (While the birds are an external force working their way in, the parasites are an internal force, working their way out.)[10]

Unfortunately, Robin Wood's critique of *Shivers* has set the tone for the customary critical reception of all Cronenberg's films. Wood describes *Shivers* as

> a film single-mindedly about sexual liberation, a prospect it views with un- mitigated horror. The entire film is premised on and motivated by sexual disgust. The release of sexuality is linked inseparably with the spreading of venereal disease. . . . The parasites themselves are modelled very obvi- ously on phalluses, but with strong excremental overtones (their colour). . . . *Shivers* systematically chronicles the breaking of every sexual- social taboo—promiscuity, lesbianism, homosexuality, age difference, fi- nally incest. . . . The film shows absolutely no feeling for traditional rela- tionships (or for human beings, for that matter): with its unremitting ugliness and crudity, it is very rare in its achievement of total negation.[11]

Critics like Andrew Parker, who attacks Cronenberg for being homo- phobic, and Barbara Creed, who sees him as misogynistic, follow in Wood's footsteps by seizing on this motif of sexual disgust.[12] They fail to recognize that he is using sexually transmitted disease as a metaphor for the infinite interdependence of relationships and the permeable boundaries among organisms. Just as Bob Flanagan turns his own body into a medical exhibition, confronting the taboo topics of sexuality and disease without shame or guilt, Cronenberg investigates how our moral and aesthetic views might be transformed if we adopted the scientist's view of "pathology." In contrast to *Wolf,* a cautionary tale about AIDS that glorifies the heterosexual couple and the individual's triumph, Cro- nenberg maintains that the real question is, "How does the disease per- ceive us? That illuminates what we are" (CC, 83–84). He explains:

> To understand physical processes on earth requires a revision of the theory that we're all God's creatures—all that Victorian sentiment. It should cer- tainly be extended to encompass disease, viruses and bacteria. Why not? A virus is only . . . trying to live its life. . . . It's about trying to understand interrelationships among organisms. . . . The fact that it's destroying you by doing so is not its fault. . . . In *Shivers* I was saying "I love sex, but I love sex as a venereal disease." . . . For them it's very positive when they take over your body and destroy you. It's a triumph. (CC, 82)

It would have been easy to turn *Shivers* into a paean to the "age of Aquar- ius" (yet another vestige of romanticism), but far from endorsing a utopia of "free love," Cronenberg's vision is much more sinister: by film's end, all the ruptured surfaces have been resealed as a new form of control as- serts itself, one which makes sex addiction the norm. *Shivers* introduces a new form of horror: the saturation of society with compulsive eroti-

cism.[13] Far from being liberating, sex is one of the easiest ways to regulate the population—a new form of consumption and conformity that gives the lie to *Wolf*.

If *Wolf* is about a hard-on, so is *Rabid,* but Cronenberg illustrates how far removed the denatured postreproductive world is from the spermatic economy that organized bodies in the nineteenth century. Rose (Marilyn Chambers) undergoes experimental plastic surgery after a motorcycle crash, but her charlatan plastic surgeons accidentally create a penile, syringelike organ under her armpit which gives her the sex drive of a vampire (Fig. 22).

In the figure below, Chambers assumes the classic feminine posture of a victimized heroine, eyes wide with terror. Her face is as expressive and

Figure 22 Marilyn Chambers in *Rabid* (Cronenberg, 1976). Copyright 1977 New World Pictures, Inc.

exaggerated as a character in a silent movie; however, she herself is the vampire. She returns the male gaze with the cold stare of a Medusa. Just as Freud suggests that the snakes in Medusa's hair are little penises, in this image the penislike protuberance under Chambers's armpit visually suggests the phallus's aggression and ubiquity. It transforms her into a sexual predator. To look at this image is to see sexuality's disturbing undercurrents. The image represents visually the unsettling metamorphosis of actual body parts. It destabilizes all our cherished concepts of the fixity of either sex or gender. This image shows the site of contamination, for Montreal's entire population becomes rabid, including the doctors who declare it a disaster zone under martial law.

Like *Shivers*, *Rabid* is not only about sex addiction, but about the commodification of sex. Marilyn Chambers, former star of Ivory Snow soap commercials, became an international celebrity in the porno film *Behind the Green Door* (1972), which was still raking in money when *Rabid* premiered. *Rabid* capitalizes on Chambers's notoriety, but instead of casting her as the wholesome girl-next-door, *Playboy*-style, in *Rabid* she is slatternly and hard-bitten (a Cronenberg pun). *Rabid* is a parable of the porno queen's revenge: far from passively acquiescing to men's looks, she is an active "looker," cruising the malls and boulevards. Rose "turns on" her victims: in one scene, she enters a porno theater where the men are sex-starved; she is merely hunting for dinner. Her victims all have the kinds of stereotypical macho roles that one finds in porno magazines: a farmer, truck driver, doctor, and suave playboy all bite the dust when she bites them. The spermatic economy in the nineteenth century promoted rational citizenship, bourgeois family life, patriarchal authority, and lobbied against sexual pollution and prostitution, but all those ideals are demolished in *Rabid*. As in *Shivers*, sex is merely another commodity, saturating and seducing. The major sites of consumer culture—cinema and mall—first become predatory battlefields, then crypts. When even Santa Claus is assassinated in the mall, Cronenberg's satire strikes to the heart of consumerism: consumers are cannibals, and civilization is only a thin veneer, "plastic," like the cosmetic surgery industry that promotes the beauty myth. If Orlan is one kind of "cutup in beauty school," staging plastic surgery on her own face in art galleries, *Rabid* is another. Cronenberg's iconoclasm shows how beauty is produced through tedious labor and repetition. Like Orlan, Cronenberg enjoys camp and comedy: one girl keeps returning to the clinic for nose jobs because "Daddy says it's too much like his and that's why he wants me to change it. I'm terrified to find out what it really means."

Cronenberg follows the same philosophical tradition that links Dostoyevsky, Nietzsche, Bataille, and Céline, the tradition central in Julia Kristeva's *Powers of Horror: An Essay on Abjection.* When Rose dies, her body—as stiff as a mannequin, a sex toy, or a Barbie doll—is thrown into a garbage truck. Wood identifies "total negation" as a characteristic of Cronenberg's films, but he makes no effort to explain the philosophical foundations. *Rabid*'s denouement resembles Orlan's negation of interiority, for as with Orlan, when one "opens up" Cronenberg's characters, one finds nothing—no immunity, no transcendence, no relief from the ills that plague us or the plagues that kill us.

Bodily diseases in *Rabid* and *Shivers* are transformed into mental diseases that body forth in *The Brood* (1979). Just as the two earlier films satirize the desire to "get back to the garden," *The Brood* satirizes the human potential movement, one of the most popular of pop-psychology movements in the 1970s. One of its most successful leaders was Werner Erhard, founder of est (Erhard Seminar Training), who repudiated his own history as a Jew, abandoned his family, and trained legions of followers to get in touch not with the animal within, but with the "inner child." An entrepreneurial showman, Erhard made a fortune through behavior modification and canny marketing. His parodic counterpart in *The Brood* is Dr. Hal Raglan, inventor of "Psychoplasmatics," which enables patients to manifest repressed fears and aggressions through physical outbreaks on their own bodies. Cronenberg thus literalizes Freud's theories of the body's symptoms "expressing" repressed traumas. He also makes literal the idea of "a creative cancer: something that you would normally see as a disease now goes to another level of creativity and starts sculpting with your own body" (CC, 80). With characteristic Cronenbergian perversity, the human "potential" Dr. Raglan unleashes—the inner child—is not sweetness and light, but demonic, unpredictable, paranoid, and murderous.

"What would happen," Cronenberg asks, "if rage took bodily form?" *The Brood* is a horror version of *Diary of a Mad Housewife.* Nola Carveth (Samantha Eggar) lives in a bourgeois world that seems placid on the surface, but festers with abuse, alcoholism, adultery, cancer, madness. Her husband's job as architectural restorer mirrors his futile efforts to prop up the collapsing edifice of the family.[14] Nola gives birth to fetal monsters who embody her rage and carry out her unconscious desires. The implication of castration in her name signifies society's revulsion for the monstrous womb's reproductive and devouring capacities.[15] As in the art of Kiki Smith and Mike Kelley, the paradigmatic figure of

abjection is the mother, for it is she who is bound to the messy world of menstruation, childbirth, lactation, breast-feeding. It is she who tends the infant's bodily functions. When Nola licks the blood off her new-born, she literally embodies the *intimacy* of terror.[16] Eventually "the brood" murders Nola's abusive parents, then Dr. Raglan. They finally threaten her daughter and husband, who only escapes by strangling Nola. Despite Nola's death, the strange skin growths that will eventually meta-morphose into full-fledged monsters of rage are already festering in Nola's daughter: in the final scene, the daughter's skin crawls, and her eyes re-veal the hatred *she* in turn will loose upon the world.

If the subversive *Rabid* lies beneath the legitimate *Wolf, The Brood* lies beneath *Kramer vs. Kramer,* a sentimental tale of yuppie divorce and custody trials. "*The Brood* was my version of *Kramer vs. Kramer,*" Cronenberg confesses: "I was really trying to get to the reality . . . which is why I have disdain for *Kramer.* I think it's false, fake, candy. There are unbelievable, ridiculous moments in it that to me are emotionally com-pletely false, if you've ever gone through anything like that."[17] Amid his own searing divorce and custody battle, Cronenberg made *The Brood* to expose "the nightmare, horrific, unbelievable inner life of that situa-tion. I'm not being facetious when I say I think it's more realistic, even more naturalistic, than *Kramer*" (CC, 76) (Fig. 23).

Cronenberg's point is explicit in the two images juxtaposed in Fig. 23. In the photo from *Kramer vs. Kramer,* Meryl Streep's body language and posture convey maternal solicitude, protection, and engagement with her son. She lies on the ground, putting herself on the same level as her son, whose demeanor is as innocent as a cherub. In contrast, in the photo from *The Brood* Samantha Eggar's face is covered with the blood of the amorphous shape she has just pulled from her own womb. She is mon-ster, midwife, and mother all in one. Wrapped in the white gown worn in delivery rooms *and* asylums, she is a visual embodiment of the mon-strous mother. The photo makes explicit the primal image of animal pos-sessiveness, for it evokes a bitch licking a newborn pup.

"Custody" in *The Brood* means "possession"; what does it mean to be possessed; to possess someone else? Emotional vampirism is a sen-tient force in Cronenberg's universe; transformed into physical vam-pirism, it preys on parents and children alike. In contrast to mainstream films' glorification of "family values," Cronenberg shares J. G. Ballard's and R. D. Laing's view of the family itself as the source of psychosis. The socialization process breeds madness. As Philip Larkin writes in his poem "This Be the Verse," "They fuck you up, your mum and dad." They also

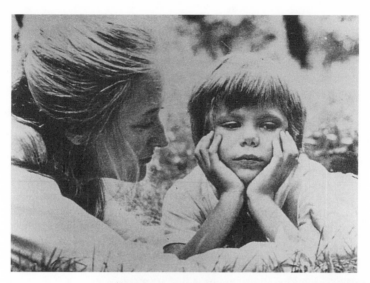

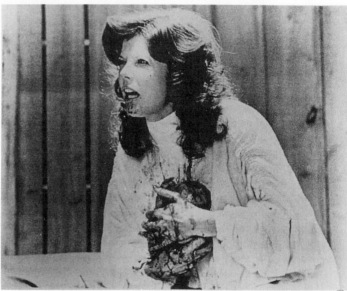

Figure 23 Motherhood: Meryl Streep in *Kramer
vs. Kramer* (Robert Benton, 1979) versus Samantha
Eggar in *The Brood* (Cronenberg, 1979); distributed by
Concorde / New Horizon. In *Cronenberg on Cronenberg*,
ed. Chris Rodley (London: Faber and Faber, 1992).

fill you up, producing a brooding rage that is "primal, nearly foetal, nearly formless . . . [The brood are] creatures from the unconscious, making the mental physical" (CC, 84).

Cronenberg portrays the symbiosis between the mental (nervousness, anxiety) and the physical (pain, disease). His films anatomize "the nervous system," meaning the literal and visceral body, from the brain to the spinal column to the ganglia. At the same time, "the nervous system" signifies the systems of control that regulate human behavior, labor, and desire—what have collectively been called the "informatics of domination."[18] Cronenberg clearly has the latter meaning in mind constantly, as he reveals in commenting that "a film like *Videodrome,* which deals specifically with sadomasochism, violence and torture, is naturally going to have a lot of nervous systems on edge" (CC, 98). Censorship, surveillance, genetic and drug-test monitoring, televisual communications, and other technological means of regulating the body are Cronenberg's target. Whether one thinks of aerobics or Prozac, the body is a colonized, sentient entity:

> I don't think that the flesh is necessarily treacherous, evil. . . . It is cantankerous, and it is independent. The idea of independence is the key. It really is like colonialism. The colonies suddenly decide that they can and should exist with their own personality and should detach from the control of the mother country. At first the colony is perceived as being treacherous. It's betrayal. Ultimately, it can be seen as the separation of a partner that could be very valuable as an equal rather than as something you dominate. I think that the flesh in my films is like that. I notice that my characters talk about the flesh undergoing revolution at times. I think to myself: "That's what it is: the independence of the body, relative to the mind, and the difficulty of the mind accepting what that revolution might entail." (CC, 80)

Biological insurrection recurs in all Cronenberg's films; one patient in *The Brood,* suffering from lymphosarcoma, files suit because he has become convinced that Dr. Raglan incited a riot in the patient's nervous system: "Raglan encouraged my body to revolt against me and it did. I have a small revolution on my hands and I'm not controlling it!" The patient believes that one kind of "perverse implantation"—the legal system—can regulate and protect him from the other ones, but man's pride in his rationality and will is delusional. Far from endorsing the myth of a benevolent and well-ordered universe, Cronenberg's vision is Hobbesian. Our ills are systemic: intricately enmeshed implantations, like the Hobbes parasite in *Shivers,* work from the insides of our bodies outward,

conspiring to eat us alive. Cronenberg was justly proud of the structure of *The Brood,* which he called "the most classic horror film I've done: the circular structure, generation unto generation; the idea that you think it's over and then suddenly you realize that it's just starting again" (CC, 78). In Shakespeare's Sonnet 12, "When I do count the clock," the defense against the Grim Reaper is to "breed, to brave him when he takes thee hence"; breeding is the braving of time. But as in *Rabid,* one finds no transcendence, no salvation in *The Brood.* Instead, death feasts on the corpses it kills, and festers in the organs of the young till its hour comes round again.

SCRAMBLING THE CODES: *VIDEODROME* (1982)

If there is no escape from corporeality, neither can one escape televisual technology. Since so many kinds of grafting of the organic and inorganic occur in *Videodrome,* J. G. Ballard's observation is prophetic: "Television seems to me to play a particularly important role in the continuous flood of images with which it inundates our brain: it perceives things on our behalf, and it's like a third eye grafted onto us."[19] Television does not just *reflect* subjectivity, it *constitutes* it; that is the idea Cronenberg literalizes when the Marshall McLuhanesque character Brian O'Blivion robotically repeats, "The television screen is the retina of the mind's eye; therefore the television screen is part of the physical structure of the brain." Cronenberg's ferocious satire overliteralizes the claims not just of McLuhan, but of Debord and especially of Baudrillard, who insists that television implies not a "society of spectacle" (Debord's term) but rather "the *very abolition of the spectacular.* . . . There is no longer any medium in the literal sense: it is now intangible, diffuse and diffracted in the real, and it can no longer be said that the latter is distorted by it."[20]

All the artists in *Bad Girls and Sick Boys* begin from that starting point, which explains why they are ambivalent about the very possibility of transgression, despite the efforts of politicians and pundits to demonize them. It also explains why their work centers so obsessively on mimesis and vision. Television has reoriented our concept of time and space, for the continuous flow of discontinuous images, the endless combinations of signs and codes shape us far more than we shape them. As Shaviro points out,

> Media images can no longer refer to a real that would be (in principle) prior to and independent of them; for they penetrate, volatilize, and thereby (re)constitute that real. . . . The more images are flattened out and distanced

from reality, the more they are inscribed in our nerves and flash across our synapses. . . . We have entered a new regime of the image: one in which vision is visceral and intensive instead of representational and extensive.[21]

Whereas the filmmakers discussed in Chapter 4 expose the work that goes into the production of porn, *Videodrome* depicts the visceral, intensive effect of saturation by sexual commodities. The mise-en-scène commences with a business meeting devoted to the mechanics of the porno industry. Max Renn (James Woods) is a sleazy producer who thinks he is so cool that nothing can shock him. He wants something more hard core. He gets his wish when he discovers *Videodrome,* not realizing that the video broadcast signal has been implanted in his own body (Fig. 24). This photo explicitly embodies the body's uncanny capacity for metamorphosis: the slit in James Woods's stomach is purposely shaped like a vagina, and the grimace on his face denotes his anxiety at being forced to feel inside himself. Disgust and fear are also evident in his expression; is he thinking of castration and the vagina dentata as he watches his hand disappear? The photo presents a misplaced genital, but there are *two* misplaced genitals in the scene, for what he is searching for is the phallic-shaped gun that has just disappeared into the vaginal slit. Far from being erotic, the effect of the photo is emetic. There is nothing subtle about the photo or about Cronenberg's investigation of sexuality's guises, props, and misalliances.

Speculation is the motor that drives the narrative, commencing with the business discussion about porn at Max's cable television station. Whereas *Inserts* depicts the consumption of porno films in cinema's infancy, *Videodrome* depicts contemporary porn as a transglobal commodity. In the early days of pornographic cinema, one could distinguish the country of origin and the target audience (excretory acts for the French; flagellation for the British; sodomy and bestiality for the Italians).[22] But today the site of production is shifting, multiple, fluid: the snuff film Max thinks is produced in Malaysia actually comes from a signal in Pittsburgh.

"Scrambling the codes" is Cronenberg's metaphor for televisual subjectivity and transnational capital. "Speculation" is a portmanteau pun, signifying sight as well as investment: the villainous Barry Convex is the CEO of Spectacular Optical, whose multinational corporation manufactures everything from "inexpensive glasses for the Third World to missile-guidance systems for NATO," as well as the Videodrome signal. He is a master of spectacle, working his salesmen up to an orgiastic pitch at

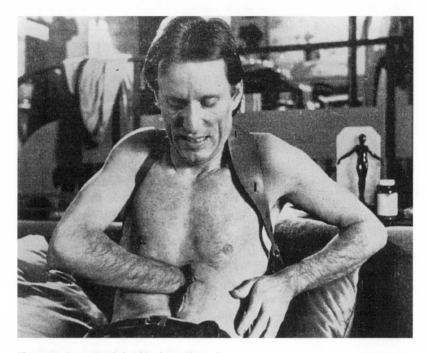

Figure 24 James Woods in *Videodrome* (Cronenberg, 1982; distributed by MCA/Universal. In *Cronenberg on Cronenberg,* ed. Chris Rodley (London: Faber and Faber, 1992).

a sales convention that combines elements of the revival meeting, the circus, and the casino.

Videodrome was invented by O'Blivion as the next stage of man's evolution as a technological being, but his partners have killed him and intend to use Videodrome as a mind-controlling device, using Max's own morally bankrupt cable channel. Max's violent hallucinations are induced by a signal coding which causes a brain tumor, transforming his reality into video hallucination. The plot thus grafts the genres of pornography and horror with such psychological thrillers as *The Manchurian Candidate.* The medium is the message in *Videodrome,* for Cronenberg refuses to differentiate reality from hallucination for the viewer: we slip into Max Renn's hallucinations unannounced, adopting his first-person perspective. As he loses his sense of reality, the film willfully disintegrates (CC, 94).

"Scrambling the codes" also signifies how Cronenberg transforms por-

nography's conventional functions. Max's role in the media is complemented by that of radio personality Nicki Brand (Deborah Harry), who has an "Emotional Rescue" talk show (not unlike Ricki Lake, Geraldo, or Oprah). As her name suggests, she is a brand, a product (her name also alludes to the kinky pleasure she gets from nicking her skin in sadomasochistic rites of mutilation). Whereas Marilyn Chambers actually was a porno star, Nicki Brand longs to become one: in a scene where the snuff film merges with a game show, Nicki wants to be a contestant. Paying homage to the Surrealists, her mouth metamorphoses into a breathing, pulsating television screen. When Max tries to insert his head in the television, the surreal suggestion of the vagina dentata is juxtaposed with oral sex ("giving head") and the threat of castration. She warns him not to use the television sexually because "it bites," a pun on sound bites that sell products, from politicians to porn. As Gertrud Koch points out, "Pornographic cinema emerges at the end of a developmental process in a society of specialization and differentiation. . . . The differentiation of pornography as a product parallels developments in society, as producers speculate on the consumer's current and projected needs and taboos."[23]

Max Renn is searching for new products and new markets that will anticipate and fulfill consumers' "projected needs and taboos"; he rejects a series that has "something too . . . soft about it. I'm looking for something that will break through—something tough." But Cronenberg's literalism exposes the "deep structure" at work in the logic of television. Like Brian De Palma, he shows how every aspect of television—talk shows, porn, news, sports—is an excuse for the commercials that constitute television. Cronenberg goes further: rather than people buying the products in commercials, *they* are the product being sold. Television sells its viewers to the advertisers (in the form of focus groups, target audiences, and so on).[24] Consumers' "current and projected needs" are easier to mold and manipulate than advertisers are. This helps to explain why it is increasingly difficult to pitch (much less sell) any idea—whether a film, a novel, or a work of criticism—that does not fit the corporation's preconceived mold.

To support her argument that pornography is about the sex act, whereas horror is about gender, Carol Clover uses *Psycho* as her model: "As victim is to killer, the audience is to Hitchcock, and audiences of horror film in general are to the directors of those films."[25] The viewer, therefore, is placed in the feminine position. After *Psycho*, *Videodrome* is Clover's primary example: "Cinefantastic horror . . . succeeds in incorporating its spectators as 'feminine' and then violating that body—which

recoils, shudders, cries out collectively. . . . Despite the (male) hero's ef-
forts to defend his mental and physical integrity, a deep, vagina-like gash
appears on his lower abdomen. Says the media conspirator as he thrusts
a videocassette into the victim's gaping wound, 'You must open yourself
completely to this.'"[26] Since Laura Mulvey's groundbreaking work on spec-
tatorship, the male gaze has become a critical commonplace, but Clover
suggests the need for further research about *men*'s identification with
women.[27] Cronenberg extends those processes of identification imagina-
tively by depicting *Videodrome* as a precursor of virtual reality. He adds
to the multiple significations of "the nervous system." As Shaviro notes,

> Video technology is no longer concerned merely with disembodied images.
> It reaches directly into the unseen depths, stimulating the ganglia and the
> viscera, caressing and remolding the interior volume of the body. [Max's
> slit] is at once an actual slot for inserting prerecorded videocassettes, a link
> between surface (skin, membrane, retina, image screen) and volume (the
> thickness and multiple convolutions of the entrails), and a vaginal orifice,
> indicating the sexualization and "feminization" of Max's body.[28]

Only through a meltdown of the old Cartesian dualities of mind and body,
inside and outside, reason and emotion can new possibilities of evolu-
tionary metamorphosis emerge. But just as "evolution" does not neces-
sarily connote "Enlightenment progress," the melding of organic with
inorganic does not automatically insure either a happy ending or utopia.
Max appears to kill the evil partners before going into hiding; he then
appears to commit suicide when ordered to do so by Nicki Brand's tel-
evision image, who assures him that he must surrender the old flesh and
embrace the new. Whether the ending of *Videodrome* is positive or neg-
ative is virtually undecidable, for Max "commits suicide" after seeing
his suicide on television, but the spectator cannot be sure whether he has
fulfilled the ambiguous potential of "new flesh," or whether he is merely
caught in yet another cycle of rewind-playback.[29]

Just as the heroine of *Rabid* develops a penis to supplement her vagina,
Max develops a vagina-VCR, and the two female leads develop penises
in one of *Videodrome*'s alternative endings. Bianca, Nicki, and Max are
sexually entwined, all able to penetrate each other polymorphously with
mutated sex organs. This is as close as one ever gets to a "happy ending"
in Cronenberg's films. The scene would have clarified the film's allusions
to "new flesh," but it was ultimately dropped. The film was subsequently
censored first by the MPAA and then by Universal Pictures, which ren-
dered the entire concept of "new flesh" incoherent (CC, 97, 103–4).

No wonder Martin Scorsese compares Cronenberg's films to those of

Luis Buñuel.[30] Cronenberg's surrealism distinguishes him from other Canadian filmmakers, who are best known for documentary realism. "To censor myself, to censor my fantasies, to censor my unconscious . . . it's like telling a surrealist not to dream" (CC, 99). As in *Un Chien andalou* (1929), where a razor cuts across an eyeball, the very multiplication of "vision machines" in *Videodrome* suggests blindness, castration, lack. By literalizing "spectacle," Cronenberg suggests that the eye is a "hysterical, unreliable organ": in Vladimir Nabokov's *Lolita,* those are the words Humbert Humbert uses to describe his heart; Cronenberg, when asked about specific influences on his cinema, says, "I often point to Vladimir Nabokov and William Burroughs" (CC, 152). Like Cronenberg, Nabokov had an avid interest in biology and the natural world; he was a renowned lepidopterist. Cronenberg is indeed among the most literary of contemporary filmmakers (far more so than Martin Scorsese, for example, whose encyclopedic knowledge of film does not extend to books) (CC, 72). Of Nabokov, Cronenberg remarks: "Nabokov himself said that there's nothing so exhilarating as philistine vulgarity—with some irony, but not total sarcasm. . . . He absolutely adored movies, went to see them all the time and talked about them. He understood the energy of movies, the narrative drive of movies and the collision of imagery. It's possible that he loved the movies whose literary equivalents he would have despised" (CC, 52–53). Perhaps none of Cronenberg's films capture "philistine vulgarity" better than *Videodrome.* His allusion to "the collision of imagery," moreover, recalls the technique of the metaphysical poets, which he consciously strives to imitate: "John Donne's definition of metaphysical poetry was poetry in which normally unharmonious elements are violently yoked together. . . . I was a big fan of the metaphysical poets. Take 'The Flea,' a perfect example . . . the concept of fleas sucking the blood of both lovers and therefore mingling it together. Let's say that *The Fly* is metaphysical horror" (CC, 134).

Nowhere is metaphysical horror more apparent than in Jeff Goldblum's transformation from human into insect in *The Fly.* That progression can be seen in Chris Walas's drawings (Fig. 25). Jeff Goldblum's unusual features—bulbous eyes, wide cheekbones—are perfectly suited to the transformation charted here: his face becomes more gnarled, his already-large forehead more prominent, his brow more furrowed. In the drawings, his chin slowly disappears and his eyes come to dominate his entire head. Walas's drawings are biologically precise; he shares Cronenberg's love of anatomy and entomology, yet even in Goldblum's final insect form, one can see traces of a "family resemblance" to his initial

Figure 25 Jeff Goldblum's metamorphosis in *The Fly* (Cronenberg, 1986; distributed by Twentieth Century Fox), drawings by Chris Walas. Copyright Brooksfilms and Chris Walas. In *Cronenberg on Cronenberg,* ed. Chris Rodley (London: Faber and Faber, 1992).

human countenance. Step by step, these drawings for *The Fly*'s special effects embody Ovid's ideal of metamorphosis and Cronenberg's expression of it.

Three years after *Videodrome*'s release, Britain introduced the Video Recordings Bill, which targeted films in a new subgenre, dubbed the "video nasty." Lawmakers were particularly disturbed by the potential damage to children who might have access to objectionable material in the burgeoning home video industry; as a result, in 1985 Britain became the first country to censor and classify videos for viewing in the home (CC, 106). In his State of the Union address in 1996, President Clinton urged passage of a telecommunications bill that would permit parents to install a V-chip to censor material, and the bill passed the following month. Legislators have thus turned out to be more literal than Cronenberg himself, for their underlying assumption is that an image can kill (CC, 108). What *Videodrome* posited as an element of the cinefantastic—exposure

to violent imagery via videocassette automatically leads to violent deeds—is now the dominant phobia, giving rise to a new wave of repressive, omniscient laws.

ABJECT AND UNCANNY: *DEAD RINGERS* (1988)

When I watch t.v. talk shows, all I want to see are
FREAKS! . . . The only reunion show I want to see
is of Siamese twins.
> *Roseanne Barr's farewell to Johnny Carson,*
> *May 20, 1992*

If *The Brood* embodies the intimacy of terror, *Dead Ringers* explores the terror of intimacy.[31] Cronenberg first conceived of the film after reading a tabloid newspaper headline, "Twin docs found dead in posh pad" (CC, 135).[32] The twins are "pod people"; they become distinguished gynecologists in the field of infertility, but psychically they never mature; they remain undistinguished, undifferentiated, amorphous. They are driven by an unconscious compulsion to explore not just the womb, but all that connects womb, home, and the uncanny. The most uncanny thing of all is the idea of being buried alive by mistake, writes Freud: "And yet psychoanalysis has taught us that this terrifying phantasy is only a transformation of another fantasy which originally had nothing terrifying about it at all, but was qualified by a certain lasciviousness—the phantasy, I mean, of intra-uterine existence."[33]

That fantasy of intrauterine existence recurs throughout the film; visually, the set design for the twins' fashionable apartment was done in aquamarine to suggest an intrauterine environment, and the uncanny is never far from mind.[34] From the opening scene in 1954 when they are twelve, the twins speculate obsessively about intrauterine existence. They are fascinated by the idea that fish, which live in water, can reproduce without touching. From this sole original desire springs their choice of career, their sexual partner-swapping, and their invention of the Mantle retractor, which brings them fame and fortune in the field of female infertility. As researchers, they relegate human sexuality and reproduction to the petri dish and the microscope; in their hands, bodies are not born, they are made.[35] As gynecologists, they are voyeurs who get to touch as well as to look, in a controlled clinical environment. They are control freaks.

Few films in recent memory capture the disturbing causes and consequences of psychic fusion in such psychological detail. Cronenberg's aim

was to reveal something about the psychological nature of twins, rather than merely making a good twin–evil twin movie, like the original *Dead Ringer* with Bette Davis, or *The Dark Mirror* (CC, 138). Even *Sisters* seems conventional by comparison, although De Palma concludes with a psychoanalytic portrait of the causes of the evil twin's psychosis: a repressive mother. De Palma focuses on unrequited love, but Cronenberg focuses on unrequited life (CC, 149). Peter Greenaway's *A Zed and Two Noughts,* which premiered two years before *Dead Ringers,* has uncanny similarities: twin zoologists lose their wives in a car crash, and slowly descend into madness, obsessively filming the decaying corpses of zoo animals. Their folie à deux culminates with them filming their own suicide. As Greenaway notes, "The facts, fictions, mythology and apocrypha on twins are limitlessly rich—two of everything, the search for your other half, mistaken identities, mirror-imaging, substitution, the doppelgänger, the lateral line and cloning. . . . Cinema is far too rich and capable a medium to be merely left to the storytellers."[36]

Barrenness links such disparate films as *The Dead Zone* and *Naked Lunch* to *Dead Ringers.* In the latter, the women are infertile, but it is the doctors who are sterile. What interests Cronenberg is that the twins' link is also a lack, a fundamental lack where self should be. That lack results in the uncontrollable multiplication of identificatory processes, which explains why there are not just two but multiple dead ringers in the film: the Mantle twins; the twin prostitutes Elliot hires; the Siamese twins, Chang and Eng. Bev first identifies with Chang and Eng when he dreams of a *Shivers*-like physical growth binding him to Elliot (whom he calls "Elly"); in his dream, he is in bed both with his girlfriend, Claire, and with Elly. In the film's final scenes, the repressed material returns: splayed out and prone in a gynecological operating chair, Elly is unconscious when Bev, in a drug-induced hallucination, vivisects Elly. Does he wish to separate himself, or to join them forever?

Structured by the fears of separation and abandonment, *Dead Ringers* is a remarkable meditation on the horror film as a genre. While Elliot fears abandonment (hence his visit to Claire to thwart Bev's defection), Bev fears separation (hence his *Shivers*-like dream). Once these fears are activated, an obsessive search for replacement fetishes commences: archaic gynecological instruments; the gold-plated Mantle retractor Bev caresses while stoned; and drugs, which they use to "get synchronized." Like husband and wife, Elly is the "outside man," who butters up potential grant donors, makes speeches, and delivers lectures, while Bev is the "inside man," who performs surgeries and research.[37] Viewed this

way, Claire (Geneviève Bujold) is the adulterous third party who divides the happy couple, introducing, as Elly notes, "a confusing and possibly destructive element into the Mantle brothers' saga."

In the classic vampire film, the multiplication of pointy objects and body parts (ears, fingernails, teeth) signifies the phallus and exploits "the problematic of belief . . . it [the phallus] is there, not there."[38] The problematic of belief in *Dead Ringers* is that the twins are two, not one. As in *The Brood,* the nervous system's tyrannical control over the body provides the clue to the twins' dilemma: they are so thoroughly fused that they have no independent will. When Bev shops for Italian furniture, for instance, the designer insists that taste is a matter of the individual nervous system. Bev retorts, "That presupposes that you *have* an independent nervous system." Confronted with Bev's reluctance to confide about or "share" Claire with him, Elliot shouts, "You haven't even fucked Claire Niveau till you tell me about it! You've had no experience till I've had it too," revealing the extent to which the twins prey on each other.

As a vampire movie, *Dead Ringers* makes *Wolf* look as farcical as *Love at First Bite,* for Cronenberg depicts the deep structure of emotional cannibalism. It is Claire who first recognizes that the twins are vampires: "Bev is the sweet one and Elliot's the shit. . . . [Bev] butters the women up, then [pointing to Elliot], Dracula here polishes them off." Bev and Elly have split Dracula's dual nature: by day he is nothing; by night he is powerful and sexually charismatic. His essential impotence and inertia are transformed at night into paranoid aggression, which preserves him from catatonic collapse, decomposition, and dissolution—the fate that eventually befalls the twins as a result of splitting parts of the psyche.

Since *Dead Ringers* filters the horror genre through the prism of gynecology, many feminists criticized Cronenberg for playing "to the sadistic desires of the spectator who might derive pleasure from watching pain inflicted on women's genital organs."[39] But far from arousing pleasure, the film invokes two distinct types of horror, divided along gender lines. *Women's* horror lies in their fear of gynecologists' misogyny, botched diagnoses, monstrous births. Viewed this way, *Dead Ringers* belongs in the tradition of *Rosemary's Baby, The Handmaid's Tale,* and *Coma* (the last of these deals with murdered medical patients whose organs are sold on the black market; Geneviève Bujold stars as a young doctor who becomes suspicious when her girlfriend dies during a routine abortion). *Dead Ringers* resembles other Cronenberg investigations of monstrous births and reproductive technologies (*The Fly, Shivers, The Brood,* and *Scanners*). When Bev disrupts a banquet in his honor, coarsely com-

plaining to the assembled dignitaries, "I slave over the hot snatches and Elliot makes the speeches. I do everything for the bimbos except stick it in them," Cronenberg confirms women's deep-seated suspicions of medical malpractice and misogyny.[40]

Men's horror is no less pervasive, but its sources are different. The litany in Freud is by now familiar: the fear of castration, the fear of envelopment in the all-devouring womb, the reproductive-generative matrix in general and female genitals in particular are well-documented sources of horror for men.[41] Cronenberg confirms the gendered differences in viewers' reactions: "For a lot of women, the opening scene of gynaecological examination is no big deal . . . but, for a lot of men, that very first scene is the worst. They've never been there; they've never seen it; they don't want to think about it" (CC, 147) (Fig. 26).

Cronenberg *forces* men "to think about it" by depicting Bujold in the gynecological examination chair, surrounded by medical equipment, legs spread in stirrups. Indeed, the image's explicit motive seems to be to incite *further* anxiety in men, for laid out on the table next to her are scores of clamps, forceps, and scissors—items that are generally irrelevant to the exam in question (as every *woman* knows). The scene perfectly epitomizes the idea of "the male gaze," for the spectator's position is aligned with the male actor's (Jeremy Irons) in the foreground, although his focus is on her lower body, mysteriously shrouded. Her enigmatic look and averted eyes mark her "to-be-looked-at-ness"; the indignity of her posture marks her vulnerability.

Men do not want to think about gynecology because it violates their idealizations of romantic love—the very mystique *Bad Girls and Sick Boys* is dedicated to dismantling. Indeed, one talk show host on British television was so freaked out by the topic of gynecology that he walked off his own television show while interviewing Cronenberg. He kept repeating, "My God, gynecology, why gynecology?"[42]

Viewed this way, *Dead Ringers* belongs in the tradition of such science fiction horror films as *The Thing, Invasion of the Body Snatchers, Altered States, Innerspace, Demon Seed,* and the *Alien* trilogy. All of these films rework the primal scene in relation to the representations of other forms of copulation and procreation. *Alien,* for example, opens by exploring the interior of the space ship (whose computer life-support system is named Mother). In the opening rebirthing scene, the astronauts wake up from their sleep pods; copulation is unnecessary because the human subject has been born fully developed.[43] Hence the appeal of

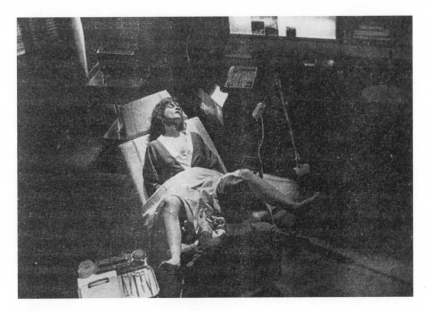

Figure 26 Claire Niveau (Geneviève Bujold) at her gynecological exam, *Dead Ringers* (Cronenberg, 1988; distributed by Twentieth Century Fox). Copyright Mantle Clinic II Ltd., in association with Morgan Creek Productions, Inc. In *Cronenberg on Cronenberg*, ed. Chris Rodley (London: Faber and Faber, 1992).

parthenogenesis in the opening scene of *Dead Ringers,* where the young twins question the necessity of sex.

Dead Ringers explores different forms of knowing: the twins value empirical evidence, scientific objectivity, comprehensive mastery. Cronenberg speculates that those very values also make gynecology an unpleasant topic for men:

> The . . . reason gynaecology weirds men out is that they are jealous. Their wife is known better, not just physically because, yes, you could look up there yourself with a flashlight. The gynaecologist's understanding of what it all does and how it works is greater than yours. . . . It's his knowing stuff that you can never know. I don't want to discuss whether I've looked up my wife with a flashlight or not, but absolutely I wouldn't be afraid if I needed to. Neither would she. But it's something else. It's a very potent metaphor, such a perfect core to discuss all this stuff. (CC, 145)

It seems fair to say that if Annie Sprinkle did not exist, Cronenberg would have invented her, for by inviting strangers to look inside her with a speculum and flashlight, she seeks to explore the same core, the same metaphor. She literalizes that metaphor through burlesque, and Cronenberg does so through horror, but they both capture the nasty curiosity of children playing doctor. Cronenberg juxtaposes medical research's way of knowing with Claire Niveau's intuitive skills; long before she discovers that Bev is a twin, she realizes intuitively that there is some disturbance in his psychic life. Trained as an actress to explore the psyche and respond to the emotions, even her name suggests a higher level of illumination. The same applies to Cronenberg, who notes,

> I was doing these twins from a woman's point of view. They are so horrific, and yet still charismatic and exotic. In a crude sense, it's certainly the least macho movie I've done: there are no guns, no cars. *Scanners* was very masculine by comparison. Even *The Fly* was machinery-dominated. In *Dead Ringers* the machinery is the gynaecological instruments. They're very menacing on screen, but actually rather effete. (CC, 147)

Cronenberg's Eros is an ordeal of fascination. Elliot is fascinated with Claire's external status as movie star, whereas Bev's fascination focuses internally on her "fabulously rare" trifurcated uterus.[44] Even more disturbing than the numerous examples of doubling in the film are the examples of tripling: Claire's three-chambered uterus; Elliot's ménage à trois with twin prostitutes; the ménage he tries to initiate with his girlfriend and Bev; Claire's naive hope that she might be able to carry triplets in her trifurcated uterus. That hope parallels the twins' impossible desire: they each want their own womb, plus one for the Other, woman.[45]

The publicity stills reinforce this idea (Fig. 27). They are seated in a restaurant with a mirror behind them. All three gaze directly at the camera, but only Bujold's eyes seem to reflect the enlightenment her name implies. Seated between the twins, Bujold explicitly "divides" them in this photo. It is unsettling to see the actor Jeremy Irons in duplicate; even more unsettling is Bujold's resemblance to the two images of Irons—as if all three figures in the photo were triplets. What is uncanny is that all three share the same dark hair, the same dark eyes, the same thin mouths. Geneviève Bujold is a "dead ringer" for the "twin" Jeremy Irons.[46]

Curiously, this film about the quest for fertility is bereft of parents. In the opening sequence, the boys are shown symbolically exiting from their parents' home, moving outside into the world; this scene complements the closing shots of them sealed in their apartment.[47] But the archaic, de-

Figure 27 Geneviève Bujold and Jeremy Irons, *Dead Ringers* advertisement. Courtesy CBS/Fox Video and British Film Institute stills archive.

vouring mother haunts all horror films. Like Nola Carveth's malevolent impulses in *The Brood,* the absent mother breaks out at inopportune moments: Claire demands at one point to know why Bev's mother gave him a girl's name. Near the end, celebrating their birthday with cake and soda pop while stoned on heroin, Elly demands to know where the ice cream is. "Mummy forgot to buy some," Bev replies, as Elly weeps bitterly, foreshadowing Bev's keening once Elly is dead. This crying-out theme is a central characteristic of the abject, which functions to purify our defilements and abominations, as Barbara Creed explains in discussing Julia Kristeva's theory of abjection: "The central ideological project of the popular horror film [is] purification of the abject through a 'descent into the foundations of the symbolic construct.'"[48]

As boys, their infantile fantasies of immaculate conception are displaced onto the female anatomy doll they dissect in their room. The fantasy of self-generation complements that of fusion. The desire to wrest sexuality away from maternity and paternity is fulfilled in their clinic; far removed from flesh and blood, even their surreal red surgical gowns may be designed to disguise any spilled blood.[49] These surrealistic red gowns resemble Orlan's idea of commissioning designer surgical costumes

from Gaultier; like Cronenberg, her aim is to turn the medical amphitheater into a stage, highlighting the Artaudian theatricality of the procedures and dramatis personae. Orlan and Cronenberg share the same objective of emptying out psychic investments, idealizations, meaning itself. All there is is the body, and the body itself is merely a costume.

By seizing the modes of reproduction, the twins repress both the maternal threat of engulfment and the paternal threat of castration. They banish the penis as well as the phallus, insisting that they "don't do husbands." But the phallus haunts the periphery, as when Bev dreams that Claire bites through the clawlike growth that joins him to Elly; she extracts a phallus with her teeth. Claire becomes the surrogate monstrous mother. Barbara Creed writes:

> His terror is a response to the abject nature of his nightmare in which he imagines the birth scene, or primal scene, as one overlaid with the terror of castration. Here castration is represented not as a fantasy about the origin of sexual difference, but rather as a fantasy about the origin of subjectivity. Separation and difference are the price one pays for subjectivity. . . . As in *Dead Ringers,* the woman in *The Brood* uses her teeth to divide, to separate. She is the monstrous mother of symbolic castration. It is in relation to her body that the crucial separations of infancy and childhood take place.[50]

In *Videodrome,* Max Renn loses the ability to distinguish inside from outside, self from other; in *Dead Ringers,* the twins suffer from the same fundamental incapacity to differentiate self from other, male from female, vagina from stomach. As Marcie Frank notes,

> The Mantle retractor . . . is their first step in developing the technology to work themselves out of the womb. . . . [Bev's disintegration is marked by] his confusion of the insides of the body with the outside and his displacement of the vagina and uterus onto the abdominal region, foreshadowing Elliot's gruesome death. . . . For the twins, instruments facilitate the substitution of one region of the body for another, one type of body (male) for another (female). . . . The impetus of the film is toward Bev's exposing the inside of his brother's body . . . to expose the difference between it and a female body.[51]

Ironically, Cronenberg confesses that he made the film "primarily out of the female part of myself" (CC, 147). Initially Bev's is the feminine role, painfully shy, withdrawn, passive. When he forsakes Claire to concentrate on drugs, however, the passive-active dichotomy subtly shifts: as in *Jane Eyre* and *The Yellow Wallpaper,* Bev becomes like the "madwoman in the attic," locked in, medically supervised, infantilized—treated, in short, pre-

cisely the way he and Elly used to treat their female patients. Bev embodies the powers of the weak, which Elliot finally realizes he is powerless to resist: "Whatever is in his bloodstream goes directly into mine."

Bob Flanagan's focus on "sadomedicine" from the masochistic perspective of the *patient* comes to mind, for the patient in *Dead Ringers,* Claire Niveau, is also a masochist. When her agent warns that she might be humiliated, she confesses that she likes humiliation. The film's one scene of lovemaking is preceded by Elliot's threat: if Bev doesn't have sex with Claire, Elliot will, and he'll "do terrible things to her." Cut to a darkened room where we hear sounds of labored breathing—childbirth or sex? Claire's arms become visible, tied to the bed with surgical ties in sadomasochistic sex. The viewer does not know which twin she is with, the cruel Elliot or the tender Bev, even when Claire begs, "Please don't tell anybody about me. I'm so vulnerable. I'm slashed open," presaging Elliot's final fate. (Not until later does the viewer discover that the lover in this scene was Bev.)

But Cronenberg's primary focus is on the *doctors'* sadism, which he repeatedly aligns, following Freud, with scopophilia, which is defined as "pleasure in looking," the desire for mastery through the look.[52] Since the Mantles invented the instrument that facilitates mastery in looking, their investment in their authority is correspondingly greater. As Bev's drug-induced deterioration progresses, his "bedside manner" becomes more grandiose and aggressive. He accuses one patient of having sex with a dog, and tries to substitute a gold retractor for a speculum. "We have the technology," he cries petulantly, "it's the woman's body that's all wrong!"

Abjection creates "a hole in the psyche"; it signals "a failure to recognize its kin" (PH, 5)—an idea Cronenberg literalizes by making the "kin" twins.[53] At the end, they wander in tandem from room to room like Tweedledum and Tweedledee, chanting nursery rhymes. If technology initially enables the twins to work themselves out of the womb, their apartment—covered with filth, rotting food, vomit, excrement, and blood—shows at the end that they have worked their way back *in.*[54] The process is conceptualized spatially: the film begins with the twins' departure from their mother's house into the great world, but by the end they have become enveloped by the uncanny element engulfing them, the emblem of the oceanic totality of the mother's body. They regress to the state of utter undifferentiation, "where meaning collapses, the place where 'I' am not" (PH, 54–55). The twins' tragic flaw is misrecognition not just in seeing, but in *knowing,* re-cognition. The Mantles' identity is dismantled through *méconnaissance* and miscarriage, words that reverberate throughout the film. These (con)fusions drive the twins to their

fate, which unfolds as inexorably as Greek tragedy. When Bev "oper-
ates" on Elly to sever their bond, their birthday becomes their deathday.
Searing questions haunt the film's ending: does the final act separate the
twins for good, or unite them forever? These enigmas illuminate the film's
somberness, its inexorable movement toward the final tableau, the pietà
of brothers dead in each other's arms.

Ironically, Cronenberg puts himself in the position of the gynecologists;
he relates to their drive for perfection and mastery. (In *The Fly*, he liter-
ally put himself in their place: he played the role of the gynecologist and
directed Geena Davis's birthing scene from between her legs.) He confesses
that he too is a "control freak" in the cinematic lab: "I am being this cli-
nician, this surgeon, and trying to examine the nature of sexuality. I'm do-
ing it by creating characters I then dissect with my cinematic scalpels. . . .
I'm driven to look at [sexuality] . . . because it keeps provoking me. . . .
It's part of my nervous system up there" (CC, 151). These revealing words
recall Kracauer's description of cinema's aim: to transform "the agitated
witness into conscious observer . . . [to keep] us from shutting our eyes to
the 'blind drive of things.'" To extend Cronenberg's own analogy, the cam-
era is to the speculum as the director is to the gynecologist. He compul-
sively confronts the enigmas of sexuality and incites analysis of what pro-
vokes him. Cronenberg too "has the technology": computer programming
makes the camera far more fluid than it used to be; now the camera can
pan and dolly the same way twice and the screen can be spliced more pre-
cisely. After the "A" and "B" sides of a scene are shot, they are subtly
composited using a soft-edge matte so that the splicing point is virtually
invisible.[55] The sets had to be very solid, to allow computerized motion-
control camera work in the twinning shots. They were built on high plat-
forms, to allow the special-effects team to operate from below (CC, 143).
The daunting task of differentiating Elliot from Bev, and Jeremy Irons from
Jeremy Irons confronts the spectator, as Marcie Frank notes:

> Although this is psychically possible, it is physically impossible; and in be-
> ing forced to acknowledge this contradiction, we are forced to adopt a tech-
> nical perspective to which we subordinate our experience of viewing the
> film. With the twins played by Jeremy Irons, a recognizable star, instead
> of by unknowns—who might actually be, or whom we might believe to
> be, twins—Cronenberg uses technology not to produce verisimilar effects
> but to extend the concerns of the film to the medium itself.[56]

Special effects, including Cronenberg's own technical innovations, now
enable spectators to "look inside" the body in ways that were never pos-
sible before. Cronenberg enables us to stare "at the world as though it

were a naked body"[57]—viewed from the insides. Drawing on the ways technology has reorganized the human senses, he defines a new aesthetic: "We've not designed an aesthetic for the inside of the body any more than we have developed an aesthetic of disease. Most people are disgusted—like when they watch an insect transform itself. But if you develop an aesthetic for it, it ceases to be ugly."[58]

No one knows better than Cronenberg the staying power of visual conventions and mythologies, signified in the opening credits of *Dead Ringers* by the anatomical woodcuts and drawings by Jacob Rueff, Andreas Vesalius, and Ambrose Paré depicting Siamese twins, freaks, monstrous births, open wombs and wounds. These works visually signify the history of art as well as of medicine, from Galen's concept of anatomy as an "opening up in order to see deep or hidden parts." Cronenberg is acutely self-conscious about the parallels he draws between medicine and cinema: one of his own production companies was called the Mantle Clinic II, Ltd. (CC, 184). Like medicine, cinema, "the medium itself," is a highly specialized analytic activity. Medicine and cinema both isolate objects from their contexts in time and space ("We don't do husbands!"). Where pornography isolates a single human activity—sex—horror isolates death. "The basis of horror," Cronenberg reflects, "is that we cannot comprehend how we can die." Thus the true significance of the title emerges only retrospectively, for the point is not that the twins are *identical* but that they are *dead*.[59]

The concepts of being and nothingness, as well as the meaning of transgression and taboo, are abiding preoccupations for philosophers from de Sade to Kristeva. Cronenberg approaches pornography, horror, and abjection as subjects of philosophical inquiry, filtered through the prisms of science, medicine, and technology. His films are anatomies of technology's impact on the posthuman psyche, with particular emphasis on behavioral and genetic experiments, the saturation of reality by simulacra, subversions of sex and gender. He seizes the body as material and metaphor, combining the visual and tactile, pleasure and power, anxiety and ambivalence. He accentuates the snares of the visual order by turning the cinematic apparatus against itself, subverting the camera's objectivity with a visceral surrealism. Cinema is a laboratory for the aesthetic Cronenberg is helping to dissect and create. Martin Scorsese sums him up this way: "David Cronenberg is definitely twentieth century— late twentieth century! He's like something we have no control over: the imminent destruction of ourselves."[60]

Arresting Fiction

6

J. G. Ballard's Atrocity Exhibitions

Were David Cronenberg and J. G. Ballard separated at birth? Like the twins in *Dead Ringers,* both began their careers as medical students; both are fascinated with anatomy, biology, sexuality, and postmodern postmortems. Their symbiosis is not just temperamental but professional, for Cronenberg recently adapted Ballard's novel *Crash* to the screen. If Cronenberg is "like something we have no control over: the imminent destruction of ourselves," Ballard believes "we must immerse ourselves in our most destructive element—ourselves."

August 11, 1994, Waterloo Station, London: A bomb scare unhinges me as I board the train to Shepperton, the perfect paranoid beginning for my pilgrimage to interview J. G. Ballard, postmodern master of menace and dread. The passing scenery of industrial London's detritus reminds me of everything he has ever written, from *The Drowned World* to *War Fever.* His modest home lies near the Shepperton film studios, where Steven Spielberg filmed Ballard's memoir, *Empire of the Sun,* three years after Ballard wrote it, an eerie twist of fate that led Ballard to remark, "Deep assignments run through all our lives. There are no coincidences."[1]

While politicians and pundits debate whether media images of sex and violence are harmful, no one addresses the real questions: Why do sex and violence have such an abiding and pervasive *appeal?* What function do they serve? For forty years Ballard has been mapping the coordinates of sex and violence in the most unlikely places: in the fusion of pornog-

raphy and science, memory and history. Instead of vainly trying to suppress the dark side of the human heart, Ballard suggests that like Kurtz, we explore "the horror" of our anarchic impulses: "I think we're all perhaps innately perverse, capable of enormous cruelty and paradoxically (this is difficult to put into words), our talent for the perverse, the violent, and the obscene, may be a good thing. We may have to go through this phase to reach something on the other side, *it's a mistake to hold back and refuse to accept one's nature.* . . . One has to, as Conrad said, immerse oneself in the most destructive element, and swim."[2] Ballard follows Dostoyevsky, Nietzsche, and Freud in mapping this dark continent, specifically invoking *Notes from Underground*'s attack on the Enlightenment ideals of rationality and utilitarian productivity. Just as Ballard (quoting pioneer British neurologist Charles Sherrington) defined "the individual" as "a four-dimensional object of greatly elongated form" (AE, 12M), Dostoyevsky defined man as "the ungrateful biped," as much in love with destruction as with creation. To defy family, church, school, and the state, to prove that he is not an automaton, man will defiantly act out of sheer caprice and self-destructiveness.

Ballard views time geologically, space galactically, humans in evolutionary terms as a species. It is not a perspective that panders to popular taste; it is too disorienting for commercial consumption, too clinical for college literature courses. Yet Ballard should be required reading, first because so many of his predictions about the shape of the future have already come true. Ballard has a protean ability to turn science (relativity, chaos theory, set theory, quantum mechanics) into fiction. This is not merely a matter of inventing new metaphors, although that is no mean feat. Rather, he reconceptualizes the reading process itself, forging connections between information theory, transformational grammars, and cognitive processing. His work is an archive of fantasy's shadow realm, a realm that has been transformed by architecture, fashion, advertisements, freeways, and space travel. As archivist, he provides a glossary of the psychopathology of daily life.

I am greeted by a genial, robust, sixtyish man. He shows me into a small living room, dominated by a bright orange couch, a unicycle, and books (including galleys of one on Buñuel). Each item seems portentous as a rune in a setting straight out of Surrealism, the art form that combs the convulsiveness of eroticism in the labyrinths of the unconscious. An enormous painting of bare-breasted women by Paul Delvaux, the Belgian Surrealist, dominates one wall: one woman lies splayed naked in a pool; another has her back to the viewer. Anyone who wants to under-

stand Ballard has only to look at the painting, as enigmatic as "the codes of insoluble dreams" (AE, 9). The painting is a copy made from a post-card; the original was destroyed in World War II.

For the next three hours, we discuss everything from assassinations to Zone Books' publication of "Project for a Glossary of the Twentieth Century"—the media, Kennedy, Reagan, and Clinton, Thatcher, the royal family, youth, feminism, relationships between men and women, painters. We discover a shared admiration for Richard Longo (who once sent Ballard one of his books); Longo's numerous photographs of .22-caliber pistols resemble Ballard's own obsession with the iconicity of violence: "Sirhan Sirhan shot Robert F. Kennedy. And Ethel M. Kennedy shot Judith Birnbaum. And Judith Birnbaum shot Elizabeth Bochnak. . . . And James Earl Ray shot Martin Luther King. . . . And Coretta King shot Jacqueline Fisher. . . . And Lee Harvey Oswald shot John F. Kennedy. And Jacqueline Kennedy shot Mark S. Goodman" (AE, 101–3). I have com-pressed his massive list, but by mixing the names of the famous and in-famous, the obscure and the invented, Ballard drives home the sense-lessness of violence, the repetition compulsion of the death instinct.

We discuss Edward Kienholz, whose work Ballard pulls out at one point: "Have you seen *The Beanery*—it's fantastic!" We discuss *The War Memorial, The State Hospital, The* [Abortion] *Operation,* and *Back Seat Dodge '38*. I flash on the scene in *Crash* where the narrator, named James Ballard, drives while his wife and friend have sex in the back seat: Kien-holz's *Dodge* translates *Crash*'s voyeurism, the sordid but mesmerizing fusion of sex and technology, into three dimensions. I tell Ballard about Bob Flanagan's *Visiting Hours,* a site-specific installation which trans-forms the museum into a hospital ward, with Bob as the resident patient, and how it reminds me of walk-in Kienholzes. We both admire George Segal, too. It strikes me that all three of these artists share Ballard's own abiding obsession with the failure of communication, with human lone-liness on a planetary scale. Their works are raw, edgy, spectral as fossils. When I mention Mark Rothko's description of Segal's work as "walk-in Hoppers," Ballard remarks, "Those volcanic ash figures, straight out of a modern Pompeii. I fit in a reference to him in *The Atrocity Exhibi-tion,* along with the Surrealists."[3]

Having just visited Freud's house in Hampstead the day before, where a plaster cast of *Gradiva* hangs in Freud's study, I recall how Pompeii captured Freud's imagination, as well, and tell Ballard how eerie it was to hear a recording of Freud's *voice*—something one seldom thinks about, given the dominance of his image and letters. Ballard shares Freud's in-

tense preoccupation with the buried life, repression, aggression, and cat-aclysms of the unconscious. Ballard's interest in psychoanalysis dates back to his undergraduate days at Cambridge, where the dons responded to Freud with "gales of laughter. In 1949, Sigmund Freud was still regarded as hilarious" (JGB, 109).

LK: Have you ever been in analysis?

JGB: No. It's very uncommon here. You need to be very ill. But I did appear in a film answering a questionnaire designed to expose psychopaths: "Do you love your mother? Are you ever cruel to animals?" They sat me down in front of a camera, and I answered randomly. Of course, any true psychopath would see through the leading questions instantly.[4]

LK: What do you think about R. D. Laing? Your fiction reminds me of Laing's *Sanity, Madness and the Family.* [In one story, a family uses con-tinuous video projection to shield each member's fears and hostilities; *High Rise* features a character named Dr. Laing.]

JGB: I was always very suspicious of Laing. His views on the sources of schiz-ophrenia were so wrong-headed, at odds with modern research, which has now shown that it's a matter of chemistry in the brain running amok.

Ballard's own definition of schizophrenia in "Project for a Glossary of the Twentieth Century" comes to mind: "To the sane, always the most glamorous of mental diseases, since it seems to represent the insane's idea of the normal."[5] I feel like Alice interviewing the Cheshire cat.

LK: Laing has a novelist's vision of illness—which of course some people felt about *Freud,* too!

JGB: Exactly! Thomas Szasz called Freud an *ideologist.* There's a lot of truth in that. It makes a lot more sense to view him as a novelist.

THE NERVOUS SYSTEM

Ironic reversal: Freud, the analyst who writes like a novelist, versus Bal-lard, whose novels read like psychiatric case studies. Personality disor-der profiles, psychological inventories, sexology statistics, clinical diag-noses of psychoses pervade his fiction, but the uncanny thing is how much they *fail* to explain. One of Ballard's abiding themes is the incommen-surable gap between language and experience.

That failure accounts for the obsessive-compulsive quality of *The Atrocity Exhibition,* a collage-novel unlike any other. Composed between 1967 and 1969, the novel features fragmented settings, states, and "sit-uations"—auto crashes, mental breakdowns, laboratory experiments,

mental wards. It assembles psychic symptoms and consists of "episodes" rather than chapters. Like Dostoyevsky's underground narrator, the main character is not a hero but an antihero, unmoored by the catastrophes he has witnessed. So fractured is his identity that his name changes from episode to episode: Talbott, Travis, Travers, Traven.[6]

JGB: *The Atrocity Exhibition* is about a psychiatrist having a nervous break-
 down. Every single chapter is a psychodrama, as Dr. Nathan, the com-
 mentator, points out. Traven wants to kill JFK again—but *in a way that
 makes sense.* What he's doing in each "episode" is setting up a psycho-
 drama, which he devises like an impresario, using emblematic objects
 like motorcades. He then assembles these as the mise-en-scène of his psy-
 chodrama, and then he stages a drama, a conclusion, an Act Five that
 will release all this repressed material. All are part of an attempt to deal
 with the essential mystery of deep space, and what it means to the central
 nervous system. Each episode tackles a major element of a huge spiritual
 and psychological crisis. What's significant is its total fragmentation.

Is Ballard's allusion to "the central nervous system" literal or metaphor-
ical? The answer is *both:* from the forebrain to the midbrain and stem,
which controls olfactory, memory, and autonomic nervous system func-
tions, down through the spinal column with its branches, synapses, and
ganglia, the nervous system connotes *control, hierarchy,* and *intelli-
gence*—three words that reverberate politically as well as physically. No
wonder society's invisible systems of surveillance make us *nervous.*[7] Bal-
lard shows how synapses and neurons are affected by these invisible net-
works of power, a technique Cronenberg duplicates, as we have seen.

Through the technique of collage, Ballard puts into prose the para-
digmatic postmodern experience of fragmentation. Computers and hy-
pertext have made this technique commonplace today, but Ballard's sty-
listic innovations were way ahead of their time. As in collage, Ballard
pastes layers of narrative, but refuses to resolve them in a single, unified
text. Instead, he deconstructs them. The 1990 edition of *The Atrocity
Exhibition* adds another layer, for Ballard provides a glossary, com-
menting in the margins on the text he wrote twenty years earlier. As
William Burroughs laconically observes in the preface, Ballard's charac-
teristic technique is "magnification of image to the point where it be-
comes unrecognizable. . . . This is what Bob Rauschenberg is doing in
art—literally *blowing up* the image. Since people are made of image, this
is literally an explosive book" (AE, 7).

Burroughs and Ballard are both iconoclasts—sometimes in a comic key,
as Burroughs is in the preface, sometimes blending the tragic and the comic.

Travers's recurrent obsessions only make sense when contextualized historically, for the twentieth century itself is "the atrocity exhibition," a spectacle of barbarism from the assassinations of the Archduke Francis Ferdinand to John Fitzgerald Kennedy. Interned in a Japanese camp following the siege of Shanghai in World War II, Ballard was irrevocably shaped by the apocalyptic images of death and destruction that he witnessed, culminating in the atomic bomb explosion in Nagasaki on August 9, 1945: it was "a furnace heated by a second sun . . . the soundless light . . . seemed to dress the dead and the living in their shrouds."[8]

The Atrocity Exhibition signifies the twentieth century: trench warfare, nerve gas, genocide, Hitler, Hiroshima, and Vietnam, all burned into the mind's eye in a series of images: aerial photographs of Auschwitz; the Zapruder film of Kennedy's assassination; a napalmed Vietnamese girl running naked down a road, screaming after the air strike in 1972 near Trang Bang, South Vietnam. Ballard's collage-novel reassembles the searing images imprinted on the inchoate collective psyche. The novel's title refers literally to an exhibition of paintings by inmates of an asylum. The book opens: "A disquieting feature of this annual exhibition was preoccupation with the theme of world cataclysm, as if these long incarcerated patients had sensed some seismic upheaval in the minds of the nurses and doctors" (AE, 9). Ballard comments: "*The Atrocity Exhibition*'s original dedication should have been 'To the Insane.' I owe them everything" (AE, 9M). Ballard's lunatics see the sick souls of their caretakers. They are more in tune with the reality of inner space than the outer world is, which merrily goes about its business of destruction: H-bomb tests in Nevada; stockpiles of nuclear arsenals; proliferating toxic wastes; nuclear tests in the South Pacific.

Advocates of censorship insist that images of sex and violence (on television, computer networks, in music, and so on) have a direct impact in real life. Conversely, opponents insist on distinguishing representation from reality. But Ballard offers a third viewpoint, more complex than either of these two: fantasy has overwhelmed reality (the theme of *Videodrome*). For forty years, Ballard has been demonstrating that reality consists solely of competing and contradictory "windows" or narratives—another idea rendered less alien today by the advent of hypertext. His aim is to isolate the levels that coalesce to create images, in order to magnify the fragments, as he explained in 1968: "Fictional elements in experience are multiplying to such a point that it's now almost impossible to distinguish between the real and the false . . . one has many layers, many levels of experience going on at the same time. On one level, the

world of public events, Cape Kennedy and Viet Nam mimetized on bill-boards. On another level, the immediate personal environment. . . . On a third level, the inner world of the psyche. Where these planes intersect, images are born" (JGB, 159).

I used the word *metaphorology* to describe the new metaphors Ballard invents. When print was the dominant medium, James Joyce, writing in Homer's wake, may have suffered from "the anxiety of influence," but Ballard argues that today, the novelist's biggest competitors are the media and advertising. The problem is not tradition versus individual talent; the problem is that the playing field is now crowded with commercial competitors. Everybody is in the fiction-making business. Ballard's collage-novels juxtapose narrative layers, but it is up to the reader to assemble and decipher them, something one does automatically when watching television, channel-surfing from one discontinuous story to the next, absorbing multiple layers of narrative simultaneously. *The Atrocity Exhibition* translates that visual process to the medium of print. Hence the relevance of Lacan's Mirror Stage in Ballard's oeuvre: the psychiatrist's nervous breakdown is caused by the schisms between image and reality, a gap the "unfulfillable consumer" (JGB, 96) strives valiantly to erase. Given the lack of coherence in the modern world, paranoia and schizophrenia seem to be the only "sane" responses. Television, politics, the press, and advertising have utterly reorganized fantasy; Ballard's characters are recording the results of that reorientation, as he explains: "The characters in [my] stories occupy positions on these various levels: On the one hand, a character is displayed on an enormous billboard as a figment in some vast CinemaScope epic. On another level, he's an ordinary human being. . . . On a third level, he is a figment of his own fantasy . . . today, when the fictional elements have overwhelmed reality, one has to distinguish between the manifest content of reality and its latent content" (JGB, 159). Only the latent level explains what is really happening in contemporary culture.

Travers is not a "character" so much as a cluster of psychological symptoms: narcissism, loss of emotion, obsessive-compulsive disorders, paranoia, schizophrenia. His precursor is Robert Musil's *Man without Qualities;* his heirs are David Cronenberg's zoned out, feckless antiheroes. Travers's fixations are all reported in the pseudoclinical style of a psychiatric case study. That style is officially endorsed by legal, medical, and forensic experts. So pervasive is this clinical language that it has come to seem "natural." Despite the grim events it recounts, *The Atrocity Exhibition* is often hilarious, because Ballard exposes the culture of experts.

Hence the crisis of legitimation that so famously defines our time: the "experts" are mere storytellers. That does not mean they are harmless, for they can deploy the full arsenal of intelligence to back up their versions of reality, as Ronald Reagan's success in mobilizing the Defense Department and the nation to endorse his Strategic Defense Initiative (nicknamed Star Wars) demonstrated.

Ballard and I discuss the contradictory messages that the Holocaust Museum in Washington, D.C., disseminates. Its aim is to bear witness so history does not repeat itself, but it forces one to ask whether history does anything *but* repeat itself. The museum itself is an atrocity exhibition.

JGB: Perhaps today the museum is a lay cathedral. It's as close as one gets to worship today, to a holy sanctum. When I come to Washington, I must look at the Holocaust Museum. The danger is that it will veer into a Madame Tussaud chamber of horrors. Still, people have got to be reminded. I shouldn't use the word, but it sounds like it's hovering on the margins of Disneyland. The entertainment culture is outside of time. For most people, the past has become uncoupled from the present. It's proceeding along a track at apparently the same pace as the present, but a gap is opening up. When college students come round to see me, I'm often struck by how little they know of what *I* think of as quite recent events, like the Vietnam War. Their knowledge comes from films.

While psychologists and policy wonks debate whether exposure to television images of sex and violence induces antisocial behavior, Ballard posits a paradox: the appeal of sex and death on-screen is directly related to the fact that in reality they have become wholly conceptual. That is the disadvantage Nicole Simpson and Ronald Goldman share, as former district attorney Ira Reiner explained on the *NBC Evening News* on July 8, 1994, in exquisitely Ballardian forensic rhetoric: "The decedent is always an abstraction, while the defendant remains vividly real." Death today is wholly conceptual. Among the general population, it used to be customary for people to die at home, which gave death a concrete reality; today, terminal patients hooked to hospital machines make the meaning and even the *moment* of death ever more difficult to define. That is why an "ordeal artist" like Bob Flanagan stages his struggle with cystic fibrosis: on the one hand, he demonstrates how conceptual death has become, mediated by medical technology. On the other hand, he confronts spectators with a "terminal case"—*theirs* as well as his own.

As Cronenberg points out, "Life and death and sexuality are interlinked . . . separate sexuality from the function of childbearing and then

what is it? What could it become? What should it become?" (CC, 65). Sex's function shifted from procreation to recreation with the invention of the birth control pill, which Ballard describes as "Nature's one step back in order to take two steps forward, presumably into the more potent evolutionary possibilities of wholly conceptualized sex" ("Project," 271). Wrested from biology and gender alike through reproductive technologies and sex reassignment surgery, sex has become even more "conceptual" since Ballard wrote those words. Pat Norman, heralding New York City's massive mobilization for the twenty-fifth anniversary of Stonewall in June 1994, celebrates "a city full of lesbian and gay and bisexual and transgendered people."[9] Books like *The Last Sex: Feminism and Outlaw Bodies* repudiate "the cult of gender . . . and . . . binary genetic codes" and extol the virtues of "recombinant sex in the age of transgenders."[10] This is what Ballard means by a whole new order of sexual fantasies: "Organic sex," he predicted in 1970, is becoming impossible because "if anything is to have any meaning for us it must take place in terms of the values and experiences of the media landscape, the violent landscape" (JGB, 157). Today, more than twenty-five years later, that observation comes closer to accounting for the appeal of sex and violence than all the pious moralizing and grim foreboding that issues from politicians or censors of cyberspace.

JGB: Have you ever heard of an experimental novelist named Ann Quin? She was associated with *Ambit,* the magazine I edited for some years. I organized a competition for the best short story written under the influence of drugs, which created a scandal in Britain; I was threatened with prosecution for "creating a public mischief"—quite a serious criminal offense in this country. Ann Quin won, for a story about being under the influence of the birth control pill.

We both laugh.

With the invention of VCRs, videocams, computers, and virtual reality, many of Ballard's other prophecies have come true. One has only to open *Mondo 2000,* the computer hacker's guide to cyberpunk, wetware, designer aphrodisiacs, and technoerotic paganism to see this. *Mondo 2000* features Queen Mu as the Domineditrix, ads for Desktop Mistresses, and beefcake porn. Not all of it is sexist: lesbian feminist Susie Bright's *Virtual Sex World Reader* is another guide to the sensuous world of sexual simulation, made possible by virtual reality. The Internet has sex advice columns like *alt.sex.bondage,* which answers E-mail questions about fisting, anal sex, leather, latex, and play parties. Long before the invention of virtual reality, Ballard predicted: "For the first time it will

become truly possible to explore extensively and in depth the psychopathology of one's own life without any fear of moral condemnation . . . limitless simulations can be played out . . . [enabling] one to explore, in a wholly benign and harmless way, every type of impulse—impulses so deviant that they might have seemed, say to our parents, to be completely corrupt and degenerate" (JGB, 159).

No wonder Ballard has a cult following among technoculture freaks and heavy metal aficionados; these are the same groups (Sonic Youth, Nine Inch Nails, and Danzig) that feature Bob Flanagan and Sheree Rose exploring sadomasochistic impulses that would make their parents shudder. When *Heavy Metal* interviewed Ballard in 1982, he noted:

> A lot of my prophecies about the alienated society are going to come true. . . . Everybody's going to be starring in their own porno films as extensions of the polaroid camera. Electronic aids, particularly domestic computers, will help the inner migration, the opting out of reality. Reality is no longer going to be the stuff out there, but the stuff inside your head. It's going to be commercial and nasty at the same time, like "Rite of Spring" in Disney's *Fantasia* . . . our internal devils may destroy and renew us through the technological overload we've invoked. (JGB, 155)

Destroy *and* renew: neither a prophet of doom nor a naive extoller of technology's virtues, Ballard has never been a typical sci-fi writer. Science fiction was born of mid-twentieth-century optimism; it reflected an interest in technology, the future, and outer space, which quickly bored him. Modern science fiction was the first casualty of the world it helped to create. To Ballard, *2001: A Space Odyssey* "signified the end of the heroic period of modern science fiction—its lovingly imagined panoramas and costumes, its huge set pieces, reminded me of *Gone with the Wind*, a scientific pageant that became a kind of historical romance in reverse, a sealed world into which the hard light of contemporary reality was never allowed to penetrate" (JGB, 97).

In contrast to Kubrick's hermetically sealed world, in Ballard's, history is never far from mind. The past, for instance, was a casualty of Hiroshima and the nuclear age, which by definition forced us to think prospectively: "So in turn the future is ceasing to exist, devoured by the all-voracious present. We have annexed the future into our own present, as merely one of those manifold alternatives open to us. . . . We live in an almost infantile world where any demand, any possibility, whether for lifestyles, travel, sexual roles and identities, can be satisfied instantly" (JGB, 97). To Ballard, the cyberpunk movement is already over, because its imagery now pervades mainstream culture, in advertising, television,

and fashion.[11] It is not easy to portray the banality of everyday life while simultaneously documenting the minute process by which its materiality is bleached out, reduced to the level of abstraction, as in a *Details* fashion layout. (See Fig. 33 later in this chapter.)

Ballard's views of the interrelationships between past, present, and future reveal how limited our definitions of fiction, genre, and literature itself are, for to classify him merely as a "science fiction" novelist is like saying Einstein was good at arithmetic. As early as 1962, he realized that outer space was passé; the really interesting journeys of the future would involve inner space:

> I'd like to see [time] used . . . [for] the elaboration of concepts such as the time zone, deep time and archaeopsychic time. I'd like to see more psycholiterary ideas, more metabiological and metachemical concepts, private time systems, synthetic psychologies and space times, more of the remote, somber half worlds one glimpses in the paintings of schizophrenics, all in all a complete speculative poetry and fantasy of science. (JGB, 155)

His exhortation, moreover, cuts both ways: if scientists should speculate more about the poetry and fantasy of science, more humanists should immerse themselves in the hard sciences to grasp how these disciplines have transformed artistic practices, whether one thinks of the impact of chaos theory on literature, or Cronenberg's metaphoric use of immune systems, or the new incorporations of organisms and machines.[12]

Ballard is an iconoclast and absurdist. Influenced by the Surrealists, who used the unconscious to wage war on society and art, he strives to codify the inner experience of the senses, to anatomize the mythologies of the psyche. He invariably underscores precisely those aspects that humanity (and the humanities) should investigate, but instead disavows: cruelty, blood lust, barbarism. What novelist could have invented the Kennedy saga (including Chappaquiddick's drowned girl in a car)? What happens when the psyche is confronted with events the mind cannot compass, like John F. Kennedy's assassination? The very compulsion to repeat signals the failure of language and imagination, which consequently remains fixed in retrospective fascination on the frozen moment captured in the Zapruder film of the motorcade at Dealey Plaza.

LK: The inevitable question: how did you learn of Kennedy's assassination?

JGB: My wife—who was to die one year later—telephoned me from her mother's home. I don't want to sound sick, but the assassination was an enormously energizing event. It sent ripples out. It changed our perception of the world. In a sense the media pulled the trigger, because

but for JFK's elevation to media star, Oswald wouldn't have wanted to kill him. This is the curious thing. He was a twentieth-century *deity*, bigger than any film star. Neither Eisenhower, Roosevelt, nor Churchill were mythic figures in the sense Kennedy was—what gave him his special magic was that he was the first leader created by the media. He was the first to straddle the two worlds between the pre-electronic media and the new media. He was on the cusp. He's the creature emerging out of the sea and crawling up on the beach. That will never happen again. It was extraordinary to see him cut down.

LK: That's what DeLillo seizes upon in *Libra*—Oswald's psychic fusion with Kennedy—how they both had brothers named Robert; their wives were both pregnant at the same time, etc.

Mark Chapman's obsession with John Lennon and John Hinckley's with Jodie Foster have made the phenomenon more familiar now, but few besides Ballard and DeLillo thought to apply it to Oswald. In fact, one of Ballard's marginal comments about Oswald could easily appear on a book jacket blurb for *Libra:* "Oswald's Historic Diary, which he began on October 16, 1959, the day of his arrival in Moscow, is a remarkable document which shows this inarticulate and barely literate man struggling to make sense of the largest issues of his day" (AE, 31M).

Ballard mentions casually that Don DeLillo sent *Libra* to him, although he has yet to read it. This is a confession I find incredible, because while the American academy is lionizing DeLillo,[13] no one has acknowledged his enormous debt to Ballard—unlike DeLillo himself. A partial catalogue of their shared obsessions includes JFK, Jackie, Marilyn, Oswald, apocalypse, celebrity, chaos theory, the aura, Warhol. Among the many parallels are the schizophrenics' paintings that fuse "Freud and Elizabeth Taylor in their Warhol-like effects" and resurface in *Mao 11* when DeLillo describes a woman photographer contemplating Warhol's portrait of Mao: "Possibly in this one picture she could detect a maximum statement about the dissolvability of the artist and the exaltation of the public figure, about how it is possible to fuse images, Mikhail Gorbachev's and Marilyn Monroe's, to steal auras, Gold Marilyns and Dead-White Andys."[14]

Just as Ballard describes the Warren Commission Report as "the novelization of the Zapruder film" ("Project," 271), DeLillo describes it as the novel James Joyce might have written if he had moved to Iowa City and lived to be a hundred.[15] Julian Schnabel could have been speaking of Ballard when he remarked that Warhol's violent images "presented the horror of our time with the thoroughness of Goya in his time. That horror is random, arbitrary, cosmically meaningless."[16] Depth is ban-

ished; surface is all. *The Atrocity Exhibition*'s obsessions with guns, car crashes, the A-bomb, mass production, repetition, and seriality prompt me to ask Ballard what he thinks of Warhol.

JGB: I was very impressed by what Warhol had done. I still am. He commented so brilliantly on the mass media. His art is dedicated to it. His painting makes no sense if you can't visualize the mass media. But it's quite possible that in the future the mass media as we know it will no longer exist; then his work will be meaningless.

I ponder this, thinking of the competition among Viacom, Paramount, AT&T, and other telecommunications giants to alter radically the media landscape. The merger of Walt Disney Company with ABC for $19 billion has blurred the already dissolving boundaries between entertainment and news. It will become increasingly difficult even to imagine what it might mean to think against the grain—as if it isn't already! I recall Baudrillard's definition of the masses as our model of social simulation: "The social annihilates itself in its own magnifying mirror, making the masses the purest product of the social, and its most perverse effect."[17] From Walter Benjamin's celebration of the mass-cultural art form of film to Warhol's painting of mass-produced Campbell's Soup cans, art has become a copy of a copy for which there is no unique original, no aura. Yet soon, Ballard predicts, Warhol's Campbell's Soup can will look as quaint as *American Gothic*. No tradition, no ritual in Benjamin; no history, no memory in Warhol—and soon, no context in which Warhol will have meaning. It will be impossible to reconstruct the chain of significations linking reality-referent-signifier-copy.

We talk about the price of fame. Ballard is fascinated by the fact that American writers, such as Pynchon, Salinger, Hemingway, are so often completely "derailed" by success.

JGB *(tone of incredulity):* Kurt Vonnegut and Philip Roth spent years writing about being a famous writer. It's definitely damaged them, whereas here, it makes absolutely no difference! *Empire of the Sun* was a colossal success, but the impact on my daily life was nil. It doesn't mean anything here.

LK: American authors become gurulike authorities on every topic imaginable. Joan Didion tells of taking her ten-year-old daughter, Quintana, along on the promotion for *The White Album*. By the end of the tour, even Quintana had developed sound bites on the inevitable question, "Where is America going?"

JGB *(laughing):* I remember how impressed I was on my book tour with the scale of America—the malls in particular.

Despite the repressive mechanisms society has perfected to censor the unconscious, it nevertheless erupts insistently, with all its contradictions. The jury is still out on the impact of new technologies on the human psyche, but Ballard clearly sees alienation, guilt, and estrangement as hallmarks not of the twentieth-century novel, but of the *nineteenth*—a reaction against the massive restraints of bourgeois Victorianism. For better and worse, optimism, naïveté, and guilt-free enjoyment of all the mind's possibilities are twentieth-century inventions (JGB, 96). New perversions have supplanted those of a bygone (Freudian) age, as Ballard observed in 1970:

> A whole new kind of psychopathology, the book of a new Krafft-Ebing is being written by such things as car crashes, televised violence, the new awareness of our own bodies transmitted by magazine accounts of popular medicine, by reports of the Barnard heart transplants, and so on. There's a new textbook of psychopathology being written. . . . What we're getting is a whole new order of sexual fantasies, involving a different order of experiences, like car crashes, like traveling in jet aircraft, the whole overlay of new technologies, architecture, interior design, communications, transport, merchandising. These things are beginning to reach into our lives and change the interior design of our sexual fantasies. We've got to recognize that what one sees through the window of the TV screen is as important as what one sees through a window on the street. (JGB, 157)

To illustrate how things like architecture and interior design reflect a whole new order of sexual fantasies, one has only to think of how the folie à deux in Cronenberg's *Dead Ringers* is extended to the twins' taste in furniture and interior design. Similarly, architect Arata Isozaki consciously designed the Los Angeles Museum of Contemporary Art in 1986 to embody "the exquisite shape and proportion of . . . Marilyn Monroe—classic, voluptuous, and sensuously draped to enhance and tantalize."[18]

Movie stars and royalty shape sexual fantasies in other ways as well. They are so much a part of our psyches that memories of them often substitute for actual memories based on personal experience, invading our thoughts and dreams. In *The Atrocity Exhibition,* Elizabeth Taylor is a recurrent fixation among Ballard's obsessions, her mass-produced image circulating in Warhol canvases. Taylor is one of many icons who has become even more ubiquitous since Ballard wrote *The Atrocity Exhibition:* her name sells cologne, her birthday bash was held at Disneyland, her latest wedding was at Neverland, Michael Jackson's theme-park estate. When she rushed to Jackson's defense against child molestation

charges, the public was treated to the sardonic spectacle of one simu-
lacrum validating the authenticity of another.

But Ballard's hero dreams not of living but of dying with Elizabeth
Taylor: their cars would collide and her face would crash through the
windshield "like a *death-born* Aphrodite," a phrase that shows how Bal-
lard translates Western civilization's ancient myths into the contempo-
rary urban landscape. Advertising similarly names products from Greek
mythology: Nike running shoes, Mercury cars, Trojan condoms. Rather
than condemning advertising as a degraded art form, Ballard exploits it:
he composes entire "novels" that should be published as advertisements,
including one that is designed to go on billboards.[19] What, Ballard asks,

> can Saul Bellow or John Updike do that J. Walter Thompson, the world's
> largest advertising agency and its greatest producer of fiction, can't do bet-
> ter? . . . The social novel is reaching fewer and fewer readers, for the clear
> reason that social relationships are no longer as important as the individ-
> ual's relationship with the technological landscape of the late 20th cen-
> tury. . . . The writer today . . . is now merely one of a huge army of people
> filling the environment with fictions of every kind. To survive, he must be-
> come far more analytic, approaching his subject matter like a scientist or
> engineer. (JGB, 99)

It is in this sense that Ballard is a "scientist" of fiction, rather than merely
a "science fiction writer." The *New York Times* recounts citizens' dreams
of movie stars: Tim Welsh, marketing manager at Merrill Lynch, con-
fessed, "I was playing catch with Robert Redford in *The Natural.*" "Af-
ter I saw the movie *Broadcast News* I dreamed—more than once—that
I was having sushi with Holly Hunter," said Mia Freund Walker, story
developer for *20/20*.[20]

Although Americans often define movie stars as America's surrogates
for royalty, Ballard sees the British royal family as a surrogate for Hol-
lywood stars. His views were confirmed in 1993 in a *Wall Street Journal*
report on thousands of Britons who dutifully dream regularly of Her
Majesty the Queen. In some dreams, she represents the ultimate fear of
humiliation; subjects find themselves standing naked and ashamed be-
fore her. For many others, she snuggles the dreamer to her breast, giv-
ing new meaning to the phrase "Queen Mother."[21] In a perverse twist
on such fantasies (and before punk rockers made it fashionable to de-
face mass-produced images of the Royals), Ballard devotes one chapter
of *The Atrocity Exhibition* to "Princess Margaret's Facelift," another to
"Queen Elizabeth's Rhinoplasty." In 1995 he appeared on a PBS special,
discussing the iconic signification of Princess Diana. Since image con-

struction is what the Royals now do best, Ballard dissects Britons' psychic investments with surgical precision.

LK: Do you think the monarchy will disappear in our lifetime?

JGB: Oh, I'd *love* that! It might happen in your lifetime, maybe, but not in mine. You see, we've nothing else in Britain. And people know that. They are our equivalent of Hollywood. They are the only thing we're preeminent in. They are more famous than Japanese royalty, though less venerated. They are a soap opera—it's got everything: wayward daughters, the eldest son, deeply serious and troubled. The grumpy father. It'd be terribly funny if it weren't so sad.

Ballard wants to incite a revolution in consumer desire—prompted in part because the Disneyfication of society and personality has reached outlandish proportions. I tell him about riding in the teacups at Disneyland when I was a child; Walt Disney was sitting in the teacup next to mine. I remember thinking at the time, *"He's come to play with his toys!"* Now, forty years later, Disneyland conceals the fact that it is the "real" America, which has become exactly like it, malled over.[22]

LK: Do you know who first introduced Disneyland to the nation on television? None other than Ronald Reagan.

JGB *(incredulous but gleeful):* No—really! Fantastic!

I tell Ballard that couples can now marry at Disneyland, complete with footmen, Cinderella's carriage, and Mickey Mouse in attendance—a development even Ballard had not anticipated when he wrote:

> All over the world major museums have bowed to the influence of Disney and become theme parks in their own right. The past, whether Renaissance Italy or ancient Egypt, is reassimilated and homogenized into its most digestible form. Desperate for the new, but disappointed with anything but the familiar, we recolonise past and future. The same trend can be seen in personal relationships, in the way people are expected to package themselves, their emotions and sexuality in attractive and instantly appealing forms. (AE, 51M)

Even a cursory glance at the personals advertising section or computer networks verifies this point. As Ballard predicted, social relationships are no longer as important as the individual's relationship with the technological landscape of the late twentieth century. The epoch of the posthuman is marked by this interaction with machines. The Japanese word for a new personality type is *Otaku*—people who prefer to interact with machines rather than people. Instead of defining themselves in essentialist or individualistic terms, *Otaku* are defined by their possessions. They em-

body the concept of "person-as-information." No one and no thing can be too artificial.[23] In the *Post Human* show which toured Europe in 1992, Kodai Nakahara's *Date Machine* installation features a bed surrounded by nine televisions, countless stereos, amplifiers, and computers (Fig. 28). Humans are absent, while the machines are omnipresent, alive. Six-foot-tall Yamaha stereo speakers flank each side of the bed. All the components of a seduction are present, except for the couple. But the environment also evokes Masters and Johnson's laboratory experiments: all the equipment is ready to record every stimulus-response that is about to take place, or has just concluded; the pristine pillows are wired with electrodes, and spotlights, like those in an interrogation room, are focused on the bed. *Date Machine* illustrates the rapt, mindless fascination of the visual. Pleasure comes solely from the voyeuristic consumption of components. It is also a commentary on how conceptual sex has become.

LK: Would you like to visit Japan?

JGB: Yes, I'd love to visit because I think the future will proceed from both

Figure 28 Kodai Nakahara, *Date Machine* (1992). Photo credit: Satani Gallery, Tokyo, Japan. Courtesy Jeffrey Deitch.

America and Japan—they both have enormous evolutionary potential and are growing at an enormous rate.

LK: What did you think of Los Angeles?

JGB: I liked L.A. a lot. It's like a Troy composed of media strata. The media past is there. As you drive around, it's all half familiar, because you've seen it in a thousand TV episodes. All tacky, but it has a deep, mythic layering that's marvelous! Like in Baudrillard's *America*. He treats America as a huge pop art object. I like his idea of simulacrum, which I take to mean that what you constantly see in the U.S. are copies—but copies that have never had an original. That is what is so clever. That's the uncanny thing! It's an exhilarating country. You sense it's on a larger and higher plane. Something—possibly its size—has allowed it to generate this extraordinary civilization. I know when I was doing book tours in 1988, in malls, you feel this *planetary loneliness* of America, because it's so vast.

LK: Do you read any other French theorists?

JGB: No, I'm sorry to say. The only French thinker I read at all is Baudrillard. But only some of him. Some of it is totally impenetrable. He wrote complimentary things about *Crash* but, having written my own novel, I *still* couldn't understand him! *[Laughter.]* But I loved *America*. Some Americans are insulted when I quote this, but Baudrillard says that America is the only primitive society today—by which he means the only precursor of advanced societies of the future. The rest of the world—Europe—is going nowhere. You can forget about them. In America, you see the future in its primitive, prehistoric state.

This remark strikes me as quintessential Ballard—his ability to collapse time so that you are compelled to contemplate the prehistory of the future, as if *Blade Runner* were colliding with the La Brea tar pits. Far from deploring sex and violence, Ballard argues, we should approach pornography and horror the same way we approach Icelandic myths: as forms of storytelling that reveal the culture's anxieties, obsessions, contradictions. Writers and critics must analyze the latent as well as the manifest layers of meaning, the "grammar" and "types" structuring popular culture's phantasmagoria.

Some critics are doing just that. Carol J. Clover's *Men, Women, and Chain Saws* analyzes the grammar and types in slasher films, whose main consumers are adolescent boys. Since the slasher is always impotent, the unconscious *appeal and function* of these films are to assuage sexual insecurities in general, castration anxieties in particular. Pornography, Clover concludes, is about sex (the act); horror is about gender.[24]

But Ballard complicates Clover's thesis by using pornography to intercept horror, and vice versa. "In a sense," Ballard notes, "pornogra-

phy is the most political form of fiction, dealing with how we use and exploit each other in the most urgent and ruthless way" (JGB, 98). Like those reversible figures that appear as either a white rabbit or a black cat, perspective oscillates in his fiction. Phoebe Gloeckner's illustrations in *The Atrocity Exhibition* enhance the process (Fig. 29). Does her illustration of fellatio depict porn or horror? Sex or gender? If it is about sex, is the act pleasurable or painful? If it is about gender, does it reveal the female fear of penetration or the male fear of castration? The proximity of penis to teeth evokes the vagina dentata. If a woman interprets this as a menacing image, she must acknowledge that it poses an equal threat to a man. Gloeckner's illustrations each open multiple "windows" on Ballard's fractured view of "reality." Evoking Duchamp's urinal, she juxtaposes penises with pipe hoses, arteries with freeways, sexual reproduction with cell reproduction.

RONALD REAGAN REDUX

No wonder there were such vehement attempts to censor *The Atrocity Exhibition,* with its satiric exposé of the hypocrisy and cynicism of corporate America, politics, and the police. Ballard wryly notes: "*The Atrocity Exhibition* was due to be published in the U.S. by Doubleday, but two weeks before publication the entire edition was withdrawn and destroyed on the orders of the firm's boss, Nelson Doubleday, an old boy of extreme right-wing views who has donated a helicopter to the California police (a nice twist—the rich man no longer bequeaths a Rubens to King's College but a riot-control weapon to keep down the student body)" (JGB, 162). Nelson Doubleday's helicopter was used to quell a Vietnam War protest at the University of California, Berkeley, which occurred when Ronald Reagan was governor of California. Reagan's chilling solution for suppressing student protest: "If it takes a bloodbath, let's get it over with. No more appeasement."[25] Control, surveillance, intelligence: no wonder the nervous system looms large in Ballard's universe.

If Ronald Reagan had not existed, Ballard would have invented him. The Great Communicator's true genius was to empty himself so the public could project its fantasies onto him. To Ballard, the former Hollywood actor saved his best role for last: he played benevolent father to a nation longing for Daddy. But Ballard remembers a less kind, less gentle Reagan—the Reagan who as governor of California had no compunction about inflicting riot police and the National Guard on university students and antiwar protestors. As an undergraduate and graduate

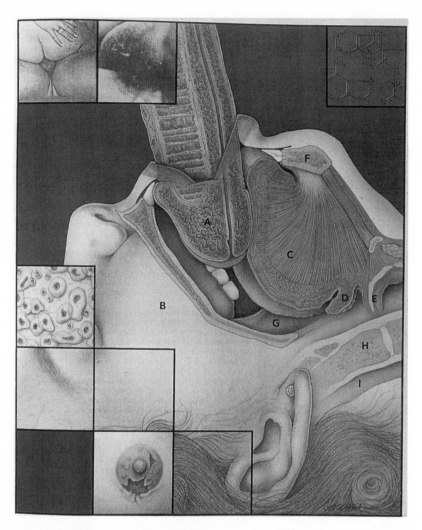

Figure 29 "Fellatio," illustration in J. G. Ballard,
The Atrocity Exhibition. Copyright J. G. Ballard 1990,
ed. V. Vale and Andrea Juno, illustrated by Phoebe
Gloeckner (San Francisco: Re / Search Books, 1990).

student at the University of California, Santa Barbara, I remember this Reagan, too. In 1967 Ballard wrote "Why I Want to Fuck Ronald Reagan," and the bookseller was prosecuted for it: "The defence lawyer asked me why I believed 'Why I Want to Fuck Ronald Reagan' was not obscene, to which I had to reply that of course it was obscene, and intended to be so. Why, then, was its subject matter not Reagan's sexuality? Again I had to affirm that it was. At last the lawyer said: 'Mr. Ballard, you will make a very good witness for the prosecution. We will not be calling you'" (AE, 105–6M).

Above all, Reagan's disconcerting habit of confusing reality with his old movie roles makes him the perfect butt of Ballard's satire; beneath the veneer of geniality, he embodied the anality of the 1980s with his merciless stance toward the poor, his aggressive militarism, and his extravagant Star Wars fantasies. Ballard's droll observation:

> What had blown Nelson Doubleday's fuses was a section of the book entitled "Why I Want to Fuck Ronald Reagan." The next firm to take the book, E. P. Dutton, were delighted with this piece, and thought seriously of using it as the book's title. Now they too have had cold feet. I was interested to learn that among the things that most bothered them were "16 references to Ralph Nader." In vain did I protest that anyone in public life attempting to involve us in his fantasies can hardly complain if we involve him in ours. (JGB, 162)

The confusion between fiction and reality crystallized in one supremely ironic moment when ex-Situationists reproduced "Why I Want to Fuck Ronald Reagan" on Republican National Committee stationery and distributed it at the 1980 Republican convention. Imagine the Republicans' bewilderment when they read: "The motion picture studies of Ronald Reagan . . . created a scenario of the conceptual orgasm . . . a unique ontology of violence and disaster" (JGB, 88–89) (Fig. 30).

LK: I met several ex-Situationists when I was living in Berkeley in 1991–92. They protested in the wake of the Rodney King verdict. Although the police instantly imposed a curfew and smashed photographers' cameras, one photo of police in riot gear was plastered all over town the very next day, above the slogan, "San Francisco: One Neat City!" How did the good cloth-coated Republicans at the Cow Palace react to your survey?

JGB: The delegates assumed that it was a position paper, commissioned from a wacky think tank.

LK: Like from a forensic psychiatrist!

JGB: Exactly! I used to go to these think tanks, to study their assessments of psychological factors.

During these assassination fantasies

Ronald Reagan and the conceptual auto-disaster. Numerous studies have been conducted upon patients in terminal paresis (G.P.I.), placing Reagan in a series of simulated auto-crashes, e.g. multiple pile-ups, head-on collisions, motorcade attacks (fantasies of Presidential assassinations remained a continuing preoccupation, subjects showing a marked polymorphic fixation on windshields and rear-trunk assemblies). Powerful erotic fantasies of an anal-sadistic character surrounded the image of the Presidential contender. Subjects were required to construct the optimum auto-disaster victim by placing a replica of Reagan's head on the unretouched photographs of crash fatalities. In 82 per cent of cases massive rear-end collisions were selected with a preference for expressed faecal matter and rectal haemorrhages. Further tests were conducted to define the optimum model-year. These indicate that a three-year model lapse with child victims provide the maximum audience excitation (confirmed by manufacturers' studies of the optimum auto-disaster). It is hoped to construct a rectal modulus of Reagan and the auto-disaster of maximized audience arousal.

Tallis became increasingly obsessed

Motion picture studies of Ronald Reagan reveal characteristic patterns of facial tonus and musculature associated with homoerotic behaviour. The continuing tension of buccal sphincters and the recessive tongue role tally with earlier studies of facial rigidity (cf., Adolf Hitler, Nixon). Slow-motion cine films of campaign speeches exercised a marked erotic effect upon an audience of spastic children. Even with mature adults the verbal material was found to have minimal effect, as demonstrated by substitution of an edited tape giving diametrically opposed opinions. Parallel films of rectal images revealed a sharp upsurge in anti-Semitic and concentration camp fantasies (cf., anal-sadistic fantasies in deprived children induced by rectal stimulation).

with the pudenda of the Presidential contender

Incidence of orgasms in fantasies of sexual intercourse with Ronald Reagan. Patients were provided with assembly kit photographs of sexual partners during intercourse. In each case Reagan's face was superimposed upon the original partner. Vaginal intercourse with 'Reagan' proved uniformly disappointing, producing orgasm in 2 per cent of subjects. Axillary, buccal, navel, aural and orbital modes produced proximal erections. The preferred mode of entry overwhelmingly proved to be the rectal. After a preliminary course in anatomy it was found that caecum and transverse colon also provided excellent sites for excitation. In an extreme 12 per cent of cases, the simulated anus of post-colostomy surgery generated spontaneous orgasm in 98 per cent of penetrations. Multiple-track cine films were constructed of 'Reagan' in intercourse during (a) campaign speeches, (b) rear-end auto-

collisions with one and three-year-old model changes, (c) with rear exhaust assemblies, (d) with Vietnamese child-atrocity victims.

mediated to him by a thousand television screens.

Sexual fantasies in connection with Ronald Reagan. The genitalia of the Presidential contender exercised a continuing fascination. A series of imaginary genitalia were constructed using (a) the mouth-parts of Jacqueline Kennedy, (b) a Cadillac rear-exhaust vent, (c) the assembly kit prepuce of President Johnson, (d) a child-victim of sexual assault. In 89 per cent of cases, the constructed genitalia generated a high incidence of self-induced orgasm. Tests indicate the masturbatory nature of the Presidential contender's posture. Dolls consisting of plastic models of Reagan's alternate genitalia were found to have a disturbing effect on deprived children.

The motion picture studies of Ronald Reagan

Reagan's hair style. Studies were conducted on the marked fascination exercised by the Presidential contender's hair style. 65 per cent of male subjects made positive connections between the hair-style and their own pubic hair. A series of optimum hairstyles were constructed.

created a scenario of the conceptual orgasm,

The conceptual role of Reagan. Fragments of Regan's cinetized postures were used in the construction of model psychodramas in which the Reagan-figure played the role of husband, doctor, insurance salesman, marriage counsellor, etc. The failure of these roles to express any meaning reveals the non-functional character of Reagan. Reagan's success therefore indicates society's periodic need to re-conceptualize its political leaders. Reagan thus appears as a series of posture concepts, basic equations which re-formulate the roles of aggression and anality.

a unique ontology of violence and disaster.

Reagan's personality. The profound anality of the Presidential contender may be expected to dominate the United States in the coming years. By contrast, the late J. F. Kennedy remained the prototype of the oral object, usually conceived in pre-pubertal terms. In further studies sadistic psychopaths were given the task of devising sex fantasies involving Reagan. Results confirm the probability of Presidential figures being perceived primarily in genital terms; the face of L. B. Johnson is clearly genital in significant appearance – the nasal prepuce, scrotal jaw, etc. Faces were seen as either circumcised (J.F.K., Khrushchev) or uncircumcised (L.B.J., Adenauer). In assembly-kit tests Reagan's face was uniformly perceived as a penile erection. Patients were encouraged to devise the optimum sex-death of Ronald Reagan.

Figure 30 "Official Republican 1980 Presidential Survey," from J. G. Ballard, *The Atrocity Exhibition*. Photo credit: *The Atrocity Exhibition* Copyright J. G. Ballard 1990, ed. V. Vale and Andrea Juno (San Francisco: Re/Search Books, 1990).

LK: It's funny how Reagan and Thatcher bonded.

JGB: I used to scandalize Laura Mulvey, because she was bitterly anti-Thatcher, by saying, "Laura, the British people are not *worthy* of Thatcher!" She thought I was joking, but I meant it seriously. I didn't dare explain that I meant that she was the last decisive leader, the last with an aura. There's no magic to any sort of myth-making now.

LK: Because we all see the ghost in the machine?

JGB: Yes, and we're all much more critical. One has the sense that they've really hamstrung Clinton. Compared to Clinton, Reagan came across as a man of immense dignity. Yet he confirmed a kind of unstated logic of America of the twentieth century—the reductio ad absurdum which would end with Mickey Mouse as president. Congress would make provision which would eventually allow nonhumans or electronic individuals to run for office.

LK: A vision of Max Headroom flits across my consciousness,[26] quickly followed by an image of the black boombox in the center of an amphitheater at a pep rally for Ross Perot during the 1992 campaign. His faithful followers gathered around the box to listen to his yappy-Pekinese tape-recorded voice; Perot was nowhere to be seen.

JGB: The Reagan candidacy wasn't far short of Mickey Mouse.

LK: That's what a lot of my fellow Californians and I thought about *Nixon!* In view of your hypothesis about Reagan's anality, it's interesting to see how *oral* Clinton is. The media compiled a montage of him on the campaign trail scarfing down hamburgers, ice cream, hot dogs, etc., all over America. Washingtonians considered posting signs along the inauguration parade route: "Please don't feed the president." Gennifer Flowers tells the tabloids that he's great at oral sex. Even the saxophone is an oral instrument! Perhaps his greatest flaw is his inclusiveness—whether one thinks of the early town meetings or electronic conferences, he wants to take everyone *in*—in both senses of the word! *[Laughter]*

Small wonder then, that in "The Secret History of World War 3" (written in 1991), Ballard imagines World War III as an event that totally escapes the world's attention, because the media is focused on Reagan's failing health. Ballard imagines Reagan as still being president at the age of eighty-three in 1994, but he is

> scarcely more than a corpse wired for sound. . . . The American public was almost mesmerised by the spectacle of the President's heartbeat. The trace now ran below all other programmes, accompanying sit-coms, basketball matches and old World War II movies. Uncannily, its quickening beat would sometimes match the audience's own emotional responses, indicating that the President himself was watching the same war films, including those in which he had appeared. (AE, 122)

Reprising his amputee role in *Kings Row,* did Reagan grasp the irony of

entitling his autobiography *Where's the Rest of Me?* The public is a parasite on Reagan the "host"; both are infected with the same cultural amnesia. Ballard writes: "The nation was thrilled to know when Mr. Reagan moved into REM sleep, the dream-time of the nation coinciding with that of its chief executive" (AE, 122).

One of Ballard's projects is an archive of images of the twentieth century.[27] I suggest that he add to his archive Benetton's advertisement of Reagan's face covered with Kaposi's sarcoma (Fig. 31). Benetton introduced the ad in the summer of 1994, but they had to abort the campaign abruptly once Reagan's diagnosis of Alzheimer's was announced later in the year. The visual image was accompanied by a mock obituary clearly inspired by Ballard:

> When former U.S. President Ronald Reagan died from AIDS complications in February of last year, the world lost a courageous leader. Reagan is best remembered for his quick and decisive response to the AIDS epidemic early in his presidency. In June of 1981, against the counsel of his closest advisers, the President interrupted national television programming to explain the findings of his emergency health task force and urge the use of condoms. . . . U.N. Secretary of AIDS Services Margaret Thatcher observed, "Ronald Reagan will be remembered for his courage and foresight but above all, for his boundless compassion."[28]

Benetton's audacity would have packed a greater wallop had they disseminated this image during Reagan's (or even Bush's) administration. But the fantasy of what Reagan *could* have done in 1981 reminds us of what he actually *did* do in 1985: he appointed the Meese Commission on Pornography to stem the tide of *images* of sex, while denying the effects of AIDS on the world's population.

While rebellious artists explore sex conceptually, legislators strive to eradicate fantasy entirely. Those lobbying to eradicate desire include antipornography feminists and all the other neo-Puritanical watchdogs. Ballard's entry for *X ray* in "Project for a Glossary of the Twentieth Century" reads as follows:

> Does the body still exist at all, in any but the most mundane sense? Its role has been steadily diminished, so that it seems little more than a ghostly shadow seen on the X-ray plate of our moral disapproval. We are now entering a colonialist phase in our attitudes to the body, full of paternalist notions that conceal a ruthless exploitation carried out for its own good. This brutish creature must be housed, sparingly nourished, restricted to the minimum of sexual activity needed to reproduce itself and submitted to every manner of enlightened and improving patronage. Will the body

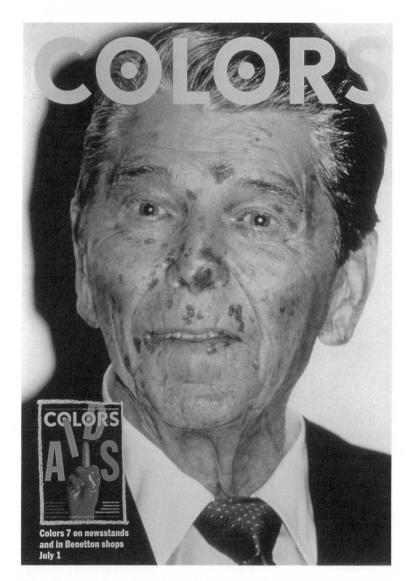

Figure 31 Benetton advertisement: Ronald Reagan
with AIDS. Concept: O. Toscani; Carlos Mustienes,
Colors magazine #7, 70 Rue des Archives 75003 Paris,
France; *Colors* is a Benetton Corporation magazine
(special issue on AIDS), 1994.

at last rebel, tip all those vitamins, douches and aerobic schedules into Boston harbor and throw off the colonialist oppressor? ("Project," 269)

Once again, Cronenberg's affinities with Ballard are apparent, for this passage echoes Cronenberg's own view of the body as a colony in revolt against the mind-oppressor.

We talk about Catharine MacKinnon, who has been on British television quite a lot recently, and who epitomizes the colonialist oppressor's attitude toward the body. Ballard later writes to me: "MacKinnon . . . is clearly crazy—it's fascinating that nonetheless she thrives—-radical climatic change allows bizarre species to flourish briefly."[29] Ballard's novel *Rushing to Paradise* (1994) features a fanatical feminist separatist who bears a strong resemblance to MacKinnon. He remarks gleefully that it's sure to offend everyone: environmentalists, animal rights activists, feminist separatists, neo-Puritans of every stripe. Set on an atoll in the South Pacific, it is the story of Dr. Barbara Rafferty, whose zealous mission is to save the albatross. She assembles a team of fellow crusaders, including a sixteen-year-old boy who soon discovers that Dr. Rafferty is exploiting him as a sperm donor; she views men as an inferior species, to be "put down."

> The biggest problem the world faces is not that there are too few whales or pandas, but too many men. . . . Their time has passed, they belong with the dugong and the manatee. Science and reason have had their day, their place is the museum. . . . We'll always need a few men, but very few, and I'm only concerned with the women. I want Saint-Esprit to be a sanctuary for all their threatened strengths, their fire and rage and cruelty.[30]

"I have to be careful with my sense of irony," Ballard remarks ruefully. "It isn't always detected. There's supposed to be a lot of humor in *The Atrocity Exhibition*—as well as in *Rushing to Paradise*."

The latter novel resembles William Golding's *Lord of the Flies* in a satiric mode. The fanatical Dr. Rafferty has transformed herself from a right-to-die advocate (whose role in assisted suicides is suspicious) into an animal rights activist who cares more for the lowly manatee and albatross than for humanity in general, men in particular. She combines facets of Conrad's Kurtz with the real-life Jim Jones. Paradise soon becomes the site of mass murder, disease, decay. With Ballard's uncanny sense of timing, the American edition appeared just when Greenpeace protests about France's resumption of nuclear testing on South Pacific atolls dominated the news, the week of July 10, 1995.

In fact, not a day goes by that some news item doesn't strike a Bal-

lardian chord. In 1991, he suggested that NASA is little more than a pub-
lic-relations enterprise, one that ignores the need for research on the psy-
chological impact of space travel (AE, 43M, 71M); in the summer of
1995, the American who is part of the much-ballyhooed joint U.S.-Rus-
sian team complains bitterly about the food, conditions, and his isola-
tion from his compatriots. The same week, on July 20, 1995, CBS
Evening News reports that each space capsule has a "suicide lock" to
prevent a berserk astronaut from destroying himself, the crew, and the
craft.[31] (Needless to say, Apollo 13, that summer's blockbuster movie hit,
ignored such issues.) In 1992, Ballard defined "retroviruses" as "patho-
gens that might have been invented by science fiction. The greater the
advances of modern medicine, the more urgent our need for diseases we
cannot understand" ("Project," 275). By 1995, films about retroviruses
flooded the market: Outbreak, Species, Congo, 12 Monkeys, which all
wrongly reassure us that humans are still in control.

In 1967, Ballard wrote about imaginary exhibitions of the paintings
of schizophrenics; on August 6, 1995, the New York Times Magazine
reported on the residents of a mental hospital near Vienna who are com-
manding top gallery spaces for their art.[32] The same day marked the fifti-
eth anniversary of the atomic bomb attack on Hiroshima; commemora-
tors and antinuclear activists mobilized to protest against France's
resumption of nuclear testing in the South Pacific. Attorney General Janet
Reno's complaints about violence on the television show Murder, She
Wrote look pretty silly compared to the wholesale slaughter of human-
ity throughout the twentieth century.[33] Ballard strips away the cherished
beliefs, the sacrosanct ideologies that delude us as the century winds
down. He shares Freud's archival imagination, isolating and analyzing
things that had heretofore floated along unnoticed in the broad stream
of perception. The Atrocity Exhibition is a Psychopathology of Daily Life
for our time. Ballard's "Project for a Glossary of the Twentieth Century"
gives us the proper perspective from which to assess the contemporary
debate about sex and violence, for it is written for a reader far in the fu-
ture who might wonder what these quaint notions used to mean. His
"glossary" consists of unalphabetized, free-association entries. Pornog-
raphy is nothing but "the body's chaste and unerotic dream of itself."
Modernism is "the Gothic of the information age." Satellites are "gan-
glions in search of an interplanetary brain." The Apollo mission is "the
first demonstration, arranged for our benefit by the machine, of the dis-
pensability of man," that recent invention who will shortly disappear.
Ballard brushes history against the grain, revealing the psyche's deepest

vicissitudes. He X-rays society, stripping away the layers of human vanity. He documents the untold story of caprice, whim, and irrationality that gives the lie to the Enlightenment myth of progress perpetrated by all those who seek to discipline and punish the body and protect us from ourselves.

FROM NOVEL TO SCREEN: BALLARD'S AND CRONENBERG'S *CRASH* (1996)

Ballard wrote *Crash* in 1973, long before body piercing became a fad and *impact* a verb. He names his protagonist James Ballard, and makes him an advertising executive (perhaps a gesture of jokey revenge on the legions of admen who have usurped the novelist's role?). In an airport hospital ward (usually reserved for air crash victims), Ballard meets Dr. Helen Remington, whose car he hit and whose husband he killed. Helen is transformed into an avenging angel of sex; she and Ballard become wildly promiscuous: "This obsession with the sexual possibilities of everything around me had been jerked loose from my mind by the crash."[34]

All of Ballard's characteristic motifs coalesce in *Crash:* simulation; the way fiction has overwhelmed reality; how sex and death have both become increasingly abstract and conceptual; the potency of the inorganic world and the eroticism of the technological landscape. Ballard describes *Crash* as "the first pornographic novel based on technology" and remarks that "sex times technology equals the future" (JGB, 98, 164). This is the world of the posthuman—the world in which we live, move, and have our being. Phoebe Gloeckner's drawing of an "arterial highway" illuminates Ballard's allegory (Fig. 32). Ballard externalizes the nervous system, maps the routes to madness and violence that are never far from the surface. He transports us to the doomed terrain of breakdown and concrete. The potential for disaster is wildly exciting.

If Ballard's other work sometimes invokes *Heart of Darkness, Crash* suggests Conrad's "Secret Sharer," for the narrator's homoerotic doppelgänger is Vaughan, a charismatic "hoodlum scientist" who specializes in forensic photography. By the conclusion, Ballard speculates that Vaughan may be a hallucination, mirroring his own fantasies and projections: "The crash was the only real experience I'd been through in years" (*Crash,* 39). Vaughan suffers from a narcissistic character disorder and a number of obsessions, including Kennedy's assassination (he drives an identical 1963 Lincoln Continental); celebrities in general, in particular those who died in car crashes (Jayne Mansfield, James Dean). Eventually, after numerous rehearsals, he orchestrates his own death in

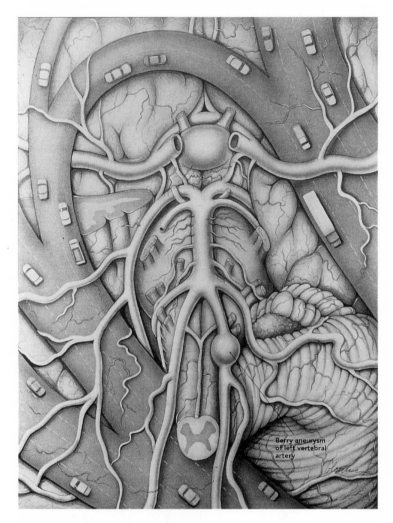

Berry aneurysm
of left vertebral
artery

Figure 32 "Arterial Highway," illustration in J. G.
Ballard, *The Atrocity Exhibition*. Copyright J. G. Ballard
1990, ed. V. Vale and Andrea Juno, illustrated by
Phoebe Gloeckner (San Francisco: Re/Search Books,
1990).

a crash with Elizabeth Taylor's limousine. Rather than turning away from catastrophes, Ballard turns the nervous system inside out, magnifying the flayed skin beneath all our defenses: "Trying to exhaust himself, Vaughan devised a terrifying almanac of imaginary automobile disasters and insane wounds. . . . For him these wounds were the keys to a new sexuality born from a perverse technology. The images of these wounds hung in the gallery of his mind like exhibits in the museum of a slaughterhouse" (*Crash*, 13).

It is not sexuality that is perverse here—it is technology. The "perverse technology" of the automobile feeds our fantasies of speed, escape, freedom, and mobility in sleek style, giving birth to a new sexuality. Just as Warhol created *Optical Car Crash* on silkscreen (1962), *Orange Car Crash Ten Times* (1963), and *Five Deaths Seventeen Times in Black and White* (1963), J. G. Ballard arranged his own exhibition of crashed cars in 1969. No wonder V. Vale and Andrea Juno, publishers of Re / Search Books, and Mark Pauline, who has staged numerous performance pieces featuring industrial explosions in his Survival Research Laboratories, see Ballard as a hero: he was writing the handbook for industrial culture, inventing "survival research" experiments while they were still in junior high school.[35] Indeed, Road Research Laboratories, which orchestrates car crashes and crash impact tests on dummies, figures prominently in *Crash*. Ballard describes a Danish porn magazine that uses the car as sexual prop: "Couples in group intercourse around an American convertible . . . teenagers in an orgy of motorized sex on a two-tier vehicle transporter, moving in and out of the lashed-down cars . . . the forests of pubic hair that grew from every corner of these motor-car compartments" (*Crash*, 104). The latter image evokes Magritte's painting *Le Viol*, which superimposes a woman's torso and pubic hair over her face, another homage to Surrealism. Perverse as the foregoing passage seems, it has already been turned into a cliché in an advertisement for Diesel Jeans (Fig. 33). Models' bodies are picturesquely splayed on concrete amid a four-car pile-up. One model's head is propped on a chrome fender pillow; another body is draped over the roof; the scarf of a third is arranged to suggest strangulation. One prostrate model smiles and waves at the camera as Japanese tourists take photos. Spectators seated on the periphery buy popcorn from a vendor, as if the catastrophe were a sports event. In the back seat, a black model spreads her legs wide, while a pathologist checks another model's pulse. The whole layout gives new meaning to the term *fashion victims*.[36] Surrounded by filth and carnage, the advertisement equates sex and death, car crashes with orgasm. The ad makes

visual the pathology Ballard is dedicated to decoding: the aestheticizing of catastrophe and voyeurism, melded in what might be called "forensic chic."

J. G. Ballard has been subjected to several supremely Ballardian ironies. First he had to wait years for society to catch up with his sensibility. Once it did catch up, he was quickly co-opted in such ads as that for Diesel Jeans. His work combines the Theater of Cruelty and the Theater of the Absurd—Artaud and Ionesco. Only by "swimming" in the "destructive element" can one acknowledge the appeal of violence.

I wrote Ballard in June 1994, asking him how it felt to see another of his predictions come true: when he described the car as a total metaphor for life in today's society, did he know that on June 17, 1994, O. J. Simpson would flee in a suicidal panic in his white Bronco? Although no one understands the fatal alchemy linking celebrity, cars, and disaster better than Ballard, even he may have been startled to see the allegory of psychic disturbance become so literal when Simpson led police on a chase on Los Angeles freeways, the surrealism of the stately slow-motion pursuit by phalanxes of police cars augmented by the hysteria of helicopter news reporters. At a loss to explain the logic of the event, they resorted to logistics: would Simpson take the 91 freeway to the 110? The 110 to the 10? The panic of reporters striving to fill the vacuum of dead airtime with vacuous speculations was unusual because it was unscripted—yet it was straight out of a script by Buñuel. Like maniacs in Ballard's fiction, Angelenos haphazardly abandoned their cars during the Friday rush hour to catch a glimpse of the former football star in the back seat with a gun to his head. They refused to stay in their own lanes, or even in their vehicles. They were dying to see if Simpson would commit suicide.

What movie did O. J. think he was in—*Speed* or *The Longest Yard*? What movie did the police think they were in—*Thelma and Louise*? Had he been anyone else, O. J. Simpson would perhaps have ended up looking like *The Godfather*'s Sonny Corleone on the New Jersey turnpike, riddled with bullets. The unedited spontaneity of the spectacle was mesmerizing because it exposed America's *carceral* organization—that system of control, hierarchy, and intelligence again, the ultimate aim of which is incarceration.[37] It was thrilling to see massive police mobilization momentarily neutralized, although the fact that it could be deployed at any moment also gave viewers a kick.

There is thus very little fiction in Ballard's universe; instead, there is a surfeit of reality. To Ballard, the roles have been reversed because "we live in a world ruled by fictions of every kind—mass merchandising,

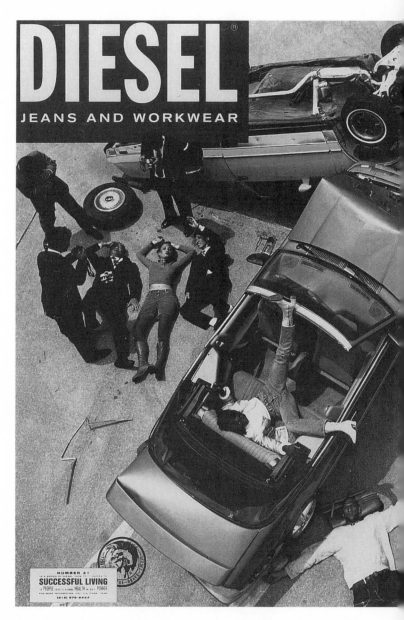

Figure 33 Diesel Jeans advertisement,
Details magazine (September 1994).

advertising, politics conducted as a branch of advertising, the instant translation of science and technology into popular imagery . . . the preempting of any free or original imaginative response to experience by the television screen. We live inside an enormous novel. For the writer . . . the fiction is already there. [His] task is to invent the reality" (JGB, 98). Ballard merely magnifies each microscopic fragment. In so doing, he follows the procedures of the Surrealists, who submitted fantasies to "the formal inquisition of the sciences, psychoanalysis preeminent among them," in order to produce a heightened sense of reality (JGB, 102).

JGB: In real life, there are no plots, no stories, no—or very few—dramatic resolutions, in the sense we know them in drama. Real life is much closer to the texture of *The Atrocity Exhibition*.

LK: So you view yourself as a realist?

JGB: Exactly!

His affirmation strikes me as uncanny, since David Cronenberg said precisely the same thing when he argued that, in contrast to the fake emotions of *Kramer vs. Kramer, The Brood* is "more realistic, even more naturalistic."

On March 18, 1996, J. G. Ballard wrote David Cronenberg: "Your film of *Crash* absolutely stunned me! It's the most powerful and original film I've seen for years. In many ways, it takes off where my novel ends, and is even more drastic and mysterious. . . . The actors are superb. . . . Together [they] help to create a masterpiece of cinema that will be the film sensation of the 1990's. Thank you for a brilliant achievement!"[38] David Cronenberg's screen adaptation has the darkly stylish look of a Helmut Newton fashion layout—cool and elegant. James Spader stars as Ballard, an apt choice, since Spader has made a career of playing passive, sexually ambiguous and impotent heroes *(Bad Influence, sex, lies, and videotape)*. The cast also features Rosanna Arquette, Elias Koteas (as Vaughan), Holly Hunter (as Dr. Remington), Deborah Unger in an intensely uninhibited performance as Ballard's wife, Catherine.

Cronenberg returns to some of his abiding themes, which here have the same weight and melancholy as in *Dead Ringers:* duplication and reproduction, repetition and rehearsal. The whole film is about forms and surfaces, a visual essay on method. Dueling sex scenes alternate between husband and wife, who enjoy taking other lovers, then reporting their exploits to each other. Through clever cross-cutting, Unger's exact sexual positions are duplicated by Spader. They are poised for re-presentation, just as Vaughan restages celebrated car crashes. All are engaged in

a quest for authenticity, for something that will break through the co-coon of modern life—a theme Cronenberg has been exploring at least since *Videodrome.*

Howard Shore's haunting music eerily evokes the convulsiveness of eroticism, just as Peter Suschitzky's gorgeously somber cinematography depicts the alienation of the technological landscape. He subtly evokes Surrealism's tropes: one image of a wig resting on a teapot wittily pays homage to Magritte's *Le Viol;* after Vaughan kisses Ballard, he speeds away, down a street full of mystery and melancholy straight out of de Chirico.

As in the Diesel Jeans fashion layout, *Crash* merely makes literal the implicit suggestions of advertisers. Since they use sex to sell cars, why not take them at their word and turn the car into an erotic aid?

James Spader and Rosanna Arquette (the latter playing a voluptuous cripple hobbled by prosthetics) rendezvous in a Mercedes showroom. Advertising has always capitalized on the connection between the female body and the auto body; in this photo, Cronenberg merely literalizes the connection (Fig. 34). Arquette's black leather miniskirt mirrors the black leather interior of the Mercedes. The shiny steel chrome on her leg brace mirrors the car's chrome. Mouth open, she seductively caresses the car the way one might caress a lover. Everything in the photo duplicates the clichés of thousands of automobile advertisements, but the leg brace (the result of a car accident) adds an incongruous element. She proceeds to rub herself all over the car; once seated behind the wheel, her brace slashes the expensive leather to pieces, to the consternation of the showroom salesman.

Why not act out all the desires that the advertisers capitalize on? Just as Ballard asks "will the body at last rebel, tip all those vitamins, douches and aerobic schedules into Boston harbor and throw off the colonialist oppressor?" ("Project," 269), here the characters throw off their seat-belts, smoke and drink heavily, get stoned, drive recklessly, smash cars. They rebel against society's institutionally enforced means of loboto-mizing them in the name of protecting them from harm. Sex is merely one means of revolt.

Crash is hypnotic and seductive. Although the sex scenes are as ex-plicit as anyone has seen in some time, they have the strange, stylized decorum of a masque, a danse macabre. Just as Spader and Koteas are locked in a homoerotic embrace, Rosanna Arquette and Holly Hunter rendezvous in an auto junkyard in the film's penultimate scene. They curl up together in a car, as if in a coffin. In the film's final scene (not in the

Figure 34 Rosanna Arquette with a showroom Mercedes in *Crash* (Cronenberg, 1996). Photo credit: J. Wenk/Fine Line Features, copyright Orion Communications, 1996.

novel, but invented by Cronenberg), Catherine and Ballard orchestrate a collision that leaves Catherine without a scratch; she weeps from disappointment. Ballard comforts her with extraordinary tenderness: "Maybe the next one, darling, maybe the next one."

Both scenes convey an unbearable sadness, a palpable despair. Cronenberg is hardly the first to explore the connection between sex and death, but he takes it to another level by highlighting the detritus of industrial existence; the setting is noxious, denatured, fouled by toxic wastes, pollution, congestion, overpopulation, sewage, concrete. It is not merely the individual who is death-seeking—it is the entire civilization. Few films today actually strip the veil of familiarity from one's eyes. After a press preview at the Charles Theater in Baltimore, I felt as if I were seeing the whole decaying urban infrastructure for the first time. I pass the Reliable Body and Fender Shop; dozens of bums are drinking from brown bags. One limps; another is deranged. Why object to a film about

destroyed autos when our throwaway society relentlessly destroys people? I see smokestacks on the horizon, sewage in the harbor, miles of abandoned rowhouses. The only remnant of nature is memorialized in car models: Cougar, Mustang, Pinto, Bronco. I pass a Jeep Cherokee with the word *Refugee* on its license plate. Is the driver a refugee from the past, or from the future?

Crash created a scandal when it premiered at the Cannes Film Festival on May 19, 1996. Some members of the audience booed; some press critics recoiled in horror. Said Cronenberg, "We almost felt cheated . . . the cast and I, we were *ready"*—ready to discuss the film's meaning seriously with the public.[39] But other viewers found it beautiful and disturbing, a methodical exploration of risk and eroticism.[40] It won a special award "for originality, for daring and for audacity" at the closing-night award ceremonies, but two jurors abstained from voting on the award. Their concern: copycat incidents of people driving recklessly! Atom Egoyan, another Canadian filmmaker, reported that the debate was the most banal, silly discussion among a group of quite intelligent people.[41]

Of the film's French reception, in contrast, Ballard remarked: "The French of course totally got the point. The film opened there two months ago, and in its first week was the top box office film in France, an amazing achievement bearing in mind that this is not a piece of popular entertainment." Matters in England, however, were different; Ballard reported that Alexander Walker wrote a blistering attack, calling it "the most depraved film ever made." In a typical ironic aside, Ballard added, "Clearly, total artistic success."[42]

Although it screened at the London International Film Festival on November 9, 1996, it has already been banned in the London borough of Westminster, where the lucrative West End cinemas are located. Britain's National Heritage, led by Secretary Virginia Bottomley, blamed Cronenberg for the Dunblane massacre and the unrelated stabbing of a school principal.

Attempts are also under way to ban *Crash* in Argentina and Italy. Indeed, although Neapolitan politicians are notorious for their ability to disagree on just about anything, almost every faction, from the ultra right-wing National Alliance to the Communist party have demanded that the film be banned.[43] Have the Italians forgotten their countryman Filippo Tommaso Marinetti, whose Futurist manifesto (published in 1909) was the first paean to the automobile? Marinetti was the first visionary to make poetry of the fusion of flesh and metal. He celebrated the new man

created by technology and glorified the automobile as a symbol of technology's promise, predicting that the machine would redraw the cultural and aesthetic map of Europe.

In the United States, Ted Turner, vice-chairman of Time Warner, "just about needed a seatbelt to keep from flying out of the screening room" when the film was screened for him by Fine Line Features, a Turner subsidiary.[44] Turner condemned *Crash* in a speech at the Museum of Television and Radio on November 4, 1996, saying that he was "appalled by" the film. Then, in an outlandishly disingenuous aside, he said he had "compromised my standards for the almighty dollar."[45] He "made it clear that he would be very displeased to see the film released," and managed to delay the U.S. premiere from October 1996 to March 21, 1997.[46]

The saga of *Crash* shows just how far we have traveled since Doubleday tried to ban J. G. Ballard's "Why I Want to Fuck Ronald Reagan." Global entertainment conglomerates have consolidated to such an extent that Fine Line had no choice but to capitulate to Turner's whim. Cronenberg may have thought of turning to Miramax, but Miramax had been sold to Disney Coporation, and Disney rejects any film rated NC-17. There was nowhere else to go.[47]

Judge Jerome Frank's dire warning in *Roth v. United States* (1957) again comes to mind, but the situation is even more dire than Frank predicted, for rather than having judges serve as arbiters of aesthetics, we are now at the mercy of moronic British matrons like Virginia Bottomley and media moguls like Ted "the Mouth" Turner. Are these really the people we want deciding what we can see and hear? Like Ballard, Cronenberg keeps his finger on the pulse of the deep irrationality at the heart of society—even when accusatory fingers are pointing at *him*.

In a telephone interview with David Cronenberg in Toronto on March 4, 1997 (one week before the press screening), I asked him how he was feeling about *Crash*'s adventures.

LK: I've been following *Crash*'s odyssey—what do you think it would take to make people understand that the impact of art is not a kind of monkey-see-monkey-do robotic response?

DC: I think the basic issue is that the price of democracy is eternal vigilance. Any amateur psychologist can see that these impulses to censor spring from fear and a desire for control. People see things on screen that they are afraid of. That's why it comes out in such a simplistic way, with such energy. This is why people want to censor it.

LK: It was irritating when Margaret Atwood said film should be censored but not fiction.

DC: Yeah, I was pretty shocked myself that she would say that. I don't know if she'd say that today—that was ten years ago—actually almost exactly twelve years ago. It's difficult to be empathetic to an artist working in another medium. Ironically, we were both members of PEN/Amnesty International. She thought that then; today, if I got put in jail for my movies, I wonder, would she think that would be okay?

LK: You once said, "To censor myself is like telling a Surrealist not to dream"—did you censor yourself in *Crash*? If so, how much?

DC: No, I didn't censor myself. But of course you never make a movie in a vacuum . . . you're making it for people, you're making it for a large audience . . . it becomes a communal project. And of course you have an ideal audience that you have in your head. It's a very difficult juggling act, as any filmmaker knows.

LK: It's interesting how prophetic Ballard has become.

DC: Yes—a lot of his prohecies have come true—just as he predicted! And he enjoys this role. For instance, the very concept of a celebrity stalker didn't exist, but Vaughan embodies that. Myself, I can't even come close to him in terms of his prophecies.

LK: *Videodrome* seems fairly prophetic—the vision of a world seamlessly enveloped in spectacle. That's certainly far more pervasive today than in 1982. Did any of Ballard's references seem dated?

DC: There were things in the book that I changed. For example, I don't have Elizabeth Taylor in the film. There are two reasons for that: she is getting older, and what she symbolized for an older generation she no longer symbolizes to the younger audience today. But the other thing is in turning the book into a movie . . . I was afraid certain elements would make it very easy to dismiss. But it does have the re-creation of traffic accidents and of James Dean as icon—younger audiences can still relate to that.

LK: Does the same logic apply to JFK's assassination—did you eliminate that?

DC: No, I do use that car—but some Canadians didn't get the allusion, which surprised me. I thought the event was enormous for Canadians, too, but apparently not.

LK: Don DeLillo calls the assassination "the seven seconds that broke the back of the American century"; Ballard told me that DeLillo sent him *Libra*.

DC: I have that book right here but I haven't read it.

LK: I think it would be wonderful if you made it into a movie. But many people must have ideas for what you should do next.

DC: That's an interesting question too because I often feel that I don't have a good reason for things I turn down. But I'm an outside observer of American life—so in the case of the assassination, it's hard to capture all the allusions. Oliver Stone does it very well in *JFK*, but I would feel that I was faking American references. I'd need to do a lot of research.

What's perfect about *Crash* is that it's very innocent: because there is a strange sense in which it's a meditation on postindustrial culture. But it's ironic: here you have a Canadian filmmaker interpreting a British novel about American icons, and we just dive right into it.

LK: I know you were interested in adapting Bret Easton Ellis's novel *American Psycho* to the screen, and you offered some astute insights into the novel's satire on commodity culture. Could you tell me why you ultimately decided against making it into a film?

DC: I just read that Mary Harron is now making it—another Canadian. When I read she was making it . . . I thought, "Good luck to her." Because she'll need it. The terrible thing is that my first thought was, "Well, maybe only a woman could make this . . . and not get attacked." Well, you know, it's too bad that I even have to think that only a woman could make it. I was disgusted to have had such a reaction, because it speaks volumes, doesn't it?

 I really felt that I could not crack that book. It's so much an interior monologue. I wanted the film to have that sensitivity to commodities, shoes, to American products. My problem was, how to signal the importance of a $900 ostrich handbag or designer shoes visually on the screen?

LK: Maybe you could use subtitles, like Woody Allen does in *Annie Hall*.

DC: I thought of that. And the answer is maybe, but I think that is a case where there was too much that simply is not translatable.

LK: It's interesting because in a way, you're *Ellis's* ideal audience, just as you're searching for an ideal audience for *Crash*.

DC: Well, I did meet with him. . . . I think he really thought—he was resigned to the idea that I'd just make a slasher movie, and I tried to reassure him that I wanted to make a serious movie. . . . So either he couldn't figure out how to translate it into a screenplay, or just didn't think it would work—the interior stuff. I told him it was a brilliant book.

LK: I've always thought that you're by far the most literate of contemporary filmmakers, far more than Scorsese, for example, who is a film encyclopedia, but not really a reader. I'm thinking specifically of your love of Nabokov. What do you think about the current controversy over *Lolita*?

DC: I talked to Adrian Lyne recently, and told him that in a bizarre way, it's a worse time *now* to make *Lolita* than it was for Kubrick in 1962! A $40 million movie and he still has no takers in America for distribution.

LK: The new puritanism, isn't it?

DC: Yes, and just when we were beginning to get sophisticated. I'm at a point in my life where I've rarely seen such fearful reactions—it's as if this is the first issue people have ever really experienced on a personal level and they want to censor it because they're afraid.

LK: There are all these references to "the nervous system" in your work—

do you read theorists like Michael Taussig, who wrote a book called *The Nervous System,* or Jean Baudrillard (whom Ballard admires)?

DC: I don't know those writers, but I read Oliver Sacks and various stuff on the brain. It's so existentially satisfying just to be a neurologist: to be a neurologist *is* to be an existentialist—to understand issues of humanity, subjectivity that you're confronting, and to see that the body has a life of its own in a sense.

LK: You've been saying this since *The Brood.*

DC: Yes, that's true.

LK: You must be weary of waiting for people to get the point, to get with the program. In all your films, you've really been quite consistent in exploring our psychopathology.

DC: Yes, it certainly seems so to me—though the interviewers who keep asking me what I think of *Braveheart* don't seem to see it.

LK: I see *Crash* as the perfect antidote to the syrupy sentimentality of Claude Lelouch's *A Man and a Woman.*

DC *(laughing):* There were nice race cars in that film—that Ford GT!

LK: It's always seemed to me that women are the least romantic characters in your films—Deborah Harry in *Videodrome,* Marilyn Chambers in *Rabid.* It's as if men still want to lug around some vestigial pedestal to put women on, and the women themselves are bored silly by that.

DC: I think that's really true . . . actually a lot of actresses were very envious of these roles in *Crash,* which Hunter, Unger, and Arquette recognized were plums—although very daring.

LK: Since some feminists have given you grief, I should confess that I'm the author of *American Feminist Thought at Century's End.* The aim in my new book is to counteract the antipornography crusade of Catharine MacKinnon and Andrea Dworkin.

DC: MacKinnon has had enormous impact, especially in Canada. Her crusade has its foundation in anger . . . it's a miracle that any film gets made with that kind of pressure.

LK: She has certainly shifted the entire emphasis away from the criminality of obscenity and toward the viewpoint of "harm"—"will this harm us, will that harm us?"

DC: Yes, and Canadians have a tendency in that direction anyway. The downside in Canada is that anybody who's really spectacular can't really stand out. There's a great emphasis on conformity.

LK: To me, you and Ballard are the true realists—that's why *The Brood* is more realistic than something sentimental like *Kramer vs. Kramer.* You're just recording what you see in society, and people refuse to acknowledge it; it must be maddening.

DC: Yeah, some just want palatable entertainment.

LK: You and Ballard are writing a new *Psychopathology of Daily Life.* I asked Ballard if he'd ever been in analysis—have you?

DC: No, I've never felt the need, or thought I'd benefit . . . though I am curious, just because so many people I know have been, though I don't know anybody who has done it to the extent of say, Woody Allen.

LK: We can see how well *that's* working!

DC: *[Laughs]*

LK: In connection with *Dead Ringers,* you once said that you approach making a film as a way of exploring a problem or an enigma you're grappling with—was that true in *Crash,* and if so, what was the problem?

DC: It's not a problem of neurosis, it's coming to terms with the existential bargain. It's a meditation on love, sex, and mortality. You know, in England, one critic was scandalized and actually said, "GEE—he's sort of connecting sex and death . . .!" That's been going on for a thousand years!

LK: Precisely because sex and death are becoming more and more abstract and conceptual, we seem to be acting out in more and more phenomenal ways.

DC: Yes, that's true.

LK: Ballard said something amazing to me: he said that eventually media and spectacle will have enveloped us so seamlessly, that even Warhol won't make sense someday. I was just looking at Warhol's paintings of car crashes and wonder if you had Warhol in mind. Is *Crash* in a sense the endgame of *Videodrome?*

DC: No, it's a slightly different take, a different feeling. The novel is very disembodied, but the film is very body-conscious. It's all about forms and surfaces. I wanted it to be seductive and hypnotic. I suppose if you asked me to compare the two, there's a sense in which the visual material parallels the interior thoughts of the characters, which is difficult to do.

LK: Yes, I think that's why Jane Campion's adaptation of Henry James's *Portrait of a Lady* didn't work—James's interior monologues simply didn't translate.

DC: That was a strange case . . . as soon as you saw the opening, you knew there was desperation there. Somewhere in her, she was saying, "I missed it somewhere after all."

LK: I've read a number of conflicting reports about Cannes, about Coppola's role and the jury's reaction. Can you clarify?

DC: Coppola was a supporter—he actually shook hands and congratulated me after the screening. The two jurors who abstained did so because they worried that people might actually DO the things they saw on screen.

LK: Did Ballard collaborate on the screenplay?

DC: No, I sent it to him and he made some suggestions which I did take, and I was interested to know how he felt about the last scene, which is different from the book—it's a scene I added. Have you read the

screenplay? It's selling very well in England because they can't see the movie!

LK: I thought it was banned only in the West End?

DC: It's not banned, but it hasn't been given its certificate yet and the censor there is actually, as far as I'm concerned, just stalling till the election because he feels the political pressure, which has become very powerful.[48]

LK: Do you think technology will eventually make the pornography debate obsolete?

DC: I hope so! But it could just turn out to be something else to control. No one has really explored politically what male sexuality is and female sexuality is—what it might be, potentially—what it *can* be. These are the subjects that have to be explored completely. Nothing really really happens until these things are addressed. The film is really about sex, love, and mortality.

LK: The Internet has created such a sense of intimacy . . . the immediacy and decentralized quality are irreplaceable.

DC: Yes, the Internet is daring and thrilling as an alternative, especially when the dominant impulses are first fear, next control.

LK: It almost seems like the chasm in culture is greater today than in the 1960s. On the one hand, the Brian Mulroneys and William Bennetts are horrified by popular culture. On the other hand, we have these blasé computer whiz kids, into heavy metal, computer games, simulations of all kinds. Is that what *Existenz* [Cronenberg's next film, which starts filming in Toronto in the fall of 1997] is about?

DC: *Existenz* is a name of a virtual-reality game. It's a sci-fi film about a society in which interactive game designers are the most powerful members of society.

LK: Kind of like Ted Turner today!

DC: *[Laughs]*

As I mull over our conversation, I think how Elias Koteas subtly evokes Robert De Niro in *Taxi Driver,* another film about celebrity, transference, voyeurism, and disaster. To Vaughan, these random catastrophes are enormously fertilizing and energizing events. Obsessed by Albert Camus' crash, Vaughan is the new existential hero. In a world of chance encounters, forensics has become a new form of performance art. He merely takes to an extreme what society takes halfway, acting on the abiding appeal of sex and violence.

That appeal extends to many events that censors would not consider banning, although they are clearly pornographic: news photos of war and massacres, disasters at military air shows and drag car races, the Armed Forces Museum's display of John F. Kennedy's brain and veterans' limbs, the Washington, D.C., Holocaust Museum, which features

Nazi experiments on human bodies. All of these examples epitomize J. G. Ballard's definition of forensics: "On the autopsy table science and pornography meet and fuse."

Vaughan's profession is no accident: no one who watched the Rodney King and Reginald Denny beatings, Los Angeles burning, or O. J. Simpson's trials can deny that as a society we share Vaughan's addiction to forensics and fatality. In the Simpson case, the grisly murders, catalogue of wounds, 911 emergency telephone transcripts, and DNA evidence were restaged day after day in the media. Just as J. G. Ballard once wrote a story in which news reports of Ronald Reagan's failing health eclipsed news of World War III, Americans were so transfixed by the O. J. Simpson saga that news of the civil trial verdict upstaged President Clinton's second State of the Union address.

From this perspective, Princess Diana's death in a car crash in Paris on August 31, 1997, was utterly overdetermined. The paparazzi fed the public's insatiable appetite for her image; both consumed her. In a television interview, the attorney in charge of licensing the images of James Dean and Jayne Mansfield urged Diana's family to move swiftly to copyright her. The mass spectacle of mourning suggests that, as Don DeLillo puts it in *Mao II,* "the future belongs to crowds."[49] The frail and flawed princess was a perfect symbol of transference, a Rorschach test, a blank screen on which people could not resist projecting their fantasies and fears.[50] The subsequent backlash against the throne for maltreating her in life and in death raises numerous questions. Was the fatal accident a cocktail of death and desire? Shouldn't the monarchy have insisted on protecting the mother of the future king? Should grief be private or public? Is privacy itself dead? If, in seven seconds, JFK's assassination broke the back of the American century, will Princess Diana's death break the monarchy? Eroticism, voyeurism, and celebrity crystallized in one fatal moment, which, like the Zapruder tape, will be replayed forever.

In *Crash,* Vaughan asks, What does it mean to "witness"? What counts as evidence? Is science objective or prurient? What are the origins of our wounds? What is the crime and who are the culprits? While society remains locked in denial and disavowal, its destructive impulses erupt unabated. *Crash*'s only crime is that it exposes the darkest sides of human nature—the sex and death drives.

Criminal Writing

JOHN HAWKES AND ROBERT COOVER

John Hawkes and Robert Coover are two of the acknowledged masters of postmodern experimental fiction. They are also close friends who seem to have agreed a long time ago not to pander to popular taste. Consistently refusing to capitulate to the public's insatiable demand for realism, they satirize mimesis. Their novels are like funhouse mirrors, full of grotesque distortion. Their abiding theme is writing as a process, indelibly marked by the influence of older forms and past masters. Their fiction is an elegant affirmation of poststructuralist tenets: the pleasure of the text; chance and indeterminacy; the free play of signifiers and narrative codes. Different narrative codes collide: one finds elements of the detective story, slapstick, masquerade, dream, ritual, sacrifice, fables, and fairy tales. They have an encyclopedic knowledge of the conventions that have shaped narrative, from Menippean satire to the movies. Like the other artists in *Bad Girls and Sick Boys,* their innovations blur the boundaries between different media. Coover's *Night at the Movies* links the grammar of fiction to the grammar of film, criticizing Hollywood for hooking us on adventure, comedy, and romance. Coover combines cartoons, a weekly serial, a travelogue, short subjects, and three feature-length films; the novel commences with the soothing words, "Ladies and Gentlemen May safely visit this Theatre as no Offensive Films are Ever Shown Here."[1]

Since these two authors are remarkably prolific, space does not permit discussion of each writer's oeuvre. Instead, I have selected two nov-

els that bear the uncanniest resemblances: Hawkes's *Virginie: Her Two Lives* (1981) and Coover's *Spanking the Maid* (1982). Both portray the novel as a dialogic genre, in dialogue with such past masters as the Marquis de Sade, whose pursuit of the absolute in pleasure has irresistible appeal. Many of the motifs of the antiaesthetic can be traced to Sade: he dismantles the mind-body dichotomy; he substitutes antiromance for the true, the good, and the beautiful; he demolishes the illusions of autonomy and objectivity. The celebration of the imagination, the erotic, and individual revolt in *Bad Girls and Sick Boys* is indebted to Sade's literary experiments, which Hawkes and Coover explicitly reaccentuate.

Their topic is the ardors (in both senses of the word) of literary composition. While stressing the *graphos* in *pornographos,* they simultaneously show how inextricably interwoven pornography and erotica have been through the ages. The opening epigraph of *Virginie* reads: "My subject was, from the start, that wisp of shell-pink space shared equally, I am convinced, by the pornographic narrative . . . and the love lyric, from the troubadours, say, to the present."[2] Despite age-old attempts to differentiate pornography from erotica, the distinctions remain arbitrary, elitist, and subjective, as Susan Sontag demonstrated long ago.[3] In "Erotica vs. Pornography," Gloria Steinem blithely equates pornography with sex, erotica with love; erotica, she maintains, "contains the ideal of love, positive choice, and the yearning for a particular person. Unlike pornography's reference to a harlot or prostitute, erotica leaves entirely open the question of gender."[4] In keeping with the antiaesthetic of the artists in this book, the appeal of porn is precisely that it is antiromantic, since the ideology of romantic love functions so repressively for women in particular. As Ellen Willis points out:

> The view of sex that most often emerges from talk about "erotica" is as sentimental and euphemistic as the word itself; lovemaking should be beautiful, romantic, soft, nice and devoid of messiness, vulgarity, impulses to power, or indeed aggression of any sort. Above all the emphasis should be on relationship not (yuck) organs. This goody-goody concept of eroticism is not feminist, it is feminine.[5]

Sade resisted all attempts to sanitize and rationalize desire. He paid dearly for his resistance: twenty-seven years in prison for refusing to repent, recant. His writing is literally a criminal act—a fact Hawkes and Coover take pains to emphasize, for the revulsion to Sade comes from those who cannot bear to be confronted with the latent criminality of the mind.[6]

JOHN HAWKES, *VIRGINIE: HER TWO LIVES* (1981)

The first characteristic that strikes one on beginning to read *Virginie* is Hawkes's literariness. In an unprecedented preface, he lists his influences:

> One episode departs from *Vive La Mariée,* by P. Quentin, and two others from Georges Bataille's *L'histoire de l'oeil.* The adaptations from the French are mine, and include the debate poem of Gaucelm Faidit, Tristran L'Hermite's seventeenth-century map of love, "Royaume d'Amour," and two of the *Chansons de Toile,* thought by some to date back to the earliest troubadours.
>
> French though it purports to be, and conceived though it was in a reverie about de Sade, nonetheless this book contains its English-language borrowings, notably from Charlotte Brontë. Finally, 1740 was the year of de Sade's birth.

Critics have often remarked that Hawkes's books read as if they have been translated from another language; here he both translates and imitates the précieux mannerisms of eighteenth-century French writers in his stately, formal prose.[7] Two epigraphs follow: "Birth was the death of her" (Samuel Beckett), and "Beauty is paradox" (Heide Ziegler), followed by a poem about love's deceptions. These elaborate framing devices highlight the novel's artifice, thwarting attempts to read it as a realistic narrative. Even more disorienting, the novel consists of two discontinuous narratives in journal form. Virginie is an eleven-year-old girl leading two lives: in the first she is the assistant to Seigneur in Château Dédale in 1740, the year of Sade's birth. In the second, she is the younger sister of Bocage, a lusty Parisian cabbie and pimp in a surrealistic brothel in 1945. Virginie's journals document both lives: the austere aristocratic setting contrasts with the bawdy lowlife of postwar Paris. The first narrative is a Gothic fairy tale; the second is a Rabelaisian carnival. The text is a tissue of grafts; as in Sade, sex-textual relations lead everywhere.

Virginie in 1740 assists Seigneur, a Sadean master who rounds up peasant women in the countryside and transforms them into fit consorts for other decadent aristocrats. Seigneur is a "passion artist," like Michael in *The Lime Twig* (1961), Cyril in *The Blood Oranges* (1970), and Konrad Vost in *The Passion Artist* (1978). Seigneur's "life's work" is as Creator; when the novel opens, he has transformed twenty-five women from "raw material" into allegorical ideals, each embodying a different aspect of femininity: Colère, Bel Esprit, Volupté, Finesse, Magie (Anger, Wit, Voluptuousness, Delicacy, and Magic). Seigneur's transformations require rigorous discipline. There are the Mornings of the Noblesse, the Rites of Noontide, a full curriculum of tests and competitions. The women keep

journals and receive chastisements. The aim of all trials and rituals is to set an honored place for each woman in the Citadel of the Desire to Please, which cannot be traversed without passing first through the Labyrinth of Surrender All.

As in Sade, the implicit attraction of the regimen is that it permits women to cast off the traditional roles of daughter, wife, mother. Just as the French performance artist Orlan uses plastic surgery to transform her face into a composite of Western civilization's greatest paintings of feminine beauty, Hawkes shows how femininity has been constructed through the ages: in love lyrics by the troubadours, in tapestries, paintings, and books. It takes seven artists' masterpieces for Orlan to create the ideal composite; it takes five women to form the perfect ideal of womanhood in *Virginie*. Like Orlan, Hawkes approaches Seigneur's project with irony. He demonstrates that Nature copies the book: Seigneur has amassed an extensive library "depicting woman in her various amorous lives from glory to despoliation" (105). One way to read *Virginie* is as a feminist text, dedicated to deconstructing the traditional roles of womanhood even as they are painstakingly delineated.

In keeping with Sade's subversive theme of criminality, Seigneur's "regimen of true eroticism" is devoted not to nature but to artifice. He teaches his charges that artifice is the essence of nature; it is impossible to commit a crime against nature, because crime is the very spirit of nature—cruel, duplicitous, destructive, and capricious, as Sade notes: "You shall know nothing if you have not known everything, and if you are timid enough to stop with what is natural, Nature will elude your grasp forever."[8]

The novelist must learn the same lesson: only when the conscious self opens to the unconscious and to all experience does Nature reveal herself. Thus *Virginie* is a metaphor for the art of the novel. Hawkes's elaborate portrait of the women's education makes allegorical the contradictory components of creativity. Seigneur specifically instructs the women to create prose, not poetry, for "the poet's medium is the single word; the prose writer's is the sentence. The word is the gem, but the sentence is the entire crown" (104). Since the novelist's aim is to teach and to delight, Hawkes reminds us that pornography has traditionally had a pedagogic component. "It is a school society (and even a boarding-school society)," as Barthes slyly notes.[9] The Sadean boudoir is a university for the senses; it belongs among the schools of classical philosophy.[10] The novelist must thus combine Seigneur's traits (discipline, decorum, mental acuity) with Virginie's (receptiveness, childlike wonder, reverie). Alluding to the ancient debate about whether the aim of art

should be to teach or to delight, Virginie sums up these dualities, while affirming that pleasing is paramount: "The art of pleasing is only one of creativity's voices, and not its mind. But of all the voices of creativity, the one known as the art of pleasing is the strongest, the richest, the most splendid, the most unpredictable and ever new. So exalt the labyrinth!" (186–87).

Seigneur's most exemplary student is thus Virginie herself, who aids him on his quest for new converts, prepares the women for rituals and trials, and idolizes him. She frequently comments self-reflexively on her writing, referring to the "scattered copybooks of my journal" (9); the *"fair copy of what I once wrote,"* "sequences of prose like these" (88); and "such scenes as I witness and write down" (191).[11] As in Sade, Virginie's perspective is paradoxically pure, lucid, and utterly amoral.

This contradiction gives the novel much of its irony. Virginie is a tissue of erotic figures; at one point she exclaims, "I am transported, though I cannot be!" (31). She is a metaphor (from the Greek *metapherein,* "to transfer, to bear, to transport one thing to another") in the same sense Roland Barthes uses to describe Sade:

> In Sade, libidinous practice is a true text—so that concerning it we must speak of *pornography,* which means: not the discourse being sustained on amorous acts, but this tissue of erotic figures, cut up and combined like rhetorical figures of the written discourse. In the scenes of sexual acts, we thus find configurations of characters, series of actions, strictly analogous to the "ornaments" collected and named by classical rhetoric. In the first place, *metaphor,* indiscriminately substituting one subject for another according to a single paradigm.[12]

Barthes illuminates the structural function of Virginie's time traveling: the single paradigm of which she is a metaphor is the creative act—Eros is the vehicle, Art the tenor.[13] As a "tissue of erotic figures," Virginie evokes not just rhetorical tropes, but previous literary heroines—Pamela Andrews, Clarissa Harlowe, and Jane Eyre—other virginal narrators who are covertly sexually attracted to sadistic masters.[14] Hawkes also imitates eighteenth-century epistolary conventions, for Virginie is a first-person writer as well as narrator, like Richardson's and Brontë's heroines. She embodies the ambiguities of innocence and experience, and stands for Fidelity, for rather than questioning Seigneur's authority or condemning him morally, she merely records in sumptuous detail the perversions she witnesses. One of Hawkes's achievements is that he never violates Virginie's point of view; he maintains her purity of vision throughout.

He finds other means of counterpoint and contrast, particularly in the

juxtaposition of Seigneur and Bocage, Seigneur's 1945 counterpart. Their dual characterizations point toward the third way to read the novel: as a deconstruction of masculinity.[15] This aspect is the most parodic, for it exposes the fixity of masculine sexual obsessions, as well as the kind of solipsism and narcissism one finds in Samuel Beckett's work. If Seigneur's grandiosity recalls Don Quixote, Bocage is Sancho Panza. Where Seigneur's paradigm is the labyrinth, Bocage's (whose establishment was once a château) is the Sex Arcade, where he is master of revels for a circle of prostitutes who stage charades and bacchanalian feasts. As in the 1740 tale, bondage and punishment are sexual stimulants, although discipline is lax. If Seigneur's world seems to epitomize the Lacanian Symbolic order, with its elaborate allegorical sign systems and strictly dichotomized differences between Ladies and Gentlemen, Bocage's realm is the Imaginary, ruled by anarchic libidinous impulses. Everyone generously gives and partakes of the pleasures and largesse all bodies have to offer. The Lacanian parallels are not exact replicas of Lacan's schema; instead they are poetic evocations, drawn in broad strokes. Seigneur is mind; Bocage is body—the Rabelaisian lower body that eats, shits, fucks. Nothing could be more carnivalesque than his amorous Sex Arcade.

Hawkes parodies the supreme worship of the phallus, a trait shared equally by Seigneur and Bocage: the erect penis of one client is wrapped in gauze to resemble a puppet, and Bocage despises people "who think we do not live solely by the sphinx [vagina] and zizi [penis]!" (200). As if comically endorsing Lacan's concept of the phallus as a transcendental signifier—one that reduces woman to a symptom of the man—Seigneur's Tapestry of Love features "a scepter as tall and big around as Seigneur himself! . . . No other object was included; there was not the smallest detail to detract from the scepter and its domination of the field" (205).[16] But (as in Lacan) the illusory nature of this glorification is emphasized, for Virginie at first seems prepared to worship the "full, dark, throbbing" scepter unreservedly, until she calls it a "magnificent mirage," a viewpoint seconded by Seigneur: "Exactly so, and exactly as are the man, the woman, the labyrinth itself. The scepter is the emblem of them all! and just as indestructible! and as much a mirage!" (205).

Hawkes also contrasts the eighteenth century with the twentieth, for while Seigneur represents the austere monarchy of sex, Bocage represents the lower classes in bourgeois society, where even married couples participate.[17] In Seigneur's world, as in allegories of courtly love, love and marriage are antithetical: "What the religieux call adultery is in fact a necessity of love. . . . Yet, paradoxically, marriage is antithetical to love,

since duty is the fundament of marriage, and duty, by definition, destroys the free reciprocity which is the heart of love" (174). Seigneur follows the Kantian imperative to experience his aesthetic creations (the women) from a contemplative distance, whereas Bocage represents the opposite pole of active involvement. The elegance and aesthetic superiority of the eighteenth century contrasts with the corruption and vulgarity of our own.[18]

In both epochs, the claims and privileges of the phallus are ultimately pricked not by Father but by Mother—the dark, vengeful, jealous devourer. Both narratives end in doubling and incest, repetition and revenge. In the 1945 tale, Maman, who at the outset is rendered mute by a stroke, regains her faculties and wreaks vengeance on Bocage and Virginie for their incestuous union by setting fire to the house; they both perish. Hawkes thus juxtaposes Eros and Thanatos, the sex drive and the death drive. The return of the repressed is figured in the Mother. In the 1740 tale, we discover that Seigneur is Virginie's brother and father. Because he repudiates the sexual advances of Comtesse, a dominatrix who is his lover, as well as being his (and Virginie's) mother, she incites the women of Dédale to ravish him, then burn him at the stake. "Now I must die for my art, as I have long known I must," he says (206). When he exhorts Virginie to jump into the flames with him, she complies: birth is the death of her.

His murder and her suicide confirm the Sadean concept that sovereignty asserts itself by an enormous negation; the transcendent power of negation does not depend on the objects it destroys.[19] In this regard, Virginie resembles Sade's Juliette: "By passing through ideas and words, bodies and desires, Juliette damages the finitude of their forms and links them to infinity. She actually acquires her extraordinary traveling speed from this liberation of energy: as a being in search of its form beyond forms, Juliette is the embodiment of the finest idea of freedom that one can possibly acquire."[20] Virginie embodies that ideal; she too passes beyond the human order into a region where the inhuman splits off from the human. As her name implies, she remains virginal in 1740; even when she participates in the orgies in 1945, her inner remoteness remains intact. She is a "still unravished bride of silence and slow time," a time-traveler who has disembodied memories in 1945 of her 1740 fate: "*Oh, but I spy myself, and distantly! and small! in flames! But where? And when? And whose voice cries 'Virginie' and why do I yearn? For what? For whom? Now time's curvature and earth's as well are as taut as my own tenderness, as I stretch and yearn toward some fiery end of silence and clear space*" (31).

By evoking Keats's "Ode on a Grecian Urn," Hawkes highlights the novel's underlying theme: the tension between art and life, immortality and mutability, aesthetic detachment and involvement. Virginie can yearn, arms outstretched, like the figures on the urn who are frozen in postures of "mad pursuit" and "wild ecstasy." Like the speaker in the ode, she asks myriad questions, but just as the only "answer" the urn offers is "Beauty is truth, truth beauty," Hawkes's "answer" to the dilemmas he poses is "Beauty is paradox." Virginie's story is a fairy tale, as utterly erotic as Juliette's; yet hers is an erotic solitude not unlike Sade's.[21]

In his preface, Hawkes claims to have conceived the novel in a reverie about Sade, a confession that reminds us how crucial dreams are in all of Hawkes's fiction[22] and how crucial they are to creativity in general. Freud similarly insisted on the importance of dreams and reveries in the creative process.[23] But rather than being able to isolate influences and construct a straight genealogical line from the troubadours forward, Hawkes's influences lead everywhere, just as the novel's genealogies are marked by excess in the doubling of roles of mother-lover in Comtesse, father-brother in Seigneur, brother-lover in Bocage. In this light it is interesting to note that although Sade is customarily viewed as a precursor to Freud, Lacan dismisses that genealogy:

> That Sade's work anticipates Freud, even as concerns the catalogue of perversions, is a piece of absurdity reiterated in the literary world, and for which the specialists, as always, must be held responsible.
>
> On the other hand, we maintain that the Sadeian boudoir equals placenames taken by the schools of classical philosophy: Academy, Lyceum, Stoa. In both cases, the way for science is made ready by reforming the position of ethics. Here, yes, a clearing-up takes place which will then have to swim for the next one hundred years across the depths of taste before the path of Freud can be practicable. Then count in another sixty years for everyone to realize why.[24]

Sade's literature of negation cleared a path for science to follow, but it took one hundred years before what Freud called "the science of psycho-analysis" fully confronted Sade's philosophy, and sixty years more to comprehend the scope of the abyss (with help along the way from the Surrealists, Blanchot, and Bataille). Freud was foremost among those who predicted the resistance in response to his discoveries. Sailing into New York harbor in 1910, he reportedly said, "I am bringing them the plague": his medical metaphor stands both for the scientific announcement of a *scientia sexualis* and the scientist's anticipation of the moral revulsion with which the public would greet the news.[25] With the detachment and

objectivity of a scientist, Sade confronts the abyss of anarchic impulses. As Annie Le Brun notes, "How could I not be grateful to him for having shown me that within every forceful thought lies an intense wish to be nothing?"[26]

Hence the four deaths by fire in *Virginie* have a philosophical significance, for in pursuit of the absolute, one must confront the void. The furies seek to obliterate not just Seigneur but his art, jubilantly declaring, "Your art is dead! In days to come, nothing shall remain of it but a few blackened stones. . . . Your page is justly blank, Seigneur" (212). But something nevertheless *does* remain: Virginie's journal, the book we are reading. Like Sade's Juliette, *Virginie* shows us how thought and desire are inseparable, how the erotic imagination is exalted by the act of writing, and how the act of writing is nurtured by erotic exaltation.[27] The triple deconstructions of femininity, masculinity, and craft in *Virginie* cannot be corseted by a single plot, viewpoint, or dogma. Hawkes's labyrinth of textual allusions testifies to aesthetic excess; no matter how many inquisitions try to quench it, some residue remains, as in Virginie's final valediction: "Remember the ghosts of dead flowers" (215). The novel is an extended meditation on the relationship of author to muse, artist to soul, conscious to unconscious, text to body. Hawkes's incantatory prose succeeds by amassing sensuous detail; it seduces through enchantment. No wonder his writing has been called "the most sensuously seductive prose in current American letters."[28]

ROBERT COOVER, *SPANKING THE MAID* (1982)

Robert Coover shares Hawkes's preoccupation with the interrelationships of femininity and masculinity, sex and text, pornography and pedagogy. In *Sade, Fourier, Loyola,* Barthes remarks, "Today's pornography can never recapture a world that exists in proportion to its writing, and society can never condone a writing structurally linked to crime and sex."[29] An elegant aphorism, but what does it mean? Obviously, today television makes it impossible for writing to compete with the incessant bombardment of images. Was there ever "a world that existed in proportion to its writing"? Probably not, but the eighteenth-century novel, particularly the epistolary novel, at least aspired to a verisimilitude that made the acts of living and writing codeterminous, whether one thinks of Sade, or Samuel Richardson's *Clarissa,* or Laurence Sterne's *Tristram Shandy.* It is the world of the eighteenth-century novel that Hawkes and Coover both try to recapture. So much for the first part of Barthes's sen-

tence; what does he mean by a society that "can never condone a writing structurally linked to crime and sex"? Sade is perhaps the first structuralist, for he explores the "deep structure" of desire and exposes the latent criminality of mind no society wishes to confront.

Spanking the Maid appears to be about the futile efforts of a master (simply named He) to train his servant girl (She). When She fails at her lessons, the master spanks her. As in *Virginie*, the master plays the pedagogue, and the girl is an anxious student, eager to please. Both master and maid are locked in pursuit of an absolute ideal. Yet from the outset, the allegorical positions of He and She reveal that Coover's subject, like Hawkes's, is the ardors of literary composition, for the first page inscribes its own revisions and corrections in the process of production:

> She enters, deliberately, gravely, without affectation, circumspect in her motions (as she's been taught) . . . glancing briefly at the empty rumpled bed, the cast-off nightclothes. She hesitates. No. Again. She enters. Deliberately and gravely, without affectation, not stamping too loud, nor dragging her legs after her, not marching as if leading a dance, nor keeping time with her head and hands, nor staring or turning her head either one way or the other, but advancing sedately and discreetly through the door, across the polished floor, past the empty rumpled bed and cast-off nightclothes (not glancing, that's better), to the tall curtains along the far wall. As she's been taught.[30]

As in Sade, the sexual activity and the written description of it follow hard on one another. As in Hawkes, the maid's actions are a metaphor for the novelist's. "No. Again" refers both to the maid's revision of her motions and to the novelist's of his prose. Coover's topic is the obsessive-compulsive nature of literary composition, with its false starts, dead ends, tedious labor, unremitting discipline, punishment, and repressions.

As in *Virginie, Spanking the Maid* seems at first to posit a series of structural polarities: male-female, master-maid, active-passive. But Coover proceeds to deconstruct them. For instance, it is the *maid* who is active, toiling ceaselessly at her appointed rounds. In contrast to the master, moreover, she enjoys her work. Like Hawkes, Coover echoes Keats: the maid creates "a kind of beauty, revealing a kind of truth" (28). Like Virginie, she never challenges the master's authority or rebels against her lot.

The master is supposed to instill discipline, order, and decorum. Toward this end, he obsessively consults manuals and conduct books with sayings like: "If domestic service is to be tolerable, there must be an attitude of habitual deference on the one side and one of sympathetic pro-

tection on the other" (33). The manuals promulgate the principle of utility, the Enlightenment dream of perfectibility. Utilitarianism has been satirized in fiction before, for example in Dickens's characterization of Thomas Gradgrind in *Hard Times,* and Dostoyevsky's *Notes from Underground.* As in the Sadean theater of rules and regimens, the master relies on manuals to tell him how to fit the punishment to the crime—"positions to be assumed, the number and severity of the strokes generally prescribed to fit the offense" (45–46). In terms of Coover's sustained metaphor, the master's manic reliance on manuals suggests that one must "master" the rules and conventions of prose, but no mere manual can teach the novelist how to create. Nor can aesthetic value be apprised from any criteria that makes utility paramount.

As in *Virginie,* then, master and maid allegorize two sides of the creative process: mind and body, mental and physical, order and beauty. But, just as Hawkes wrote *Virginie* out of a reverie about Sade, Coover also highlights the Keatsian roles that indolence, reverie, and dreams play in creativity, for the master's sole activity (besides spanking) is sleeping, and he has troubling dreams. Moreover, in some dreams, *he* is the submissive recipient of the lash: "He awakes from a dream (something about utility, or futility, and a teacher he once had who, when he whipped his students, called it his 'civil service')" (11). Just as Hawkes weaves courtly love into his tapestry, Coover reminds us that one of the distinguishing characteristics of such allegories as *Roman de la Rose* is the dream-vision. Not only is the unconscious structured like a language, but it is a language that consists of slips, paraphraxes, and aural puns that belie the decorum of waking life. The unconscious insistently violates ideals and self-images. The teacher in the dream calls his lectures "lechers," highlighting once again the pedagogic component in pornography. Linguistic disorder parallels the master's psychic disorder; he seems to be in the grip of aphasia as well as hysteria. His job is to control others, but he is comically out of control himself.

Just as Hawkes parodies Seigneur's and Bocage's solipsistic celebration of the phallus, Coover pokes fun at its prestige, for however much the master strives for control, his penis perversely insists on poking out of his pajamas like a "dangerous dew-bejeweled blossom: a monster in the garden" (22). His bed becomes a symbol of everything he wishes to repress, everything that defies the neat utilitarian abstractions he believes in. In the bed, the maid finds "old razor blades, broken bottles, banana skins, bloody pessaries, crumbs and ants, leather thongs, mirrors, empty books, old toys, dark stains. Once, even, a frog jumped out at her. No

matter how much sunlight and fresh air she lets in, there's always this dark little pocket of lingering night which she has to uncover" (28–29). Whatever systems or philosophies we devise, the body will erupt to mock our schemes and abstractions. Some residue of the unconscious always resurfaces, as when the maid finds a dead fetus in the master's bed and drops it in the toilet. Hawkes's fiction evokes the same image when a dead fetus surfaces on a fishing pole after a flood:

> The constructed vision, the excitement of the undersea life of the inner man, a language appropriate to the delicate malicious knowledge of us all as poor, forked, corruptible, the feeling of pleasure and pain that comes when something pure and contemptible lodges in the imagination—I believe in the "singular and terrible attraction" of all this.
>
> For me, the writer of fiction should always serve as his own angleworm, and the sharper the barb with which he fishes himself out of the blackness, the better.[31]

Hawkes and Coover thus share J. G. Ballard's view that man must immerse himself in his most destructive element—himself—and swim. The fetus is the indelible memory-trace, the residue of regression, aggression, infantile fantasies, and unformed perversions—all the unconscious processes that will erupt, regardless of the "civil services" society marshals to repress them.

Where does the darkness originate? Like Rosencrantz and Guildenstern, master and maid are haunted by questions of origins: they are pawns trapped in the labyrinth of fiction. She asks, "When . . . did all this really begin? When she entered? Before that? Long ago? Not yet?" (22). Of the master Coover writes:

> Sometimes, as now, scratching himself idly and dragging himself still from the stupor of sleep, he wonders about his calling, how it came to be his, and when it all began: on his coming here? on *her* coming here? before that, in some ancient time beyond recall? And has he chosen it? or has he, like that woman in his dream, showing him something that for some reason enraged him, been "born with it, sir, for your very utility"? (30)

Coover's comic questions have their origin in Sade, who pursues them in a thousand different ways in some twenty volumes: "What are men, if before God they are nothing? What is God when compared to Nature? And what in fact is Nature, which is compelled to vanish, driven to disappear by man's need to outrage it?"[32]

Spanking the Maid explores the realm of the irrational (rage, desire, sexual aggression) and the futile attempts to stamp it out. Although

Coover treats it lightly, the master-slave dialectic is never far from mind: "The moment my independence does not derive from my autonomy but from the dependence of others upon me, it becomes obvious that I remain bound to the others and have need of them, if only to reduce them to nothing."[33] Each has desires that exist because the other cannot satisfy them. This explains why Coover's master so often seems helpless; his vision of himself depends on her, just as Seigneur's depends on Virginie. The master's solipsism keeps him from self-recognition; he is a parodic symbol of the Enlightenment's ray of reason, left in the dark:

> Though he was thinking "invention," what he has heard in his inner ear was "intention". . . . [He yearns to] change places with her for awhile just to ease his own burden and let her understand how difficult it is for him. . . . When the riddles and paradoxes of his calling overtake him, wrapping him in momentary darkness, he takes refuge in the purity of technique. (71, 72, 78)

The reader finds herself in the same position as the writer, trying to decipher the novel, following all leads and cues, but failing to synthesize the parts into one coherent whole. As in *Gerald's Party* (1985) and *John's Wife* (1996), in *Spanking the Maid* Coover exploits this collision of codes in slapstick, masquerade, dream, ritual, sacrifice, detective story, and pornography. Both Coover and Hawkes strive to arouse the reader sexually and, in my view, both succeed. The densely ambiguous passage just quoted suggests that a realm of truth lies just outside master's reach. He yearns to understand a mystery that seems lodged in the body in general, the female body in particular. Since the Fall, toil and death have been inherent in the human condition; the master occasionally has glimmers of a prelapsarian paradise, forever beyond reach. His repeated attempts to remember his dream signify his futile attempts to connect with this netherworld. He and the maid are both tied to their "devotions," their common pursuit of the elusive goal, perfectability. "Though elusive, what else is there worth striving for?" is the text's repeated refrain (80). Since some feminist literary critics are as literal as the master is,[34] Coover is perhaps satirizing them when he compares the maid to a blank page: "Maybe it's some kind of communication problem . . . her soul's ingress . . . confronts him like blank paper . . . a perversely empty ledger. . . . Sometimes, especially late in the day like this, watching the weals emerge from the blank page of her soul's ingress like secret writing, he finds himself searching it for something, he doesn't know what exactly, a message of sorts, the revelation of a mystery" (81, 86–87).

Far from resolving the contradictions it presents, the novel remains as paradoxical at the end as at the beginning. Since both master and maid are driven by the compulsion to repeat, the text is circular, rather than linear. The last words are: *"Perhaps today then . . . at last!"* The whole cycle of striving for perfectability will begin again. Every day, the writer begins again, hoping to make progress, to correct egregious errors, to discover the meaning of the enterprise and the manuscript; just as in *Virginie,* the art is "all the more devotional for having been rendered meaningless" (52). Every writing day is spent rewriting and rereading. Writing is a form of self-flagellation, a process of turning back the covers and looking at unspeakable practices and fantasies. It is the writer who is plagued by the compulsion to repeat, the writer who lacerates himself with self-doubt, whose portrait of the "condition of humanity . . . keeps getting mixed up somehow with homonymity" (99). Like *Virginie,* *Spanking the Maid* is a testament to (and of) obsessional language, technique, artifice, reverie. Both texts embody the "Mosaic Law of postmodernism": "the law of mosaics or how to deal with parts in the absence of wholes."[35] Hawkes and Coover assemble a great number of fictive possibilities and possible interpretations without resolving them into one monolithic interpretation. They poke fun at their distinctly male worldview: if woman is the blank page, existing solely to be written on, man operates by a spermatic economy, for the author must impose a taboo against immediate gratification if the text is to proceed: "Only in its taboo against immediate and total discharge, against ejaculation . . . does all narrative, but especially the pornographic and lyrical *ars erotica,* allow innocence and intoxication to feed on each other, affirming life up to the moment of death."[36]

Feed on each other they do: *Spanking the Maid* ends in a comic explosion of puns, homonyms, and homologies, a kind of Nabokovian "callipygomancy," where the master "floats helplessly backward," borne ceaselessly into the past. Coover and Hawkes have no moral in tow; instead, their novels are affirmations of the specifically sexual pleasures of the text. Virginie's final journal entry reiterates the *morte* in *nature morte:* she evokes beauty that must die, abjuring readers to "remember the ghosts of dead flowers," the afterimage of the long ago and far away, which has been the essence of romance since *Le Roman de la Rose,* lyric par excellence of those ancient pornographers, the troubadours.

The latent criminality of the human mind is thus an irresistible subject to these two postmodern masters. Sade's works are a dissertation on crime, a new "'language of crime,' or new code of love, as elaborate as

the code of courtly love."[37] In exploring the vicissitudes of the psyche, Sade finally stands alone. Paradoxically, although he is the founder of a discourse reaccentuated by Barthes, Hawkes, and Coover, his writing can never be *reduced* solely to discourse, for it is a criminal act, which resulted in numerous inquisitions and imprisonments. If the role of ideology is to justify the unjustifiable, in *The One Hundred and Twenty Days of Sodom*, Sade lays bare the most unjustifiable passions in order to show how justifications can be made to serve any feeling, especially the loftier ones. Sade exposes all ideologies that produce ideas without bodies, ideas that develop only at the expense of the body, and instead he tries to think through the relationship between the mind and the body as no one else has done.[38] To repeat: aversion to Sade is the result of the revelation of criminal tendencies with which the mind cannot bear to be confronted. Hawkes clearly has Sade in mind when he summarizes fiction's function: "Fiction should achieve revenge for all the indignities of our childhood; it should be an act of rebellion against all the constraints of the conventional pedestrian morality around us. Surely it should destroy conventional morality. I suppose all this is to say that to me the act of writing is also criminal. If the act of the revolutionary is one of supreme idealism, it's also criminal. Obviously, I think the so-called criminal act is essential to our survival."[39]

Virginie and *Spanking the Maid* are both less than twenty years old, but one nevertheless wonders whether these novels could even be published today. Now that publishing houses have become multinational conglomerates, readers are offered a steady diet of pedestrian prose, pedestrian morality. Hawkes and Coover remind us of what is possible in fiction and of what fiction makes possible.

New Inquisitions

KATHY ACKER AND WILLIAM VOLLMANN

Kathy Acker and William Vollmann are emerging as two of the leading voices of their generation. Both live on the margins of "respectable" society: *Whores for Gloria* (1991) is set in San Francisco's seedy Tenderloin district, where Vollmann once lived; Acker has lived in San Francisco and New York, where she worked in a sex show. They emulate the example of John Hawkes and Robert Coover by stubbornly avoiding the mainstream, and Sade is similarly central in their work: one of Vollmann's stories is "De Sade's Last Stand," and Sade's characters reappear throughout Acker's fiction.[1] Both Acker and Vollmann focus on the sadomasochism of everyday life—the raw obscenity of poverty and power relations in contemporary America. Their narrative experiments advance the antiaesthetic aims of other artists discussed in this book by exploring the interpenetration of mind and body, high and low culture, art and politics. To them, postmodernism is not merely a style but an oppositional politics, a means of exposing social and political dogmas, of deconstructing traditions, cultural codes, and origins.

The novel first emerged as a significant literary phenomenon in Spain,[2] where Cervantes's *Don Quixote* defined it as a self-conscious, ironic, and antimimetic genre. Numerous postmodern writers have reaccentuated Cervantes: Nabokov's fiction is full of allusions, and Cervantes was the focal point of his lecture series. Coover's *Pricksongs and Descants* places a Cervantes-like "prologue" midway through his collection of "fictions," and Jorge Luis Borges's *Labyrinths* invents an author who rewrites *Don*

Quixote verbatim in the twentieth century,[3] one who "has enriched, by means of a new technique, the halting and rudimentary art of reading."[4] Nevertheless, it is startling to discover two recent novels with so many parallels, both written in homage to Cervantes. Both reemphasize Cervantes's themes of emotional deprivation, physical need, and greed. Acker's *Don Quixote* (1986) and Vollmann's *Whores for Gloria* both transport the Knight of the Woeful Countenance to the mean streets of urban America.

In some ways, Don Quixote is a prototypical "performance artist," for he transforms the passive activity of reading into an active mode; he internalizes his experience of books and performs them.[5] Acker and Vollmann want to see how Cervantes's dialogic debates about romance, illusion, and reality translate in the final quarter of the twentieth century. They show what happens when one adds popular music, film, and television to the Don's mania for books: Don Quixote, after all, is the first popular culture junkie. In a culture hooked on romance, how can one reconcile the damaging effects of the ideology of romantic love with the desperate yearning for love? Is ideology by definition quixotic? Are romance and imagination refuges or traps? The protagonist in *Whores for Gloria* is a deranged Vietnam veteran whose sovereign lady love is the (seemingly imaginary) Gloria, just as Don Quixote transforms the slatternly Aldonza Lorenzo into "Dulcinea del Toboso." Acker's heroine is a love junkie, too, a voracious reader and lover in the tradition of Charlotte Lenox's *Female Quixote* and Flaubert's *Madame Bovary.* Both writers drew implicit parallels between past Inquisitions and present censorship campaigns. Cervantes, after all, was no stranger to repression; *Don Quixote* was conceived in prison.[6]

KATHY ACKER, *DON QUIXOTE* (1986)

The paradox confronting Acker is how to reconcile the need for love with a critique of romance's ideology. Since in her view, men and literature have conspired to convince women that love is their sole raison d'être, she traces the evolution of romance from Amadis of Gaul to modern romance. Courtly love, already outdated by 1615, gives way to such debased versions as harlequin romances, which celebrate feminine masochism and portray love as the sole source of fulfillment. Acker transforms Quixote into a woman driven by sexual and emotional need. As one critic notes: "Acker speaks from a level that is both above and below the urbanity of everyday life."[7] While one of Acker's voices in the novel is that of the paranoid social observer, another is the infant who

simply wants, who is desperate for some—any—emotional connection. Acker's prose elevates presocial, primal emotions. Her *Don Quixote* has been called a cri de coeur,[8] although it is more a scream than a cry.

Being female, Quixote is immediately launched in medias res into the messy physical world of sex and reproduction. The novel commences with Don Quixote undergoing an abortion, an operation that in one stroke drives her mad and plants the insane idea for her quest. Her act of supreme idealism is to make the decision to love: "By loving another person, she would right every manner of political, social, and individual wrong: she would put herself in those situations so perilous the glory of her name would resound."[9] The abortion is the first of many ritual debasements of the flesh she undergoes to fulfill her quest for the Holy Grail. Abortion is to Acker what spanking is to Coover: a metaphor for the travails of composition, the bleeding of texts into one another. Abortion, however, is more than metaphor: Acker confessed that she picked up Cervantes's novel to divert her attention from her own impending abortion: "I couldn't keep my mind off the abortion so I started writing down what I was reading, but the abortion kept getting into it."[10] Part 1, "The Beginning of Night," traces Quixote's transformation into a knight surrounded by idiots, bureaucrats, and paperwork. Her "armor" is the paper hospital gown she dons for her abortion. The abortion has driven her crazy: "When a doctor sticks a steel catheter into you while you're lying on your back and you do exactly what he and the nurses tell you to; finally, blessedly, you let go of your mind" (9). Catheter is a portmanteau pun suggesting *hack,* a synonym for a writer, like "all the hacks on grub street" (9). *Hack* is also a verb, what some critics think Acker does to fiction.[11] To read Acker's fiction, you must "let go of your mind": readers must relinquish conventional expectations of plot and characterization. (The title of another Acker novel, *Great Expectations,* is an allusion to the "great expectations" readers bring to the act of reading—the desire for unity, resolution, and closure.) Her novels are "hallucinatory," but since the reading process is purposely disorienting, "hallucinogenic" may be a better word. Indebted to William Burroughs and J. G. Ballard, her collage-novels are like action painting: you drop in and out whenever and wherever you wish. She does to the written page what Orlan does to her face: she cuts it up and reassembles it to highlight the arbitrariness of the construction, and to show how it is fabricated. Her Quixote's final words are "Make Me up" (207). I argued in Chapter 2 that if Emma Bovary is a female Quixote, Orlan is her daughter; Acker's Quixote is her granddaughter.

Acker stages the production of writing as an experiment in psycho-

analytic transference: she does not so much write "about" literature as "to" literature, weaving into her novel masterpieces by many authors: Catullus, Sade, Proust, the Brontës. In keeping with her Quixote's gender bending, she identifies with all the characters, male and female. The experience of reading is disorienting, but it distills some fundamental kernel from the original text. With Charlotte Brontë, for example, she turns the theme of lovesickness into an analysis of feminine masochism, distilling the lesbian subtext between Jane Eyre and Helen Burns: Acker's Jane Eyre abruptly declares that "the name of my love, her name is Burn. She's the one the teachers flog" (158). Masochism becomes a means of rebellion for Acker's Don, daily assaulted by the disciplinary mechanisms of family, school, nation. To explain why women have a quasi-monopoly on masochistic pleasure, Acker incorporates Sade's Delbene and Juliette into her fiction. As Robert Siegle notes, she discovers that "if identity is painfully etched, then pain recalls the moment of inscription and the *non*cultural memory of flesh before the cut of the pen."[12]

Acker says the same thing about the art of tattoo. In an interview, she relates the words *tattoo* and *taboo,* describing her motivation to get tattooed as springing from the fact that "NO!" "is the very first word . . . burnt in your flesh":

> Tattooing . . . [is] art that's on your flesh. . . .
> Julia Kristeva has written a book, *Powers of Horror,* about . . . [how] art comes from a gesture of power turned against itself. She calls it "ejection": when you take that emotion and turn it *in* on itself—which is what tattooing does.[13]

As with the other artists in *Bad Girls and Sick Boys,* the theme of abjection thus ties Acker's novel to Kristeva, for tattooing is one means of dismantling the mind-body split, of elevating a low art to high art, and of accentuating the relationship between power and emotion. Tattooing is a means of imprinting on the body what has been repressed by the culture.

Acker's mock essays combine literary criticism and critical theory. In addition to Kristeva, she is particularly indebted to the *écriture féminine* of Hélène Cixous and Luce Irigaray. Acker too critiques the phallocentric view of woman as either a sexual commodity or a mere void: "If I wasn't loved, I couldn't fit into this marketplace or world of total devaluation" (115).[14] Cixous's "Laugh of the Medusa" calls for "the invention of a *new insurgent* writing" that "will return to the body" and "will tear her away from the superegoized structure in which she has always occupied the place reserved for the guilty."[15]

Robert Siegle compares Cixous's remarks about Woman to the self-sacrificing quest of Acker's Don. Just as Cixous speaks of Woman's "capacity to depropriate unselfishly, body without end, without appendage, without principal 'parts,'" Siegle argues that "it is precisely the abandonment of the logic of *'principal* parts'" which lies behind each formal tactic of Acker and which most offends the unsympathetic among her reviewers."[16] Acker's insurgent writing puts into practice Cixous's theories. Like so many of the other artists I discuss here, she repudiates the high modernist values of aesthetic autonomy and objectivity. Her work consists of holes, not wholes, and she uses the former word in the vulgar sense to refer literally to her vagina and metaphorically to her all-consuming need for love: "Endless hole I am an endless hole I can't bear this" (158). The same image of the fetus found earlier in Hawkes's and Coover's work uncannily recurs in Acker's, signifying unformed consciousness, repressed desires, the buried life. Don Quixote's abortion is a rebellion against social control; by aborting the overdue fetuses of her angry critique, she converts the "sickness" of her life experience into the "knightly tool" of fiction.[17]

Ideally, love should be a mutual exchange between two parties, but since solipsism and narcissism have blinded men, from Cervantes's Don forward, Acker laments that "on no side, from no perspective, do women and men mutually see each other or mutually act with each other" (94). Indeed, as in Cervantes, the most appropriate description of Acker's characters is "solipsistic," whether love is heterosexual or homosexual, adult or familial. The family is the origin of repression: after the Don runs away from home and is forced to return, the mother in *Don Quixote* is jubilant: "You've come back to prison of your own free accord." The father commands: "You're my property. . . . From now on, you will do whatever . . . and more important, be whoever I order you. This is a safe unit" (116).

Writing in the tone of a bright (if maniacal) undergraduate, Acker repeats indoctrinating history lessons verbatim; her mock naïveté sometimes resembles Hawkes's *Virginie.* Just as Cervantes parodied the notion that words are deeds, Acker presents a compendium of novelists who parody the mimetic fallacy. The plagiarized text is overwhelmed by the preoccupations she imposes on it.[18]

The result is a magical mystery tour from *El Cid* to Visconti's film *The Leopard,* by way of Sartre, Frank Wedekind, Hobbes, Marx, Gertrude Stein, and particularly Russian Constructivism. In the 1920s, the Russians were already experimenting with the devices Acker uses: the de-

struction of plot, character, and unity, simultaneous viewpoints, interpolated tales, fable and allegory, and alienating devices to defamiliarize mimesis.[19] Acker also invokes Burroughs's famous rallying cry of the Beats, "Nothing is true, everything is permitted." She borrows the technique of false attribution made famous in such tales as Borges's "Pierre Menard, Author of the *Quixote*":

> Menard . . . has enriched, by means of a new technique, the halting and rudimentary art of reading: this new technique is that of the deliberate anachronism and the erroneous attribution. This technique, whose applications are infinite, prompts us to go through the *Odyssey* as if it were posterior to the *Aeneid* . . . this technique fills the most placid works with adventure. To attribute the *Imitatio Christi* to Louis Ferdinand Céline or to James Joyce, is this not a sufficient renovation of its tenuous spiritual indications?[20]

All of Acker's writing might be seen as a response to Borges's satiric, mock-naive motto in this tale: "Every man should be capable of all ideas and I understand that in the future this will be the case." By imitating Cervantes, Acker reminds us that readers are not naive, impressionable automatons. The very fact that we need reminding speaks volumes about Cervantes's relevance today. Acker sees fiction as a dialogic, intertextual, and contentious zone of anarchic imagination. Her novel is a vertiginous assault on the conventions of reading, logic, narrative construction, and expository argument.

Just as Cervantes satirizes the pedants, Acker is horrified by the way scholarship reinforces institutional interests. Imitating Quixote's mad logic, she lumps all the "evil enchanters" together: the media, the academy, semiotics, Andrea Dworkin, leftists, and liberals have all contributed to the Stalinist stifling of creativity in the art world. Combining the delusional style of Don Quixote with the fervor of a rock star groupie, her female Quixote sardonically proclaims that rock star Prince is a savior who will "restore us to those lowest of pleasures: . . . Fucking, food, and dancing. This is the American Revolution" (22). What the original Quixote found glorious in books, Acker's finds in popular music and other adolescent, hedonistic forms of consumption, a theme that will be repeated in Bret Easton Ellis's *American Psycho*. Acker does not endorse her heroine's viewpoint any more than Ellis endorses his serial killer's, but she distills the punk movement's aggressiveness and hostility in such sentences, sometimes imitating the lexicon, texture, and raging repetition of the early Sex Pistols, combined with the drugged synthesizer tonalities of Laurie Anderson's lyrics.[21]

As Walter Reed points out, the reader of Cervantes confronts his or her own potential power—the power of the intermediary role *as* reader, capable of rearranging unwritten experience. The first part of *Don Quixote* structures this potential power as a dialectic of interpolation and interruption.[22] Acker's interpolations serve the same function. In Part 2, "Other Texts," she dramatizes the impossibility of being a female Quixote: "Being Dead, Don Quixote Could No Longer Speak. Being Born Into and Part of a Male World, She Had No Speech of Her Own. All She Could Do was Read Male Texts Which Weren't Hers" (39). How can the woman artist invent a language in such circumstances, when all language fails to encapsulate experience? She obsessively compiles the patriarchs' sexist definitions of Woman through the ages, from Plato, the Bible, and the Spanish Inquisition to the present moment. "What does it mean to be female?" she asks. The question provokes a cacophony of competing voices: since institutionalized religion demonizes women, Acker endorses Sade's view that atheism is "the most honorable course a human person can take in the face of religion."[23] To be female is to stick "the stake through the red Heart of Jesus Christ," since Christianity inculcates women with self-loathing, abnegation, and sacrifice (28). Catholicism, in particular, is "really a secret order of assassins" (24), a proclamation clearly meant to invoke Cervantes's inquisitors.

Acker's interpolated essays do not so much analyze as electrocute history. In keeping with the mock-naive tone, Acker's Don goes to America to find out how politics works. Like the other artists in *Bad Girls and Sick Boys,* Acker demonstrates that politics today consists of contests over competing representations. To Don Quixote's horror, she discovers that the citizens have been indoctrinated by the great American myths, "for economic and political war or control now is taking place at the level of language or myth" (177). Acker reminds us that far from fleeing from tyranny, the Puritans founded their own tyranny: "These New Worlders had left England not because they had been forbidden there to worship as they wanted to but because there they, and more important, their neighbors weren't forced to live as rigidly in religious terms as they wanted" (117–18). Like her other mock essays, this one is a parody of rote recitation. The founding fathers were zealots, hypocrites, capitalists: "In 1658 the Massachusetts Bay House Deputies passed the Death Penalty against Quakers" (118). Now, the mercantile interests of America are protected by latter-day "saints" like Nixon, Carter, Reagan, and Kissinger, manipulators of the military-industrial complex, "dogs" who promote destruction and death, for international finance is a highly successful war strategy (73).

The numerous animals in Acker's novel are reminiscent of George Or-well's *Animal Farm*, another dialogic novel which depicts the pigs as the rulers, the pack of fierce dogs as "enforcers." The female Quixote rails against starvation in Biafra, AIDS in Haiti, nuclear holocaust. Acker zanily juxtaposes high culture and low, serious world problems and petty academic squabbles. Who are the evil enchanters of this world? Andrea Dworkin, the *Times Literary Supplement,* and Ronald Reagan control the nexus of government and culture (101). The United States is run by the media and the dogs' greed. Don Quixote has been transformed from impossible dreamer into conspiracy theorist, a paranoiac trapped in the nightmare America created.

WILLIAM VOLLMANN, *WHORES FOR GLORIA* (1991)

Just as Kathy Acker takes us through the looking-glass, William Voll-mann has long been interested in the Land of Counterpane, a realm of childhood reverie.[24] He shares Acker's interest in presocial states and an-tisocial behavior. He too is obsessed with the incommensurability of lan-guage to describe experience, and with the theme of lovesickness. *Whores for Gloria* begins with an epigraph from St. Ignatius of Loyola: "Love consists in a mutual interchange between the two parties."[25] The epigraph is ironic, however, since no visible "interchange" between "knight" and "lady" occurs in the novel. Jimmy, the first-person narrator, is a Vietnam veteran who is homeless, deranged, and doomed to wander through the bars and brothels of San Francisco's Tenderloin district. He has taken up permanent residence in his imagination, where he converses with an imaginary love, Gloria. He reminds us of the etymological meaning of *pornographos,* for the novel is literally the writing of, on, about, and by hookers: Jimmy spends his days with prostitutes, but what he wants from them more than sex are their memories and life stories. These he offers in obeisance to Gloria, the focal point of all his dreams. But first, he care-fully selects and mentally edits the stories. In this regard, Jimmy's role as narrator parallels Vollmann's as author, for the novel consists of many prostitutes' stories that Vollmann himself assembled and edited, as he explains in the first chapter, entitled "The Album." In one sense, the novel is a photographic record of these women's lives and hard times. In an-other sense, it is a portrait of Jimmy's "image-repertoire." This may not sound like the Cervantes most readers remember, but Vollmann seems to have nearly total recall, evoking Quixote's unprecedented speech to the galley slaves in praise of the sexual procurer in the well-ordered state.[26]

Like Cervantes, Vollmann highlights the novel's self-reflexivity by blur-
ring the lines between illusion and reality with a disclaimer: while the
novel is fictitious, "all of the whores' tales herein, however, are real" (1).

Jimmy offers Gloria the hookers' tales to entice her to return to him.
Just as Don Quixote turns Aldonza Lorenzo into Dulcinea del Toboso,
Jimmy's Gloria signifies love, youth, hope, fulfillment—all the things that
are absent in Jimmy's life. Absence is the novel's focal point, for since
Jimmy never sees Gloria, the reader cannot be sure whether she ever ex-
isted or is a figment of his imagination. But that does not deter Jimmy;
instead, it inspires him to sally forth in search of more stories. Like Acker's
Quixote, Jimmy is driven mad by sexual and emotional need. Since
Jimmy's imagination filters out reality, Vollmann's task is to enable the
reader simultaneously to believe in Jimmy's vision and to perceive the
sordidness, brutality, and viciousness of the world Jimmy filters out—no
mean feat. The novel unfolds not as a series of events but as a series of
tableaux, like snapshots in "The Album" on the first page. Vollmann is
renowned for combining the verbal and the visual. He was influenced by
the Comte de Lautréamont (the pen-name of Isidore Ducasse, who wrote
Les Chants de Maldoror in 1868–69 and was later canonized by the Paris
Surrealists). Vollmann borrows from Lautréamont's modular structure,
using the short vignette as a building block. Vollmann's aesthetic inter-
est in horror can be traced to both Lautréamont and Poe.[27] For exam-
ple, far from being pornographic, Vollmann's description of sex with the
prostitutes emphasizes the physical decay of bodies scarred by malnu-
trition and poverty. One hooker gives Jimmy a venereal disease. They
have sex on his kitchen floor, which is black with grime. Later we learn
that she dies violently, but she had AIDS anyway. All the characters'
deaths are overdetermined.

While Cervantes's Quixote models his behavior on chivalric conduct
books and sells all his property so he can indulge his insatiable appetite
for romances, Jimmy is not much of a reader anymore. But he still loves
tales, cashing in his monthly disability checks to pay the hookers to share
their "happy" childhood memories. They seldom *had* happy childhoods,
so they make things up, which creates much of the tension and poignancy
of Vollmann's prose. ("Make Me up!" cries Acker's Don.) Jimmy caresses
these stories like flesh: "fingering Melissa's memories as though they were
breasts, the softness and succulence of them; he could twist them into
different shapes as he sucked on them; he kissed their round pink areo-
lae of sadness and tried not to mind them" (27–28). Jimmy weaves the
prostitutes' memories together, invents his ideal lady, then adores his in-

vention. Just as "unheard melodies are sweeter," Gloria's value lies in her unattainability, a leitmotif in chivalric romance. Jimmy is so solipsistic, however, that he seldom sees the prostitute in front of him. He assumes that sex is fun for the hookers, though they invariably correct him: "It's never really been *fun*. . . . Most of the *fun* I get out of it's the money" (29). In this regard, he resembles the narrator in Vollmann's ironic tale "The Happy Girls," who assumes that hookers are happy to be with him, but later admits "the probability that I myself was another of these tolls exacted from her."[28] A Thai prostitute in this tale has a tattoo reading "Hurt in Love," which might serve as Acker's motto, too. Indeed, Acker uncannily recounts how she used to absorb the strippers' tales when she worked in a sex show in New York: "Between each show . . . I would go to Tad's Steakhouse and would write, just to keep my mind together otherwise I would have flipped out. I would spend most of my time hanging out in the dressing room with all the other strippers hearing stories. It was the days of a lot of drugs, especially hallucinogens, so the girls just got totally wacked out of their minds and would tell great stories."[29]

In contrast to Tom Wolfe's *Bonfire of the Vanities,* which is about the "Masters of the Universe" on Wall Street, Jimmy is "master" of San Francisco's meanest streets, at least in his imagination. As in Cervantes, love not only brings Jimmy a sense of well-being, it provides him with a mission and an identity: "Being in love . . . is a beautiful feeling it makes me take big steps walk fast knowing the whole Tenderloin belongs to me. I could go ANYWHERE because I'm master of all I survey" (79). Jimmy dreams of getting cleaned up, getting a job, marrying Gloria, buying a house. Since Vollmann never violates the consistency of Jimmy's narrative point of view, it is easy to overlook the pathos of his subtle critique: where Don Quixote's dreams were extravagant, Jimmy's are extremely modest. He merely wants a small sliver of the American dream. But society has made even the most modest dreams impossible: in the 1980s low-income housing was reduced by 75 percent; between 40,000 and 200,000 people live on the streets of every large city; the economic recession drastically reduced the number of available jobs; and cutbacks in veterans' benefits swelled the ranks of a burgeoning underclass. Although Articles 22–27 of the United Nations' Universal Declaration of Human Rights list food, housing, and medical care as fundamental human rights, these rights are violated daily on every city street in the United States.[30] It is a tribute to Vollmann's craft that he defamiliarizes this abject world without pious moralizing or cheap sentimentality. We are a long way from *Man of La Mancha.*

If, as David Foster Wallace observes, all writing is "the act of a lonely solipsist's self-love,"[31] the ubiquity of Cervantes's Quixote takes on added significance. Just as Jimmy "walls" himself up "gorgeously" in imagination, Vollmann confesses, "My primary world is just this one basic 'dream world' that I've been in from the time I was a kid."[32] Jimmy is as solipsistic as Don Quixote, but given the brutal nature of the contemporary urban landscape, sheer survival is an achievement, and solipsism is a form of armor. Vollmann gives us a glimpse into Jimmy's "skull-house." He has a naive faith in the value of self-knowledge, although, as always, it is a virtue he attributes to Gloria: "without Gloria I wouldn't know myself" (78). Vollmann shows how Jimmy flitters in and out of self-awareness, oscillating between lucidity and delusion. At some points, he speaks of illusion as a vital necessity, as in one of the passages that most explicitly evokes Cervantes: "Sunglasses make the world quieter and safer, as if you are viewing things behind smoked windows fronting your skull-house: you are inside and the world is outside, and the world cannot see into you; mirror sunglasses double the armor" (50); "We all must build our worlds around us, bravely or dreamily, as long as we can we shelter ourselves from the rain, walling ourselves in gorgeously" (45). Jimmy's dream world is a prison house, but it is the only "shelter" available. His carefully cultivated illusions are the only thing he owns.

The war in Vietnam is imprinted in Jimmy's flesh and memory; the shadow of the war falls over the entire novel. Jimmy's sidekick is "Code Six," a fellow Vietnam veteran who plays Sancho Panza to his Quixote. He and Jimmy served together in Vietnam in 1968; neither has been sober since. Code Six suffers from delirium tremens; sometimes he sees dragons. Once he and Jimmy are discharged, they come home to watch the war on television. Vietnam was the first war to invade American living rooms every night on the evening news, with visions of body bags, bombed buildings, napalmed children, assassinations on the boulevard, the self-immolation of monks. America's ambivalence toward its mission and the people it supposedly wanted to liberate is reflected in Code Six's racist thoughts: "*There* are some soldiers, thought Code Six as he watched, soldiers like Jimmy and I were, fighting the fucking GOOKS and SLANTS And SLOPES, soldiers trotting single file across a smoking field . . . it was a rule of Code Six's . . . to keep the volume turned to zero because certain sounds from Nam gave him nightmares" (36). So much for making the world safe for democracy. Vollmann simultaneously manages to convey the meanness of human nature while evoking pity for Code

Six's terrors. Jimmy's post-traumatic stressed out friend "sometimes stood in the middle of the sidewalk, grey-grimed with grief, wobbling on his legs, bending and muttering and stinking," like Jimmy himself (74). Jimmy and Code Six stand for all Vietnam veterans, forgotten in a war Americans do not want to remember. The past is horror, the present bleak, the future nonexistent. Alcoholism, addiction, homelessness, despair: no wonder Vollmann calls the Tenderloin "Hanoi USA," a demilitarized zone in the inner city. The abjection of Jimmy and Code Six exposes the lie beneath all glorious constructions of masculine and military power.[33]

To Vollmann, the ultimate pornography is not sex, but war. Obscene images of war from all over the world dominate the evening news. When President Bush addressed a joint session of Congress on the eve of the Persian Gulf War in 1991, he proclaimed the end of "the Vietnam Syndrome." Bush meant that he would not send American boys into battle with their hands tied, which the military insists is what happened in Vietnam. He would make sure the United States emerged victorious. The Persian Gulf War would restore honor to the American soldier, and by extension, virility to the American male.[34] With such promises as a rallying cry, Americans supported the war, although it is now clear that the war failed to live up to its manifest destiny. Instead, diseased veterans are now watching their own bodies deteriorate from a mysterious cluster of diseases vaguely labeled "Persian Gulf Syndrome." Vollmann's research has taken him to Sarajevo, Afghanistan, Somalia, Southeast Asia; nothing, in his view, is more obscene than dropping bombs on Iraq.[35] He notes: "Pornography need not be sexual in content. The vicious mendacity of President Bush and his managers on the subject of the Gulf War is a good example of political pornography. These statements gave many Americans pleasure and disgusted me. By my standards they were obscene."[36]

There is no end to "the Vietnam Syndrome"—the more politicians repress it, the more it resurfaces, particularly when contemplating military intervention today. Whether one thinks of the ignominy suffered by returning veterans, the controversy marking the erection of the Vietnam War Memorial, or the fates of those afflicted with Agent Orange, the Vietnam War is everywhere. Michael Herr's experience is an emblem of America's: "I went to cover the war, and the war covered me."[37] The specter of our involvement in Vietnam still casts a shadow over America. No wonder Vollmann found inspiration in Cervantes's novel; he captures the fin-de-siècle melancholy of a maimed ex-soldier, striving to create out of a life of disillusion, privation, and poverty.

What becomes of Jimmy and Gloria? Although Gloria remains a cipher, Jimmy believes his rituals are bringing her ever closer; the whores' stories and Jimmy's faith make her almost palpable. But he finds it difficult "to anchor her to earth." By the end, the reader assumes that Gloria was merely a figment of Jimmy's imagination, but a sudden reversal occurs on the last page: Code Six reports that Gloria shoots Jimmy in the back. But Code Six is a notoriously unreliable narrator and his version contradicts information we have received on the novel's opening page: Jimmy killed himself by swallowing athlete's foot medicine. "Loving Gloria, he died in inconceivable agony. When they collected a sample of his urine, it melted the plastic cup.—*That,* it is safe to say, is despair" (1). That may be a tall tale, too; the real point is that Jimmy dies multiple deaths: whether he took poison or was murdered, Jimmy's existence in San Francisco was posthumous, for he "died" as a functioning human being in Vietnam.

Taken together, these two novels are a map of the political landscape over the past twenty-five years. Acker focuses on the Nixon and Ford administrations, Vollmann on the fallout from the Reagan-Bush debacle. In both, the dogs of war are omnipresent, devouring the resources that might feed the hungry and house the homeless. Politicians today have little to say about the obscenity of daily life—they just do not want art to expose it. Inquisitions are always justified by spurious appeals to moral virtues and family values, but the function of fiction is to repudiate indoctrination by family, school, and state and rewrite it through rebellion and revenge.

If the formal, stately prose in John Hawkes's *Virginie* conjures the medieval tapestries of courtly love, Vollmann and Acker conjure the pornographic imagination of R. Crumb.[38] Both Acker's and Vollmann's characters are obsessional, incantatory. Both seize the rhythms of the inner city to accentuate the crying-out theme and to expand its sociopolitical implications. Although Acker's Quixote and Vollmann's Jimmy both die at the end, the utopian potential they embody remains indelibly etched in the reader's memory. Fantasy and imagination are wellsprings of memory, a contradictory source of pain and pleasure. In words Jimmy might have spoken, Acker's heroine in *Don Quixote* proclaims: "The world is memory. I don't remember anymore because I refuse to remember anymore because all my memories hurt. . . . I'll remember: I won't repress I won't be a zombie, despite the pain, I will have life" (63). One thinks of Beckett's *Unnamable:* "I can't go on, I'll go on." Or Faulkner's *Wild Palms:* "Between grief and nothing I'll take grief." Acker and Vollmann belong in the ranks

of the stoic comedians who struggle to salvage some remnant of imagination, despite massive forces of repression. They insist on the vitality of outcast dreamers who defy society's attempts to censor and who resist all those "evil enchanters" working in concert to turn us into docile subjects.[39] Just as Acker's Quixote wants "to remake the world into love," Code Six pronounces the final elegy for Jimmy: "He coulda saved the world."

Vollmann's and Acker's achievement is to underscore the political implications of ideology while simultaneously capturing the intense yearning for connection and community. They expose all ideologies that produce ideas without bodies, ideas that develop only at the expense of the body, and instead try to think out the relationship between the mind and the body as few before them have done. All great anatomists are those on whom no genre is lost. Cervantes mocks epic, pastoral, romance, comedy, and devotional literature. Anatomists take high and low materials and tease them into art, often seducing minor genres into brilliance, as Cervantes did with Renaissance chivalric romance,[40] and as Acker and Vollmann do with Cervantes and with works in a variety of media. As Richard Kostelanetz notes:

> In practice, new fiction usually rejects or ignores the recently dominant preoccupations of literature to draw selectively upon unmined or unfashionable strains of earlier work, recording an esthetic indebtedness that may not be immediately apparent. Therefore, thanks to innovative work, certain otherwise forgotten precedents are revived in literature's collective memory. Furthermore, new work tends to draw upon materials and structures previously considered beneath or beyond fiction, as well as upon new developments in the other arts.[41]

In assessing the merit of new fiction, the critic's responsibility is at least to recognize the author's aims and identify the precedents the author is reviving. Yet not one critical essay has yet compared *Whores for Gloria* to *Don Quixote*. Acker is even less understood; she has been dismissed by some reviewers who are still hooked on realism, the very genre her novels subvert. Some critics simply despise experimental fiction. As Siegle points out, "It is quite distressing when intelligent readers grow intolerant, and it is diffcult to resist accusing the nay-sayers of political or existential cowardice as they reject the constant change that marks the cultural process. . . . None of these writers risks as profound a social anger as Kathy Acker."[42] Reviewers are generally kinder to Vollmann, although they do not always recognize the materials he revives, either. Charles Monaghan is one exception; just as today, we look back over several centuries at Cervantes, he suggests that

a century from now, readers may look upon our time as the golden age of the American novel. Certainly, there are at least three writers now living and working who can be ranked among the eight or 10 greatest novelists America has produced, joining the likes of Melville and Hawthorne, Twain and James, Wharton and Faulkner. The three are William Gaddis, Thomas Pynchon and the comparatively unknown William T. Vollmann, who is only 33 years old.[43]

By wrestling with the paradoxes of the Knight's dreams and delusions, Acker and Vollmann not only teach us to read Cervantes a little better, but also remind contemporary readers that Cervantes's irony cuts both ways: on the one hand, he satirizes the philistines, censors, and religious fanatics who have no use for imagination, idealism, or art; on the other hand, Cervantes mocks Don Quixote's literalism. Yet many of the attacks on the arts in the 1980s and 1990s are based on the premise that audiences inevitably imitate whatever they read, see, or hear. That double-edged satire is the basis of Cervantes's abiding appeal for Acker and Vollmann. They reaccentuate the subtle interplay of irony, ambiguity, and paradox, reminding us of the complex interrelationships between imagination and reality, heroism and delusion, words and deeds.

FROM WORK TO HYPERTEXT

Viktor Shklovsky argues that Don Quixote was originally conceived as a simple character, but that he grew in complexity because of the demands on him as a connecting thread between the different stories and different types of discourse in Cervantes's novel.[44] Hypertext expands the idea of Quixote as a "thread"; today we would call him a link, node, or network. Just as Orlan and Bob Flanagan are seizing new technologies in medicine to subvert old forms, narratives, and modes of being, these novelists are seizing new technologies to expand the form of fiction. They are creating new textual spaces and new spaces of knowledge. Poststructuralist theories of linguistic contradiction and undecidability paved the way for these developments, for since language has far more significations than can ever be consciously contained, no author ever "masters" language, or is fully in command of his intention. Even Balzac, considered the greatest master of realism, is not the final authority or arbiter in the house of fiction. Far from being a "cosmos in miniature," his work can be disassembled and reassembled by the reader. By performing this operation on Balzac, Roland Barthes shows how "the death of the author" gives birth to the reader. Deconstruction's detractors have long cited

this relativization of the relations between author, reader, and critic as evidence of moral relativism and cognitive nihilism, but these theories (now more than thirty years old) anticipated the advent of computers and have finally been vindicated by hypertext.[45]

Just as the reproducibility of the photograph and film liquidated the traditional value of the cultural heritage at the beginning of the century, hypertext liquidates the traditional "moral of the story," substituting simultaneity, multiplicity, indeterminacy. When William Bennett, a latter-day Gradgrind extolling the virtues of utilitarianism, was head of the National Endowment for the Humanities and later secretary of education, he urged educators to instill lessons about "the moral of the story" in the classroom, an exhortation he fulfilled himself when he wrote *The Book of Virtues*. (Unsurprisingly, tolerance is not among the virtues he extols.) Bennett exemplifies the suspicion of art which dominates the public sphere. A philosopher by training, he insists that the legacy of our classical heritage is inviolate.[46] Ironically, by opening multiple windows on reality, hypertext exposes all such coercive directives as ideological, didactic, and *quixotic*.

Hawkes, Coover, Vollmann, and Acker all engage in painstaking rewritings of "the classics" to tease out latent significations embedded in the text that are dangerous or subversive. Acker is both author and reader, a "plagiarist" who highlights and further extends the "dangerous supplement" of significations already embedded in fiction. With Hawkes, Coover, and Vollmann, she endorses the "death of the author" in such novels as *In Memoriam to Identity* by plagiarizing Rimbaud and Faulkner. Moreover, all their work fulfills Foucault's prediction that "as our society changes, at the very moment when it is in the process of changing, the author-function will disappear, and in such a manner that fiction and its polysemic texts will once again function according to another mode."[47]

That new mode is hypertext. Whereas book culture is unidirectional, in hypertext, relations lead everywhere. It breaks the bonds of linearity and stasis. The reader is fully interactive as a player in the text. Just as the myth of the inviolate body has been a long time dying, so has the myth of the inviolate literary text. But the seeds of its destruction were evident from its inception, for in *Don Quixote*, Cervantes subverts Aristotelian mimesis and defines the novel as an antiaesthetic, antilinear, dialogical genre. This aspect of Cervantes's subversiveness is yet another element that appeals to the writers I discuss here. As Robert Coover notes, "Through print's long history, there have been countless strategies to

counter the line's power, from marginalia and footnotes to the creative innovations of novelists like Laurence Sterne, James Joyce, Raymond Queneau, Julio Cortázar, Italo Calvino and Milorad Pavic, not to exclude the form's father, Cervantes himself."[48] Coover might have also cited William Faulkner, who wanted the four narratives in *The Sound and the Fury* printed in different colors, or Doris Lessing's *Golden Notebook,* which uses italics, asterisks, and marginal notations to indicate simultaneous thought processes. With the advent of hypertext, the reader can pursue various diverging and crisscrossing paths through a story or poem. Small wonder, then, that Borges's "Garden of the Forking Paths" and Coover's "Babysitter" are renowned precursors, for they celebrate the multiplicity of narrative possibilities. Stuart Moulthrop has written a hypertext version of Borges's tale; Coover's confronts readers with the fact that no single narrative is the "right" one. By illustrating how traditional reading brainwashes readers, Coover makes a fundamentally moral point about the nature of fiction and the reader's responsibility.[49]

Thus, the fact that these novelists subvert what Coover calls "the implacably linear medium of printed text"[50] does not mean that they are rejecting morality: many insist that nonlinearity is more truthful to experience.[51] (As we saw earlier, that is why J. G. Ballard insists that he is a realist.) If Burroughs and Ballard were early pioneers in the use of collage, Acker, Vollmann, and Coover are producing "a new kind of fiction, and a new kind of reading. The form of the text is rhythmic, looping on itself in patterns and layers that gradually accrete meaning, just as the passage of time and events does in one's lifetime."[52] Electronic publishing may break the stranglehold of Aristotelian mimesis for good. As Coover points out, "Much of the novel's alleged power is embedded in the line, that compulsory author-directed movement from the beginning of a sentence to its period, from the top of the page to the bottom, from the first page to the last. . . . True freedom from the tyranny of the line is . . . possible now at last with the advent of hypertext."[53]

Hypertext has also transformed the nature of *criticism:* while reading any single tale, one can call up textual variations, historical information, bibliographical and biographical data, and comparative fragments. One of the tropes in Vollmann's *You Bright and Risen Angels* (1987) involves the computer's role in presenting the narration; Larry McCaffrey notes that the glossaries, charts, and footnotes in all of his work "seem to aspire to the status of hypertext."[54] Moreover, one of the tales in Vollmann's book *The Rainbow Stories* is devoted to Mark Pauline, the engineer of Survival Research Labs, which is featured in *The Industrial Culture Hand-*

book, edited by V. Vale and Andrea Juno (who also appear in the tale). Pauline, whom Vollmann calls "My First Personality Cult," seems to be the incarnation of Vaughan in Ballard's *Crash.*[55]

Another way these authors are contributing to this new criticism is by publishing stories and novels electronically. Coover, Acker, and Vollmann have all published in *Postmodern Culture,* an electronic journal devoted to disseminating new modes of criticism and creative writing.[56] Coover is one of the leading teachers of hyperfiction at Brown University, one of several national centers. He notes that "hypertext" has already given way to "'hypermedia,' combining graphs, photographs, sound, music, animation, and film."[57] Kathy Acker's decision to transform Don Quixote into a woman makes sense when one thinks how fluid identities are in cyberspace; one can never be sure if one's correspondents have assumed an identity or a gender that bears any relationship to physical bodies.

Coover points out that hypertext's champions often assail the arrogance of the novel, but their own claims are hardly modest: they proclaim that the three great events in the history of literacy are the invention of writing, the invention of movable type, and the invention of hypertext. George Landow contrasts the pessimistic tone of poststructuralists with the hopeful tone of hypertext: "Most poststructuralists write from within the twilight of a wished-for coming day; most writers of hypertext write of many of the same things from within the dawn."[58] But Landow ignores the elegant wit and comedy of such mock-serious essays as Derrida's *Post Card,* which proclaims the end of the postal epoch while meticulously reinscribing all the traits that marked it. The text is a "perverformance": as the peripatetic French professor darts around the globe, juggling his professional and amorous obligations, he speculates on Socrates, Freud, love, and letters in an era of global telecommunications. He is frenetic, not elegiac.[59]

Furthermore, as I have argued from the outset, the interpenetration of high and low in theory, culture, and practice is one of the major tenets of the antiaesthetic mode these writers are developing. For instance, Kathy Acker discusses critical theory in an interview with Sylvère Lotringer, noting that meeting Lotringer "changed me a lot because by introducing me to the French philosophes, you gave me a way of verbalizing what I had been doing in language . . . and then when I read *Anti-Oedipus* and Foucault's work, suddenly I had this whole language at my disposal."[60] This point is crucial politically, for in many neoconservative quarters—including in the academy—critical theory remains as threat-

ening today as when *Of Grammatology* was published, as demonstrated by the controversy at Cambridge University in 1992 over the intention to award an honorary degree to Jacques Derrida.[61] It fuels controversies ranging from the publication of Bret Easton Ellis's *American Psycho* to Catharine MacKinnon's attack on anticensorship feminists and deconstruction (see Chapter 9). Although Landow elides this issue, he does signal the new threats posed by hypertext: "Electronic text processing marks the next major shift in information technology after the development of the printed book. It promises (or threatens) to produce effects on our culture, particularly on our literature, education, criticism and scholarship, just as radical as those produced by Gutenberg's movable type."[62]

In my discussion of new black British cinema (Chapter 3), I argued that filmmakers like Isaac Julien and theorists like Kobena Mercer are making us rethink the relationship between margin and center. That is precisely what hypertext has the potential to do: to invent a politics of multiple centers and plural strategies, to deconstruct and transform work, race, gender, and power relations in both the public and the private sphere.[63] I said in the prologue that the artists and writers in *Bad Girls and Sick Boys* are translators, for only they can go beyond technology to analyze its manifest and latent meaning and import. Some commentators erroneously regard new electronic communications systems merely as transparent tools that bring new efficiencies but maintain the status quo regarding family, community, and state. This view remains circumscribed by modernity, rather than postmodernity, as Mark Poster points out.[64] In contrast, the artists in these pages are using these technologies to invent new cultural formations, new spaces of knowledge, and new identities. They subvert the utilitarian goal of producing more efficient, productive subjects of hierarchy, surveillance, and control. They are devising a new strain of resistant literature—resistant to idealized visions of the autonomous human being, citizen, consumer. They are scrutinizing the kinds of subjects emerging, for better and worse, via these new technologies. Bataille's famous aphorism is never far from mind: "Transgression does not negate an interdiction; it transcends and completes it." As Bill Nichols points out in "The Work of Culture in the Age of Cybernetic Systems,"

> The transgressive and liberating potential which Bataille found in the violation of taboos and prohibitions, and which Benjamin found in the potential of mechanically reproduced works of art persists in yet another form. The cybernetic metaphor contains the germ of an enhanced future inside a prevailing model that substitutes part for whole, simulation for real, cy-

borg for human. . . . The task is not to overthrow the prevailing cybernetic model but to transgress its predefined interdictions and limits, using the dynamite of the apperceptive powers it has itself brought into being.[65]

These novelists thus endorse J. G. Ballard's prediction that "electronics will aid the inner migration" and that "our internal devils may destroy and renew us through the technological overload we've invoked" (JGB, 159, 155). Destroy *and* renew: these writers have a sophisticated vision of technology's ruses and limitations, as well as its potential. They are acutely aware that—like the Author—the computer can be an instrument of containment or transgression: it can be used either for control or to unleash a latent utopian potential. This double vision is crucial to their original and audacious contributions. Not all postmodern writers are innately transgressive, but those discussed here are simultaneously exposing and exploiting the work of culture in the age of cybernetic systems. Their perception of the "deep structure" of postindustrial society parallels Walter Benjamin's perceptions about the role of mechanical reproduction in the age of industrial capitalism. They are resisting the logic of late capitalism and commodity exchange. Their experiments are a blueprint for decentering control and disseminating the new spaces of knowledge they are in the process of inventing.

Masked Passions

MEESE, *MERCY,* AND *AMERICAN PSYCHO*

The relationship of words to deeds is central in Andrea Dworkin's *Mercy* and Bret Easton Ellis's *American Psycho,* but each novel shows how vexed that relationship is. To Dworkin, words *are* deeds. Any image, either visual or in print, of women's subordination poses "a clear and present danger" to women everywhere. The rhetoric that originally applied to sedition Dworkin appropriates for pornography.[1] On the surface, she has nothing in common with Bret Easton Ellis; she sees him as a pornographer, while Ellis sees Dworkin as a feminist Nazi. The choice to discuss them in tandem, however, has a perverse logic, for both have been the targets of hate mail and death threats, and both have had protracted legal battles. Their novels share startling similarities, too: set in New York City, both depict the predatory struggle between rich and poor. Both end with an apocalyptic vision of brutality and an indictment of American materialism. Both are "emetic" (the word Judge Woolsey used to justify freeing James Joyce's *Ulysses*): they are sexual turn-offs, not turn-ons.

Most important, both novels were dismissed as trash, a point that raises interesting issues where censorship is concerned, for it is much easier to justify censorship when a work's literary merit has not yet been established—frequently the fate of new fiction. Most major American writers were untaught in their heyday, until sympathetic critics rescued them from oblivion, as was the case of Raymond Weaver with Herman Melville, Arthur Mizener with F. Scott Fitzgerald, Philip Young with Ernest Hemingway, and Malcolm Cowley with William Faulkner.[2] In con-

trast to Cowley, many uncomprehending critics condemned Faulkner's fiction. Indeed, thirty years after publication of excerpts from *Ulysses* in *The Little Review* there was still no authoritative judicial definition of "obscene," or any judicial understanding of literary value. Judge Curtis Bok wrote the first thoughtful opinion in 1948 when he freed *Sanctuary* and *The Wild Palms*.[3] Anyone can be against censorship once a book becomes acknowledged as a masterpiece. Works should be protected precisely because recognition of their merit is seldom instantaneous, but works that may well be "trash" deserve equal protection, too.

ANDREA DWORKIN, *MERCY* (1990)

Andrea Dworkin strode into Passages, an upscale bookstore in Corte Madera, California, on September 20, 1991. She proceeded to read from *Mercy* with such intensity that she frequently gasped for breath. The affluent audience listened to one sordid description after another of hunger and homelessness, prostitution and pornography. Dworkin's semiautobiographical narrator (named Andrea) is successively victimized by childhood sexual abuse, rape, imprisonment, and madness.[4] Since Dworkin blurs the lines between fiction and autobiography, the audience had no idea how to respond to Dworkin during the discussion period. I slyly remarked that her prose style (not content) reminded me of Kathy Acker's raw, spontaneous emotion—an idea Dworkin found offensive. (Later, I remembered how Acker makes Dworkin the butt of satire.) She also rejected the audience's suggestion that therapy could reform violent men; the only surefire remedy, she argued, was for women to kill men.

That is also the "final solution" that *Mercy* posits, after documenting the inexorable fury and disintegration of the author-narrator. "Andrea" was born in Camden, New Jersey, in 1946, misunderstood by parents, teachers, and friends. By the time she was ten, she had been sexually abused several times. Between the ages of eighteen and twenty-seven, Andrea experienced the full force of "Amerika's" power, imprisoned for anti-Vietnam activism. Dworkin is not interested in rational arguments. In Marin County, she confessed that she wrote *Mercy* specifically because she was sick of logical debate over pornography. She wanted to show how pornography *feels* to its victims. (The novel's basic premise is that any woman involved with either the production or consumption of porn is a victim.)

Mercy is a manifesto, but Dworkin consistently confuses cause and effect. Although she is a lesbian, Dworkin dismisses lesbian porn as "male

identified . . . reifying the status quo."[5] Any lesbian who enjoys porn is a victim of false consciousness. To her, porn is porn, case closed. Holly Hughes, a lesbian performance artist whose National Endowment for the Arts funding was rescinded, disagrees: "If you argue that getting the *Playboys* out of the 7-Eleven is going to drive down the rape rate, then you also have to give credence to the religious Right's claims that representations of gay and lesbian lives are going to cause homosexuality."[6] *Mercy* is polemic masquerading as fiction. In this regard, it is consistent with Dworkin's previous work. A brief history helps contextualize *Mercy:* Kate Millett's *Sexual Politics* was published in 1970, the same year the Lockhart Commission on Pornography recommended repealing obscenity laws. In *Mercy* the symbol of female sexual slavery is *Deep Throat,* which premiered in 1972. Dworkin published *Woman-hating* in 1974. By the end of the 1970s, feminist antiporn organizations proliferated, including Women against Pornography (New York), Women against Violence against Women (Los Angeles), and the Pornography Resource Center (Minneapolis).[7] Dworkin published *Right-Wing Women* in 1978 and *Pornography: Men Possessing Women* in 1981. With Catharine MacKinnon, she published *Pornography and Civil Rights* and drafted antipornography ordinances in Indianapolis and Minneapolis in 1983–84; these ordinances were subsequently tested in Suffolk County, New York, in 1983, and in Los Angeles and Cambridge, Massachusetts, in 1985, the same year that President Ronald Reagan convened the Meese Commission on Pornography, led by then Attorney General Edwin Meese. In 1992, MacKinnon delivered the Christian Gauss Memorial Lectures in Criticism at Princeton University, subsequently published as *Only Words.*

Only Words and *Mercy* must be read (and virtually seem to have been written) in tandem, for together they provide a comprehensive overview of the rhetoric and logic of the antiporn movement. The cornerstone of that logic shifts the punishment for pornography away from criminality and into the arena of civil rights. The fundamental precept involves what legal scholars call "the viewpoint of harm": if you depict any image that I maintain is harmful to me, I can sue you on the grounds that you have violated my civil rights. For the first time in history, then, *censorship* would be a means of *furthering* civil rights. Supporters of the ordinance compare the critique of pornography with the critique of racism.[8] This is precisely Dworkin's strategy in *Mercy,* in which Andrea equates women in the porno industry to blacks during slavery: if a black man were being

lynched, Andrea would rush to his aid, but no one rushes to help the women on Forty-second Street. But by equating slavery with strip shows, Dworkin trivializes slavery and strips it of historical specificity.

The rhetorical force of her argument, indeed, depends on defining pornography as a trans-historical phenomenon, the core of women's oppression, as a diagram entitled "The Condition of Women" in *Right-Wing Women* illustrates (Fig. 35). In this graph, Dworkin depicts concentric circles radiating outward from a central core. Pornography is that core. The graph makes explicit her faulty cause-and-effect logic: porn is responsibile for all the varieties of exploitation women have endured throughout history. She thus takes a remarkably complex set of circumstances and conditions and reduces them to an oversimplified diagram.

Dworkin makes no attempt to distinguish material that is sexually explicit from that which is sexist, or from that which is violent: all three categories are equivalent.[9] As Donald Downs notes, "for Dworkin, pornography . . . is the microcosm that reflects the macrocosm of patriarchal society."[10] By defining porn as the *core* of women's oppression, Dworkin ignores all the other pressing economic and social realities women have confronted in each country and each specific historical period: rigid patriarchal structures in home, family, and church; limited access to education; inadequate social services and health and child care; lack of protection from police and the law. The assumption that once pornography is eradicated women's oppression will vanish is disproved in countries like Saudi Arabia and Iran, where women's rights are suppressed as ruthlessly as pornography is. Dworkin's legislation, moreover, is racist and discriminatory; it worsens the situation of poor women, women of color, single mothers, lesbians, and immigrant women—all those who are first to feel the effects of economic recessions, cutbacks in social services, and the reversal of affirmative action. The antiporn movement blithely attempts to unify people who are in reality divided by class, race, and sexual preference.[11]

Since affluent neighborhoods have been transformed into gated communities armed with security systems, the true core of the inner city has become where homeless people and prostitutes are subject to constant surveillance. Since Ronald Reagan took office, police have gained far greater summary jurisdiction over the poor than ever before; the writ of habeas corpus can be suspended in drug busts, and the suspect's property (including all property necessary to support one's livelihood) can be confiscated indefinitely. The 1996 antiterrorism bill passed by Congress

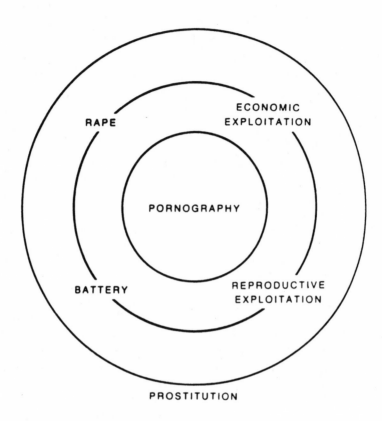

Figure 35 Andrea Dworkin, "'The Condition of Women':
Pornography as the Core of Women's Oppression." In
Andrea Dworkin, *Right-Wing Women* (New York: Coward-
McCann, 1978).

was the last nail in the coffin of habeas corpus; federal courts must now
defer to the state court's decision, unless it was "arbitrary" or "unrea-
sonable." The bill permits immigrants, including permanent and tem-
porary residents, to be deported on the strength of secret evidence that
neither the immigrant nor his or her attorney would ever see. It also rein-
troduces the concept of guilt by association: any foreign group can be
labeled as "terrorist" by the secretary of state; it then becomes a crime

to support even the *lawful* activities of that group—a direct contravention of the Supreme Court's rulings in the wake of McCarthy-era smear tactics.[12] Meese commissioner Park Dietz has proposed cutting the criminal justice system loose entirely from the construct of free will, or the "guilty mind," with the result that criminal justice would be shorn of its punitive aspect. The primary function would be incarceration for life.[13] Dietz's "carceral imagination" is not only far from fanciful, but well on its way to fulfillment.

MacKinnon and Dworkin also contributed to this punitive project by defining pornography as "the sexually explicit subordination of women, graphically or in words." As Downs reports, however, the notion of "subordination" is vague and broad enough to cover a wide amount of material presently protected by First Amendment law, which is why Judge Sarah Evans Barker (a Reagan appointee) invalidated the Indianapolis case *American Booksellers Assn. v. Hudnut* on November 19, 1984. The U.S. Court of Appeals in Chicago (7th circuit) upheld her decision on August 27, 1985.[14] The Dworkin-MacKinnon ordinance breaks with past legal precedents regarding obscenity in another important respect, because it eliminates the defense that publishers, retailers, or distributors did not know the nature or contents of the material. As in the Hicklin doctrine of 1868, it permits censorship on the basis of even a single isolated passage, in contrast to the requirement in *Miller v. California* that the material be "taken as a whole."[15] Thus, following Hicklin's standards, action could be brought even against a broadcaster if an abnormal person committed a sexual crime inspired by something he or she heard or saw. In fact, the new law is even more repressive than the Hicklin doctrine, for if a plaintiff can demonstrate that a sexual assault resulted from her attacker's exposure to pornography, then not just the rapist but the producers, distributors, booksellers, art museums, or video stores who sold the alleged pornography can all be sued.[16]

The most sweeping transformation involves language itself, for MacKinnon's ironically titled *Only Words* reveals just how literally she and Dworkin are in their insistence that words are deeds, and that words, images, and representations are the source of harm. Drawing on the speech act theories of John Searle and J. L. Austin, they argue that pornography is not expression, but action. Pornography should be defined as a species of "group libel" or "fighting words": "by their very nature [they] carry the immediate potential for injury."[17] Not only is this another evocation of the "clear and present danger" rhetoric, but it insists that danger is imminent. *Only Words* begins:

> Imagine that for hundreds of years your most formative traumas, your daily suffering and pain, the abuse you live through, the terror you live with, are unspeakable—not the basis of literature. You grow up with your father holding you down and covering your mouth so another man can make a horrible searing pain between your legs. When you are older, your husband ties you to the bed and drips hot wax on your nipples and brings in other men to watch and makes you smile through it. Your doctor will not give you drugs he has addicted you to unless you suck his penis.[18]

Under MacKinnon's own legislation, this passage could be banned, since it can be taken out of context and extracted from the whole. The confrontational use of "you" works rhetorically to personalize the issues, while simultaneously transforming porn into a trans-historical phenomenon ("for hundreds of years"). The ontological foundation of female subjectivity, the passage implies, is victimization, sexual subjugation, and powerlessness. The essence of masculinity, conversely, is the use of sex as violence; the abuse of power and authority by fathers, husbands, doctors; the equation of the penis with naked aggression. As Carlin Romano points out, MacKinnon "exalts the ideology of victimization" where women are concerned while remaining "utterly oblivious to how her writing about men mirrors the ways of talking about women that she despises. Nothing infuriates her more than men calling women 'cunts'—*prima facie* cases of sexual harassment in her view—yet she repeatedly reduces men to penises and erections."[19]

That reductiveness recalls J. G. Ballard's MacKinnon-like Dr. Rafferty, the feminist zealot in *Rushing to Paradise* who is determined to eliminate men from the species. If words are deeds, then an editorial criticizing the president is treason.[20] When Romano tried to demonstrate this point by turning MacKinnon's own rhetorical strategies against her, all hell broke loose: he received hate mail, threats, attempts to sabotage his career as literary critic of the *Philadelphia Inquirer,* including, according to some reports, veiled threats from MacKinnon's allies.[21]

Mercy is a grudge novel, written to settle some scores. Judgment is Dworkin's theme: Andrea is a female Job, railing against God's silence before the sufferings of women; railing against Birkenau, the mass suicides of Masada, the world's history of rape and torture of women: "A blind fury pushed you out of [the womb] onto this earth, this place, this zoo of sickies and sadists. You are an avenging angel; you have a debt to settle; you have a headstart on suffering" (166). One of the scores she settles is with anticensorship feminists. Dworkin frames her narrative with the cool, dispassionate analysis of a "so-called pro-pornography femi-

nist." This character is named Not Andrea, which reveals how stark the polarity is between those *with* Dworkin and those *against* her.

All said, there is surprisingly little mercy in *Mercy*. A better title would be *Intolerance*. It is as if Bertha Mason took over the narrative of *Jane Eyre;* indeed, if MacKinnon has proved expert at using the master's tools to dismantle his mansion of legal fictions, Dworkin is Bertha, the dark double, who would burn the house down. Not only is there no redemption in *Mercy*, there is no catharsis—except that which comes from killing, and surprisingly, it's *Andrea* who gets off on killing. Here's a surprise one would not expect in *Mercy*, which is allegedly at the other end of the spectrum from Ellis's "splatter fiction": the heroine ends by murdering drunk homeless men: "I like to pick on men at least twice my size . . . I pick them big and mean, the danger psyches me up but what I appreciate is their surprise, which is absolute, their astonishment, which invigorates me; how easy it is to make them eat shit; they will always underestimate me . . . I fucking smash their faces in . . . I kick them blind . . . another girl for choice" (324–25).

With the logic of the mad, Andrea concludes that men will not stop raping women until women start killing them—the same exhortation Dworkin made in Marin County. Andrea is judge, jury, and executioner. Despite the novel's title, Andrea's vengeance relentlessly proceeds with mercy toward none. Rather than resolving the dilemmas the novel poses, Dworkin's solution is as exquisitely simple as Kurtz's in *Heart of Darkness:* "Exterminate all the brutes!"

CENSORS AS PERVERTS: THE MEESE COMMISSION ON PORNOGRAPHY

The Meese Commission repudiated Dworkin's lesbianism and feminism but appropriated her ideas. The 1,960 pages of *The Attorney General's Commission on Pornography Final Report* (1986) depict Zeal in the Land of Busy, for the range of documents catalogued would enervate even the most motivated masturbator: 725 books, 2,000 magazines, and 2,300 films were studied. The taxonomic skills of the commissioners would inspire envy in Sade: they alphabetized the porn, detailing in Dragnet-style prose the acts, positions, and perversions involved: "Naked caucasian-female lying on her back with two male caucasian erect penis [sic] touching her cheek, next to her wide open mouth."[22] This is the kind of clinical, seemingly emotionless language of experts that J. G. Ballard satirizes in *The Atrocity Exhibition.* One FBI agent unintentionally evoked mirth when he described the dirty photos he confiscated, including the terrify-

ing one of a "woman surrounded by a vagina." On publication, the *Final Report* immediately sold out, which led ACLU lawyer Barry Lynn to quip, "I fully defend my government's right to publish filth."[23] In San Francisco, lesbian sex worker Susie Bright cheerfully confessed, "I masturbated to the Meese Commission Report, until I nearly passed out—it's the filthiest thing around! And they know it."[24]

One could argue that both the 1970 and the 1986 commissions were merely political spectacles, but the Meese Commission was flagrantly ideological. As the Meese commissioners themselves emphasize, they were at a distinct disadvantage: the Lockhart Commission (empaneled by Lyndon Johnson in 1968, although its report was not published until 1970 when Nixon took office) was allotted over $2,000,000, whereas the Meese Commission had a scant $500,000, which, when inflation is computed, meant that the first commission had sixteen times the resources of the second one. The 1970 commission spent two years compiling its findings, while the Meese Commission spent only one. In 1970, over eighty studies examining various aspects of pornography were funded, including national in-person surveys of public attitudes, correlational studies, and causal links between pornography and violence. None was funded in 1986.[25] The 1970 panel, which was well balanced between liberals and conservatives, not only commissioned original research, but invited more than one hundred national organizations to express their views, which represented the entire ideological spectrum. It devoted 25 percent of its report to "Positive Aspects of Sexuality," including proposals for sex education.[26] (Today, more than twenty-five years later, the systematic dismantling of sex education seems criminal since young people are among the fastest-growing population at risk from AIDS.) From the outset then, the 1986 commission's research and conclusions were deeply flawed. It made no attempt to disguise its ideology, epitomized by Reagan's comments when he convened it: "We had identified the worst hazardous waste sites in America. . . . It was about time we did the same with the worst sources of pornography."[27]

Although the Meese Commission became known as the "F-troop of the erogenous zones," its impact is no laughing matter. Edwin Meese boasts that in 1983–84, there were 6 indictments for pornography; between 1989 and 1990, there were more than 110.[28] Imagine the surprise of "respectable" corporations like RCA, CBS, Ramada Inns, Warner Communications, and the Southland Corporation (owner of 7-Eleven stores) when on February 11, 1986, they were notified that they had been identified as distributors of porn; they had thirty days to respond or be

identified as "pornographers" in the *Final Report*. This is why the Meese Commission became known as "the McCarthy hearings of sex." The 7-Eleven stores subsequently removed not just *Playboy* and *Penthouse* from their shelves, but also *Rolling Stone* and *Cosmopolitan*. To facilitate maximal surveillance, the Meese Commission recommended numerous punitive measures: change state misdemeanor statutes to felonies; make mandatory a minimum sentence of one year for any violation of federal law involving obscene material; exploit RICO (Racketeer Influenced Corrupt Organizations) provisions in obscenity cases. The Justice Department jump-started the notorious National Obscenity Enforcement Unit (NOEU). Laws against child pornography are already on the books (*New York v. Ferber* 458 U.S., 747 [1982]), but NOEU pressured states to redefine child pornography to include photographs and films of minors in conditions of immodest nudity, seeking thus to curtail the freedom of photographers to photograph children nude or partially clothed—even when the photographer is their parent, as in the case of Sally Mann.[29] Fine-art photographer Jock Sturges was robbed of his livelihood for over a year after his equipment was seized (some of it irreparably damaged) in a San Francisco raid on his home-studio in 1990, but the grand jury refused to indict him for any crime.

Edward de Grazia highlights the bias against film and photography in particular,[30] which helps to explain why the Robert Mapplethorpe affair was utterly overdetermined. After the show was canceled by the Corcoran Gallery in Washington, D.C., in 1989, it moved to Cincinnati, where Dennis Barrie and the Cincinnati Contemporary Arts Museum in 1990 became the first director and first museum ever indicted for the archaic offenses of "pandering obscenity" by illegally displaying Mapplethorpe's photos of nude or partially nude children. Although this point is seldom mentioned, I think what most enraged prosecutors and politicians like Jesse Helms was that a gay man took the nude photos of children. But the Meese Commission and NOEU had already paved the way for such prosecutions. Alan Sears, the Meese Commission's executive director, was instrumental in advancing the Cincinnati prosecutions; today Sears works for a right-wing fundamentalist organization called the National Coalition against Pornography. Donald Wildmon, Pat Robertson, and Ralph Reed have become potent political forces, as have two former Meese commissioners, James Dobson, president of Focus on the Family, and Gary Bauer, head of the Family Research Council. Dr. Dobson "is one of the best-kept secrets in America . . . extremely influential"; when he asked radio listeners to protest a bill that would have restricted

home schooling, the congressional switchboard was paralyzed by nearly a million calls. Senator Dole consulted Bauer before delivering his tongue-lashing of Hollywood in October 1995. Today Bauer is "one of the most vigorously courted figures in the country," one who forced "all the candidates to compete with each other for this agenda,"[31] which is why Senator Dole, Pat Buchanan, Lamar Alexander, Richard Lugar, and Phil Gramm dutifully trooped to the Road to Victory conference in Texas in the fall of 1995 to enlist the religious Right's support before the 1996 primaries. (They would not permit Arlen Specter, a Jew opposing their agenda, to share the podium with his presidential rivals.)[32]

Just as the Meese Commission ignored Andrea Dworkin's lesbianism and feminism, they ignored the possibility that dysfunctional families and psychosexual disturbances might have origins in anything besides porn. At no point did any commissioner suggest strengthening sexual harassment laws, or removing spousal immunity in sex assault cases, or enhancing sex education. They failed to establish a direct cause-and-effect relationship between consuming porn and violent behavior. Contrary to popular mythology, child pornography is seldom a factor in child abuse cases; moreover, laws against child porn are already on the books.[33] At no point did any commissioner suggest that society needs a children's bill of rights, which might provide children with economic independence. Runaways do not go into prostitution because their parents see pornography; instead, they are forced to a life on the streets because there are no social services to protect them. A children's bill of rights would give children the right to be sexual (including gay or lesbian) while protecting them from unwanted sexual contact. Ending child and spousal abuse depends on changing the way family life is lived in our society,[34] something the Meese Commission was not prepared to do.

It is easy to be against pornography in theory, until one tries to tackle its policing in practice. Censor boards rarely consist of the rational and tolerant people one finds among gays, transsexuals, or sex workers. The reality is that men like those on the Meese Commission will be deciding what we get to see, read, write, and say. Who are these men, and what has become of them since serving as Meese commissioners?

Father Bruce Ritter received the first annual Charles Keating Award and $100,000 for establishing Covenant House for runaway boys in New York City. Father Ritter insisted that only missionary-style sex between heterosexual married couples is permissible. He condemned Dr. Ruth Westheimer for being a "pornographer," since she extolled orgasms in premarital sex. Father Ritter was eventually relieved of his duties at

Covenant House when two men charged that they had been molested by him years earlier, as runaways in residence. He was also charged with misappropriation of funds.

Perhaps the most fascinating commissioner was Dr. Park Elliott Dietz, a forensic psychiatrist and criminologist who specializes in violent crime and sexual disorders. Dietz maintains that aberrations develop when young males masturbate to images of deviant or criminal behavior, yet even he has admitted that detective magazines may have far more impact on serial killers than porn does.[35] What has become of Dr. Dietz? During the Clarence Thomas–Anita Hill Senate Judiciary Hearings, senators Joseph Biden, Alan Simpson, Orrin Hatch, and Arlen Specter frequently used such psychiatric labels as "fantasist" and "erotomania" to discredit Anita Hill. That clinical "spin" was supplied by Park Dietz, although it is clearly unethical to diagnose a woman whom he had never met.[36] Ironically, Catharine MacKinnon defends Anita Hill, but sees no contradiction in working behind the scenes on the Meese Commission with the same man who provided the ammunition to smear Hill.[37]

Dietz has never treated any patient, nor does he have any patience with traditional psychiatry's emphasis on the origins of neurosis and psychosis, the nexus of family relationships, or the vicissitudes of psychic life. As we shall see in *American Psycho,* one of the chief traits of the serial killer is his identification with machine technology, media, and a contagious relation to the subjects he imitates. Joyce Johnson's profile of Dietz reveals chilling points of resemblance between Dietz and Jeffrey Dahmer: Dietz's father trained him to conquer his queasiness by showing him surgical procedures over the dinner table; he learned to "isolate affect," to use "desensitization" as a defense mechanism, and to decrease emotional response through repeated exposure. Dietz interrogated Dahmer about how he held the knife when dismembering bodies, how he avoided acid burns when soaking them, how he preserved skulls: "It was more the feeling of one specialist comparing notes with another," and, though he hesitated to use the word, he confessed that meeting Dahmer was "a treat."[38] Dahmer is the mirror image of his forensic pursuers.[39] Dietz never testifies for the defense, only for the prosecution, even in such cases as that of Kenneth Sequin, who murdered his wife and two children as the result of psychotic delusions that led him to believe he was taking them into the afterlife. Sequin's attorney bluntly ridiculed Dietz's expertise: "Dr. Dietz sees things through the eyes of the prosecutor, through the eyes of the New York State Police, the FBI. [He] is a wonderful actor. . . . Just as an actor can convince you by his role-playing

that he is a psychiatrist, so can Dr. Dietz. But no one would ever contend that an actor truly has a psychiatric opinion that is valid."[40]

The FBI and the Bureau of Alcohol, Tobacco, and Firearms apparently disagree, for Park Dietz was among the experts advising them how to handle David Koresh and the Branch Davidians in Waco, Texas, on April 19, 1993.[41] The result was 80 men, women, and children dead; 168 dead in the subsequent bombing of a federal building in Oklahoma City, on April 19, 1995, which Timothy McVeigh allegedly claims was carried out on the anniversary of Waco as revenge. Responding to an inquiry about his lack of medical training and practice, Dietz responds defensively: "Physicians! They're so removed, they don't understand what's really affecting people. They're worrying about things that happened twenty years ago and asking people about the impact on their families and they just don't get it—how the culture is dramatically changing."[42]

Where should physicians look instead? To "the culture" in general, particularly "popular culture," specifically Hollywood. For a specialist whose aim is to dismantle the insanity defense, Dietz's blaming popular culture for society's "core" problem is as simplistic as Dworkin's blaming porn as the core of women's oppression and MacKinnon's blaming deconstruction for porn. Dietz explains: "When I get to the bottom of each problem I look at, I keep finding television, Hollywood, the media, an unregulated industry standing behind the First Amendment, and gaining power despite their harmfulness, because they—unlike everyone else—needn't be accountable or compensate their victims. They should pay for the harm that they do."[43] Dietz here repeats almost verbatim the Meese Commission's justification for focusing on harm. (The influence of MacKinnon and Dworkin can be seen throughout the report; volume two includes "The Question of Harm"; "Harm and Regulation"; "What Counts as Harm?"; "Our Conclusions about Harm"; and "Victimization.") Although the commission was specifically organized to refute the findings of the 1970 Lockhart Commission, it was forced to concede that it reached many of the same conclusions: no empirical evidence proves that explicit sexual materials cause sex crimes, violence, or criminal behavior. The *Final Report* drew extensively on the research of Daniel Linz and Edward Donnerstein, psychologists who have since disassociated themselves on the grounds that their research was distorted by the commission. The commission was forced to concede that "pornography and obscenity" are impossible to define.[44] As a result, they relied on anecdotal evidence and personal testimony; one pathetic individual after another testified that pornography led to masturbation which led to alco-

holism, drugs, unemployment, dysfunctional relationships—everything but blindness.

The handiwork of MacKinnon and Dworkin is clearly evident in the emphasis on harm in Senate Bill 1521, the Pornography Victims' Compensation Bill, which would allow "victims" of porn to sue producers and distributors of obscene films and books on the grounds that the material contributed to the crime. *The Accused* is one film that could be banned, since it depicts a gang rape. The bill would result in book banning by bankruptcy, because it enables litigants to bring frequent lawsuits for unlimited money damages against booksellers.[45] John Irving's friends at PEN report that numerous women have written PEN saying that they view Bill 1521 as "payback" for the Senate Judiciary Committee's mishandling of the Clarence Thomas–Anita Hill hearings. By this logic, Irving notes, men should write the committee arguing for *more* pornography as "payback" because Mike Tyson was found guilty of rape.[46]

The only commissioner who has the dubious distinction of serving on both the 1970 Lockhart and the 1986 Meese commissions was the porn watchdog of Cincinnati for over thirty years. In 1957 Charles Keating used his vast wealth to establish the CDL, which first stood for Citizens for Decent Literature, then Citizens for Decency through Law, then the National Coalition against Pornography, and (as of 1990), the Children's Legal Foundation. Fellow Meese commissioner Alan Sears is legal counsel. Keating bankrolled the legal arm of the antiporn far Right, which helps to explain why Cincinnati became the first city ever to indict an art museum and its director. He subsequently looted Lincoln Savings and Loan and defrauded its parent company of more than $250 million. In 1992, Keating was convicted on seventeen charges of fraud and sentenced to ten years in prison; on January 6, 1993, he was found guilty in Los Angeles of seventy-three federal counts; he has cost U.S. taxpayers $2.6 billion. The *Los Angeles Times* reported that U.S. District Judge Mariana R. Pfaelzer sentenced him to twelve years and seven months, which must be served concurrently with his ten-year term. The *Times* reports that the savings and loan industry disaster may eventually cost U.S. taxpayers $500 billion.[47] In view of the Meese Commission's reliance on the viewpoint of harm, the justice meted out seems poetic as well as juridical, for Judge Pfaelzer added seven more years to the five-year mandatory penalty dictated by federal sentencing guidelines because "the scope and reach of the instant offense is staggering. . . . The guidelines do not reflect the total *harm* to the community."[48]

But the damage Keating caused is far more extensive than this, and

most of it never made its way into either the news or the courtroom. When Congress passed the Garn–St. Germain Act in 1982, which deregulated the thrift industry, they opened the floodgates for unscrupulous practices, junk bonds, risky investments, and corruption. Michael Milken and his brokerage firm, Drexel Burnham Lambert, quietly bought Lincoln Savings and Loan for Charles Keating—a transaction done *so* quietly that even bank regulators failed to notice. In 1986, Lincoln invested $100 million in the Ivan Boesky Limited Partnership, with Drexel charging a $4 million brokerage fee. When Boesky lost the thrift's money, he was not on the hook, Drexel was not on the hook, and Lincoln was not on the hook. The taxpayers were.

Keating made many other strange deals: in 1987 Lincoln made a $30 million loan to a company controlled by two close political associates of Sen. Dennis DiConcini of Arizona; they had huge liabilities, yet paid no collateral. Here, too, the principals were not left holding the bag, the taxpayers were. Finally, when Bank Board chairman Edwin Gray began investigating Keating, President Reagan's chief of staff, Donald Regan, first tried to fire Gray, then threatened to arrest him (for enforcing the law). Keating hired Alan Greenspan, then an economist in private practice, to certify that Lincoln "poses no foreseeable risk to FSLIC." An emboldened Keating began selling worthless bonds issued by his holding company, American Continental, to thousands of people, many of them orphans and elderly.

Today, the General Accounting Office estimates that the savings and loan fiasco will cost the nation $380 billion, yet the Clinton administration and the 106th Congress are again looking at banking deregulation, going so far as to contemplate opening the way for ownership of banks by commercial firms. This suggests that they did not learn a thing from history. Alan Greenspan is now chairman of the Federal Reserve Board. Michael Milken and Ivan Boesky are both out of jail. On October 3, 1996, Keating was released, too, following a court ruling that jurors at his 1993 federal trial had been inappropriately influenced by their knowledge of Keating's conviction in California State Court. The remainder of his criminal convictions were thrown out by a federal district court on December 2, 1996. His state convictions had been overturned in April 1996, because the trial judge gave improper instructions to the jury. That trial judge, who subsequently turned the O. J. Simpson murder trial into a circus, was Lance Ito.[49]

The inevitable question is, Should lawmakers be monitoring dirty pictures or dirty bankers? Charles Keating exercised the raw political power

of a sovereign nation. Father Ritter is the Catholic Church's worst night-
mare. Park Dietz makes *Crash*'s Vaughan look like Rebecca of Sunny-
brook Farm. All three remind us again of J. G. Ballard's portrait of the
sick souls of society's putative caretakers. The inescapable conclusion is
that if men like these are allowed to "protect" citizens from pornogra-
phy, we citizens are also at their mercy.[50]

BRET EASTON ELLIS, *AMERICAN PSYCHO* (1991)

Ironically, the heroes of Bret Easton Ellis's novel are Michael Milken,
Ivan Boesky, and Donald Trump. The only problem is that the narrator
who idolizes them is a psychopath. Ellis's narrator is a Wall Street stock-
broker, Patrick Bateman, whose name (echoing Norman Bates in Hitch-
cock's *Psycho*) suggests his predatory way of baiting his victims. He is a
serial killer interested in designer drugs. No matter how much stimula-
tion he gets (from sex, commodities, television, music, food, drugs, even
murder), he remains completely anaesthetized.

We have already seen how David Cronenberg and Brian De Palma
graft pornography and horror in film. Ellis translates the codes and con-
ventions of those two film genres into fiction. That is no small feat. Like
De Palma, Ellis records the humor of obsessional compulsions: Bateman
has seen *Body Double* thirty-seven times. By combining horror and porn,
Ellis "turns off" the audience. The detailed descriptions of gruesome mur-
ders encapsulate the entire history of horror as a film genre, from *Psy-
cho* to *Friday the 13th, Halloween,* and their sequels. The novel's con-
nective tissue is a series of cinematic clichés: the helpless coed, the
voyeuristic stalker, the desire to turn the body inside out.

In "The Twenty-somethings: Adrift in a Pop Landscape," a prescient
essay published shortly before *American Psycho*, Ellis characterizes the
impact of television, film, and music on people born between 1961 and
1971. He describes the "overlay of freakishness" of the sexuality in films
like *Blue Velvet* and *9½ Weeks,* and shrewdly notes that in horror films,
"twenty-something audiences often root for both" hero and villain, one
of whom "gives us a knowing wink by capping off the slaughter with an
ironic fillip."[51] In short, he reminds us of the distance between repre-
sentation and reality. *American Psycho* merely codifies the conventions
in these films, while duplicating their "willing suspension of disbelief."

Ellis also reminds us how to read allegory, for the novel is an allegory
of Reagan's America. Just as J. G. Ballard wrote "Why I Want to Fuck
Ronald Reagan" to accentuate the aggressive anality of Reagan's gu-

bernatorial regime, Ellis uses cannibalism as an allegory for the consumptive greed of the Reagan administration.[52] *American Psycho* demonstrates that pornography, drugs, television, and advertising all share the same aim: to *capitalize* on anxiety. The aim of ads is to inspire envy: to make you want what others own. Beneath that message, society propagates belief in itself: the Pepsi generation, the heartbeat of America, and so on. Where ads promise happiness, porn merely promises pleasure. Moreover, magazines like *Hustler* routinely ridicule society's most cherished illusions. Romance, youth, beauty, truth, democracy, justice, equality, success, and capitalism are all targets of Larry Flynt's satire. *Hustler* has even featured graphic pictorials on the consequences of venereal disease, hardly the typical turn-on.[53]

Why do not more people complain about the latent pornography of even the most innocuous television commercials? The average cold or laxative commercial on television celebrates the violence of inequality by depicting women as doting slaves to the normal functioning of their husbands' bronchial tubes or bowels. Only pornography explains *why* such ads are effective: the slavishness of women is erotically thrilling.[54] *American Psycho* puts the buried message under a microscope, magnifying the commercialization of mass culture by taking it literally.

The novel also satirizes Americans' widespread belief that they are victims of sexual repression. The cure for such repression is constant talk about sex—on television shows hosted by Oprah Winfrey, Phil Donahue, and Geraldo Rivera. If we can just unlock the mysteries of sexuality, so the argument goes, we will discover the authentic identity from which we have become alienated. Ellis mercilessly exposes the fallacies in these cherished assumptions. He satirizes television talk shows to demonstrate that, far from being repressed, our culture is relentlessly obsessed with staging sex, *with making sex speak*. Talk shows capitalize on voyeurism. They are the real "how-to" manuals in our society: how to get a date, how to be a good lover, how to find happiness and the "G spot." Such seeming interest in the welfare of the individual masks the real function of television, which is to make us buy things. The result: we think of ourselves as a market rather than as a public, as consumers rather than as citizens.[55] Guests on talk shows are on a par with the products advertised: their shared motive is maximal exposure.

Is *American Psycho* more "psycho" than the average spate of topics on television talk shows? *Time* magazine (October 14, 1991) charted the formula for a successful ratings sweep by linking one item from each of four columns (Fig. 36).

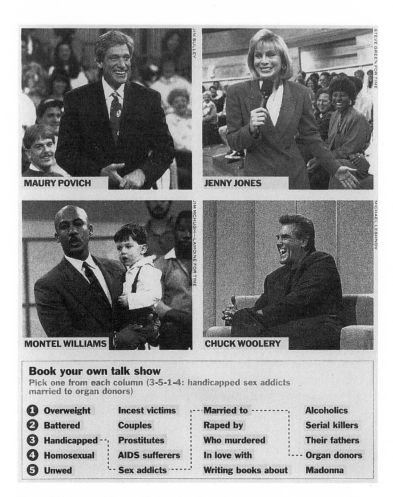

Figure 36 *Time* magazine, article on television talk shows (October 14, 1991). Copyright 1991 Time Inc.

The images of the talk show hosts are as revealing as the chart, for they grin at the camera while they encourage their guests to confess every conceivable vice, dysfunction, or perversion. Each host tries to mime solicitude, when the host's true motive is to excite the audience. The upbeat demeanor, the canned compassion and canned applause are all the more incongruous when juxtaposed with the sordid tales of incest, abuse, and perversion exposed in the telltale graph. Moreover, the photo exposes the hosts' true motive, which is to beat their competitors in the ratings.

How many formulaic elements can one find in *Mercy*? *Battered unwed lesbian incest victim raped by alcoholics, writing a book about how pornography drove her insane.* In *American Psycho*? *Unwed sex addict serial killer, who murders prostitutes, in love with Whitney Houston* (substituting for Madonna). Since I began writing this book, many more elements of popular culture have been targeted by politicians, including the talk shows just mentioned.

American Psycho resembles a novelistic version of *Consumer Reports*: it is a how-to guide to the best clothes, food, furniture, stereo components, rock and music videos money can buy. It is also a how-to manual about one-upmanship: how to get the best table in restaurants; how to get tickets to sold-out Broadway shows; how to get preferential treatment everywhere. Ellis depicts a society that fills every minute of the day with salesmanship and self-promotion: talk show experts, politicians, entrepreneurs, rock stars (U-2's Bono), movie stars (Tom Cruise), military men on the lecture circuit (like Oliver North, whom Bateman idolizes). We consume celebrities. As Guy Debord notes, their function is to live for us: "Under the shimmering diversion of the spectacle, banalization dominates modern society. . . . The celebrity, the spectacular representation of a living human being, embodies this banality by embodying the image of a possible role. Being a star means specializing in the seemingly lived; the star is the object of identification with the shallow seeming life that has to compensate for the fragmented [lives] which are actually lived."[56] Ellis captures this banalization to a tee—that is what makes the novel difficult (and purposely tedious) to read.

Since Ellis never mentions F. Scott Fitzgerald, no one seems to have noticed that he has seized one sentence from *The Great Gatsby*: Nick Caraway describes listening to Jay Gatsby's story about the sad thing that happened to him in his youth as being like "skimming hastily through a dozen magazines."[57] *American Psycho* merely *literalizes* that idea: reading it is like skimming *GQ, Rolling Stone, Interview, Playboy, Hustler, Spy,* and *New York Magazine,* complete with music and food reviews. If

Ellis borrows from Jay Gatsby the motif of serial self-invention, his great-est debt is to Dostoyevsky's *Notes from Underground*. Ellis adapts the underground narrator's lament:

> Leave us to ourselves, without our books, and at once we get into a mud-dle and lose our way—we don't know whose side to be on or where to give our allegiance, what to love and what to hate, what to respect and what to despise. We even find it difficult to be human beings, men with real flesh and blood *of our own;* we are ashamed of it, we think it a dis-grace, and are always striving to be some unprecedented kind of general-ized human being. We are born dead, and moreover we have long ceased to be the sons of living fathers; and we become more and more contented with our condition.[58]

Ellis updates Dostoyevsky by adding popular culture—films, television, and pop music—to books. Reviewing, Ellis suggests, is the national pas-time: consumers read, dress, dance, vote, see films, and eat in restaurants according to journalists' edicts. Journalists interview other journalists on television, as if the sum of worldly wisdom were bounded by the tube. Everybody works for the network; everybody plays to the camera. Ellis is hardly the first writer to tackle this theme; Paddy Chayefsky's screen-play *Network* is a brilliant precursor, Oliver Stone's *Natural Born Killers* a recent reincarnation.[59] But in Ellis's case, reviews *of* the novel dupli-cated the satire of reviewing *in* the novel: few went to the trouble to read it, preferring instead to let critics like Roger Rosenblatt "snuff this book."[60] Rosenblatt assumed that Ellis and Patrick Bateman are inter-changeable, despite the fact that the novel's repellent, emotionless prose marks the distance between novelist and narrator. In fact, not one word in the novel suggests that Ellis shares his narrator's sentiments. Behind Dostoyevsky one finds Cervantes, for just as *Don Quixote* satirizes the mimetic fallacy by having the Don imitate everything he reads, Ellis in-vents an impressionable copycat killer to skewer those critics who re-gard readers as mere dupes, incapable of distinguishing representation from reality. That is why his portrait of robotic consumption is so ex-aggerated, and why so many name-brand products are amassed in such tedious detail.

The passage I have quoted from Dostoyevsky is not the one Ellis chooses for his epigraph, however; and since his epigraph provides clues about evidence contained in the novel, it is worth quoting in its entirety:

> Both the author of these *Notes* and the *Notes* themselves are, of course fictional. Nevertheless, such persons as the composer of these *Notes* not only exist in our society, but indeed must exist, considering the circum-

stances under which our society has generally been formed. I have wished to bring before the public, somewhat more distinctly than usual, one of the characters of our recent past. He represents a generation that is still living out its days among us. In the fragment entitled "Underground" this personage describes himself and his views and attempts, as it were, to clarify the reasons why he appeared and was bound to appear in our midst. The subsequent fragment will consist of the actual "notes," concerning certain events in his life.[61]

Bateman is "one of the characters of our recent past," that is, the 1980s. He was bound to appear in our midst because of the decade's ruthless cynicism and acquisitiveness. He is fictional, not to be confused with Bret Easton Ellis. But he is also a fantasist, and Ellis obliquely suggests that the murders he describes may also be fiction. *American Psycho* is a fantastically overfictionalized text: the fact that no one pays attention when he keeps insisting that he is a psychopath may indicate that his crimes remain in his head, imagined but not executed. This perhaps explains why one chapter is entitled "April Fools." Several of Bateman's alleged murder victims (Paul Owen, Tim Price) resurface by novel's end. Critics assert that Bateman does not kill until page 131, but Bateman claims to have killed three, possibly four people by then.[62]

Where Patrick's only existence is within fiction, Andrea Dworkin maintains that her only existence is within reality, which is why she uses her real name in *Mercy*. My point is that in both novels, these are fictional devices; Dworkin re-creates reality *as if* it is all true. Where Dworkin treats readers to a eulogy about Huey Newton, Ellis offers a treatise on Huey Lewis. Bateman repeatedly demonstrates that he is an unreliable narrator, not unlike Jimmy in *Whores for Gloria,* who similarly recounts multiple deaths, sometimes of the same person. By the end of the novel, Bateman's credibility is in shreds; on one talk show, the host interviews a Cheerio; on another, a boy falls in love with a box of soap. Shoes by "Susan Warren Bennis Edwards" become shoes by "Warren Susan Allen Edmonds," then shoes by "Edward Susan Bennis Allen."[63] Each product name in the series adds to the cumulative absurdity of the serial consumption, extended even to our "consumption" of the book we are reading, as Elizabeth Young points out: "Detail by detail, as if bricking up a tomb, Ellis defines Patrick's insanity and our own place within it . . . if it is as blunt and simplistic as its critics claim how have they managed to miss everything of significance within the book?"[64]

Ellis has obviously learned from J. G. Ballard: he parrots the polarizing, mind-numbing language of the media, just as Ballard satirizes the

pseudoclinical language of experts. It was Ballard who said thirty years ago that no novelist could compete with the J. Walter Thompson advertising company; *American Psycho* merely goes Ballard one better, by creating a "character" who consists solely as a composite of advertising products, slogans, and "values." How different is Ellis's novel from the Diesel Jeans fashion spread of the car accident (Fig. 33)? To ban Ellis, Diesel Jeans must be banned, too. David Cronenberg was so taken with *American Psycho* that he wanted to make it into a film, but finally concluded that it would not translate to the screen:

> I was amazed at how good the book was. I felt it was an existentialist epic. . . . You invent a world where clothes and money and brand names are the value system and you are in the mind of someone who is locked into that. But inside that mind there is an awareness that it all is meaningless and artificial, completely invented. And the murders, the hideousness, are an attempt to break out of that, to try to shatter it and to connect with something real.[65]

Mary Harron, who cowrote and directed *I Shot Andy Warhol,* has now decided to film *American Psycho,* which, she says, "was misjudged. The violence was so extreme they couldn't see anything else. It's a great black satire of the '80's."[66] It is an interesting moment in culture when the filmmakers are better readers than the literary critics.

Paradoxically, one reason the novel may be difficult to translate to the screen is that Ellis has translated what we see visually on the screen in horror films into prose, transcribing the thousands of discrete sights, sounds, and sensations the brain records in each frame of any horror film. As in the films *Body Double* and *Inserts,* the effect is emetic, not arousing. Long immersed in Hollywood, Ellis aims to demythologize it; rather than "covering" Hollywood, he wants to "uncover" it. Ellis's revealing introduction to David Strick's book of photographs, *Our Hollywood,* could serve as an introduction to his own novel: "The recurring motif is indifference, which I think is the book's true subject. Most of the photographs deal with detached reactions to unreal circumstances. . . . It's a death letter. . . . It's also the closest thing to a visual representation of Nathanael West's *The Day of the Locust* that any photographer has come up with."[67] *American Psycho* is a death letter, too—a death letter for the consumptive greed and entitlement of the 1980s. The passage just quoted underscores Ellis's abiding interest in the dark realities beneath the illusions Hollywood manufactures and suggests why he might be interested in turning the tables and transforming visual images into written ones. Only one or two critics recognized Ellis's achievement: Christopher Lehmann-Haupt said that Ellis

"is not a leering sensualist or cynical pornographer but rather a cartoonist trying to animate *Tales from the Crypt*."[68]

The novel's implicit motto is "Kill yuppie scum before they kill you." The last chapter, called "The End of the '80's," makes clear the novel's debt to allegory: Bateman's heroes are Ivan Boesky, Donald Trump, Michael Milken. He works at Pierce and Pierce, a loosely veiled pseudonym for Merrill Lynch, Pierce, Fenner and Smith (where a stockbroker once confessed to me that his colleagues have long referred to their clientele with the charming motto, "Murder 'em, lynch 'em, pierce 'em, fuck 'em and forget 'em"). The lines between fiction and reality are as blurred here as in Dworkin's novel, though the intent and resulting effects are dramatically different.

The model antipornography civil rights ordinance defines pornography as "the graphic sexually explicit subordination of women through pictures and/or words, including by electronic or other data retrieval systems. . . . Women are presented dehumanized as sexual objects, things, or commodities."[69] The real question is, What would be exempt from such an ordinance? What would such an ordinance make of the fact that we are living in a *posthuman* world, reflected in films, television, and fiction about cyborgs, terminators, body parts that have metamorphosed through technology? As the definition is presently worded, every single work I discuss in this study would be banned, including black feminist filmmaker Ngozi Onwurah's *Body Beautiful,* since an aging mastectomy patient's fantasy of lovemaking could be construed as "dehumanizing" because it focuses on such body parts as the (missing) breast. Dworkin's legislation would prohibit production of images that commodify women, but Ellis's point is that nearly *everything* in America instantly becomes commodified. An ironic confirmation of that process can be traced to his "Twenty-somethings" essay, for since its appearance, the entertainment industry has saturated the market with television shows like *Beverly Hills, 90210, Melrose Place,* and *Friends,* and films like *Singles, Single White Female, Flirting with Disaster,* and *When Lucy Fell.* We have Ellis to thank for identifying a new consumer focus group.

Bateman is the conspicuous consumer run amok, the truest true believer in the promises of Madison Avenue since Lolita. It is not enough just to *use* commodities; they have to have a certain cachet in the marketplace. How else can one explain the fashion for wearing designer labels *outside* of one's clothes? Guy Debord again comes to mind: "The satisfaction which no longer comes from the *use* of abundant commodities is now sought in the *recognition* of their value as commodi-

ties."[70] That explains why Ellis lists scores of recognizable name brands in every chapter: Maud Frizon shoes, Donna Karan dresses, Giorgio Armani overcoats. If you recognize these names, you are instantly implicated in their reification. In that sense, you and I are Ellis's implied *targets* rather than *readers*.

One of the chief traits of serial killers is repetitive identification with machine technology in general, the media in particular. Since Jack the Ripper, serial killers have established a kind of intimacy with technologies of relay and communication.[71] Bateman is programmed to consume, and that, more than murder, lies at the root of his psychosis. Pornography is a *static* world: men are always erect, women always insatiable. It is also a *status* world, as *Playboy*'s motto "Man at his best" makes clear—meaning, of course, the best that money can buy. Bateman's cardinal virtue is his "hardbody," and working out is an autistic occupation that "entails no relation to others," which is why it appealed to real-life serial killers Dennis Nilsen and Peter Sutcliffe ("the Yorkshire Ripper")—both of whom were bodybuilders.[72] At one point, Bateman argues hysterically with his girlfriend over whether they are using the best condom—"best" according to the ads, of course. Elsewhere, he masturbates while looking at a Calvin Klein ad, a scene Brian De Palma would certainly relish, since he insists that he is perfectly willing to have his films censored, so long as Calvin Klein is censored, too. Even Dworkin might agree that the real issue in the porn debate involves the culture's corporate investment in the images in question.

The critical reception of *American Psycho* exposed that investment in startling ways. The novel begins with a curious caveat: "This is a work of fiction. [It is] imaginary and . . . not intended to . . . disparage any company's products or services." Initially I thought this bizarre disclaimer was part of the novel's satire, until I heard rumors that American Express considered suing Ellis and his publisher not for obscenity, but because the psychopath uses an American Express credit card to cut his cocaine, pay for his dinner, and order prostitutes and room service. Maybe American Express's reaction is not as ridiculous as it looks, especially since one of the National Organization for Women's tactics was to contact the companies whose products are used to do violence to women in the novel, "including a camel-hair coat from Ralph Lauren used to stifle a woman's screams."[73] Similarly, the new Euro Disney outside Paris refused to let Ellis into the amusement park, as if his very presence would taint the atmosphere. In another show of unctuous piety, Disney cut a scene of a teenager lying in the middle of a highway from the film *The*

Program, after a teenager died imitating the stunt. Mindlessly knuckling to Janet Reno's ultimatum to Hollywood to censor itself or she would do it for them, Disney became the first studio to engage in self-censorship. The gesture cost them nothing, since the film, like Euro Disney, was already a commercial flop.

Yet Disney's Touchstone Pictures felt no compunction about producing such violent films as *The Hand That Rocks the Cradle,* another example of the emerging subgenre of yuppie horror films that revolve around peril to painstakingly acquired yuppie commodities. Ellis deserves credit for turning this new subgenre on its smug head, for where most of these films portray violence as springing from extrinsic sources, Ellis exposes its intrinsic origins. He drives this point home in "The Twenty-somethings": "Hungering to find ourselves represented on our own terms, we flocked to 'Ghost' and 'Flatliners,' both of which deal with life after death . . . [in] flashy images of beautiful put-upon twenty-somethings coming to grips and surviving the Circumstances. . . . It isn't the murder of the investment banker (Patrick Swayze) that upsets and moves this generation; it's the pleasure denied him—the pleasure of his recently renovated SoHo loft."[74] Ellis's essay is not only shrewd but prophetic, since he anticipates Douglas Coupland's novel *Generation X* (1991) about "the MTV generation," as well as the "Rock the Vote" initiative in 1992. Three years after Ellis's essay appeared, Alexander Star analyzed the 1992 election, noting that "Rock the Vote" reflects "middle-aged retailing of youth empowerment . . . proudly claiming the mantle of political crusades of the past, it mobilizes young people to fight for a right that already exists and that no one is threatening to revoke. . . . [It] simulates the ersatz populism of the business elite . . . and organizes young people to support Time Warner's right to speak, not their own."[75]

Paramount Communications' right to speak won in the Ellis affair. The corporation owns Simon and Schuster, which was originally slated to publish Ellis's novel, but reneged on the contract just a month before the book was scheduled to arrive in bookstores.[76] Sonny Mehta finally published it in Random House's Vintage Contemporary series, and sold 250,000 copies. Mehta and Ellis both received anonymous death threats, including several photos of Ellis with an ax drawn in his forehead, eyes gouged out. In Los Angeles, the National Organization for Women set up a telephone hotline excerpting a single passage to incite listeners to boycott the novel, which they labeled a "how-to novel on the torture and dismemberment of women." Kathleen Jones protests that "what began with the feminist call for the construction of aesthetic communities of

diversified practices seems to have been reduced to the construction of a sisterhood of surveillance," with feminist tactics duplicating those of the Meese Commission on its Houston tour.[77] The National Organization for Women went so far as to organize boycotts of all Knopf and Vintage titles. De facto censorship set in after publication when numerous book-sellers refused to carry the book, much less promote it. My own diffi-culties in purchasing a copy in the Bay Area were duplicated by John Sutherland in southern California: "This novel is not available (even as an ordered item) from my local bookshop, which nonetheless defiantly stocks the paperback *Satanic Verses*. Dworkin's *fatwa* is more effective than the Ayatollah's in Pasadena."[78] As Elizabeth Young points out,

> It soon became impossible for anyone to focus on the novel at all, let alone pay any attention whatsoever to "the language, the structure, the details." Had they done so it would have forestalled many of their criticisms. Not since *The Satanic Verses* had a book been so poorly read. It was dismally revealing of the low quality of cultural commentary in England and Amer-ica. Ellis himself was perfectly aware of the extravagant inanities of the media tirade. "Most of them haven't read it and those who have, I think, have missed it in a big way."[79]

What books *did* Simon and Schuster publish in the spring of 1991 when it rejected *American Psycho* on the grounds of "bad taste"? Since Dworkin's *Mercy* might be subtitled "Women Who Kill Men Who Fuck with Them Too Much," it is ironic that Simon and Schuster's list included *Women Who Love Men Who Kill,* a study of women who fall in love with serial killers. The real reason Simon and Schuster dropped Ellis's novel is that Martin Davis, CEO of Paramount Communications, ordered Dick Snyder, CEO of Simon and Schuster, to ax it, despite the objections of senior editors who urged Snyder not to bow to corporate authority.[80] What was Martin Davis's claim to fame before this fiasco? He produced movies, including all the *Friday the 13th* films. As other publishing houses continue to be gobbled up by entertainment conglomerates, cases like this will increasingly become the norm. In fact, Martin Davis lost a three-way power struggle over the Information Superhighway, which will for-ever alter the communications industry. In February 1994, Viacom paid $9.7 billion for Paramount.[81] Negotiations between Davis, Barry Diller of QVC, Sumner Redstone, and John Malone of Viacom read like the script of *The Player* grafted with *S.O.B.* The latter title surely applies to Davis, who is a lot like Patrick Bateman—cold, cruel, and heartless, ex-ulting in one-upmanship and putdowns. Davis has been described as be-ing so mean that he will belittle aides, summoning them to stand mute

before his desk while he ignores them or criticizes their shoeshine.[82] Maybe Ellis's novel also hit too close to home at Simon and Schuster, where Richard A. Snyder was often described as "the meanest man in America."[83]

As Richard Ohmann has shown, the criterion of value in canon formation is wholly arbitrary. Popular success alone—like that of Erich Segal's *Love Story*—is not enough to insure canonization, because "gatekeeper intellectuals" are arbiters of literary merit. But canonization is saturated with class values, inseparable from ideological struggles and from the broader struggle for position and power. It is a closed circuit of marketing and consumption, for the professional-managerial class owns the publishing houses and the journals that review the books.[84] Obviously the academy often shares the same ideological values. Prestigious trade and university presses are reluctant to publish subversive criticism about postmodernism, thus perpetuating the silencing. Nor have foundations and grants organizations been bold. As Jerome Klinkowitz points out, "The refusal of both governmental and private agencies to risk anything other than reaffirmation of an academic and aesthetic status quo . . . is a national scandal."[85]

The circuit Ohmann describes has closed even more in the past decade: Harper and Row, Dell, Scribner's Sons, Viking, E. P. Dutton, and Delacorte have all been absorbed into huge entertainment conglomerates like Sony Corporation and Bertelsmann AG, which owns RCA Records and Doubleday. General Electric owns NBC and seven NBC network news shows, as well as Warner Brothers stores, eight music labels, and countless satellite and telecommunications networks; Disney/Capital Cities owns ABC, ten network news shows, five motion picture companies, eleven newspapers and television stations, Hyperion Books, and Chilton Publications.[86] We all know the result: books are "properties" distributed worldwide, serialized in magazines owned by the conglomerates, advertised in newspapers, television, and radio, turned into movies which are then rerun and syndicated on television. By 1988, about 55 percent of the book industry's revenue was already controlled by about 6 of the 2,500 publishers based in the United States.[87] Some of these changes have become obvious, but others are less so; as André Schiffrin noted in 1996, left-of-center books are now published only by such small presses as South End and Beacon; former bastions of New Deal liberalism like Harper, Random House, and Simon and Schuster now publish right-of-center books almost exclusively. Says Schiffrin: "The changes that have taken place in our media culture during my pro-

fessional life are so vast that it is hard to comprehend fully how extensive they have been."[88]

In the years since it rejected *American Psycho,* Simon and Schuster certainly seems to have lost its fastidiousness. Their list in 1994 included Howard Stern's *Private Parts* (a bestseller, now a major motion picture.)[89] Other publishers have promoted novels about serial killers, including Susanna Moore's *In the Cut* (1995) and Caleb Carr's *Alienist* (1994), about a monster-cannibal, which has been optioned by Paramount Pictures.[90] Will Self's *My Idea of Fun* (1993) is about an international financier and marketing wizard who teaches his apprentice about the recesses of the human psyche, where consumerism and psychosis converge. Dennis Cooper's *Closer* (1989) and *Frisk* (1991) have been seen by many as inspiring Ellis in *American Psycho,* but Cooper's sadomasochistic underworld is rawer and homosexual. (*Frisk* was adapted to film by Todd Verow in June 1996.) Jonathan Demme's film *Silence of the Lambs* won five Academy Awards and spawned posters and parodies like Kathy Acker's *Hannibal Lecter, My Father* (1991), which combines stories, excerpts, and interviews; the protagonist of Joyce Carol Oates's *Zombie* (1995) is a sexual maniac. A. M. Homes's *The End of Alice* (1996) is a *Lolita*-inspired novel about a nymphet killed by a psychopath; Paul Theroux's *Chicago Loop* (1990) deals with a serial killer–wolfman who initially rejects Robert Mapplethorpe's photographs, then comes to identify with them. Many of these books are serious fiction, and stress the same motifs as *Mercy* and *American Psycho:* the compulsion to repeat, an addiction to representations, and the analogy between serial killing and serial consumption. As Mark Seltzer notes, "The question of serial killing cannot be separated from the general forms of seriality, collection, and counting conspicuous in consumer society . . . and the forms of fetishism—the collecting of things and representations, persons and person-things like bodies—that traverse it."[91] An entire industry of serial-killer merchandise has also developed: trading cards and calendars featuring John Wayne Gacy, killer of thirty-three boys and young men[92]; tee-shirts for tots featuring Charles Manson's likeness; a planned auction (subsequently scuttled) of Jeffrey Dahmer's belongings.

Such hypocrisy lies at the root of many of the critical attacks on Ellis, as Fay Weldon points out in defending him: "This man Bret Easton Ellis is a very, very good writer. He gets us to a 'T.' And we can't stand it. It's our problem, not his. *American Psycho* is a beautifully controlled, careful, important novel that revolves about its own nasty bits. Brilliant."[93]

In short, Ellis is a moralist; *American Psycho* is an attack on values.

Dostoyevsky's underground narrator ironically describes *Notes* as a form of "corrective punishment" rather than literature; the same applies to *American Psycho*. In contrast to William Bennett's *Book of Virtues,* which he describes as a "how-to book for moral literacy," Ellis locates the core of the corruption in the mind-numbing platitudes Bennett has plumbed so profitably.[94]

DEAD AGAIN: BLAME IT ON THE SIXTIES

It is hardly surprising that neoconservatives hated *American Psycho*. To Carol Iannone, an adjunct professor at the Gallatin Division of New York University, Ellis's novel is less a reflection of Reagan's era than of a "quintessentially postmodernist landscape from which all traditional structures, values, truths, have been eliminated." Iannone finds it incongruous that Alfred Kazin criticized Ellis's prose, since Kazin's "denunciations of Reagan . . . have rarely been equaled in their hysteria."[95] The irony of Iannone's non sequitur is that Kazin detests postmodern literature too.[96] Iannone perversely labels Ellis as "politically correct," yet she blithely assumes that Ellis shares her politics, citing as evidence his epigraph from Miss Manners: "One of the places we went wrong was the naturalistic Rousseauean movement of the Sixties in which people said, 'Why can't you just say what's on your mind?' In civilization there have to be some restraints. If we followed every impulse, we'd be killing one another.— Miss Manners."

Iannone interprets this as Ellis's repudiation of the 1960s, which she blames for all of society's subsequent ills. But she completely misses Ellis's point, which is neither pro-1960s or anti-1960s. Instead, his point is that the killers have the most polished manners, clothes, and bodies. They prey on the underclass while maintaining impeccable manicures, cultivating restraint, inspiring admiration and envy. Patrick Bateman's prey all admire his savoir faire; that is how he catches them off guard. "Are you a model?" they all ask. Allegorically, he *is* a model, for Ellis recognizes that "the Prince of Darkness was a gentleman."

A fine ideologue, Iannone has no ear for irony. Her nomination by President Bush to the National Council on the Humanities (the advisory council of the National Endowment for the Humanities) was vigorously protested by the Modern Language Association, the American Council of Learned Societies, and the PEN American Center on the grounds that her scholarship, which consists wholly of journalistic essays in *Commentary,* is "without distinction."[97] Her dissertation at SUNY–Stony Brook in 1981

was a harsh critique of feminist scholarship, and in "Political Passages" (1988), an essay in a collection edited by John H. Bunzel, Iannone described her painful conversion from the leftist orthodoxies of the 1960s, especially feminism, as well as her return to God.[98] But she was backed by Lynne Cheney, William Bennett, and George Will, who declared that "in this low-visibility, high-intensity war, Lynne Cheney is secretary of domestic defense. The foreign adversaries her husband [Secretary of Defense Dick Cheney] must keep at bay are less dangerous, in the long run, than the domestic forces with which she must deal."[99] An astonishing statement by any standard, Will reveals exactly how the threat of enemies abroad has been replaced by pervasive paranoia about homegrown enemies—liberals, leftists, feminists, "minorities," and homosexuals. Where Iannone sees Ellis as rejecting the 1960s, Will perversely demonizes him as the era's embodiment. He uses the Ellis affair to drive an ideological stake into the heart of liberals, baby-boomers, and First Amendment "freaks." Incongruously comparing Ellis's novel to Oliver Stone's film *The Doors*, he declares, "The Sixties are now nostalgia, kitsch junk among the clutter in the nation's mental attic." The "pornographer" Bret Easton Ellis is "a Morrison for the Nineties"; both suffer from "juvenophilia . . . the foolishness of listening for wisdom from the mouths of babes and hoping that youthful vigor (the favorite word along the New Frontier when the Sixties were aborning) will liberate by smashing suffocating old structures. . . . The Sixties are dead. Not a moment too soon."[100] From Ellis to Jim Morrison to John F. Kennedy's New Frontier: Will's staggering leaps of logic inadvertently reveal how deep (and deeply political) his grudge goes.

The 1960s were further scapegoated in Allan Bloom's *Closing of the American Mind* (1987), which sold more than a million copies by comparing feminism to the Reign of Terror in the French Revolution and Woodstock to Hitler's Nuremberg rallies. Bloom dismissed analysis of other cultures as "the suicide of science" and "cultural relativism." Myron Magnet's book *The Dream and the Nightmare: The Sixties' Legacy to the Underclass* also blames "the counterculture of the '60s" for every ill in contemporary society: Magnet claims that Michael Harrington's book *The Other America* (1962), which inspired the War on Poverty, perpetuates poverty; British psychoanalyst R. D. Laing is responsible for homelessness; Norman O. Brown and Herbert Marcuse are responsible for the decline in "family values"; John Rawls, the philosopher who wrote *A Theory of Justice*, made the poor "irresponsible"; and John Kenneth Galbraith contributed to the decline of the work ethic. Rock and roll turned an impressionable generation on to crack cocaine.[101]

Why, one wonders, must the sixties be a scapegoat, pronounced dead again and again? The answer is that pornography is an epidemic of signification, and to neoconservatives, the sixties were ground zero. Lyndon Johnson's despised Lockhart Commission reached precisely the conclusions conservatives most feared: they viewed it as the blueprint for a permissive society. The ink was scarcely dry before newly elected President Nixon set about discrediting the report, warning that "permissiveness . . . regarding pornography . . . contribute[s] to . . . anarchy," and Vice President Spiro Agnew warned, "Main Street is not going to become Smut Alley."[102] George Will's attack on Bret Easton Ellis unwittingly exposes the mission of the Meese Commission in particular and neoconservatism in general: to deep-six the sixties once and for all.

Bill Clinton's connection to the 1960s explains why his detractors are so vehement. Gary W. Aldrich's *Unlimited Access: An F.B.I. Agent Inside the Clinton White House* is a case in point. Fueled by conservative publicists (including Craig Shirley, who calls himself a Dole campaign volunteer) and issued by a conservative publishing house, the book hit the bestseller list on July 4, 1996—demonstrating once again the enormous publishing clout of the Right. Aldrich's gripes encapsulate all the grudges against the 1960s I have been tracing: he objects to White House staffers who wear black, or short skirts, peasant blouses, loud ties, and earth shoes. He criticizes Hillary Rodham Clinton for favoring "tough, minority, and lesbian women, as well as weak, minority, and gay men." (Ironically, the same people who label black studies, women's studies, and ethnic studies as "victim studies" in academia see no contradiction in striking the victim chord when it suits their purposes in such legislation as Senate Bill 1521, the Pornography *Victims'* Compensation Bill.) The same people up in arms over *American Psycho*'s designer drug-induced violence supported a Persian Gulf War waged with designer bombs. Neoconservatives are nothing if not selective in their solicitude about harm. Aldrich reports that another agent said to him, "Kill the pigs. Ho, Ho, Ho Chi Minh, the Viet Cong are gonna win. That's who they are, Gary. They're the people we used to arrest." Aldrich himself policed anti-Vietnam protestors on the Washington Mall while Bill Clinton "was leading a march against his own country's embassy." Aldrich characterizes the difference between the Bush people and the Clintonites as "Norman Rockwell on the one hand and Berkeley, California . . . on the other." He calls Al and Tipper Gore "Deadheads."[103] Even Maureen Dowd, no friend of the Clintons, noticed Aldrich's obsessive-compulsiveness: "Mr. Aldrich, whose favorite words are 'impeccable,' 'letter-

perfect' and 'immaculate,' comes off as a cross between Elliott Ness and Miss Manners. . . . Coffee on the floor sends him into a tizzy . . . Poor Agent Aldrich. He's looked at life from both sides now."[104] Although Aldrich should be censured for violating the FBI code of ethics as well as their code of review regarding book publishing, his widely shared belief that the 1960s were the origin of evil in America explains why the ideological stakes in the culture wars remain so high to this day.

What is fascinating is the depth, scope, and resiliency of this collective fantasy, of which Aldrich is merely the most blatant example. Bob Dole's acceptance speech at the 1996 Republican National Convention drives home the same points: "It is demeaning to the nation that within the Clinton administration a corps of the elite who never grew up, never did anything real, never sacrificed, never suffered and never learned, should have the power to fund with your earnings their dubious and self-serving schemes." Not since Spiro Agnew has a politician's resentment been so naked. Dole seems to have forgotten that when he saw Ford, Reagan, and Nixon onstage together, he quipped (pointing to them): "Hear no Evil, See no Evil, and Evil." E. J. Dionne notes: "Leave aside the stunning assertion that this nameless elite corps 'never did anything real,' which presumes that Dole will be the arbiter of what's real and what's not. . . . when Dole moved off biography, he moved into a fantasy world where the government of the United States was morphed into the government of the Soviet Union."[105] After years of reading George Will (whose wife was one of Dole's speechwriters), it is easy to see how pervasive the rhetoric of paranoia is, which is why I have argued throughout this book that the fantasies of the Right merit at least as much scrutiny as those in art.

In another Orwellian paradox, the true child of the 1960s is not Bret Easton Ellis but Andrea Dworkin, from her Vietnam War protests to her grassroots feminism. As memoir, *Mercy* could be subtitled "The 1960s Without Nostalgia." She depicts "Amerika" as a fascist state in conspiracy against every one of its members. Just as Ellis pays homage to Dostoyevsky, Dworkin's homage is to Walt Whitman, whose vision of America epitomized the sixties' ideal of self-expression. Smack in the middle of *Mercy* is an extended (and very moving) eulogy for Blank Panther Huey Newton: "I had always admired the Black Panthers. . . . I had admired him; how he created a certain political reality; how he stood up to police violence, how he faced them down. . . . He's spectacular and there is a deep humanism in him that expresses itself precisely in surviving" (241–44). Like her feminism, lesbianism, and socialism, Dworkin's 1960s

legacy is inconvenient for the Meese commissioners, the Carol Iannones, and the George Wills of the world.

Which brings me back to my opening question: are *Mercy* and/or *American Psycho* art or trash? The answer clearly depends on the criteria of value one uses to decide; my aim here has been to expose the arbitrariness of the criteria, the contradictions in the rhetoric of pundits, and the fantasies of policymakers. My allusions in this chapter have ranged from Dostoyevsky and Whitman to Fitzgerald and Faulkner because Dworkin's and Ellis's debt to past masters merits recognition, even if their work falls short; such debts illuminate the form and function of postmodern fiction. I have purposely juxtaposed two diametrically opposed novels to demonstrate that context is all, yet context always gets lost in the shuffle in the porn debate—and would be irrelevant if pending antiporn legislation becomes law. If two authors at opposite ends of the ideological spectrum can *both* be banned, isn't that a good argument for being wary of censorship? The real test of a free society is whether it permits expression of the hateful.[106] I have tried to contextualize each writer's aims and methods, while revealing rather than disguising my own biases. The writing and reception of these novels illustrate how many passions are masked in the porn debate and how high the ideological stakes are. Whether either novel will be remembered fifty years from now is doubtful, but neither deserves to be banned or boycotted. If the public, the critics, and the academy continue to condemn what they have not read, to censor without weighing evidence, precedents, or consequences, freedom will vanish without a trace.

Epilogue

From the outset, the Meese commissioners, the National Obscenity Enforcement Unit, the Justice Department, and the legal system were doomed to defeat. They are doomed because they are trapped in a double bind: they must murder to dissect. They seek to define the human "essence" and protect it from "harm." Toward that end, they deploy numerous tactics in the guise of "protection": surveillance, forensic tests and polygraphs, protracted campaigns against innocent citizens, raids and seizures by postal and customs officials. They have implicit faith in the very tools of analysis that deny (through their machine accuracy) the human agents wielding them. They are defeated because the committee system is a product of bureaucratic technology, and that technology (of expert opinion) cannot go beyond the concept of the human and analyze the motivating forces behind and working through the human[1]—and beyond. Only art can do that.

Paradoxically, in the act of highlighting the material body, *Bad Girls and Sick Boys* casts doubt on the very notion of a quantifiable human essence. Some artists highlight the body's elemental origins, while others project it into a "posthuman" future. Even when sculptures like Kiki Smith's *Tale* (Fig. 10) display the elemental body (a woman on all fours, trailing feces), Smith invokes irreconcilable associations: Darwin and evolution, Freud and femininity, the umbilicus and the abject. The sculpture is enveloped in a complex web of contradictory significations—"tales"—about nature and culture, regression and progress, purity and danger, filth

and gender, mortality and art. Even a work that seems to reduce the human to essentialist origins instead defiantly refuses to sanitize Woman. Although each woman uses different media, the same could be said of Carolee Schneemann, Annie Sprinkle, Orlan, Ngozi Onwurah, and Kathy Acker: each sees how much women stand to gain by dismantling romantic myths of feminine protection.

All of these artists are haunted by art history and literary history, whether one thinks of Orlan morphing the *Mona Lisa* or novelists reaccentuating Cervantes and Dostoyevsky. Some memorialize earlier works whose relevance may have been forgotten, reviving cast-off forms and materials in other arts. In the process of defining their own antiaesthetic, they paradoxically remind us of ancient generic roots. When Carolee Schneemann mimes Minoan Cycladic sculpture and John Hawkes invokes the love songs of the troubadours, the etymological meaning of *radical* (root) is never far from mind. The antiaesthetic delineated in these pages pays homage to past masters of carnality, rebellion, and carnival, from Menippean satire to Sade. Many are equally obsessed with political history, whether one thinks of Ballard's preoccupation with John F. Kennedy's assassination or Vollmann's with the Vietnam War. Although television increasingly collapses the temporal distance between present, past, and future, these artists prevent the referent from disappearing. Rather than merely resorting to postmodern parody, they obsessively replay these cataclysms in a futile effort to make them make sense. They remind us that not everything that was lived directly can be reduced to a representation. That, indeed, is one rationale for their visceral graphicness.

The artists in this book look forward as well as backward, for the attempt to distill and protect a human essence is equally quixotic in the epoch of the posthuman, which by definition melds the inorganic and organic. Far from seeing technology as a threat, these audacious artists use it to create new interactivities, to give voice to new collectivities through fax and modem, pictureTel, visiophone, X rays, computer morphs, CAT and PET scans. They are scrutinizing the culture's investment in science and medicine, challenging society's most cherished assumptions about the body's sanctity. They draw back the curtain in the medical amphitheater to give us a peek not just at specific procedures, such as plastic surgery, but at death itself.

By examining the formations and functions of fantasy, these artists illustrate how ambiguous and contradictory human motivation is. Forces that defy mastery in real life, like Bob Flanagan's painful illness, are transformed into sexual pleasure through fantasy, which is then further trans-

formed through art. That art is neither didactic nor sentimental. I have called these artists boys and girls because so many strive to re-present that lost era of babyhood, with its infantile gratifications, wonder, and lack of inhibition. Since the ego itself is oriented in a fictional direction, the artists trace multiple fictions, imaginary anatomies, and sensory information mapped in and on the body. The fantasies include maternal longing *(My Own Private Idaho)*; murderous fantasies of dismemberment and disintegration *(American Psycho* and *Mercy)*. Through fantasy, one has access to otherwise forbidden realms: *The Body Beautiful* is a powerful testimonial to the subjectivity and sexuality of a (M)other; *Body Double* memorializes infantile paralysis, as well as the anxiety of impotence. Far from depicting the mind as a captain housed in a vessel, the body, these artists display the body as perceiver and receiver of information of and from the world.[2] Those displays are alternately frightening and arousing, as befits their repeated emphasis on the conventions of horror and porn.

Fantasy combines the psychic and the social: one incorporates individual dreams, memories, and desires with collective elements from both high art and popular culture. Thus popular culture *does* have an impact, though it is not as direct and dangerous as detractors imagine. Bret Easton Ellis shoves the mimetic fallacy down our throats by inventing a psychopath who *does* imitate everything he sees, and who, not incidentally, is the ideal consumer and *product* of corporate America. Although in this book I parody the monkey-see-monkey-do view of art, I simultaneously show how fictions of all kinds (in advertising, television, films, cyberspace) have *overwhelmed* reality. How else to explain American Express's overreaction to Ellis's novel? My aim has been to explore the impact of these developments on both the latent and the manifest levels, focusing on fetishism and curiosity in Mulvey, Orlan, and Julien, as well as on the aggressive anality of the Thatcher-Reagan-Bush eras as recorded by Ballard, Acker, Ellis, and Vollmann. Many of these works are products of a profound social anger, portraits of the sadomasochism of daily life.

One thing is clear: pundits and moralists are looking for porn in all the wrong places. Legislators, lawyers, the police, and the federal government are among the major disseminators of porn today, whether one thinks of the Meese *Final Report*'s catalogue of sex acts or of the pathetic testimony it solicited from "victims." Since the recommendations in the *Final Report* were implemented, thousands of citizens have been entrapped in sting operations: after Keith Jacobson was targeted by the U.S. Postal and Customs Services and the National Obscenity Enforcement Unit, he was "outed" as a homosexual in his small, Nebraska farm-

ing community and lost his job. Yet the only dirty pictures he ever possessed had been mailed to him (unsolicited) by the U.S. government over a five-year period. The federal government's antipornography tactics went too far even for the Rehnquist court, which in 1992 ruled that Jacobson had not been "predisposed to commit the crime" of buying the photographs, nor was there any evidence that he had any pedophiliac interests or had ever had sexual contact with minors. Countless other innocent individuals have been driven out of business. Among those targeted, at least five have committed suicide.[3] According to Lawrence A. Stanley, these relentless sting operations, which targeted individuals who had never displayed any interest in such materials, turned the federal government into a major marketing force of child porn in the U.S.[4]

Sometimes representatives of the federal government are porn actors rather than producers: more than five hundred Camp Pendleton Marines were implicated in a gay video pornography ring in 1993, giving new meaning to the concept of "active duty." Many more Marines nationwide have occasionally taken part in heterosexual and homosexual video porn, according to the operation's leader, who says their motives are that "they're lonely, homesick, and horribly underpaid" by the Marine Corps.[5]

What the rhetoric of the antipornography position conceals is as telling as what it reveals. Even though the viewpoint of harm has not yet been passed into law, it has become pervasive in public discourse. The media cashes in by continually highlighting new "victims" of pornography, feigning moral outrage while capitalizing on prurience. On January 26, 1993, ABC's 20/20 featured male students at Duke University who formed a "victim's" support group for their "addiction" to porn. The episode might have been titled "Melodramas of Beset White Manhood," for none of the men seemed to realize that "victimization" is relative. The median income for the entire state of North Carolina is less than one year's tuition at Duke. Yet none of the "victims" mentioned the stark contrast between their privileged status at Duke and the poverty surrounding them in Durham. Hugh Downs, host of 20/20, was so titillated that his agitation was visible to the viewer. Audience and host alike enjoyed the spectacle of sexual abasement and confession.

The same applies to news coverage of Michael Jackson's arrest for molesting a thirteen-year-old boy who claimed he could identify distinguishing characteristics on Jackson's penis, which was duly photographed by the Santa Barbara County sheriffs as "evidence." In an affidavit filed on May 6, 1994, Paula Corbin Jones made an identical claim to corroborate her allegation that President Clinton sexually harassed her in a

hotel room in Little Rock, Arkansas, on May 8, 1991. The case demonstrates yet again how representation has become the sole locale of the political. The presidential aura has diminished in an age of litigation, although the president's body has always been a national obsession: Kennedy's shattered brain, Lyndon Johnson's bladder, Reagan's colon, Bush's nausea in Japan. Each bodily eruption prompts the media to provide detailed anatomical analyses of the causes and consequences of the particular illness, sanitizing what is in fact an obscene display, while thrilling to its spontaneity. Bush's vomiting into the lap of Japan's prime minister demonstrated that sex is not really the realm in which bodily acts are obscene, disgusting, unwatchable. Somewhere between the puking scene and the sanitized rhetorical clean-up lies the pornographic, like so much vomit in the lap of luxury.[6]

Signs taken for wonders: the idea that the genitals of Jackson and Clinton are open to investigation reveals how incessantly pornography is produced in the public sphere. It is a new twist on what Linda Williams calls "the frenzy of the visible"—pornography's insatiable demand for tangible proof of female pleasure—for in these two cases, it is not the vagina but the penis that must satisfy the demand for "ocular proof." Paula Jones subsequently appeared on televangelist Pat Robertson's *700 Club* show on the Family Channel, primly regaling viewers with details of how Clinton dropped his trousers and asked her to "kiss it."[7] Although she subsequently did file suit, Jones failed to show up on the day she said she would file a $700,000 lawsuit; an Elvis impersonator came instead.

Long before Clinton strategist Dick Morris appeared on the scene, J. G. Ballard predicted that politics would become a branch of advertising. I have no objection to Morris's sexual proclivities (he enjoyed sucking prostitute Sherry Rowlands's toes); I don't even mind his multimillion-dollar advance for his tell-all book, though it would have been nice if Rowlands got equal pay for equal work. What irks me is that the same folks most fond of their private peccadilloes want to shove family values and V-chip technology down the public's throats. That stinks more than feet.

Yet if spectacle seems to have become seamless, the artists here have found ways to rip the fabric by isolating its components and analyzing its effects. No matter how one tries, there is no way to capture how exhilarating, startling, and witty these works are. Using techniques of defamiliarization and literalization, they expose the hypocrisy of certain taboos, sometimes with hilarious effects. Want to look inside a woman? Annie Sprinkle provides a flashlight and speculum. Is television control-

ling our minds? It envelops us in *Videodrome*. Does sex sell products? All of the desires that advertisers exploit are acted on in *Crash*—the characters merely cut out the middleman. By taking us inside the body, these artists X-ray the culture. Yet their awareness of commodification and spectacle makes them suspicious of the very notion of transgression. Even while they are being demonized in public discourse, they are acutely aware of the mobility of capitalism: J. G. Ballard could have predicted that the iconoclasm in *Crash* would eventually become distilled in a Diesel Jeans fashion layout, even while attempts are under way in four countries to block or ban David Cronenberg's film adaptation.

Nevertheless, these artists insist on exploring elements of psychosexual life that are far more transgressive than their detractors realize. They confront life in its most frightening forms: the intersection of the sex and death drives, the psyche's violent vicissitudes, the cataclysms that make no sense. They release something unseen and unspeakable into the marketplace. In the process, they reveal *what is really happening* in culture: increased mechanisms of surveillance and control, invisible networks of power. The "carceral imagination" is embodied in Park Dietz's exhortation to lock up the insane and throw away the key. Repudiate any investigations into the unconscious and instead blame popular culture. Antiporn legislation is only one facet of a much larger erosion of civil liberties, which has resulted in mandatory sentencing, the deployment of RICO provisions originally designed for racketeering, the suspension of habeas corpus, and, if Senate Bill 1521 passes, book banning by bankruptcy. In pursuit of protection from "harm," citizens are actually at the mercy of the censors.

Once politics is reduced to a contest of representations, it becomes convenient and easy to blame popular culture for all social ills. In Cervantes's day, clerics consigned courtly romances to the trash heap of popular culture, but *Orlando Furioso* is now a canonical text. Nevertheless, neither the passage of time nor literary reputation is an ironclad safeguard against new inquisitors: the president of the Christian Action Network dismisses even Vladimir Nabokov as promoting child abuse, just as Andrea Dworkin and George Will label James Joyce a pornographer.[8] Cal Thomas extols William Faulkner's virtues today, but fifty years ago Thomas would have been the first to ban him. Nevertheless, fifty years hence we may look back on the emerging antiaesthetic described in these pages and view it as the golden age of experimentation in art spaces, literature, and cinema. These works transform the agitated witness into a conscious observer by uninhibitedly portraying spectacles that open the

eyes and upset the mind. Following the Surrealists, they use the unconscious to wage war on society *and* art, to codify the inner experience of the senses, to anatomize the mythologies of the psyche and the culture. They all underscore precisely those aspects that humanity disavows: cruelty, blood lust, barbarism. Whether or not sex is tied to love certainly seems like an anachronistic concern by comparison. For the first time, it is becoming possible to explore the psychopathology of one's own life without fear of condemnation, in a harmless way, just as Ballard predicted, just as Bob Flanagan and Sheree Rose have done.

In the age of hypertext, the fear of postmodernism's multiple windows on reality already seems like ancient superstition. One day, perhaps, the current debates about representation and fantasy will look quaint indeed. People may marvel that sexuality was once viewed as the sacred property of individuals, or as the core of identity, or as the key to liberation. Perhaps they will look back at the final decades of the twentieth century and wonder why sex and pleasure were so threatening, why there was so much resistance to the body, when so many aesthetic experiments memorialized its metamorphosis. For pundits and policymakers, the dawn of a different economy of bodies and pleasures is nowhere on the horizon, but for the performers, filmmakers, and novelists in this book, it is already high noon.

As *Bad Girls and Sick Boys* went to press, six years of research was suddenly validated by an explosion of simultaneous events: Kirby Dick's feature-length documentary film *Sick: The Life and Death of Bob Flanagan* premiered on January 23, 1997, at the Sundance Film Festival, where it won a special jury prize for its originality and audacity. It has also been chosen to screen in the Berlin Film Festival, and in the New Directors/New Films Series (a collaboration between the Film Society of Lincoln Center and the Museum of Modern Art). David Cronenberg's *Crash* premiered on March 21, 1997. Several critics reviewed *Crash* in tandem with *Sick;* some grasped the seriousness of these joint explorations of sex, love, mortality.[9]

From my home in Washington, D.C., I had gone to California in 1991 to see how artists and writers were addressing these challenges. I lived in Berkeley, Irvine, Santa Barbara, and Los Angeles, canvassing film festivals, academic conferences, and alternative performance spaces. I met transvestites, transsexuals, radical body artists, sex workers. I watched Annie Sprinkle, Rebecca Brown, Dennis Cooper, Five Lesbian Brothers, Carmelita Tropicana, Luis Alfaro, Sapphire, Raymond Pettibon, Gary Indiana, Orlan, Isaac Julien, Holly Hughes, Deb Margolin, Don DeLillo,

Karen Finley, Tim Miller, Pomo Afro Homos, Guillermo Gomez-Peña, and Kathy Acker outrage and delight audiences from the state's bottom to top. (Acker, alas, died of breast cancer on November 29, 1997.)

In contrast to these "underground" acts, the bland tits-and-ass television series *Baywatch* was fabricated before my eyes as I rollerskated daily from Venice Beach to Malibu, past starlets and stewardesses, pierced and tattooed couples, gay Rollerbladers, past the bus with a banner that read "Destination: Catville," which houses a man who shelters nineteen strays like himself. The spectacle is hardly benign: in Bluff Park, a homeless man sleeps under a jacket emblazoned with NBC's peacock logo; another man crawls on all fours on Ocean Avenue, locked in some private delusion; a baby without arms and legs waves his stumps while his father begs on the boardwalk.

National controversies were uncanny counterpoints to my research: while Anita Hill testified before the Senate Judiciary Committee in a titillating, peep-show atmosphere, I investigated Park Dietz, the Meese commissioner who helped smear her. While the nation commemorated the tenth anniversary of the Vietnam Memorial in November 1992, I wrote about the Vietnam veteran in *Whores for Gloria* who calls San Francisco "Hanoi U.S.A." While President Clinton and Congress fought over a national health care plan, I interviewed Bob Flanagan and researched cystic fibrosis.

January 3, 1996, Long Beach Memorial Hospital: I've come to say goodbye to Bob. His upper body is bloated, his hair is long, and his gray beard makes him look like an old man. (He's only eight days into his forty-third year.) I feel I should leave quickly so he can sleep, but he clutches my hand and arm. Speech is difficult, but he is surprisingly alert and solicitous. He tells me he has converted to Judaism for Sheree. "You're probably relieved she just wanted to turn you into a Jew, instead of maybe a transsexual!" We laugh.

He has heard me speak often of Dr. Robert Gerard, the compassionate psychologist and wise teacher of esoteric Buddhism. Earlier, Robert helped me visualize Bob in a golden light, lifted out of this life by love, moving to a dimension beyond pain and struggle. Robert once told me that like-minded souls seek each other and congregate. Clinging for dear life, I think to myself.

I thank Bob for teaching me so much about gratitude and generosity, about living and creating. I kiss him farewell.

January 5, 1996: Bob lies in a plain pine box in the chapel, which is overflowing with mourners: artists, actors, writers, and poets, some in

suits, some in jeans, some in leather, with shaved heads and tattoos. Lots of children from cystic fibrosis summer camp. On tape, Bob is singing, "There'll be laughter again, but I'll be missing you." His brother speaks: one of Bob's sisters died in infancy from the same disease; another died at age twenty-one in 1979. "The Flanagan family is finally free at last of this disease," he says.

A friend from Costa Mesa High School reads Auden's eulogy for Yeats:

The provinces of his body revolted,
.
Silence invaded the suburbs,
The current of his feeling failed: he became his admirers.

Memories overwhelm me. After visiting Yeats's grave in 1994, I met J. G. Ballard, who told me that in retrieving Yeats's body from France, the Irish mixed up the bodies: a French soldier is buried under Ben Bulben! Bob *loved* this story.

I also remember when WBAI in New York City hosted a radio call-in show at the New Museum to help people understand Bob's work. The atmosphere was festive: Bob was cheerfully propped up in bed, surrounded by friends—Lynne Tillman, Andres Serrano, David Leslie, Laura Trippi, Kirby Dick, Gary Indiana, and his ministering angel, Sheree Rose.

Bob's urgent telephone call in June 1995 also comes back to me: would I infiltrate the Christian Action Network meeting to see whether they violated his copyright? (They did.) Auden again:

Intellectual disgrace
Stares from every human face,
And the seas of pity lie
Locked and frozen in each eye.

Alice Wexler's book *Mapping Fate* is about her family's struggle with Huntington's disease and their search for a cure; she once arranged for the doctor who discovered the cystic fibrosis gene to meet Bob. Now a bitter wind and moon are rising over the hillside; Alice and I are hugging each other at Bob's grave. Do we map fate or does fate map us?

On January 7, 1996, I fly home to Washington, D.C., straight into the blizzard of the century. Snow is general all over the East.

Notes

PROLOGUE

1. Michel Foucault, *The History of Sexuality,* trans. Robert Hurley (New York: Vintage, 1980); Elaine Scarry, *The Body in Pain: The Making and Unmaking of the World* (Oxford: Oxford University Press, 1985); Ludmilla Jordanova, *Sexual Visions: Images of Gender in Science and Medicine between the Eighteenth and Twentieth Centuries* (Madison: University of Wisconsin Press, 1989); Thomas Lacquer, *Making Sex: Body and Gender from the Greeks to Freud* (Cambridge, Mass.: Harvard University Press, 1990); Judith Butler, *Gender Trouble: Feminism and the Subversion of Identity* (New York: Routledge, 1990); Camille Paglia, *Sexual Personae* (New York: Random House, 1991); Mark Seltzer, *Bodies and Machines* (New York: Routledge, 1992); Susan Bordo, *Unbearable Weight: Feminism, Western Culture, and the Body* (Berkeley: University of California Press, 1993); Elizabeth Grosz, *Volatile Bodies: Toward a Corporeal Feminism* (Bloomington: Indiana University Press, 1994).

2. Barbara Stafford, *Body Criticism: Imaging the Unseen in Enlightenment Art and Medicine* (Cambridge, Mass.: MIT Press, 1991), 465–66.

3. Mark Poster, *The Second Media Age* (Cambridge: Polity Press, in association with Blackwell, 1995), 23–24.

4. Grosz, *Volatile Bodies,* viii.

5. Jacques Lacan, "The Mirror Stage as Formative of the Function of the I as Revealed in Psychoanalytic Experience," in *Ecrits,* trans. Alan Sheridan (New York: W. W. Norton, 1977), 1–8. Although the essay was not published until 1949, Lacan traces its origins to 1936—the same year Walter Benjamin published "The Work of Art in the Age of Mechanical Reproduction"—for in the first sentence Lacan notes: "The conception of the mirror stage that I introduced at our last congress, thirteen years ago, has since become more or less established in the practice of the French group."

6. Grosz, *Volatile Bodies,* 34, quoting Freud: "The ego is ultimately derived from bodily sensations, chiefly from those springing from the surface of the body. It may thus be regarded as a mental projection of the surface of the body" ("The Ego and the Id" [1923], in *The Standard Edition of the Complete Psychological Works of Sigmund Freud,* ed. and trans. James Strachey, 24 vols. [London: Hogarth, 1953–66], 19:26).

7. See, for example, Robert Con Davis, ed., *Lacan and Narration: The Psychoanalytic Difference in Narrative Theory* (Baltimore: Johns Hopkins University Press, 1983); Shoshana Felman, ed., *Literature and Psychoanalysis: The Question of Reading: Otherwise* (Baltimore: Johns Hopkins University Press, 1982).

8. Fyodor Dostoyevsky, *Notes from Underground,* trans. and intro. Jessie Coulson (New York: Penguin, 1972), 123.

9. Laura Mulvey, *Fetishism and Curiosity* (Bloomington: Indiana University Press, 1996), 6.

10. Walter Benjamin, "The Work of Art in the Age of Mechanical Reproduction," in *Illuminations,* ed. Hannah Arendt, trans. Harry Zohn (New York: Schocken Books, 1969).

11. Allan Bloom's *Closing of the American Mind* (New York: Simon and Schuster, 1987) exemplifies this nostalgia; his subtitle, *How Higher Education Has Failed Democracy and Impoverished the Souls of Today's Students,* reveals that nothing less than the salvation of souls is at stake; see also William Bennett, "'To Reclaim a Legacy': Text of Report on Humanities in Education," *Chronicle of Higher Education,* November 28, 1984, 16–21.

12. Raymond Williams, *The Country and the City* (New York: Oxford University Press, 1975), 9–12. Indeed, one of the meanings of *millennium* is "any period of great happiness, peace, prosperity, etc.; [an] imagined golden age."

13. Stafford, *Body Criticism,* 47.

14. Ibid., 12.

15. Clive Bloom, "Grinding with the Bachelors," in *Perspectives on Pornography: Sexuality in Film and Literature,* ed. Gary Day and Clive Bloom (New York: St. Martin's Press, 1988), 21–22.

16. Susan Buck-Morss, *The Dialectics of Seeing: Walter Benjamin and the Arcades Project* (Cambridge, Mass.: MIT Press, 1990).

17. Robert B. Ray, *The Avant-garde Finds Andy Hardy* (Cambridge, Mass.: Harvard University Press, 1995), 12, citing Friedrich Kittler, *Discourse Networks, 1800/1900,* trans. Michael Metteer, with Chris Cullens (Stanford: Stanford University Press, 1990).

18. Chris Rodley, ed., *Cronenberg on Cronenberg* (London: Faber and Faber, 1992), 90.

19. 37 L.J.Q.B.89 (1868). See also Edward de Grazia, *Girls Lean Back Everywhere: The Law of Obscenity and the Assault on Genius* (New York: Random House, 1992), chap. 1; and Linda S. Kauffman, review of de Grazia, in *Cardozo Arts and Entertainment Law Journal* 11:3 (1993): 765–75.

20. *Roth v. United States* 237, F.2d 796 (2d cir., 1956); see also de Grazia, *Girls Lean Back,* 280–306.

21. de Grazia, *Girls Lean Back,* 565–72.

22. Ronald J. Berger, Patricia Searles, and Charles E. Cottle, *Feminism and Pornography* (New York: Praeger, 1991), 130n2.

23. Hal Foster, "Postmodernism: A Preface," in *The Anti-Aesthetic: Essays on Postmodern Culture,* ed. Hal Foster (Port Townsend, Wash.: Bay Press, 1983), ix.

24. See Laura Kipnis's critique of Peter Burger's *Theory of the Avant-Garde* and of Mary Kelley's "Re-viewing Modernist Criticism," in *Ecstasy Unlimited: On Sex, Capital, Gender, and Aesthetics* (Minneapolis: University of Minnesota Press, 1993), 24-26.

25. C. Carr, *On Edge: Performance at the End of the Twentieth Century* (Middletown, Conn.: Wesleyan University Press, 1993).

26. Georges Bataille, *Erotism: Death and Sensuality,* trans. Mary Dalwood (San Francisco: City Lights, 1986), 63; originally published as *L'Erotisme* (Paris: Editions de Minuit, 1957).

27. Mulvey, *Fetishism and Curiosity,* 11.

28. Peggy Phelan, *Unmarked: The Politics of Performance* (London: Routledge, 1993), 167.

29. Steven Shaviro, *The Cinematic Body* (Minneapolis: University of Minnesota Press, 1993), 37, citing Jean-Pierre Leaud's speech in Jean-Luc Godard's film *La Chinoise.*

30. Mikhail Bakhtin, *Rabelais and His World,* trans. Hélène Iswolsky (Cambridge, Mass.: MIT Press, 1968); see also Michael Holquist, ed., *The Dialogic Imagination: Four Essays,* ed. and trans. Michael Holquist and Caryl Emerson (Austin: University of Texas Press, 1981); and Caryl Emerson, ed. and trans., *Problems of Dostoyevsky's Poetics* (Minneapolis: University of Minnesota Press, 1984).

31. Wendy Steiner, *The Scandal of Pleasure: Art in an Age of Fundamentalism* (Chicago: University of Chicago Press, 1995).

32. Clyde Taylor, "Black Cinema in the Post-Aesthetic Era," in *Questions of Third Cinema,* ed. Jim Pines and Paul Willemen (London: British Film Institute, 1989), 90.

33. Ronald Sukenick, *98.6* (New York: Fiction Collective, 1975), 167, cited in Jerry A. Varsava, "Another Exemplary Fiction: Ambiguity in Robert Coover's *Spanking the Maid,*" *Studies in Short Fiction* 21:3 (summer 1984): 235-41.

34. Foster, "Postmodernism: A Preface," ix.

35. Joanna Frueh, *Erotic Faculties* (Berkeley: University of California Press, 1996), 48.

36. In addition to books already cited, see Donald Alexander Downs, *The New Politics of Pornography* (Chicago: University of Chicago Press, 1989); Linda Williams, *Hard Core: Power, Pleasure, and the "Frenzy" of the Visible* (Berkeley: University of California Press, 1989); Peter Michelson, *Speaking the Unspeakable: A Poetics of Obscenity* (New York: State University of New York Press, 1993); Marcia Pally, *Sex and Sensibility* (Hopewell, N.J.: Ecco Press, 1994); Nan D. Hunter and Lisa Duggan, *Sex Wars: Sexual Dissent and Political Culture* (New York: Routledge, 1995); Nadine Strossen, *Defending Pornography: Free Speech, Sex, and the Fight for Women's Rights* (New York: Scribner, 1995); Roland K. L. Collins and David M. Skover, *The Death of Discourse* (Boulder, Colo.: Westview Press, 1996).

CHAPTER ONE: CONTEMPORARY ART EXHIBITIONISTS

1. Martin Mawyer, *Silent Shame: The Alarming Rise of Child Sexual Abuse and How to Protect Your Children From It* (self-published, 1987). Mawyer sounds like John Ray, Jr., the sociologist in the preface to *Lolita,* whose obtuseness Nabokov parodies.

2. *Bob Flanagan's Sick,* New York, Art in the Anchorage, August 1991, and Los Angeles Contemporary Exhibitions (LACE), Los Angeles, California, May 1991. All quotations by Flanagan and Rose are from my interviews with them. The first interview took place on February 19, 1993, in Los Angeles. Between 1993 and 1996, numerous additional conversations took place in Los Angeles, Irvine, Laguna Beach, New York City, and at Long Beach Memorial Hospital, where Bob died on January 4, 1996.

3. Flanagan and Rose have been frequently invited to address the Society for the Scientific Study of Sex. They have also collaborated with sexuality expert Robert Stoller, who substantially revised his views on perversion as a result of his discussions with them. Only recently have books devoted to heterosexual sadomasochism begun to receive serious widespread attention. See, for example, Gloria G. Brame, William D. Brame, and Jon Jacobs, *Different Loving* (New York: Random House, 1993).

4. Anne McClintock, "Maid to Order," *Social Text* 37 (1993): 87–116.

5. I am indebted to my student Shelley Pasnik for this idea, developed in her paper entitled "Are You Experienced? Advertising's Exploitation of Americans' Nostalgia for Childhood," which she presented at the Northeast Popular Culture Association, October 1994.

6. Simon Taylor, "The Phobic Object: Abjection in Contemporary Art," in *Abject Art: Repulsion and Desire in American Art* (New York: Whitney Museum Independent Study Program Papers, no. 3, 1993), 68, hereinafter cited parenthetically as AA.

7. *Bob Flanagan: Supermasochist* (San Francisco: Re / Search Books, 1993), 64, hereinafter cited parenthetically in the text as BF.

8. Sigmund Freud, "Creative Writers and Daydreaming," in *Criticism: The Major Statements,* ed. Charles Kaplan, 3d ed. (New York: St. Martin's Press, 1986), 419–28, rpt. from *The Standard Edition of the Complete Psychological Works of Sigmund Freud,* ed. and trans. James Strachey, vol. 9 (1908) (London: Hogarth, 1953–66). See also Elizabeth Cowie, "Fantasia," *m/f* 9 (1984): 71–105.

9. McClintock, "Maid to Order," 101–2.

10. Barbara Rose, "Is It Art? Orlan and the Transgressive Act," *Art in America* 81:2 (February 1993): 82–87, 125.

11. Camille Paglia and Alison Maddex curated the *True Phallacy* exhibition at the Clark Gallery in Washington, D.C., December 1993, which glorified penises in bronze, photography, and painting; Paglia was videotaped at the opening reception for A Rapido TV Production for *World without Walls,* Channel 4, London (produced by Peter Stuart; directed by Peter Murphy, aired March 1, 1994).

12. Peggy Phelan, "White Men and Pregnancy," in *Unmarked: The Politics of Performance* (London: Routledge, 1993), 130–45, describes how the Right systematically erases the woman in order to accentuate the fetus, who is always

described as "a little guy." Rosalind Petchesky argues that the fetal form functions symbolically to compensate for a series of losses men have experienced in the past twenty-five years, from sexual innocence to compliant women to American imperial might, in "Fetal Images: The Power of Visual Culture in the Politics of Reproduction," *Feminist Studies* 13:2 (1987): 263–92.

13. Between September 1990 and January 1991, eleven of fifteen fundraising letters from three leading religious Right groups targeted homosexuality as the most dangerous menace within America today; see *Right-Wing Watch* 1:4 (February 1991): 2.

14. Cowie, "Fantasia," 85.

15. Jacques Lacan, "The Mirror Stage as Formative of the Function of the I as Revealed in Psychoanalytic Experience," in *Ecrits: A Selection,* trans. Alan Sheridan (New York: W. W. Norton, 1977), 4–5.

16. J. G. Ballard, *The Atrocity Exhibition,* ed. V. Vale and Andrea Juno (San Francisco: Re/Search Books, 1990), 68.

17. I know of only a few exceptions to this taboo: (1) Isaac Julien's "This Is Not an AIDS Advertisement" (New York: Third World Newsreel, 1987); see Douglas Crimp, ed., *AIDS: Cultural Analysis/Cultural Activism* (Cambridge, Mass.: MIT Press, 1988); (2) Douglas Crimp's "How to Have Promiscuity in the Midst of an Epidemic," in *AIDS: Cultural Analysis,* ed. Crimp; (3) Starshu Kybartas's video *Dani,* which depicts his sexual attraction to a man with Kaposi's sarcoma, in Douglas Crimp, "Portraits of People with AIDS," in *Cultural Studies,* ed. Lawrence Grossberg, Cary Nelson, and Paula A. Treichler (London: Routledge, 1992), 117–33; (4) David Wojnarowicz's *Close to the Knives* (1991); and (5) Ngozi Onwurah's *The Body Beautiful* (1991), featuring the sexual fantasies of an aging mastectomy patient (see Chapter 3 herein).

18. Michel Foucault, *The History of Sexuality,* trans. Robert Hurley (New York: Vintage, 1980), 121.

19. Chris Rodley, ed., *Cronenberg on Cronenberg* (London: Faber and Faber, 1992), 79.

20. David Leslie, New Museum brochure for *Visiting Hours.* C. Carr compares Leslie's re-creations to J. G. Ballard's *Crash:* "I think of J. G. Ballard, whose characters read primordial messages in the technology that surrounds them, whose heroes crack through the veneer of official reality with the aid of some violent act. In Ballard's world, images are more real than real life. Someone in *Crash* collects footage of automobile collisions and dreams of dying in one himself—an act finally so real that he won't be able to watch the replay" (*On Edge: Performance at the End of the Twentieth Century* [Middletown, Conn.: Wesleyan University Press, 1993], 241).

21. J. G. Ballard, *Crash* (New York: Farrar, Straus and Giroux, 1973), 128.

22. Carol Clover, *Men, Women, and Chain Saws* (Princeton: Princeton University Press, 1992), 51–64.

23. Bob Flanagan, "Body," in *High Risk,* ed. Amy Scholder and Ira Silverberg (San Francisco: City Lights, 1991), 87.

24. The partial list following is notable for its mixture of art, video, and performance. In conjunction with the *Abject Art* show, for instance, the Whitney Museum sponsored a series of programs and videos, featuring Vito Acconci, Car-

olee Schneemann, Maria Beatty, Annie Sprinkle, and others. Although it is impossible to compile a comprehensive list of all the shows that illustrate this point, a partial list includes: *Dissent, Difference and the Body Politic,* Portland (Oregon) Art Museum, 1992; *Up with People,* Hudson Feature Gallery, New York, July 7–August 6, 1993; *Artists' Writing Reading Room: An Exhibition of Visual Artists Who Write and Writers Who Make Visual Art,* Side Street Projects, Santa Monica, California, May 1993; *Bad Girls,* New Museum, New York, 1994; *The Illustrated Woman,* The Lab and San Francisco Cameraworks, February 4–5, 1994; *Addressing Herself,* The Lab, February 2–March 5, 1994; *Hannah Wilke,* Ronald Feldman Gallery, New York, January–February 1994; Nayland W. Blake, *The Philosopher's Suites,* Thread Waxing Space, New York, 1994; *Body and Soul,* Baltimore Museum of Art, 1994; *Hors Limites,* Georges Pompidou Center, Paris, November 9, 1994–January 23, 1995.

25. *Guardian Weekly,* January 24, 1993.

26. Peter Greenaway, "Introduction," *The Physical Self,* catalogue for exhibition at the Boymans–van Beuningen Museum, Rotterdam, The Netherlands, October 27, 1991–December 1, 1992, hereafter cited parenthetically as PS.

27. Janet Maslin, "How to Rate Cannes: The Festival Is à la Folie," *New York Times,* May 14, 1996, C13, C16.

28. Jeffrey Deitch, *Post Human* (New York: Distributed Art Publishers, 1992), 15.

29. Sigmund Freud, *Civilization and Its Discontents,* trans. and ed. James Strachey (New York: W. W. Norton, 1961), 56n. Freud notes: "With man's adoption of an erect posture . . . events . . . proceeded through the devaluation of olfactory stimuli . . . to the time when visual stimuli were paramount" (54n1).

30. Mary Douglas, *Purity and Danger* (London: Routledge and Kegan Paul, 1969).

31. Julia Kristeva, *Powers of Horror: An Essay on Abjection,* trans. Leon Roudiez (New York: Columbia University Press, 1983), 135, hereinafter cited parenthetically as PH.

32. Deitch, *Post Human,* 43.

33. Judith Halberstam, *Skin Shows: Gothic Horror and the Technology of Monsters* (Durham, N.C.: Duke University Press, 1995), 18.

34. Edward de Grazia, *Girls Lean Back Everywhere: The Law of Obscenity and the Assault on Genius* (New York: Random House, 1992), 215n.

35. *Washington Post,* July 29, 1995, A1, A10.

CHAPTER TWO: CUTUPS IN BEAUTY SCHOOL

1. Gustave Flaubert, letter to Louise Colet, January 16, 1852; reprinted in *Madame Bovary,* trans. Paul de Man (New York: W. W. Norton, 1965), 309.

2. *Time,* fall 1993 special issue, cover.

3. Ibid. See also Michael Prince, "The Eighteenth-Century Beauty Contest," *Modern Language Quarterly* 55:3 (September 1994): 251–79. My thanks to Michael Prince for bringing the *Time* issue to my attention.

4. As a feminist representative of the so-called postfeminist generation, see

Naomi Wolf, *The Beauty Myth* (New York: William Morrow, 1991; rpt. Anchor, 1992; citations refer to the latter).

5. V. Vale and Andrea Juno, eds., *Angry Women* (San Francisco: Re/Search Books, 1991).

6. Throughout this section, I draw on senior curator Dan Cameron's brochure notes, *Carolee Schneemann: Up to and Including Her Limits* (New York: New Museum of Contemporary Art, November 24, 1996, to January 26, 1997).

7. Carolee Schneemann, *More than Meat Joy: Complete Performance Works and Selected Writings*, ed. Bruce McPherson (New York: Documentext, 1979), 235. *Interior Scroll* was first performed on August 29, 1975, as a part of the *Women Here and Now* exhibit, East Hampton, Long Island, and again on September 4, 1977, at the Telluride Film Festival in Colorado.

8. Robert C. Morgan, "Reconstructing with Shards," *American Ceramics* 2:1 (1983): 36–40.

9. Katrien Jacobs, "The Dismemberment of a Once Sublime Performance Artist," diss., University of Maryland, College Park, 1995, 169.

10. Interview with Andrea Juno, in Vale and Juno, *Angry Women*, 67, 69.

11. Leslie C. Jones, "Transgressive Femininity: Art and Gender in the Sixties and Seventies," in *Abject Art: Repulsion and Desire in American Art* (New York: Whitney Museum, Independent Study Program Papers, no. 3, 1993), 33–34, quoting "Carolee Schneemann: Image as Process," *Creative Camera*, no. 76 (October 1970): 304. *Abject Art* will hereinafter be cited parenthetically as AA.

12. Carolee Schneemann, letter to Linda S. Kauffman, August 5, 1996.

13. Jacobs, "Dismemberment of a Performance Artist," 171, 173; see also her chap. 2, "Myths and Rites of Dismemberment in Performance Art."

14. Morgan, "Reconstructing," 39.

15. Carolee Schneemann, letter to Linda S. Kauffman, March 1, 1995.

16. Jacobs, "Dismemberment of a Performance Artist," 167–68.

17. Vale and Juno, *Angry Women*, 76.

18. See Jacobs, "Dismemberment of a Performance Artist," 45–46.

19. Schneemann, letter to Kauffman, August 5, 1996.

20. Joanna Frueh, *Erotic Faculties* (Berkeley: University of California Press, 1996), 103.

21. I thank Carolee Schneemann for providing me with her notes on this work.

22. Carolee Schneemann, *Known/Unknown: Plague Column*, Elga Wimmer Gallery, May 18–June 30, 1996.

23. One of Sprinkle's performances is called *Post-Post Porn Modernist;* her book is titled *Post Porn Modernist* (Amsterdam: Torch Books, 1991).

24. Steve Dubin, *Arresting Images: Impolitic Art and Uncivil Actions* (New York: Routledge, 1992), 147.

25. Vale and Juno, *Angry Women*, 34.

26. Dubin, *Arresting Images*, 147.

27. Kathleen Rowe, *The Unruly Woman: Gender and the Genres of Laughter* (Austin: University of Texas Press, 1995).

28. Linda Williams, "A Provoking Agent: The Pornography and Performance Art of Annie Sprinkle," in *Dirty Looks: Women, Pornography, Power,* ed. Pamela

Church Gibson and Roma Gibson (London: British Film Institute, 1993), 186. Williams concludes (persuasively, in my view) that Sprinkle markets herself: she is the "fetishised woman *par excellence*" (187). She plays with the conventions of hard-core porn's frenzy to reveal female orgasm, an argument elaborated more fully in Williams's *Hard Core: Power, Pleasure, and the "Frenzy of the Visible"* (Berkeley: University of California Press, 1989).

29. Williams, "A Provoking Agent," 176.

30. Barbara Kruger, *Love for Sale* (New York: Harry Abrams, 1990), 17.

31. Linda S. Kauffman interview with Orlan, Paris, November 24, 1994; subsequent interview May 18, 1995. All unattributed quotations refer to these interviews. An earlier version of this section was published as "Radical Surgery," *Two Girls Review* (1995): 82–91.

32. Cited in Michelle Hirschorn, "Orlan: Artist in the Post-Humanist Age of Mechanical Reincarnation," M.A. thesis, University of Leeds, 1994, pt. 2, p. 13, quoting Keith Dovkants, "Cut Out to Be Venus," *Evening Standard,* March 23, 1994, 13.

33. Margalit Fox, "A Portrait in Skin and Bone," *New York Times,* November 21, 1993.

34. Nick Rosen, "The Birth—by Surgeon's Scalpel—of Venus," *Sunday Telegraph,* November 14, 1993.

35. Orlan, "Operation-Réussie: A Performance/Lecture," The Illustrated Woman Conference, San Francisco, February 5, 1994. My discussion draws on my interview with Orlan following the conference.

36. Simone de Beauvoir, *The Second Sex,* trans. and ed. H. M. Parshley (New York: Vintage, 1974), 65–66.

37. Barbara Rose, "Is It Art? Orlan and the Transgressive Act," *Art in America* 81:2 (February 1993): 125.

38. J. G. Ballard, *The Atrocity Exhibition,* ed. Andrea Juno and V. Vale (San Francisco: Re/Search Books, 1990), 93.

39. Hirschorn, "Orlan," pt. 2, pp. 11–12.

40. I thank Marsha Gordon for bringing this film to my attention; see her "Cinematic Body Politics in Peter Greenaway's *The Baby of Macon* and Ngozi Onwurah's *The Body Beautiful,*" M.A. thesis, University of Maryland, 1996.

41. Georges Bataille, *Erotism: Death and Sensuality,* trans. Mary Dalwood (San Francisco: City Lights, 1986), 117; originally published as *L'Erotisme* (Paris: Editions de Minuit, 1957).

42. Ken Shulman, "Peter Greenaway Defends His 'Baby,'" *New York Times,* February 6, 1994, H18.

43. Virtual Futures Conference, program notes, University of Warwick, England, May 26–28, 1995. My thanks to Clare Brant and Orlan for bringing this to my attention.

44. Sigmund Freud, "Leonardo da Vinci and a Memory of His Childhood" (1910), in *The Standard Edition of the Complete Psychological Works of Sigmund Freud,* ed. and trans. James Strachey, 24 vols. (London: Hogarth, 1953–66), vol. 11. Orlan belongs to a long line of artists who challenge the relationship between perceptual and sexual contradiction, a line stretching from Leonardo's

Mona Lisa (often rumored to be a self-portrait) to Manet's *Olympia*. See Jacqueline Rose, *Sexuality in the Field of Vision* (London: Verso, 1986), 226.

45. Parveen Adams, *The Emptiness of the Image: Psychoanalysis and Sexual Differences* (London: Routledge, 1996), 154.

46. As if to suggest the infinite extension of epistolarity in time and space, Orlan's appearance at the First Annual Performance Studies Conference at New York University in March 1994 provoked a prolonged E-mail debate, which was subsequently published in *TDR* (fall 1995). Bob Flanagan has also sparked extended E-mail debate on a computer network for people with cystic fibrosis.

47. Jacobs, "Dismemberment of a Performance Artist," 42, quoting Antonin Artaud, *The Theater and Its Double* (New York: Grove Press, 1958), 110; Robert Motherwell, *The Dada Painters and Poets* (New York: Wittenborn-Schultz, 1951), 55–65.

48. Valie Export, "Persona, Proto-Performance, Politics: A Preface," *Discourse* 14:2 (spring 1992): 26–35.

49. Tanya Augsburg, "Private Theatres Onstage: Hysteria and the Female Medical Subject from Baroque Theatricality to Contemporary Feminist Performance," diss., Emory University, 1996, 17. My thanks to Tanya for help with translation and materials, and for inviting me to participate on her panel, Gendering the Medical Body, First Annual Performance Studies Conference, New York University, March 25, 1995.

50. Export, "Persona," 28–29.

51. Ted Byfield and Lincoln Tobier, "Television," *Stanford Humanities Review* 2:2–3 (spring 1992): 90–108.

52. Adams, *Emptiness*, 158–59.

53. Ibid., 158.

54. *VST: Revue Scientifique et Culturelle de Santé Mentale* 23/24 (Sept.–Dec. 1991). (VST stands for *Vie Sociale et Traitements*.)

55. Kurt Hollander, "Mental Illness and Body Art," *Poliester* 3:9 (summer 1994): 20–29, cited in Augsburg, "Private Theaters," 43.

56. Jacques Derrida, "La Loi du Genre/The Law of Genre," trans. Avital Ronell, *Glyph* 7 (spring 1980): 177–232.

57. Linda Williams, "Second Thoughts on *Hard Core:* American Obscenity Law and the Scapegoating of Deviance," in Gibson and Gibson, *Dirty Looks*, 47.

58. Laura Mulvey, "Visual Pleasure and Narrative Cinema," in *Visual and Other Pleasures* (Bloomington: Indiana University Press, 1989), 25.

59. Joanna Frueh is the latest critic to ignore the specific genre of Mulvey's essay, the manifesto, and of its object, cinema, by fallaciously describing "numerous feminist writings mothered by Laura Mulvey's 'Visual Pleasure and Narrative Cinema' . . . [which] denied women the authenticity of their own visual and bodily experiences and have imprisoned women in the accepted reductiveness of the male gaze" (*Erotic Faculties*, 149). In *The Avant-garde Finds Andy Hardy* (Cambridge, Mass.: Harvard University Press, 1995), Robert Ray's opposition to Mulvey is equally misguided, particularly since her own aims serve as dramatic confirmation of several of his major points, particularly regarding

the ubiquity of popular culture and the impact of Surrealism—a movement deeply indebted to psychoanalysis in general, fetishism in particular.

60. J. Rose, *Sexuality in the Field of Vision,* 83–89.

61. Mulvey, "Visual Pleasure," 16. Compare Frantz Fanon, *Black Skin, White Masks,* trans. Charles Lam Markmann (New York: Grove Press, 1967), 13: "I believe that the fact of the juxtaposition of the white and black races has created a massive psychoexistential complex. I hope by analyzing it to destroy it." While Mulvey was criticized, no one objected to Fanon's formulation.

62. Mulvey, "Visual Pleasure," 20.

63. Ballard, *The Atrocity Exhibition,* 114.

64. Mulvey, "Visual Pleasure," 19, 25.

65. Wendy Steiner, "The Literalism of the Left," in *The Scandal of Pleasure: Art in an Age of Fundamentalism* (Chicago: University of Chicago Press, 1995), 91.

66. Prince, "Eighteenth-Century Beauty Contest," 279.

67. Roland Barthes, *S/Z: An Essay,* trans. Richard Howard (New York: Hill and Wang, 1978), 169.

68. See Augsburg, "Private Theaters."

69. Arthur and Marilouise Kroker, eds., *The Last Sex: Feminism and Outlaw Bodies* (New York: St. Martin's Press, 1993), 18–19.

70. Jacques Lacan discusses anamorphosis and its relation to art in *The Four Fundamental Concepts of Psychoanalysis,* ed. Jacques-Alain Miller, trans. Alan Sheridan (New York: W. W. Norton, 1978), 67–90; see also Slavoj Žižek, "Looking Awry," *October* 50 (fall 1989): 30–55, and Žižek, *The Sublime Object of Ideology* (London: Verso, 1989), 1–53; and Adams, *Emptiness,* 152–53.

71. Žižek, *Sublime Object,* 42.

72. Adams, *Emptiness,* 159.

73. V. Vale and Andrea Juno, eds., *J. G. Ballard* (San Francisco: Re/Search Books, 1984; rpt. 1989), 157.

74. Adams, *Emptiness,* 145. Adams also relates Orlan's work to Mulvey's essay on Pandora.

75. Laura Mulvey, "Pandora: Topographies of the Mask and Curiosity," in *Sexuality and Space,* ed. Beatriz Colomina (Princeton: Princeton Papers on Architecture, 1992), 60.

76. Flaubert, *Madame Bovary,* 255.

CHAPTER THREE: IMPOLITIC BODIES

1. Simon Watney, *Policing Desire: AIDS, Pornography, and the Media* (Minneapolis: University of Minnesota Press, 1987), 74.

2. See Isaac Julien and Kobena Mercer's "Introduction: De Margin and De Centre," in the ironically titled "Last 'Special Issue' on Race?" *Screen* 29:4 (autumn 1988). Their essay summarizes and endorses the arguments of Stuart Hall, "On Postmodernism and Articulation: An Interview," ed. Lawrence Grossberg, in *Communications Inquiry* 10:2 (1986), and Paul Gilroy, *There Ain't No Black in the Union Jack* (London: Hutchinson, 1987).

3. Julien and Mercer, "De Margin and De Centre," 4. Their emphasis is specifically on Britain's postcolonial subjects, but my chapter includes two American filmmakers, Scott McGehee and David Siegel.

4. Coco Fusco, "Sankofa and the Black Audio Film Collective," interview with Martina Attille and Isaac Julien, in *Discourses: Conversations in Postmodern Art and Culture,* ed. Russell Ferguson, Marcia Tucker, and Karen Fiss (New York: New Museum of Contemporary Art and MIT Press, 1990), 17–42.

5. Fusco, "Sankofa," 19–20.

6. Julien and Mercer, "De Margin and De Centre," 9.

7. Jane Gaines, "White Privilege and Looking Relations: Race and Gender in Feminist Film Theory," *Screen* 29:4 (autumn 1988): 12–27; Manthia Diawara, "Black Spectatorship—Problems of Identification and Resistance," *Screen* 29:4 (autumn 1988): 66–80.

8. Julien and Mercer, "De Margin and De Centre," 9.

9. Ibid., 8.

10. V. Vale and Andrea Juno, eds., *J. G. Ballard* (San Francisco: Re / Search Books, 1984; rpt. 1989), 157.

11. Rachel Bowlby, *Shopping with Freud* (London: Routledge, 1993), chap. 6.

12. To distinguish the character from the filmmaker, I speak of Ngozi when speaking of the various selves she presents in the film and Onwurah when referring to the filmmaker.

13. Bill Nichols, *Blurred Boundaries: Questions of Meaning in Contemporary Culture* (Bloomington: Indiana University Press, 1994), 95.

14. Susan Sontag, "The Double Standard of Aging," *Saturday Review,* September 23, 1972, 37, cited in Joanna Frueh, *Erotic Faculties* (Berkeley: University of California Press, 1996), 149.

15. Delaynie Rudner, "Breast Cancer: The Censored Scar," *Gauntlet* 2:9 (1995): 18.

16. Susan Ferraro, "You Can't Look Away Anymore: The Anguished Politics of Breast Cancer," *New York Times Magazine,* August 15, 1993, 24–27, 58–62; the issue of September 5, 1993, cited the follow-up letters and reported on the volume of mail received.

17. Rudner, "Breast Cancer," 26.

18. Ibid., 14–15.

19. Laura Kipnis, *Ecstasy Unlimited: On Sex, Capital, Gender, and Aesthetics* (Minneapolis: University of Minnesota Press, 1993), 228.

20. Nichols, *Blurred Boundaries,* 13.

21. Gilles Deleuze and Félix Guattari, *Anti-Oedipus: Capitalism and Schizophrenia,* trans. Robert Hurley, Mark Seem, and Helen R. Lane (Minneapolis: University of Minnesota Press, 1983), 96.

22. See Fernando Solanas and Octavio Gettino, "Towards a Third Cinema," in *Movies and Methods,* ed. Bill Nichols (Berkeley: University of California Press, 1976). The term was subsequently expanded with particular reference to African cinema in Teshome Gabriel's *Third Cinema in the Third World: The Aesthetics of Liberation* (Ann Arbor: U.M.I. Research Press, 1982).

23. Kaja Silverman, *The Subject of Semiotics* (New York: Oxford University Press, 1983), chap. 5.

24. Ibid., 212.

25. Frantz Fanon, *Black Skin, White Masks,* trans. Charles Lam Markmann (New York: Grove Press, 1967), 10.

26. Ibid., 10–11.

27. After East Los Angeles burned in the wake of the Rodney King verdicts in April 1992, a Museum of Tolerance was built; to demonstrate that humans "are all the same beneath the skin," one display is an interactive exhibit of X rays.

28. Louis Althusser, "Brecht and Bertolazzi," cited in Silverman, *Semiotics,* 217.

29. Silverman, *Semiotics,* 217.

30. Ibid.

31. Fanon, *Black Skin, White Masks,* 49.

32. A partial sample of other filmmakers notable for their use of visual art or photography includes Robert Altman, Stan Brakhage, Borden Chase, Maya Deren, Germaine Dulac, Oskar Fischinger, Robert Hamer, Derek Jarman, Stanley Kubrick, Fernand Léger, Len Lye, Jonas Mekas, Hans Richter, Alan Rudolph, Ken Russell, John Waters, and Wim Wenders; the films *I Shot Andy Warhol* and *Nico Icon* also come to mind.

33. Kobena Mercer, "Skin Head Sex Thing: Racial Difference and the Homoerotic Imaginary," in *How Do I Look?* (Seattle: Bay Press, 1991), 181.

34. Ibid., 190.

35. Ibid., 177.

36. *Washington Post,* February 12, 1996, B7.

37. Fanon, *Black Skin, White Masks,* 13.

38. As if to underscore the continuing relevance of the idea of "black skin, white masks," one of Isaac Julien's recent works is a video about Rush Limbaugh *(That Rush!)* which portrays the xenophobia and racism on Limbaugh's television talk show, juxtaposed with commentary by black scholars. Julien also completed a film biography of Frantz Fanon, which premiered at the American Film Institute, Washington, D.C., on April 27, 1997.

39. Colin McCabe, "Black Film in '80's Britain," in *Black Film/British Cinema,* ed. Kobena Mercer (London: I.C.A. Document 7/British Film Institute Production Special, 1988), 31.

CHAPTER FOUR: SEX WORK

1. Laurie Bell, ed., *Good Girls/Bad Girls: Feminists and Sex Trade Workers Face Off* (Toronto: Seal Press, 1987), 201, 208, 210.

2. Linda Williams, *Hard Core: Power, Pleasure, and the "Frenzy of the Visible"* (Berkeley: University of California Press, 1989), chap. 1.

3. The furor over *Peeping Tom,* which premiered the same year as Hitchcock's *Psycho,* effectively ended Michael Powell's career. As with *Inserts,* reviewers failed to notice that the film was a history of cinema, despite Powell's explanation that "it's a film of compassion, of observation, and of memory. . . . A film about the cinema from 1900 to 1960" (cited in Elliott Stein, "A Very Tender Film, A Very

Nice One," *Film Comment* 15 [1979]: 57–59). Today, it is viewed as one of the finest metafilms ever made.

4. I discuss the ordinance in greater detail in Chapter 9. The ordinance was born in 1983 in Dworkin and MacKinnon's University of Minnesota Law School class on pornography, which they designed to "bring pornography secrecy into the open, study it, and explore how women are victimized by it." They presented their draft to the city council on November 23, 1983; it passed in December 1983, and was vetoed by the mayor on January 5, 1984. See Donald Alexander Downs, *The New Politics of Pornography* (Chicago: University of Chicago Press, 1989), 56–62.

5. Marcia Pally, "Double Trouble: Interview with Brian De Palma," *Film Comment* 20:5 (Sept.-Oct. 1984): 12–17.

6. Carol J. Clover, "Her Body, Himself: Gender in the Slasher Film," *Representations* 20 (1987): 187–228.

7. Carol Clover, *Men, Women, and Chain Saws* (Princeton: Princeton University Press, 1992), 186.

8. Anthony Crabbe, "Feature-length Sex Films," in *Perspectives on Pornography: Sexuality in Film and Literature,* ed. Gary Day and Clive Bloom (New York: St. Martin's Press, 1988), 44–68.

9. For example, Michael S. Kimmel, ed., *Men Confront Pornography* (New York: Penguin, 1991).

10. Laura Kipnis, *Ecstasy Unlimited: On Sex, Capital, Gender, and Aesthetics* (Minneapolis: University of Minnesota Press, 1993), 234.

11. Ted Byfield and Lincoln Tobier, "Television," *Stanford Humanities Review* 2:2–3 (spring 1992): 90–97; Laura Mulvey also examines the pleasure of passivity in "Visual Pleasure and Narrative Cinema," in *Visual and Other Pleasures* (Bloomington: Indiana University Press, 1989).

12. Susan Barrowclough, review of *Not a Love Story,* in *Screen* 23 (1982): 26–36, cited in Clover, *Men, Women, and Chain Saws,* 57n55.

13. Pally, "Interview with De Palma," 15–16.

14. Brian Burrough, "The Siege of Paramount," *Vanity Fair,* February 1994, 123. See also Carla Hall, "Heidi Fleiss: Hollywood's Woman of the Year?" *Los Angeles Times,* August 18, 1993, Fl, 5.

15. William Friedkin's *Exorcist* (1973) was one precursor; Clover discusses menstruation in both films in *Men, Women, and Chain Saws,* 77–84.

16. This section was co-authored with Robert Kenamond.

17. See Richard Dyer, "Getting Over the Rainbow: Identity and Pleasure in Gay Cultural Politics," in *Only Entertainment* (London: Routledge, 1992), 159–72. Dyer writes: "By taking the signs of masculinity and eroticizing them in a blatantly homosexual context, much mischief is done to the security with which 'men' are defined in society, and by which their power is secured."

18. Van Sant turns each principle player into an ironic equivalent of a Shakespearean model: Scott Favor is based on Prince Hal, Mike Waters is Poins, Bob Pigeon is Falstaff, and Mayor Jack Favor is King Henry. See Lance Loud, "Shakespeare in Black Leather," *American Film* 16:9 (Sept.–Oct. 1991): 32–37.

19. Cited in ibid., 33–37.

20. For discussions of fantasy as the mise-en-scène of desire, see Barbara Creed, "A Journey through *Blue Velvet*," *New Formations* 6 (winter 1988): 97–117; Elisabeth Lyon, "The Cinema of Lol V. Stein," in *Fantasy and the Cinema*, ed. James Donald (London: British Film Institute, 1989), 147–74; and Elizabeth Cowie, "Fantasia," *m/f* 9 (1984): 71–105.

21. Sigmund Freud, *Beyond the Pleasure Principle*, trans. and ed. James Strachey (New York: W. W. Norton, 1961).

CHAPTER FIVE: DAVID CRONENBERG'S SURREAL ABJECTION

1. Chris Rodley, ed., *Cronenberg on Cronenberg* (London: Faber and Faber, 1992), 90, hereinafter cited parenthetically as CC.

2. Siegfried Kracauer, *Theory of Film* (London: Oxford University Press, 1960), 547–58; see also Gertrud Koch, "The Body's Shadow Realm," *October* 50 (fall 1989): 3–29.

3. Carol Clover, "Her Body, Himself: Gender in the Slasher Film," in *Fantasy and the Cinema*, ed. James Donald (London: British Film Institute, 1989), 91–135.

4. Joan Juliet Buck, "Live Mike: Interview with Mike Nichols," *Vanity Fair*, June 1994, 70, 72, 74, 77–78, 80–82.

5. Harry Stein, "How to Be a Man," *Esquire*, May 1994, 56–59, 62–63.

6. Peter Sloterdijk, *Critique of Cynical Reason*, trans. Michael Eldred (Minneapolis: University of Minnesota Press, 1987), 262.

7. Camille Paglia, *Sexual Personae: Art and Decadence from Nefertiti to Emily Dickinson* (New York: Vintage, 1991), 19, 21: "The source of man's cultural achievements . . . follows so directly from his singular anatomy. . . . Male urination really is a kind of accomplishment, an arc of transcendence. A woman merely waters the ground she stands on. Male urination is a form of commentary. . . . To piss on is to criticize."

8. My thanks to Art Shapiro, my fellow seminar member at the Humanities Institute, University of California, Davis, 1991–92.

9. Donna Haraway, "The Biopolitics of Postmodern Bodies," in *American Feminist Thought at Century's End*, ed. Linda S. Kauffman (Oxford: Blackwell, 1993), 199–233.

10. On *The Birds*, see Jacqueline Rose, "Paranoia and the Film System," in *Feminism and Film Theory*, ed. Constance Penley (New York: Routledge, 1988), 141–58.

11. Robin Wood, "An Introduction to the American Horror Film," in *American Nightmare: Essays on the Horror Film*, ed. Andrew Britton, Richard Lippe, Tony Williams, and Robin Wood (Toronto: Festival of Festivals, 1979); see also Robin Wood, "David Cronenberg: A Dissenting View," in *The Shape of Rage: The Films of David Cronenberg*, ed. Piers Handling (Toronto: Academy of Canadian Cinema, General Publishing Company, and New York: Zoetrope, Inc., 1983), 115–36.

12. Andrew Parker accuses Cronenberg of homophobia in "Grafting David Cronenberg: Monstrosity, AIDS Media, National/Sexual Difference," *Stanford*

Humanities Review 3:1 (winter 1993): 7–21; see also Barbara Creed, *The Monstrous-Feminine: Film, Feminism, Psychoanalysis* (London: Routledge, 1993), chap. 4.

13. Jonathan Crary, "Psychopathways: Horror Movies and the Technology of Everyday Life," *Wedge* 2 (1982): 8–15.

14. Ibid., 15.

15. Creed, *The Monstrous-Feminine*, chap. 4.

16. Steven Shaviro, "Bodies of Fear: The Films of David Cronenberg," in *The Politics of Everyday Fear,* ed. Brian Massumi (Minneapolis: University of Minnesota Press, 1993), 127. By cutting this scene, the censors inadvertently made it seem as if Nola were eating her baby—a much more violent image (CC, 85).

17. CC, 76. In an interview with Charlie Rose (June 19, 1996), James Caan confessed that he turned down the starring role in *Kramer* for precisely this reason. Dustin Hoffman won an Academy Award for the role.

18. See Michael Taussig, *The Nervous System* (New York: Routledge, 1992), and Haraway, "Biopolitics of Postmodern Bodies."

19. V. Vale and Andrea Juno, eds., *J. G. Ballard,* (San Francisco: Re / Search Books, 1984; rpt. 1989), 163.

20. Jean Baudrillard, *Simulations,* trans. Paul Foss, Paul Patton, and Philip Beitchman (New York: Semiotext(e), 1983), 54.

21. Shaviro, "Bodies of Fear," 121–22.

22. Koch, "Body's Shadow Realm," 9.

23. Ibid., 18.

24. This idea came to me while reading a newspaper article on novelist Samuel Delany, who remarks that he is "playing with [this] borrowed idea" (borrowed from Cronenberg?), *New York Times,* February 11, 1996, 49, 55.

25. Carol Clover, *Men, Women, and Chain Saws* (Princeton: Princeton University Press, 1992), 52–53.

26. Ibid., 53.

27. Ibid., 56n55.

28. Shaviro, "Bodies of Fear," 124.

29. Ibid., 124.

30. George Hickenlooper, "The Primal Energies of the Horror Film: An Interview with David Cronenberg," *Cineaste* 17:2 (1989): 4–7.

31. Shaviro, "Bodies of Fear," 129.

32. Bari Wood and Jack Geasland wrote a book loosely based on the case, *Twins.* Stewart and Cyril Marcus were born under the sign of Gemini on June 2, 1930, delivered by Dr. Alan Guttmacher, himself a twin, and later mentor to the brilliant Marcus doctors. Stewart Marcus is the model for Elliot Mantle, Cyril for Beverly. Guttmacher, a gynecologist and expert on twins, wrote that "all separate identical twins may be regarded as monsters who have successfully escaped the various stages of monstrosity," but he warned that they had to guard against "slipping back into monsterhood through psychic conjoinment." They were found dead, victims of an apparent murder-suicide pact, in July 1975 in their Manhattan apartment. See Ron Rosenbaum and Susan Edmiston, "Dead Ringers," *Esquire,* March 1976, 90–103, 135–42.

33. Sigmund Freud, "The Uncanny," in *The Standard Edition of the Com-*

plete Psychological Works of Sigmund Freud, ed. and trans. James Strachey, 24 vols. (London: Hogarth Press, 1953–66), 17:244.

34. Chris Rodley notes, "In the aquamarine design of the Mantle twins' apartment, and their strange 'otherness,' is the fish-tank approach Cronenberg applied to his characters in those early avant-garde experiments [*Stereo* and *Crimes of the Future*]" (CC, 145–46).

35. Haraway, "Biopolitics of Postmodern Bodies," 204.

36. Peter Greenaway, *A Zed and Two Naughts* (London: Faber and Faber, 1986), 14–15. My thanks to Marsha Gordon for bringing this film to my attention.

37. Stuart Klawans, *The Nation,* October 31, 1988, 431–32.

38. Roger Dadoun, "Fetishism in the Horror Film," in Donald, *Fantasy and the Cinema,* 57.

39. Barbara Creed, "Phallic Panic: Male Hysteria and *Dead Ringers,*" *Screen* 31:2 (summer 1990): 125–46.

40. A Queens congressman called the Marcus affair "a medical Watergate"; a *New York Times* editorial attacked New York Hospital–Cornell Medical Center for "stonewalling"; see Rosenbaum and Edmiston, "Dead Ringers," 90–103, 135–42. Susan S. Lichtendorf, a science writer, had a cesarean section performed by Dr. Stewart Marcus five months before his and Cyril's death. In *Ms.* (February 1976, 22–27), she reported their erratic behavior, which included Cyril's ranting that overeating during pregnancy would make her a "child murderer." Other patients reported that the twins became increasingly wrathful, like Jehovah in the Old Testament: they would fly into rages if their medical commandments were disobeyed or even questioned; they were jealous, demanding unquestioning faith and obedience (Rosenbaum and Edmiston, "Dead Ringers," 136).

41. See especially Sigmund Freud, "Medusa's Head" (1922) and "Fetishism" (1927), in *The Standard Edition,* vols. 18 and 21, respectively; "From the History of an Infantile Neurosis," in *Case Histories II* (Harmondsworth: Penguin, Pelican Freud Library, 1981) vol. 9, and "On the Sexual Theories of Children," in *On Sexuality* (Harmondsworth: Penguin, Pelican Freud Library, 1981), vol. 7.

42. Hickenlooper, "Primal Energies," 6.

43. Creed, *The Monstrous-Feminine,* chap. 2.

44. Céline, who is one of Julia Kristeva's primary examples of novelists of abjection, similarly speaks of Lola's body as "a mystical adventure in anatomical research," in *Journey to the End of the Night,* trans. John H. P. Marks (Boston: Little, Brown, 1934), 213; see also Julia Kristeva, *Powers of Horror: An Essay on Abjection,* trans. Leon Roudiez (New York: Columbia University Press, 1983), 143.

45. Creed, "Phallic Panic," 136.

46. Ibid.

47. Noxious odors from the Marcuses' luxurious Manhattan apartment led to the discovery of "the filthiest place I've ever seen," said the police sergeant. Hundreds of beer and soda cans and fifty or so empty vials of barbiturates and other drugs were found next to their bodies, but police ruled out narcotics, barbiturates, tranquilizers, and alcohol as causes of death. "Now we're going fishing for the unusual drugs," said Chief DiMaio (*Newsweek,* August 4, 1975, 29).

48. Creed, "Phallic Panic," 126.

49. Ibid., 142.

50. Ibid., 136–37.

51. Marcie Frank, "The Camera and the Speculum: David Cronenberg's *Dead Ringers*," *PMLA* 106:3 (May 1991): 459–70.

52. Mulvey, "Visual Pleasure and Narrative Cinema," in *Visual and Other Pleasures* (Bloomington: Indiana University Press, 1989), 16.

53. Susan Lichtendorf, a patient who saw the Marcus twins every two weeks for nine months, reports in *Ms.* (February 1976, 25) that Stewart once told her, "When we were children in school in the same class, our teacher asked the only children to raise their hands and each of us did. We were one birth."

54. Frank, "Camera and Speculum," 460–63.

55. Ibid., 469n7.

56. Ibid., 463–64.

57. Fredric Jameson, *Signatures of the Visible* (London: Routledge, 1990), 1.

58. Alan Stanbrook, "Cronenberg's Creative Cancers," *Sight and Sound* 58:1 (winter 1989–90): 54–56.

59. Creed, "Phallic Panic," 126.

60. David Thomas and Ian Christie, eds., *Scorsese on Scorsese* (London: Faber and Faber, 1989), 103.

CHAPTER SIX: J. G. BALLARD'S ATROCITY EXHIBITIONS

1. J. G. Ballard, *The Atrocity Exhibition*, ed. V. Vale and Andrea Juno (San Francisco: Re/Search Books, 1990), 11M, hereinafter cited parenthetically as AE. This book was originally written between 1967–69; the 1990 edition includes four new chapters and Ballard's marginal annotations. When I am referring to the marginal notes, the letter M follows the page number.

2. V. Vale and Andrea Juno, eds., *J. G. Ballard* (San Francisco: Re/Search Books, 1984; rpt. 1989), 161, hereinafter cited parenthetically as JGB.

3. The reference is: "The sculptor George Segal has made a number of plaster casts of prominent art patrons, mostly New York bankers and their wives. Frozen in time, these middle-aged men and women have a remarkable poignancy, figures from some future Pompeii" (AE, 15M).

4. The film is Sam Scoggins's *Unlimited Dream Company;* some of the questions and answers are in JGB, 51.

5. J. G. Ballard, "Project for a Glossary of the Twentieth Century," in *Incorporations: Zone 6,* ed. Jonathan Crary and Sanford Kwinter (Boston: MIT Press, 1992), 275, hereinafter cited parenthetically as "Project."

6. In our interview, Ballard paid homage to B. Traven, author of the *Treasure of the Sierra Madre,* whose "reclusiveness and lacunae of mystery" he admires.

7. See Michael Taussig, *The Nervous System* (New York: Routledge, 1992), 1–5.

8. J. G. Ballard, *Empire of the Sun* (New York: Pocket Books, 1984), 286, 297.

9. *Washington Post,* June 16, 1994, A1, B3.

10. Arthur and Marilouise Kroker, eds., *The Last Sex: Feminism and Out-law Bodies* (New York: St. Martin's Press, 1993), 17.

11. Vittore Baroni, "J. G. Ballard Interviewed," *Censorium,* vol. 2, ed. John Marriott (Toronto: Mangajin Books, 1994), 39–44.

12. On chaos theory, see N. Katherine Hayles, ed., *Chaos and Order: Complex Dynamics in Literature and Science* (Chicago: University of Chicago Press, 1991), and Hayles, *Chaos Bound: Orderly Disorder in Contemporary Literature and Science* (Ithaca: Cornell University Press, 1990); on Cronenberg's use of immunology, see Chapter 5 herein; on new incorporations, see Crary and Kwinter, *Incorporations.*

13. See "The Fiction of Don DeLillo," *South Atlantic Quarterly* 89:2 (spring 1990) (entire issue).

14. Don DeLillo, *Mao II* (New York: Viking, 1991), 134.

15. Anthony DeCurtis, "Interview with Don DeLillo," *South Atlantic Quarterly* 89:2 (spring 1990): 291–92.

16. Eric Shanes, *Warhol* (New York: Portland House, 1991), 78.

17. Jean Baudrillard, "The Year 2000 Has Already Happened," in *Body Invaders: Panic Sex in America,* ed. Arthur and Marilouise Kroker (New York: St. Martin's Press, 1987), 35–44.

18. The museum's associate director, Sherri Geldin, quoted by Jo-Anne Berelowitz, "L.A.'s Museum of Contemporary Art and the Body of Marilyn Monroe," *Genders* 17 (fall 1993): 22–40, who mistakenly assumes that this appropriation is sexist.

19. See V. Vale and Andrea Juno's 1983 interview with Martin Bax in JGB, 36–39. The use of the billboard to subvert advertising's stranglehold on public consciousness is a technique artists like Jenny Holzer and Barbara Kruger have also seized.

20. *New York Times,* February 6, 1994.

21. The *Wall Street Journal,* July 30, 1993, A1, notes that Britons began documenting dreams of the Royals after Brian Masters's *Dreams of HM The Queen* was published twenty years ago.

22. Jean Baudrillard, "The Precession of Simulacra," in *Rethinking Representation: Art after Modernism,* ed. Brian Wallis (New York: New Museum of Contemporary Art, 1984), 262.

23. Jeffrey Deitch, *Post Human* (New York: Distributed Art Publishers, 1992), 41–42.

24. Carol J. Clover, "Her Body, Himself: Gender in the Slasher Film," in *Fantasy and the Cinema,* ed. James Donald (London: British Film Institute, 1989), 91–135; see also Clover, *Men, Women, and Chain Saws* (Princeton: Princeton University Press, 1992).

25. Gov. Ronald Reagan, April 7, 1970, quoted in William A. Gordon, *The 4th of May: Killings and Coverup at Kent State* (New York: Prometheus Books, 1990), epigraph.

26. When I left London a week later, another bomb scare closed the tube station one stop from Heathrow Airport, forcing hundreds of travelers like myself to walk miles to the terminal, not knowing if we would be blown up at any mo-

ment. Amid the chaos, I was momentarily stunned to catch a glimpse of a barrier across a road: "Max. Headroom: 4 metres."

27. Some of the images from Ballard's archive can be found in Martin Bax's magazine, *Ambit;* a few are reprinted in JGB, 147–52.

28. *Colors 7,* a Benetton Corporation magazine (special issue on AIDS), 1994, 121.

29. J. G. Ballard, letter to Linda S. Kauffman, June 3, 1995.

30. J. G. Ballard, *Rushing to Paradise* (London: Flamingo, 1994), 171.

31. Ballard wrote in 1990: "Little information has been released about the psychological effects of space travel, both on the astronauts and the public at large. Over the years NASA spokesmen have even denied that the astronauts dream at all during their space flights. But it is clear from the subsequently troubled careers of many of the astronauts (Armstrong, probably the only man for whom the 20th century will be remembered 50,000 years from now, refuses to discuss the moon-landing) . . . that they suffered severe psychological damage" (AE, 43M).

32. Samantha Weinberg, "Portraits of the Mental Patient as Inspired Artist," *New York Times Magazine,* August 6, 1995, 42–43. Dr. Leo Navratil is the psychiatrist who started the project in the 1950s; the first exhibition was in 1970 in a Viennese gallery. Perhaps Ballard had these particular patients in mind.

33. In the spring of 1993, Attorney General Janet Reno warned television executives to censor themselves or the Justice Department would do it for them. Reno found even the innocuous *Murder, She Wrote* "problematic." Jeffrey Rosen, "The Trials of Janet Reno," *Vanity Fair,* April 1994, 148–51, 171–75. She also objected to cop shows like *Law and Order,* but when its star, Michael Moriarty, challenged her, she silenced him during a meeting with NBC executives. Moriarty was subsequently forced to resign from the series (*Washington Post,* June 17, 1994, B3). Moriarty says he has been "nearly blacklisted" in Hollywood, and has been "forced to move to Canada to recover my artistic freedom" (*New York Times Magazine,* June 30, 1996, 13), a fate that will become only more common with more mergers of entertainment conglomerates. What celebrity, journalist, or network chief risked challenging the inane television rating system, which was put in force in 1997?

34. J. G. Ballard, *Crash* (New York: Farrar, Straus and Giroux, 1973), 29. All subsequent references are cited parenthetically in the text.

35. V. Vale and Andrea Juno, eds., *Industrial Culture Handbook* (San Francisco: Re/Search Books, 1983); I thank Andrea Juno for putting me in touch with Ballard.

36. *Details,* September 1994, 106–7.

37. Baudrillard, "The Precession of Simulacra," 253–81.

38. David Cronenberg's home page, www.netlink.co.uk/users/zappa/jgb_dc.html.

39. Janet Maslin, "Cannes Finally Gets a Noisy Controversy," *New York Times,* May 20, 1996, C11, C14.

40. Ibid. Maslin's article is full of internal contradictions: although she reports that the audience disliked the film, she denigrates the international film world, which "can be readily wowed by any shattering of taboos." She misses

the point again in a subsequent review (*New York Times,* March 21, 1997, B3) when she describes the characters as walking through this story "in a state of futuristic numbness. . . . It's a chilling, ghastly possibility." There is nothing "futuristic" about *Crash:* Cronenberg merely meticulously records the concrete jungle we made and live in today.

41. Kauffman telephone interview with David Cronenberg, March 4, 1997.

42. Letter to Kauffman, September 30, 1996.

43. *IndieWIRE,* November 19, 1996, 2.

44. *New York Daily News,* October 15, 1996.

45. *IndieWIRE,* November 6, 1996, 1–2.

46. "The Talk of the Town," *The New Yorker,* November 25, 1996, 47–48.

47. Ibid., 47.

48. On March 17, 1997, the film censorship board passed *Crash* with an "18 or older" rating and without calling for any cuts. The board's decision is not a total victory, however, because the Westminster ban remains. Moreover, according to the *Hollywood Reporter,* conservative national newspapers have reacted by calling for the film to be completely banned in Britain.

49. Don DeLillo, *Mao II* (New York: Viking, 1991), 16.

50. Jane Gross, *New York Times,* September 13, 1997, A1, A14.

CHAPTER SEVEN: CRIMINAL WRITING

1. Robert Coover, *A Night at the Movies or, You Must Remember This* (Normal, Ill.: Dalkey Archive Press, 1992), 11. The main character is a film projectionist (a title with psychoanalytic resonance) whose function (to create "the miracle of artifice") invites comparison with the novelist.

2. John Hawkes, *Virginie: Her Two Lives* (New York: Harper and Row, 1981), 1. All subsequent references are cited parenthetically in the text.

3. Susan Sontag, "The Pornographic Imagination," in *Styles of Radical Will* (New York: Farrar, Straus, and Giroux, 1966) recuperates pornography by explicating the French literary tradition. She highlights Bataille's impact, with specific emphasis on *Histoire de l'Oeil,* from which Hawkes borrows two incidents in *Virginie.*

4. Gloria Steinem, *Outrageous Acts and Everyday Rebellions* (New York: Holt, Rinehart, and Winston, 1983), 247–60.

5. Ellen Willis, *Beginning to See the Light: Pieces of a Decade* (New York: Knopf, 1981), 219–27.

6. Annie Le Brun, *Sade: A Sudden Abyss,* trans. Camille Naish (San Francisco: City Lights, 1990), "Translator's Preface," viii.

7. David Porush, "Review: The Erotic Double Vision in Hawkes's *Virginie,*" *Eighteenth Century Life* 8:1 (October 1982): 117–21.

8. Cited in Maurice Blanchot, "Sade," in *The Marquis de Sade,* trans. Richard Seaver and Austryn Wainhouse (New York: Grove Press, 1965), 50.

9. Roland Barthes, *Sade, Fourier, Loyola,* trans. Richard Miller (New York: Hill and Wang, 1976), 24.

10. Jacques Lacan, "Kant avec Sade," in *Critique,* no. 191 (April 1963), cited in Le Brun, *Sade,* 5.

11. John Kuehl, "*Virginie* as Metaphor," *Review of Contemporary Fiction* 3:3 (fall 1983): 148–52.

12. Barthes, *Sade, Fourier, Loyola,* 133.

13. Kuehl, "*Virginie* as Metaphor," 149.

14. Ibid.

15. Peter F. Murphy, in "Male Heterosexuality in Hawkes's *The Passion Artist,*" *Twentieth-Century Literature* 36:4 (winter 1990): 403–18, suggests that from *The Blood Oranges* to *Virginie,* Hawkes presents a radical theory of male heterosexuality.

16. Kuehl, "*Virginie* as Metaphor," 150–51.

17. Ibid., 150.

18. Porush, "Hawkes's *Virginie,*" 118.

19. Blanchot, "Sade," 56.

20. Le Brun, *Sade,* 192.

21. Ibid., 201–3.

22. Albert Guerard praises Hawkes's skill in evoking "childhood terror, oral fantasies and castration fears, fears of regression and violence, profound sexual disturbances," in *Contemporary Novelists,* ed. James Vinson, 1st, 2d, and 3d eds. (New York: St. Martin's, 1972, 1976, 1982).

23. Sigmund Freud, "Creative Writers and Daydreaming," in *Criticism: The Major Statements,* ed. Charles Kaplan, 3d ed. (New York: St. Martin's Press, 1986), 419–28, rpt. from *The Standard Edition of the Complete Psychological Works of Sigmund Freud,* ed. and trans. James Strachey, vol. 9 (1908) (London: Hogarth, 1953–66).

24. Lacan, "Kant avec Sade," cited in Le Brun, *Sade,* 5.

25. Patricia Tobin, "From Plague to Porn: The Sexual Text in Freud and John Hawkes," in *Psychoanalytic Approaches to Literature and Film,* ed. Maurice Charney and Joseph Reppen (London: Associated University Presses, 1987), 282–83.

26. Le Brun, *Sade,* 213.

27. Le Brun, *Sade,* 204.

28. Tobin, "From Plague to Porn," 286.

29. Barthes, *Sade, Fourier, Loyola,* 34.

30. Robert Coover, *Spanking the Maid* (New York: Grove Press, 1982), 9; all subsequent citations are to this edition and appear parenthetically in the text.

31. John Hawkes, "Notes on *The Wild Goose Chase,*" in *Studies in Second Skin,* ed. John Graham (Charles E. Merrill Studies; Columbus, Ohio: Merrill, 1971), 788. Of *The Beetle Leg* (New York: New Directions, 1971), Hawkes remarks: "We should feel a strong attachment to human life even in its most frightening form. There is something about the fetus with its unformedness, its total tremendous potential, and its connection to lower life forms, that makes it terribly, terribly frightening." Hawkes goes on to compare the fetus to a little penis, to scare us all some more, as Tobin comments in "From Plague to Porn," 291.

32. Cited in Blanchot, "Sade," 64.

33. Ibid., 53.

34. See, for example, Susan Gubar, "'The Blank Page' and the Issues of Female Creativity," *Critical Inquiry* 7 (winter 1981): 243–63.

35. Ronald Sukenick, *98.6* (New York: Fiction Collective, 1975), 167, cited in Jerry A. Varsava, "Another Exemplary Fiction: Ambiguity in Robert Coover's *Spanking the Maid*," *Studies in Short Fiction* 21:3 (summer 1984): 235–41.

36. Tobin, "From Plague to Porn," 304.

37. Barthes, *Sade, Fourier, Loyola*, 27.

38. Le Brun, *Sade*, viii–ix.

39. Robert Scholes and John Hawkes, "A Conversation on *The Blood Oranges*," *Novel* 4 (1972): 197–207.

CHAPTER EIGHT: NEW INQUISITIONS

1. William Vollmann, "De Sade's Last Stand," *Esquire*, November 1992, 161–76.

2. Walter L. Reed, *An Exemplary History of the Novel: The Quixotic versus the Picaresque* (Chicago: University of Chicago Press, 1981), 93.

3. David Van Leer, "Punko Panza," review of Kathy Acker's *Don Quixote*, in *New Republic*, May 4, 1987, 38–41.

4. Jorge Luis Borges, "Pierre Menard, Author of the *Quixote*," in *Labyrinths*, trans. James E. Irby (New York: New Directions, 1962), 44.

5. Reed, *An Exemplary History*, 77.

6. Walter Starkie, "Introduction," *Don Quixote*, trans. Walter Starkie (New York: New American Library, 1964), 26, hereinafter cited parenthetically in the text.

7. Ann Haverley, "In the (K)night-time," review of *Don Quixote*, in *Times Literary Supplement*, May 23, 1986, 554.

8. Richard Walsh, "The Quest for Love and the Writing of Female Desire in Kathy Acker's *Don Quixote*," *Critique* 32:3 (spring 1991): 149–68.

9. Kathy Acker, *Don Quixote* (New York: Grove Press, 1986), 9; all subsequent references are cited parenthetically in the text.

10. Lori Miller, "In the Tradition of Cervantes, Sort Of," interview with Kathy Acker, *New York Times Book Review*, November 30, 1986, 10.

11. Tom LeClair, review of *Don Quixote*, in *New York Times Book Review*, November 30, 1986, 10.

12. Robert Siegle, *Suburban Ambush: Downtown Writing and the Fiction of Insurgency* (Baltimore: Johns Hopkins University Press, 1989), 105.

13. Andrea Juno, "Interview with Kathy Acker," in *Angry Women*, ed. V. Vale and Andrea Juno (San Francisco: Re/Search Books, 1991), 179. The intrepid Juno is also the model for Gudrid in Vollmann's *The Ice-Shirt*, as Vollmann discusses in Larry McCaffrey's interview in the *Review of Contemporary Fiction* 13:2 (summer 1993): 16.

14. Walsh, "Quest for Love," 158.

15. Hélène Cixous, "The Laugh of the Medusa," *Signs* 1:4 (1975): 875–93, cited in Siegle, *Suburban Ambush,* 101–2.

16. Siegle, *Suburban Ambush,* 102, quoting Cixous, "The Laugh of the Medusa."

17. Siegle, *Suburban Ambush,* 102.

18. Walsh, "Quest for Love," 162–63.

19. A discussion of Russian contributions to the novel and narrative theory in the 1920s can be found in Linda S. Kauffman, *Special Delivery: Epistolary Modes in Modern Fiction* (Chicago: University of Chicago Press, 1992), chap. 1, on Viktor Shklovsky.

20. Borges, "Pierre Menard," 44.

21. LeClair, review of *Don Quixote,* 10.

22. Reed, *An Exemplary History,* 78.

23. Angela Carter has remarked that what first attracted her to writing *The Sadeian Woman and the Ideology of Pornography* (New York: Pantheon, 1978) was Sade's atheism. The parallels between Carter's fiction and Acker's merits a separate essay.

24. William T. Vollmann, *An Afghanistan Picture Show* (New York: Farrar, Straus and Giroux, 1992); the Land of Counterpane is discussed by Madison Smartt Bell, "Where an Author Might Be Standing," *Review of Contemporary Fiction* 13:2 (summer 1993): 39–45.

25. William T. Vollmann, *Whores for Gloria* (New York: Pantheon, 1991); all subsequent references are cited parenthetically in the text.

26. Reed, *An Exemplary History,* 73.

27. Bell, "Where an Author Might Be Standing," 40.

28. Katherine Spielmann, "The Book as Apparatus: William Vollmann's Special Editions," *Review of Contemporary Fiction* 13:2 (summer 1993): 64–67, describes Vollmann's CoTangent Press, which produces artists' editions and objects: *The Happy Girls* is "a massage parlor in a box, a facsimile leading into the handprinted, hand-colored story Vollmann narrates of a visit to the shop of a group of Thai prostitutes in San Francisco's Tenderloin district."

29. Kathy Acker, *Hannibal Lecter, My Father,* ed. Sylvère Lotringer (New York: Semiotext(e), 1991), 6.

30. Martin A. Lee and Norman Solomon, *Unreliable Sources: A Guide to Detecting Bias in News Media* (New York: Carol Publishing, 1990), 263.

31. David Foster Wallace, "West the Course of Empire Takes Its Way," cited in Bell, "Where an Author Might Be Standing," 41.

32. McCaffery, "Interview with Vollmann," 9–24.

33. Elizabeth Young and Graham Caveney are thus wrong to claim in *Shopping in Space: Essays on American "Blank Generation" Fiction* (New York: Serpent's Tale/Atlantic Monthly Press, 1992) that no American fiction has tried to come to terms with the American war in Vietnam; they overlook Vollmann's work entirely.

34. On the connection between masculinity and war, see Susan Jeffords, *The Remasculinization of America: Gender and the Vietnam War* (Bloomington: Indiana University Press, 1989).

35. In "Something to Die For," Vollmann warns that television "is working to bring about the death of the book"; it rarely stands for anything, "although it does so when needed as a propaganda tool, as when one drops bombs in Iraq" (*Review of Contemporary Fiction* 13:2 [summer 1993]: 25–27).

36. William T. Vollmann, "Forum on Pornography and Censorship," *Fiction International* 22 (1992): 46.

37. Michael Herr, *Dispatches* (New York: Knopf, 1977).

38. Acker's *Blood and Guts in High School* is illustrated with the author's own "pornographic" doodles; several of her book jackets are illustrated by Sue Coe, whose work, like R. Crumb's, captures the horrors of industrial society, mechanistic labor, alienated relationships, sexual phantasmagoria.

39. Vollmann suggests the following social changes: "Abolish television, because it has no reverence for time. . . . Make citizenship contingent on literacy in every sense. Thus, politicians who do not write every word of their own speeches should be thrown out of office in disgrace. . . . Teach reverence for all beauty, including that of the word" (*Review of Contemporary Fiction* 13:2 [summer 1993]: 27).

40. Robert Stam, *Reflexivity in Film and Literature from Don Quixote to Jean-Luc Godard* (Ann Arbor: UMI Research Press, 1985), 131.

41. Richard Kostelanetz, "New Fiction in America," in *Surfiction: Fiction Now and Tomorrow,* 2d ed., ed. Raymond Federman (Chicago: Swallow Press, 1981), 86, cited in Siegle, *Suburban Ambush,* 394.

42. Siegle, *Suburban Ambush,* xii.

43. Charles Monaghan, "The Shock of the Newcomer," *Washington Post Book World,* February 13, 1994, 11.

44. Viktor Shklovsky, *Theory of Prose,* trans. Benjamin Sher (Elmwood Park, Ill.: Dalkey Archive Press, 1990), 72–73; see also Reed, *An Exemplary History,* 76.

45. As George Landow points out in *Hypertext: The Convergence of Contemporary Critical Theory and Technology* (Baltimore: Johns Hopkins University Press, 1992, 205n1), semiotics, poststructuralism, and structuralism relate to computer hypertext in important ways, but they are not essentially the same.

46. William Bennett, "To Reclaim a Legacy," text of report on humanities in education, *Chronicle of Higher Education,* November 28, 1984, 16–21.

47. Michel Foucault, "What Is an Author?" in *Textual Strategies: Perspectives on Post-Structuralist Criticism,* ed. Josué V. Harari (Ithaca: Cornell University Press, 1979), 141–60.

48. Robert Coover, "The End of Books," *New York Times Book Review,* June 21, 1992, 1, 23–25.

49. Landow, *Hypertext,* 109.

50. Robert Coover, "Hyperfiction: Novels for the Computer," *New York Times Book Review,* August 29, 1993, 1.

51. Landow, *Hypertext,* 107–8.

52. Carolyn Guyer and Martha Petry, "Izme Pass," *Writing on the Edge* 2:2 (spring 1991), cited in Coover, "The End of Books," 9, 12.

53. Coover, "The End of Books," 1, 23.

54. McCaffrey, "Interview with Vollmann," 21.

55. William Vollmann, *The Rainbow Stories* (New York: Atheneum, 1989), 445.

56. In *Postmodern Culture,* see, for example: Robert Coover, "The Adventures of Lucky Pierre," and William Vollmann, "Incarnations of the Murderer," 3:1 (September 1992); Kathy Acker, "Obsession," 2:3 (May 1992). Acker also serves on the journal's editorial board.

57. Coover, "Hyperfiction," 9.

58. Landow, *Hypertext,* 87.

59. Derrida's *Post Card* is discussed in Kauffman, *Special Delivery,* chap. 3.

60. Acker, *Hannibal Lecter, My Father,* 10.

61. The protest letter of a self-appointed, international watch-dog committee charged that "M. Derrida describes himself as a philosopher. . . . [But his] influence has been to a striking degree almost entirely in fields outside philosophy— in departments of film studies . . . or of French and English literature" (Jacques Derrida, "Honoris Causa: 'This Is Also Extremely Funny,'" in *Points . . . Interviews, 1974–1994* [Stanford: Stanford University Press, 1995]). Herman Rapaport points out that the "absurdity of wanting to deny Derrida an honorary degree revealed considerable hostility toward interdisciplinarity. . . . [The] signatories presumed that no serious philosophy could be found in Marcel Duchamp, John Cage, or Meredith Monk. Or that no collaboration between artists and philosophers could compel academic philosophers to acknowledge the limitations of their monopolistic rubrics and practices" ("Forum on Interdisciplinarity," *PMLA* 111:2 [March 1996]: 285–86).

62. Landow, *Hypertext,* 19.

63. Michael Ryan, *Marxism and Deconstruction: A Critical Articulation* (Baltimore: Johns Hopkins University Press, 1982), xiii–xiv, 114–16. Landow discusses Ryan's ideas in *Hypertext* on 179–82.

64. Mark Poster, *The Second Media Age* (Cambridge: Polity Press, in association with Blackwell, 1995), 27.

65. Bill Nichols, "The Work of Culture in the Age of Cybernetic Systems," *Screen* 29:1 (winter 1988): 22–47.

CHAPTER NINE: MASKED PASSIONS

1. Supreme Court Justice Oliver Wendell Holmes established the "clear and present danger" doctrine in 1919 to justify, retroactively, the actions of numerous prosecutors who imprisoned thousands of people for "sedition," because they expressed ideas critical of the draft, the government, or World War I. *Schenck v. United States,* 249 U.S. 47,52 (1919) (deciding that an utterance is not protected by the First Amendment when the "words used . . . are of such a nature as to create a clear and present danger that . . . will bring about . . . substantive evils"); *Debs v. United States,* 249 U.S. 211, 216 (1919) (finding well-known socialist and presidential candidate Eugene Debs guilty of sedition for speaking out against U.S. involvement in World War I); *Abrams v. United States,* 250 U.S. 616, 623–24 (1919) (holding that words that have as their natural tendency, and reasonably probable effect, the obstruction of recruitment are not protected by the First Amendment). See Linda S. Kauffman, review of Edward de Grazia, *Girls Lean Back Everywhere: The Law of Obscenity and the Assault on Genius* (New York:

Random House, 1992), *Cardozo Arts and Entertainment Law Journal* 11:3 (1993): 765–75.

2. Jerome Klinkowitz, *Literary Subversions: New American Fiction and the Practice of Criticism* (Carbondale: Southern Illinois University Press, 1985), xxvii–xxviii.

3. Kauffman, review of de Grazia, 769. Ironically, Cal Thomas, speaking in favor of killing the National Endowment for the Arts at the Christian Action Network's "degenerate art" show in the Rayburn Building in Washington, D.C., on June 27, 1995, noted that "Faulkner never received an NEA grant." Thomas seems unaware of Faulkner's censorship battles and even of the controversial content of his fiction (see Chapter 1 herein).

4. Andrea Dworkin, *Mercy* (New York: Four Walls Eight Windows Press, 1990), 1. Subsequent citations in text are by page. To distinguish the fictional narrator from the author, I refer to the former as Andrea, the latter as Dworkin, but the distinction is purposely blurred in the novel.

5. "Where Do We Stand on Pornography?" *Ms.*, January-February 1994, 39.

6. "Pornography: Does Women's Equality Depend on What We Do About It?" *Ms.*, January-February 1994, 43.

7. Donald Alexander Downs, *The New Politics of Pornography* (Chicago: University of Chicago Press, 1989), 30.

8. Ibid., 60.

9. Lisa Duggan, Nan Hunter, and Carole S. Vance, "False Promises: Feminist Antipornography Legislation in the U.S.," in *Women against Censorship,* ed. Varda Burstyn (Vancouver: Douglas and McIntyre, 1985), 135.

10. Downs, *New Politics of Pornography,* 42.

11. Donna Turley, "The Feminist Debate on Pornography: An Unorthodox Interpretation," *Socialist Review* 16:3–4 (May-August 1986): 81–96.

12. David Cole, "Terrorizing the Constitution," *The Nation,* March 25, 1996, 11–15. Shortly before the House vote, Barry Scheck, in an interview with Charlie Rose, April 8, 1996, warned that congressional Republicans are systematically dismantling habeas corpus, thereby radically undermining the Constitution.

13. Joyce Johnson, "Annals of Crime: Witness for the Prosecution," *The New Yorker,* May 16, 1994, 42–51.

14. Downs, *New Politics of Pornography,* 131, 135–39, 157.

15. The Miller ruling set forth a standard for determining whether material is obscene and thus regulatable without violating the First Amendment. It is a three-pronged test: (1) whether the average person, applying community standards, would find that the work, taken as a whole, appeals to the prurient interest; (2) whether the work depicts or describes, in a patently offensive way, sexual conduct specifically defined by the applicable state law; and (3) whether the work taken as a whole, lacks serious literary, artistic, political, or scientific value. *Miller v. California* 413 U.S. 15, 24 (1972) (citations omitted).

16. Downs, *New Politics of Pornography,* 45–67.

17. Ibid., 136.

18. Catharine MacKinnon, *Only Words* (Cambridge, Mass.: Harvard University Press, 1993), 3.

19. Carlin Romano, review of *Only Words,* in *The Nation,* November 15,

1993, 563–70. Romano speculates: "*Suppose* I decide to rape Catharine Mac-Kinnon before reviewing her book . . . *I chicken out* . . . so I do the next best thing: I *imagine* the act. . . . I write my review, describing the rape in savage, pornographic, Bret-Easton-Ellis-detail. . . . *I don't expect that the rape, as I describe it, will seem an attractive or enviable experience to anyone else.* I suspect most readers will construe it as a *theoretical* gambit" (italics added). But readers did *not* construe Romano's gambit theoretically. They ignored the hypothetical nature of the words I have italicized, as well as the distinction between fantasy and reality.

20. Wendy Kaminer, "Exposing the New Authoritarians," cited in Nadine Strossen, *Defending Pornography: Free Speech, Sex, and the Fight for Women's Rights* (New York: Scribner, 1995), 170; Strossen discusses the Romano flap on 171–72.

21. Strossen, *Defending Pornography,* 171.

22. *The Attorney General's Commission on Pornography Final Report* (Washington, D.C.: U.S. Government Printing Office, 1986), 2:1615.

23. Philip Nobile and Eric Nadler, *United States of America vs. Sex: How the Meese Commission Lied about Pornography* (New York: Minotaur Press, 1986), 1.

24. Susie Bright, *Susie Sexpert's Lesbian Sex World* (Pittsburgh, Pa.: Cleis Press, 1990), 14.

25. *The Attorney General's Commission on Pornography Final Report,* 1:224–26, 903–7.

26. Ronald J. Berger, Patricia Searles, and Charles E. Cottle, *Feminism and Pornography* (New York: Praeger, 1991), 22–28.

27. de Grazia, *Girls Lean Back,* 584.

28. Edwin Meese, "The Porn Report: Five Years Later," *Focus on the Family Citizen* 5:10 (October 21, 1991): 2–3; see also Meese, "The Attorney General Replies to His Critics," *Policy Review* 35 (winter 1986): 32–52.

29. de Grazia, *Girls Lean Back,* 582; see also endnotes on 762–65.

30. Ibid., 606–7, 677.

31. On Dobson, see Marc Fisher, "The G.O.P.: Facing a Dobson's Choice," *Washington Post,* July 2, 1996, D1–2; on Bauer, see Elizabeth Kulbert, *New York Times,* November 1, 1995, A14.

32. Frank Rich, *New York Times,* April 20, 1996, 21.

33. Barry Lynn, in Nobile and Nadler, *U.S. v. Sex,* 330; on the child pornography law *New York v. Ferber* (1982), see Downs, *New Politics of Pornography,* 136.

34. Burstyn, *Women against Censorship,* 169–78.

35. Park Elliott Dietz et al., "Detective Magazines: Pornography for the Sexual Sadist?" in Meese Commission, *Final Report,* 1:55–69.

36. Dietz was one of two psychiatrists the Bush administration enlisted to discredit Hill; the second, Dr. Jeffrey Satinover, insisted that it was impossible to diagnose Hill from a distance. See Timothy M. Phelps and Helen Winternitz, *Capitol Games: Clarence Thomas, Anita Hill, and the Story of a Supreme Court Nomination* (New York: Hyperion, 1992), 361.

37. MacKinnon, *Only Words,* 65.

38. Johnson, "Annals of Crime," 45. Unfortunately *The New Yorker* turned Johnson's extensive and meticulously researched analysis of Dietz's symbiotic identification with Dahmer into a truncated celebrity profile.

39. Ibid., 43, 45; Clive Bloom says the same thing about Jack the Ripper in "Grinding with the Bachelors," in *Perspectives on Pornography: Sexuality in Film and Literature,* ed. Gary Day and Clive Bloom (New York: St. Martin's Press, 1988), 22.

40. Johnson, "Annals of Crime," 49.

41. Telephone conversation with Joyce Johnson, April 1993.

42. Johnson, "Annals of Crime," 50.

43. Ibid. MacKinnon blames "an academy saturated with deconstruction," *Only Words,* 7.

44. *The Attorney General's Commission on Pornography Final Report,* 1:227–32, 299–306, 322–28, 737–45, 767–836.

45. *New York Times,* November 7, 1991, B4.

46. John Irving, "Pornography and the New Puritans," *New York Times Book Review,* March 29, 1992, 1, 24–25.

47. *Los Angeles Times,* July 9, 1993, A1.

48. *Santa Monica Outlook,* July 9, 1993, A1.

49. L. J. Davis, "Will Charlie Keating Ride Again?" *Washington Monthly* 29:3 (March 1997): 28–35.

50. Lisa Duggan, speech on the antipornography movement for the Boston collective Black Rose at MIT, March 29, 1985, cited in Turley, "Feminist Debate on Pornography," 90.

51. Bret Easton Ellis, "The Twenty-somethings: Adrift in a Pop Landscape," *New York Times,* December 2, 1990, H1, 37. His shrewd assessment of spectators' shifting allegiances to both heroine *and* villain has since been confirmed by Carol J. Clover in *Men, Women, and Chain Saws* (Princeton: Princeton University Press, 1992).

52. Peter Greenaway's *The Cook, the Thief, His Wife, and Her Lover* similarly ends in cannibalism to allegorize the savagery of Thatcherite England.

53. See Laura Kipnis, "(Male) Desire and (Female) Disgust: Reading *Hustler,*" in *Cultural Studies,* ed. Lawrence Grossberg, Cary Nelson, and Paula A. Treichler (London: Routledge, 1992), 373–91.

54. Leo Bersani, "Is the Rectum a Grave?" in *AIDS: Cultural Analysis/Cultural Activism,* ed. Douglas Crimp (Cambridge, Mass.: MIT Press, 1987), 214.

55. Todd Gitlin, "Prime Time Ideology: The Hegemonic Process in Television Entertainment," in *Television: The Critical View,* ed. Horace Newcomb, 4th ed. (New York: Oxford University Press, 1987), 507–32.

56. Guy Debord, *Society of Spectacle* (Detroit: Black and Red, 1977), #59.

57. F. Scott Fitzgerald, *The Great Gatsby* (New York: Scribner, 1925), 67.

58. Fyodor Dostoyevsky, *Notes from Underground,* trans. and intro. Jessie Coulson (New York: Penguin, 1972), 123.

59. In the director's version prepared for laser disk and videotape, Oliver Stone restored all 150 cuts that had been made in order for the film to qualify for an R rating from the Motion Picture Association of America. "If I'm going to take the heat, let them see what I did, not a compromised version," said Mr.

Stone. His purpose was "to depict a society saturated with extreme violence, and the way to do that palatably was to exaggerate situations so they became almost comical." Hank Corwin, one of the film's two editors, adds, "They [the MPAA board] were trying to take out violence, but what they were doing was eliminating elements that made it more of a satire" (*New York Times,* April 14, 1996, H15, 24).

60. Roger Rosenblatt, "Snuff This Book! Will Bret Easton Ellis Get Away with Murder?" *New York Times Book Review,* December 16, 1990, 3, 16; Rosenblatt also indicts Sonny Mehta for being "as hungry for a killing as Patrick Bateman" (16).

61. Bret Easton Ellis, *American Psycho* (New York: Vintage, 1991), epigraph; hereinafter cited parenthetically in text by page number.

62. Elizabeth Young, "The Beast in the Jungle, the Figure in the Carpet," in *Shopping in Space: Essays on American "Blank Generation" Fiction,* ed. Elizabeth Young and Graham Caveney (London: Serpent's Tail/Atlantic Monthly Press, 1992), 95.

63. Ibid., 102, 105.

64. Ibid., 103, 121.

65. Cronenberg quoted in Matthew Tyrnauer, "Who's Afraid of Bret Easton Ellis?" *Vanity Fair,* August 1994, 94–97, 124–25.

66. *Newsweek,* August 12, 1996, 72.

67. Bret Easton Ellis, "Welcome to the Boomtown," in *Our Hollywood,* by David Strick (New York: Atlantic Monthly Press, 1988), 12–16.

68. Christopher Lehmann-Haupt, *New York Times,* March 11, 1991, C18, 1A.

69. *Ms.,* January–February 1994, 44.

70. Debord, *Society of Spectacle,* #67 (emphasis added).

71. Mark Seltzer, "Serial Killers (1)," *Differences* 5:1 (1993): 92–128.

72. Bloom, "Grinding with the Bachelors," 23.

73. Although American Express denies exerting any legal pressure, Vintage did delete a reference to the killer being employed by the Shearson unit of American Express (*Wall Street Journal,* February 22, 1991, 1A, 1B, B5). When Reagan was president, American Express solicited First Daughter Patti Davis for a commercial appearance. Patti wittily exposes the company's naïveté about her hostile relationship with her famous dysfunctional parents: "I couldn't imagine how they would make it seem plausible. Put me in front of the White House and have me say, 'You don't know me—and they don't either'?" *As I See It* (New York: G. P. Putnam's Sons, 1992), 301.

74. Ellis, "The Twenty-somethings," H1, 37.

75. Alexander Star, "The Twenty-something Myth," *New Republic,* January 4 and 11, 1993, 22–25. As Jeff Shesol points out, by the 1996 election, the phenomenon reached hysterical proportions: the founder and director of Democrats with Attitude notes, "Precinct causes, conventions, issues meetings—young people don't like them much." What do they like? "Fun events, fun logos, fun things," like Al Franken's stand-up comedy, upbeat modern rock, bar parties, barbeques, beach balls. Politics is just another facet of pop culture, and citizens are merely consumers. *Washington Post,* March 2, 1997, C2.

76. Robert Massie, president of the Author's Guild, sees the real issue not as censorship but breach of contract: Simon and Schuster had at least two opportunities to reject the manuscript; first, when they offered Ellis a $300,000 advance, and again when he delivered the typescript. After that, they had no more right to renege than he would have had if he had found a publisher willing to pay more money (*Publishers Weekly,* November 30, 1990, 8–10). Sales figures were reported in Jennet Conant's profile of Sonny Mehta, *Esquire,* April 1993, 140.

77. Downs, *New Politics of Pornography,* 159.

78. John Sutherland, *Times Literary Supplement,* June 26, 1992, 11.

79. Young, "The Beast in the Jungle," 88, quoting Ellis in *Rolling Stone,* April 1991.

80. There had, however, been intense objections to the book internally at Simon and Schuster: Ellis's jacket illustrator, George Corsillo, refused to illustrate it; publisher Jack McKeown and editorial director Alice Mayhew hated it, as did several other senior people. Robert Asahina was Ellis's editor, but he did very little editing. Phoebe Hoban, "'Psycho' Drama," *New York Magazine,* December 17, 1990, 33–37.

81. *New York Times,* April 23, 1996, D1, D8.

82. Bryan Burrough, "The Siege of Paramount," *Vanity Fair,* February 1994, 67–70, 129–36, 138.

83. Susan Shapiro, "Judith Regan," *New York Times Magazine,* July 17, 1994, 24.

84. Richard Ohmann, "The Shaping of the Canon of U.S. Fiction, 1960–75," *Critical Inquiry* (September 1983): 199–223; see also his *Selling Culture: Magazines, Markets, and Class at the Turn of the Century* (London: Verso, 1996).

85. Klinkowitz, *Literary Subversions,* xi–xii.

86. Mark Crispin Miller, "Free the Media," *The Nation,* June 3, 1996, 9–15; fold-out chart on "The National Entertainment State," 24–26; commentary by media analysts, 14–32.

87. Paul Farhi, "The Quiet Invasion of the Media Moguls," *Washington Post,* November 27, 1988, H1, H5.

88. André Schiffrin, *The Nation,* June 3, 1996, 29–32.

89. Shapiro, "Judith Regan," 22.

90. Bret Easton Ellis reviewed Caleb Carr's *The Alienist* in *Vanity Fair,* April 1994, 108.

91. Seltzer, "Serial Killers (1)," 94.

92. *New York Times,* April 21, 1996, 45–6.

93. Fay Weldon, *Washington Post,* April 28, 1991, C1, C4.

94. William Bennett, *The Book of Virtues* (New York: Simon and Schuster, 1992) proved so lucrative ($5 million in three years) that it has spawned an entire piety industry; a more recent entry is Stephen L. Carter, *Integrity* (New York: HarperCollins, 1995).

95. Carol Iannone, "PC and the Ellis Affair," *Commentary,* July 1991, 52–54.

96. Klinkowitz, *Literary Subversions,* xxvi.

97. *Washington Post,* May 10, 1991, C1–2, which also reports that her essay "Literature by Quota" (*Commentary,* March 1991) contended that four leading black novelists—Alice Walker, Gloria Naylor, Charles Johnson, and Toni Morrison—received prestigious literary awards not on merit but because of their race. In an editorial on May 20, 1991 (p. A10), the *Washington Post* nevertheless endorsed Iannone's nomination, which failed.

98. *Washington Post,* May 10, 1991, C2.

99. George F. Will, *Newsweek,* April 22, 1991, quoted in the *Washington Post,* May 10, 1991, C1–2.

100. George F. Will, *Newsweek,* March 25, 1991, 65–66.

101. Myron Magnet, *The Dream and the Nightmare: The Sixties' Legacy to the Underclass* (New York: William Morrow, 1993); see also Sidney Blumenthal's review, *New York Times Book Review,* July 25, 1993, 11–12.

102. de Grazia, *Girls Lean Back,* 560 on Nixon; 552 on Agnew.

103. Maureen Dowd, *New York Times,* June 30, 1996, E15; see also the *Washington Post,* June 29, 1996, A1, A14, and July 3, 1996, C1–2.

104. Dowd, *New York Times,* June 30, 1996, E15.

105. E. J. Dionne, "The Burdens of Overkill," *Washington Post,* August 18, 1996, C7.

106. Including for such racist, right-wing radio talk show hosts as Bob Grant, who was fired by WABC in New York for a slur about Ron Brown following his plane crash on April 3, 1996. Disney Corporation, the new owner of Capital Cities/ABC, was pressured to fire Grant by Jesse Jackson and Al Sharpton, who crowed, "WABC ignored us for years . . . but a multinational corporation like Disney has to respond, because it's more vulnerable." Disney's capitulation shows how much independence the news media has lost, and how vulnerable they are to any interest group, whether it is Sharpton, NOW, or William Bennett. See Frank Rich, *New York Times,* April 24, 1996, A21.

EPILOGUE

1. Clive Bloom, "Grinding with the Bachelors," in *Perspectives on Pornography: Sexuality in Film and Literature,* ed. Gary Day and Clive Bloom (New York: St. Martin's Press, 1988), 21–22.

2. Elizabeth Grosz, *Volatile Bodies: Toward a Corporeal Feminism* (Bloomington: Indiana University Press, 1994), 86–87.

3. Nadine Strossen, *Defending Pornography: Free Speech, Sex, and the Fight for Women's Rights* (New York: Scribner, 1995), 95.

4. Lawrence A. Stanley, "The Child Porn Myth," *Cardozo Arts and Entertainment Law Journal* 7 (1989): 295–358, cited in Strossen, *Defending Pornography,* 95.

5. *Los Angeles Times,* August 23, 1993, A3, A20.

6. Judith Halberstam, "Forum on Pornography and Censorship," *Fiction International* 22 (San Diego: San Diego State University Press, 1992), 39–40.

7. Paragraph 22 of Paula Jones's affidavit states, "There were distinguishing

characteristics in Clinton's genital area that were obvious to Jones." Transcript of affidavit, filed May 6, 1994, *Paula Corbin Jones v. William Jefferson Clinton and Danny Ferguson,* Eastern District of Arkansas.

8. On CAN's defamation of Nabokov, see Chapter 1 herein; on James Joyce's defamation, see "Letters to the Editor from Andrea Dworkin and Others," *New York Times Book Review,* May 3, 1992, 15–16, in response to John Irving, "Pornography and the New Puritans."

9. Jack Kroll said that Cronenberg deserved the Cannes prize, and that *Sick* is "more shocking, but quieter" than *Crash: "Sick* is real, a compassionate account of perversion as a tragicomic kind of salvation" (*Newsweek,* March 24, 1997, 78).

Index

Note: Italicized page numbers represent illustrations.

Compositor: Integrated Composition Systems
Text: 10/13 Sabon
Display: Officina Sans
Printer and binder: Data Reproductions Corporation